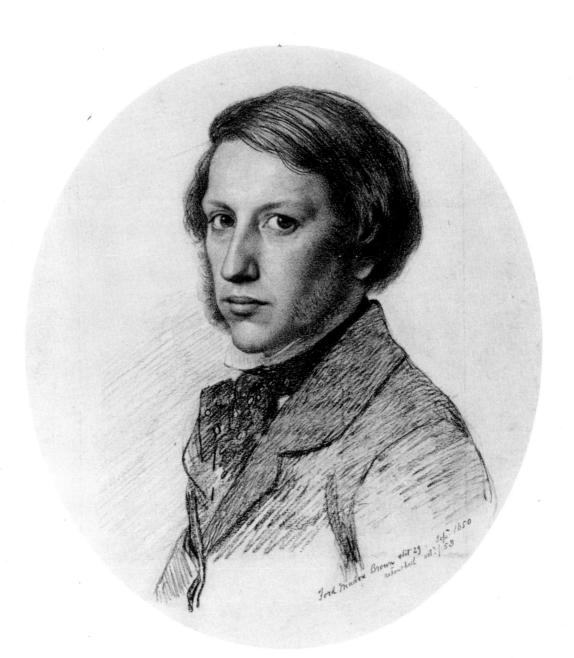

Mary Bennett

Artists of the Pre-Raphaelite Circle

The First Generation

Catalogue of Works in the
Walker Art Gallery, Lady Lever Art Gallery and Sudley Art Gallery

Published for the
National Museums and Galleries on Merseyside
by Lund Humphries · London

Copyright © 1988 National Museums and Galleries on Merseyside
and Mary Bennett

First edition 1988

Published for the National Museums and Galleries on Merseyside
by Lund Humphries Publishers Ltd
16 Pembridge Road, London W11 3HL

British Library Cataloguing in Publication Data
Bennett, Mary
Artists of the Pre-Raphaelite circle:
the first generation: catalogue of
works in the Walker Art Gallery, Lady
Lever Art Gallery and Sudley Art Gallery.
1. English paintings. Pre-Raphaelitism –
Catalogues
I. Title II. National Museums and
Galleries on Merseyside
759.2

ISBN 0 85331 539 6

Designed by Alan Bartram

Typeset in 8 on 10 point Linotron 202 Melior Light
by Nene Phototypesetters Ltd, Northampton

Printed on 135 gsm Fineblade Smooth paper, and bound by
BAS Printers Ltd, Over Wallop, Stockbridge, Hampshire

Front cover:
Ford Madox Brown, *Waiting: An English Fireside of 1854–5*
Walker Art Gallery (detail of No. 10533)

Half title:
Ford Madox Brown, *Self-portrait* (No. 10505)

Contents

Preface

In the 1850s, at a critical moment in their development, several artists of the Pre-Raphaelite Brotherhood and their circle were awarded the £50 prize at the Liverpool Academy exhibitions. Appropriately, just over 100 years later in the 1960s, the Walker Art Gallery was again at the forefront of the rediscovery of the achievements of this movement and led the way in their presentation to a new generation.

Mary Bennett, Keeper of British Art, created this pioneering role for the Gallery and has established for it a reputation as a centre for the study of this movement and of Victorian painting. She organised the brilliant series of judiciously selected one-man exhibitions of Ford Madox Brown, 1964, John Everett Millais, 1967, and William Holman Hunt, 1969. Each was accompanied by a perceptive and scholarly catalogue.

She has also turned her attention to the group of Liverpool artists such as William Davis, James Campbell and William Windus who fell under the spell of the brilliant colour and minute detail of the Pre-Raphaelites. She incorporated her researches on these artists in her far-reaching study of local art and patronage, *Merseyside Painters, People & Places*, 1978. The present catalogue on the Pre-Raphaelites of the first generation, her final work at the Gallery, gives a detailed history of each picture and attempts to set the more important ones into their contemporary context.

The enrichment of our Pre-Raphaelite holdings in recent years with such additions as the beautiful series of drawings by Ford Madox Brown, his masterly picture, *Waiting*, and the exquisite drawing of *Ferdinand and Ariel* by Millais, is the direct result of the reputation she has built up for the Gallery and the contacts that she has established.

As this is her final major contribution to the Gallery, I would like to end on a more personal note and place on record the Gallery's deep debt of gratitude to her. Many who do not know her will perhaps assume that her interests are confined to the nineteenth century. This is far from being the case. Her influence has touched all aspects of the Gallery's work. She has been particularly concerned during her career to strive for the highest standards of scholarship. Scholarship has been seen by her as the basis for presenting the collections for the greater understanding and pleasure for our wide circle of visitors.

TIMOTHY STEVENS
August 1987

Acknowledgments

Work on this catalogue has extended over a period of years. It has depended on the generous assistance of many colleagues in the art gallery and art history world, to whom I am most grateful. I should particularly like to thank my colleagues in the Walker Art Gallery for their valuable help and support, first and foremost Timothy Stevens, who, as Director of Art Galleries under Merseyside County Council, afforded me the opportunity to continue my researches in this field and to write this catalogue. He has also, together with Edward Morris, Keeper of Foreign Art, provided much unstinted advice and information; to the latter I am particularly grateful for sharing with me his researches on the Leverhulme collections. Xanthe Brooke, Jim France, Alex Kidson, Frank Milner and Lucy Wood have provided much helpful support and I am indebted to Betty Gallagher, Alison Glascott, Nancy King, Mike Lindop, Christine Parry, Lynda Strachan and Áine Wolstenholme for their understanding clerical and administrative expertise. To the staff of Liverpool City Library I owe a deep debt for their constant helpfulness and support. To Judith Bronkhurst and Malcolm Warner I owe the most up-to-date information on aspects of the work respectively, of Holman Hunt and Millais and I should particularly like to thank them for allowing me to consult their Ph.D. Theses on these artists. To the kindness of David Cordingly and M. H. S. Hickox I owe much information on John Brett; to Deborah Cherry source material on Madox Brown in addition to my own work on this artist; to George Landow permission to take advantage of his publications on Holman Hunt; to Penelope Gurland unstinted sharing of her researches on Martineau; to Ben Read valuable information on Munro and Woolner; and to Julian Treuherz much helpful information in particular to do with Manchester sources. From published sources I am particularly indebted to Virginia Surtees', Alastair Grieve's and A. C. Sewter's works for Rossetti and Madox Brown; to Marcia Pointon on Dyce, Robin Gibson on Hughes, Betty O'Looney on Sandys, Allen Staley on Pre-Raphaelite landscape and William E. Fredeman on Penkhill material and for much source material. For information and assistance of various sorts I am grateful to Thomas Agnew and Sons, Joyce Ansell, Michael Ball, Jillian Barry, Anne Buck, Juliet Cardell, Messrs Christie, the Courtauld Institute of Art, John Edmondson, the Fine Art Society, Oliver Garnett, Josephine Haven, L. Helliwell, Jane Insley, Adrian Jarvis, Bruce Laughton, Gilbert Leathart, Mrs Mary Links, Jeremy Maas, Lady Mander, Glenise Matheson, M. E. A. Mortimer, John Nichol, Richard Ormond, Leslie Parris, Messrs Phillips, Messrs Sotheby, Stephen Wildman. Acknowledgments to all my correspondents and sources should be indicated in the appropriate footnotes, but if I have inadvertently left a person or source unacknowledged I must apologise and plead indulgence for pressure of work, not from lack of appreciation.

I have been fortunate to obtain the support of present representatives of some of the artists' and patrons' families and I should like to thank Sir Ralph and Lady Millais; Lady Stow Hill; Mrs Roderick O'Conor and a private owner for permission to quote from Madox Brown papers; Miss Diana Holman Hunt and Mrs Elizabeth Burt Tomkin to quote from Holman Hunt papers; Mr J. P. Birch for permission to quote from Seddon papers; Mrs Imogen Dennis for permission to quote from some Rossetti papers; Dr Dower for permission to quote from the Trevelyan papers; and Mr Colin Rae for permission to quote from George Rae's papers. I am most grateful for permission to quote from manuscripts in their care to the John Rylands University Library, Manchester, the Bodleian Library, Oxford, the Royal Academy of Arts, London, the Henry E. Huntington Library, San Marino, California, and W. E. Fredeman and the University of British Columbia, Vancouver. I am indebted for access and information to the London Borough of Camden Local History Library, the Pierpont Morgan Library, New York, the University of Newcastle Special Collections and the Northumberland County Record Office.

For permission to reproduce photographs I have to thank the courtesy of the following public and private collections (acknowledgement accompanies each reproduction): Birmingham Museums and Art Gallery; Bradford Art Galleries and Museums; The Syndics of the Fitzwilliam Museum, Cambridge; The Fogg Art Museum, Harvard University, Cambridge, Massachusetts; The Provost and Fellows of Eton College; Miss Diana Holman Hunt; The Vicar and Churchwardens of St John the Baptist, Tuebrook, Liverpool; The Trustees of the British Museum, London; London Borough of Camden (Local History Library); The Courtauld Institute of Art, London; The Guildhall Art Gallery, London; Messrs Phillips, Auctioneers, London; The Royal Commission on the Historical Monuments of England, London; Messrs Sothebys, Auctioneers, London; The Trustees of the Tate Gallery, London; The Board of Trustees of the Victoria & Albert Museum, London; Manchester City Art Galleries; The John Rylands University of Manchester Library; The Whitworth Art Gallery, University of Manchester; The National Trust; Northampton Museums and Art Gallery; The Visitors of the Ashmolean Museum, Oxford; The Harris Museum and Art Gallery, Preston; Lord Sherfield; Mrs Elizabeth Burt Tomkin; and several private collectors.

I should also like to record my appreciation of Charlotte Burri's sympathetic editorship of my manuscript.

MARY BENNETT

Introduction

The reputation of Liverpool as a major centre for the art of the Pre-Raphaelite Brotherhood rests on two factors: its nineteenth-century collectors and the local artists who supported the circle in their first years of endeavour. John Miller (1795/6–†1873), a Liverpool tobacco merchant of no particular wealth, was the instigator of local interest and two small paintings now in the Walker, from his once vast collection of British paintings, which embraced Turner and Linnell and many local artists as well as Millais and his friends, bridge the whole period here from private sponsorship in the 1850s to public collecting in the 1980s. He commissioned Holman Hunt's brilliantly colourful small version of *The Eve of St Agnes* in the later 1850s and it remained with his family in Liverpool until bequeathed by his granddaughter in 1948. Madox Brown's exquisitely observed *Waiting: An English Fireside of 1854–5* was bought by him from the Liverpool Academy in 1857/8, sold on the final dispersal of Miller's remaining collection in 1881, passed through one major Manchester collection and was lost sight of after 1909. It re-appeared on the art market in 1985 and was purchased by the Walker to enhance our collection in this field.

Between 1850 and 1985 much had occurred in Liverpool. Miller advised the local historical painter W. L. Windus to visit the Royal Academy of 1850 when Millais' *Carpenter's Shop* was vilified in the press. Windus came back converted, and further confirmed in his judgement by Ruskin's public championship of the P.R.B. in 1851, changed his style and encouraged the artists of the Liverpool Academy to give their £50 prize offered at the annual open exhibitions, over a series of years, to several of the then controversial pictures by the circle. This support meant that Millais, Hunt, Madox Brown, Arthur Hughes, Brett and their adherents were encouraged to send many of their finest works to be seen by a public outside London. Their provincial audience however was by no means appreciative and followed the lead of the conservative press in rejecting their work. The Academy suffered severely and lost both public and Town Council support and its exhibitions faded out in the 1860s. Nevertheless at least one collector here in the 1850s besides Miller thought it worth while to purchase their work: John Brett's *Stonebreakers* with its shimmering landscape detail, was bought from the Royal Academy by Thomas Avison and shown at Liverpool, always remained here, and was bequeathed in 1918 to the Gallery. Miller was himself undeterred. He was con-cerned with the development of the artists themselves and helping them on their way. He corresponded with Millais and Rossetti, introduced both local artists and new clients to them and invited Hunt and Madox Brown to his house at Everton. For a few short years he owned the two most telling of Millais' final Pre-Raphaelite pictures, *The Blind Girl* (Liverpool Academy prize 1857) and *Autumn Leaves* (Liverpool Academy, 1858), but he could only afford to keep them for a limited time and sold them again when the market was right, as he did in turn with much of his collection, and these two pictures eventually found their places in the public collections of Birmingham and Manchester.

In the 1860s Miller's role was taken by another collector, whom he had introduced to his friends in the Pre-Raphaelite Brotherhood. George Rae of Birkenhead (1817–1902), manager of the North and South Wales Bank, developed a much more specialised collection. He began by buying from Madox Brown his early *English Autumn Afternoon* (now Birmingham), and commissioned *The Coat of Many Colours*, now in the Walker. He came especially to admire Rossetti's later sensuous style and concentrated on his work. He commissioned the splendid *Beloved* (Tate Gallery), *Sibylla Palmifera*, now in the Lady Lever Art Gallery, and bought *Monna Vanna* (Tate Gallery) from another Wirral collector to make a trio of beauties (figs 1–3). He also bought, from William Morris, a group of Rossetti's exquisite early water-colours and in later years acquired pictures by Spencer Stanhope, Arthur Hughes and J. W. Inchbold. He kept up a constant correspondence with Rossetti and Madox Brown, who offered him new canvases or explained away their long delays in finishing commissions, paid for in advance. At the dispersal of his estate, as late as 1917, a large group was acquired by the Tate Gallery and several by W. H. Lever (1st Viscount Leverhulme) of Port Sunlight.

John Miller also introduced Frederick Leyland (1831–92) to Rossetti. This selfmade, wealthy, brilliantly clever shipowner became one of the artist's two most important patrons, competing with William Graham of Glasgow and London for the artist's latest work. Leyland rented Speke Hall, where Rossetti, Whistler and Madox Brown visited in the 1870s, later owned Woolton Hall and was concerned to furnish his new London house in Princes Gate on a scale of splendour worthy of a merchant prince of the Renaissance. His taste was allied to the Aesthetic movement of which, besides Rossetti, Whistler and Burne-Jones in their very different ways, were leaders.

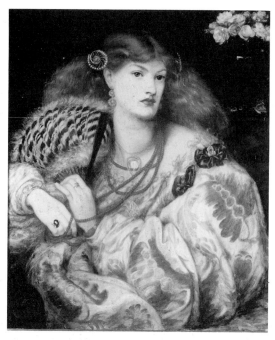

Fig.1 D. G. Rossetti, *Monna Vanna*. By permission of the
Trustees of the Tate Gallery

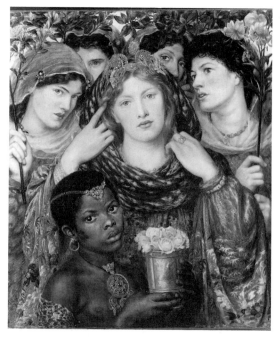

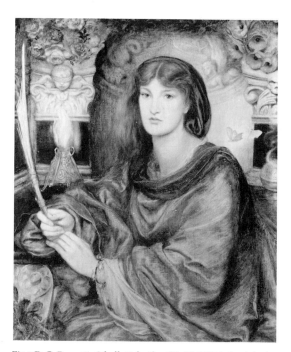

Fig.2 D. G. Rossetti, *The Beloved (The Bride)*. By permission of
the Trustees of the Tate Gallery

He also, like Graham, collected early Italian paintings.
He wished to achieve exactly the right balance of colour,
style, size and subject in the pictures which filled his
house. His famous Dining Room painted with peacocks
by Whistler in defiance of his wishes is well known.
Photographs of other rooms in his London house taken
when his estate was sold off in 1892, show his taste for
extremely rich interiors and the careful isolation of each
artist's work in a coherent group. The Drawing Room (fig.
4) contained a whole series of Rossetti's later female
beauties, of which the *Blessed Damozel* was later to go to
the Lady Lever Art Gallery.

In Liverpool of the mid-1860s big art shows had ceased
following the collapse of the Liverpool Academy and
their absence was felt. In 1871 the Town Council found-
ed their own Autumn Exhibition, run on similar lines to
the Royal Academy but with a broader coverage. The
Walker Art Gallery (fig. 5), given by the Mayor after
whom it was named, was opened in 1877 to hold these
exhibitions and at the same time its committee began
building up a permanent collection. Representative ex-
amples by the key figures in the Pre-Raphaelite circle
were soon being considered.

By this time the youthful aspirants of 1848 were long
dispersed. While in 1848 Holman Hunt, Millais and Ros-
setti had found a common purpose and an affinity of style
in their search for a more serious art, had imitated what
they knew of the innocent style of Italian art before the
time of Raphael, had achieved a brilliance of detail
and colour through looking at nature with a new and
observant eye, and had gained friends and admirers such

Fig.3 D. G. Rossetti, *Sibylla Palmifera* (No.LL 3628 below). Lady
Lever Art Gallery

Opposite: Fig.4 H. Bedford Lemere, photograph of the Drawing
Room at F. R. Leyland's house, 49 Princes Gate, London. By
permission of the Royal Commission on the Historical
Monuments of England

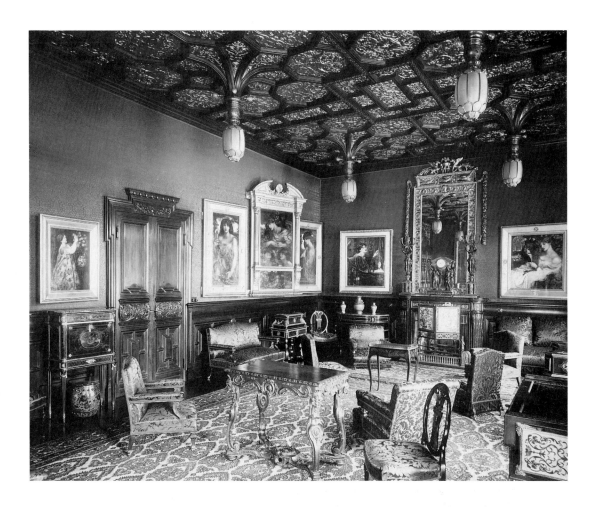

as the older Madox Brown and William Dyce (who himself better knew Italian art than any of them), their paths now barely overlapped, though each had in some degree achieved renown or success. Millais, the young paragon of technical dexterity and perfection of detail, had aligned with the Royal Academy; Rossetti had turned from his intensely personal 'mediaeval' approach in miniature-like watercolours to an even more private world of exotic romanticism and was at the heart of the Aesthetic movement; Holman Hunt had intensified his passion for truth in religious subjects and isolated himself in the Holy Land; Brett had expanded his photographic vision onto fashionably larger and larger canvases; Madox Brown's earlier historical training again dominated his thinking in combination with a new decorative sensuousness; Thomas Woolner, the sculptor of the original Brotherhood, was another adherent of the Royal Academy and was now noted for large-scale public monuments. This was the scene which presented itself at the time of the Walker Art Gallery's first entry into the field and which its collection reflects. The Gallery in no way attempted, as did its rivals at Manchester and Birmingham, to concentrate on the early years of the

Pre-Raphaelite Brotherhood. The first purchase was the large *Dante's Dream* bought from Rossetti in 1881 having been brought to public attention by the enthusiastic young Liverpool journalist T. Hall Caine, soon to become a friend of the artist and to achieve fame himself as a novelist. Millais was a problem. He had had little to do with Liverpool. His later magnificently fluent style in portraiture and pretty girls commanded very high prices. By good fortune his very first Pre-Raphaelite painting, *Isabella*, came on the market in 1881, when it was admired by the Committee; it appeared again in 1884 and was purchased. Funding was difficult for anything not bought direct from the Autumn Exhibition, whose profits provided the only capital for purchases. Holman Hunt had to wait until 1891 when the original version of his very large *Triumph of the Innocents*, dating from the 1880s and still on his hands, was purchased with the aid of a public subscription organised by his young admirer Harold Rathbone, son of P. H. Rathbone, Chairman of the Arts Sub-Committee and himself an important collector. Madox Brown was not considered. The opportunity to purchase his masterpiece *The Last of England* for £300 in 1878 was turned down and pictures he now sent over

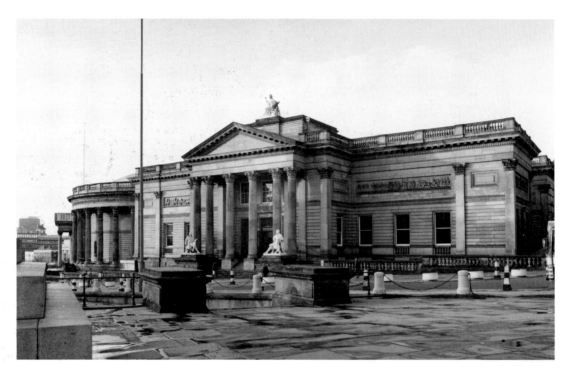

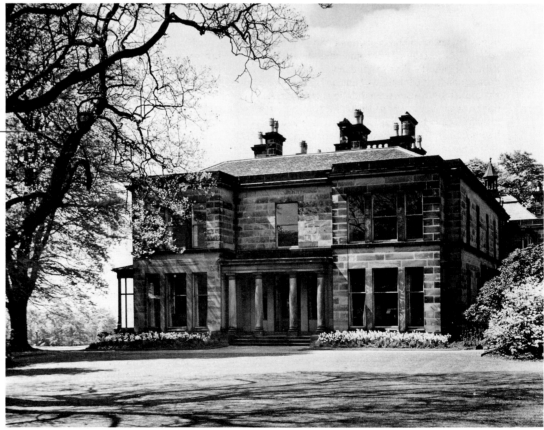

Top: Fig.5 Walker Art Gallery, Liverpool
Bottom: Fig.6 Sudley Art Gallery, Mossley Hill, Liverpool

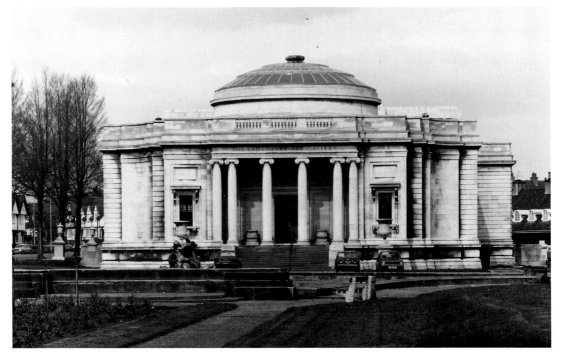

Fig.7 Lady Lever Art Gallery, Port Sunlight

from Manchester, where his ultimate works in the Town Hall were taking shape, were ignored in spite of Harold Rathbone's efforts. His work and that of the others had to depend chiefly on donations. Holman Hunt was prominent again in 1907 when the exhibition of his works, originating in London and also held at Manchester, came to the Walker, when the artist himself presented two of his portrait drawings in recognition of the support of the old Liverpool Academy. A recent painting by Brett was purchased from the Autumn Exhibition in 1900 while his *Stonebreaker* came by bequest in 1918. There was not sufficient public support for a subscription to buy Millais' *The Rescue* in 1919. Pictures from the collection were supported by a series of loans from Manchester, Lord Leverhulme (whose own art gallery was to open in December 1922), and elsewhere as one feature of the extensive Jubilee Autumn Exhibition, 1922. Subsequently, the Pre-Raphaelites, like Victorian paintings generally, faded into neglect, though never entirely losing a following. Their return to serious consideration came with the centenary in 1948, the publication of John Gere's and Robin Ironside's *Pre-Raphaelite Painters* and the various exhibitions held in London, Birmingham, Manchester and at the Lady Lever. In the 1960s the Walker mounted major exhibitions which reconsidered the careers of Madox Brown, Millais and Holman Hunt. In recent years the Gallery has taken the opportunity judicially to expand its holdings now so immensely enhanced by partnership with Sudley and the Lady Lever Art Gallery.

Sudley (fig. 6), the home of George Holt (1825–96), Liverpool shipowner and member of a prominent local family, was, with his picture collection, bequeathed to Liverpool by his daughter Emma in 1944. Holt represents that once considerable group of Liverpool merchants and collectors of the later nineteenth century who owned handsome houses and filled them with contemporary or near contemporary art, usually British and academic, which might also include examples of the Pre-Raphaelite circle or the later Aesthetes. Holt, whose accounts have been preserved, went to a variety of local dealers, bought sometimes at the Autumn Exhibition as well as at the fashionable London shows, but relied principally on the established firm of Thomas Agnew and Sons of Manchester, Liverpool and London. He spent a good deal on his collection and evidently derived much pleasure in choosing his pictures. He acquired a nicely rounded small group of the Pre-Raphaelite circle. It includes both the delicately moving small *Garden of Gethsemane* by William Dyce and the brilliantly psychedelic small version of *The Finding of the Saviour in the Temple* by Holman Hunt. Three works by Millais contrast his earliest style in landscape, his brightly dextrous sketching technique in *Ferdinand and Ariel* and his brilliantly bravura impasted brushwork in the later *Vanessa*. Some of Holt's pictures came from the sales of other merchant collectors of Liverpool and the North which he may have already known and admired. He too was to embark on direct patronage of J. M. Strudwick, pupil and follower of Burne-Jones.

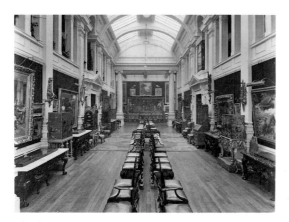

Fig.8 Main Hall of Lady Lever Art Gallery, Port Sunlight

His death in 1896 coincided with the opening phase of W. H. Lever's collecting. Lever (1851–1925), leading manufacturer, millionaire founder of Port Sunlight and successively Sir William Lever, Bart (1911), 1st Baron Leverhulme of Bolton-le-Moors (1917), and 1st Viscount Leverhulme of the Western Isles (1922), collected on a vast scale to match his resources. In contrast to such a private and characteristic collection as Holt's, or to the considered aesthetic approach of Leyland, Lever's embraced a wide horizon in painting and the decorative arts. The distinction of his collection was its specialisation in English art of the eighteenth and nineteenth centuries. His Pre-Raphaelite pictures form only a fraction even of his picture collection and those now in the Lady Lever Art Gallery (figs 7, 8) only part of what he bought of the work of the circle (see Appendix on p.197: this catalogue also takes no account of his considerable holdings in works by Edward Burne-Jones).

His collection falls into two periods: the works he bought for himself in the 1890s (after first essays in buying for his soap advertisements), and to fill his several houses at Bolton, Thornton in Wirral and in London; and those he bought from about 1910 onwards with his scheme of an art gallery in mind. Following various smaller displays, he opened a purpose-built gallery at the centre of his model village of Port Sunlight in 1922, for the recreation and pleasure of his workforce. Millais was an early favourite. He had achieved the Presidency of the Royal Academy in 1896, the year of his death, and his work was expensive. Lever bought that year, from another collection, the recent sentimental *The Nest* for over £2,000 and the charming *Little Speedwell's Darling Blue*, and soon after Millais' death, pictures dating from

his Pre-Raphaelite days: *The Black Brunswickers*, for over £3,000 and *The Violet's Message* and *Wedding Cards* (both now private collections). He had bought six by 1902 as well as engravings, and bought another fourteen drawings and oils between 1910 and 1923. The latter included several large canvases appropriate for public display. Several remained with his family and the grand fête champêtre *Spring: Apple Blossoms* (Royal Academy 1859) has been recently acquired by the newly formed National Museums and Galleries on Merseyside. For his art gallery Lever concentrated on the three original founder-members of the Pre-Raphaelite Brotherhood, Millais, Hunt and Rossetti, along with their close friend Madox Brown, and he had just one Arthur Hughes. He purchased a whole group of Rossettis in 1917 from the Rae Estate (some, including the drawings, since dispersed) and bought *The Blessed Damozel*, formerly belonging to Leyland, in 1922. Though he brought his collection to Merseyside he was very much London orientated and purchased from other important early twentieth-century collections: Millais' *Sir Isumbras* from the McCulloch collection in 1913 for over £8,000 (the largest sum he paid for one of these artists' work) and Holman Hunt's *Scapegoat* from the Quilter sale in 1923 for nearly £5,000. This picture, which even as late as 1923 commanded a considerable price, was perhaps the most telling of the whole group of his purchases. With its essentially moral image it perhaps underlines the didactic aspect of Leverhulme's intent in opening his gallery.

Parts of his collection were dispersed after his death and some at later dates. In 1978 this hitherto privately funded gallery passed to the care of Merseyside County Council, to join the Walker Art Gallery and Sudley.

These three collections, once quite independent, now all form part of the National Museums and Galleries on Merseyside. Through this amalgamation of resources they together touch on all periods of the careers of the artists of the Pre-Raphaelite circle and reveal the impact on them of popular success or of seclusion or of near failure. This catalogue concentrates on the holdings of the immediate circle, leaving the later followers of Rossetti and others of the subsequent Aesthetic movement centred on the figure of Burne-Jones to a subsequent catalogue. Within this limitation, the participants are revealed not merely in their role as heralders of a new direction in English painting but as contributors to the larger canvas of Victorian art, which has at last achieved its rightful consideration in European art history while never at any stage having quite lost its appeal to a wide circle of admirers.

MARY BENNETT

Boyce, George Price (1826–97)

Landscape painter, chiefly in watercolour. Born London 24 September 1826, son of a City wine merchant and with private means. Began training as an architect and entered as a student in the School of Architecture of the Royal Academy, 31 March 1848. From 1849 turned to landscape painting, encouraged by David Cox who gave him lessons and first influenced his style. Met Thomas Seddon and through him Rossetti, then others of the circle and Ruskin, who also gave him advice. Recorded their activities in his diary (1851–75) and collected their works. In the later 1850s his work took on the minute and detailed realism and bright colouring of the Pre-Raphaelites but broadened in the later 1860s. Later became a friend of Whistler. Exhibited at the Royal Academy from 1853 and extensively at the Society of Watercolour Painters from 1864, when he was elected Associate; and Member in 1877. Married a French girl, Caroline Soubeiran, 1875. Died London 9 February 1897.

10343. *Sandpit near Abinger, Surrey*

Watercolour,[1] 20.1 × 28.2 cm ($7^{15}/_{16}$ × $11^{1}/_{8}$ in)
Signed and dated: *G. P. Boyce 1866–7*

Showing the typically restricted space and emphasised foreground of the artist's work,[2] and already the beginnings of a broader style and more muted colouring. The reviewer in *The Art Journal*[3] commented on the singularity of his style in his exhibits at the Old Watercolour Society, 1867, of which this watercolour was one: 'G. P. Boyce has the advantage of being eccentric and his style will hardly become commonplace, save in the repetitions of his imitators. He displays pictures which, as usual, please by their peculiarities. Sometimes he is sombre, often lustrous, always harmonious even in his contrasts. That he affects subjects which an ordinary artist would condemn as unpaintable, is rather in his favour. People like to go out of the way in matters of taste, and singularity is not infrequently accepted for genius . . .' One of the other watercolours was, however, admired as an example of how simply lovely he could be.

PROV: Anon. sale Christie's 4.5.1914 (28), bt. Ethel Oliver;[4] Sir John Trevor Roberts, 2nd Baron Clwyd, who gave it to Mrs A. C. M. Jones, who in turn bequeathed it to the Walker Art Gallery, 1984.
EXH:: Old Watercolour Society, 1867 (81);[5] Tate Gallery 1987, *George Price Boyce* (46) repr.

1　On the old backing is a label of J. & W. Vokins, 14 & 16 Great Portland Street.
2　Discussed in Staley 1973, p.109.
3　*The Art Journal*, 1867, p.147.
4　An inscription on the backing gives this information.
5　A manuscript label (? in the artist's hand), is inscribed No. *6*, with this title and artist and his address *Chatham Place, Blackfriars*. He exhibited eight pictures at the O.W.C.S. in 1867.

10343. *Sandpit near Abinger, Surrey*

Brett, John (1831–1902)

Born 8 December 1831, near Reigate, Surrey, son of an army veterinary surgeon. His early interests were in both astrology and art, but after lessons from J. D. Harding and Richard Redgrave, he entered the Royal Academy Schools as a student, 22 April 1853. He was deeply impressed by Ruskin's writings on art and geology and by Pre-Raphaelite paintings; he probably first entered their circle in 1853 through Coventry Patmore. Began exhibiting at the Royal Academy in 1856. Turned from figure subjects to landscape, and visited the Alps 1856 under the influence of Ruskin's writings: there met J. W. Inchbold who spurred him on to a meticulous approach to detail in nature, which in the following year he perfected in *The Stonebreaker* (No.1632 below), which made his reputation. The personal influence of Ruskin, whom Rossetti had introduced to his work around December 1856, subsequently overweighted this attitude for a period into the 1860s. Exhibited with the Pre-Raphaelite exhibitions in the USA and Russell Place in 1857 and joined the Hogarth Club with others of the circle, 1858. Made several painting trips to Switzerland and Italy, but began painting on an increasingly larger scale and broadened his style noticeably. This was probably partly a result of his practice to paint in the studio, using oil sketches done on the spot (? and photographs) and drawing on a retentive memory. By the late 1860s he had turned exclusively to seascapes and coastal views painted with a detailed realism. From the 1870s these were chiefly scenes round the coast of the British Isles, the result of long summer visits, sometimes on his yacht. Married Mary Ann Howcraft about 1869. His scientific interests resulted in his election as a Fellow of the Royal Astronomical Society, 1871. Elected ARA 1881. Died Putney, 8 January 1902.

1632. *The Stonebreaker*

Oil on canvas, 51.3 × 68.5 cm (20¼ × 27 in)
Signed and dated: *John Brett/1857–8*
Frame: Commercial gilt wood and composition, with slightly convex border of shallow oriental-type floral pattern in formal scrolls, with scroll corners.

The view is south and south-east over the Mole valley, towards Box Hill, Surrey. The railway bridge and embankment appear in the middle distance at the right. In the vale, left of centre, is the spire of St Michael's Church, Mickleham.[1] The distant Weald fades into heat haze. Seen from a high point on a road or track where a milestone is marked *LONDON 23* and a boy is knapping flints for road-making. His patched jacket and basket lie at his side; his small terrier plays, unleashed, with his cap. A bullfinch sings from the knarled but still living tree. Among several pen and ink sketches still with the Brett family (listed below and see figs 9–12), two are dated respectively, 7 and 13 August 1857. The plants agree in appearance with a period of August to September and are, from left to right: Old Man's Beard (*Clematis vitalba*), growing over a bramble (*Rubus fruticosus agg.*); spear thistle (*Cirsium vulgare*); gorse (*Ulex europaeus*) with branches of yew behind; bramble; (?) box; beech

(*Fagus sylvatica*).[2] Edwin Brett, a younger brother of the artist, is recorded on one of the sketches as the sitter for the boy. Another sketch is inscribed *The wilderness of this world* and *outside Eden*,[3] indicating that the artist had a moral theme in mind.

David Cordingly[4] has indentified the viewpoint as probably at some point on the old Druids Walk which joined the ancient Pilgrims Way with London. The track went through the southern side of Norbury Park, which was then more open in aspect. This view is not visible from the modern highway which follows the valley. The area is associated with Neolithic flakes. Brett early showed considerable scientific interests, particularly in geology. Marcia Pointon[5] has discussed the development of these leanings in the juxtaposition of the healthy youthful labourer with the pile of flints, which she suggests is the key to the painting, underlining the briefness of life in comparison with the infinity of geological time.

The stonebreaker's youthfulness can be seen as set in contrast to the everlasting landscape. In each of the figure sketches he is shown, either standing or seated, facing away from the view; in two a signpost appears, perhaps as a rejected attempt to stress the distance from town life which the railway bridge in the painting more subtly suggests. His menial and repetitive task, which would have been familiar to contemporary viewers of the picture, makes him blind of necessity to the brilliant panorama behind him. The overwhelming note of the picture is, however, summer fruitfulness, where even the ancient tree (which might be taken as a symbol of the boy's constricted future), sends forth a single leafy branch; and the bullfinch perhaps symbolises the free human soul.[6] The message remains ambiguous[7] for the artist's vision is, characteristically of all his work, detached, in his over-riding concern for an exact and scientific description of each burgeoning detail of nature and rock formation and precise rendering of atmosphere, which reflects his enthusiasm for the writings of Ruskin.[8] It is by no means certain how much he wished to be read into it.[9]

The picture appeared at the 1858 Royal Academy, indifferently hung,[10] on the same occasion as Henry Wallis's intense and moving twilight landscape of the death of an old stonebreaker, with sociological over-tones illustrating Carlyle's *Sartor Resartus* (Birmingham City Art Gallery).[11] It is not certain whether there was any connection between the artists at this date or whether the similarity of subject was a coincidence. The pictures were not hung together, but the analogy of their subject-matter does suggest a possible link in ideas between the artists.[12] However, only the happy aspects of rural life in Brett's painting appear to have been noted by reviewers. *The Athenaeum*[13] commented on the boy's 'healthy zeal' and 'open-air face', admired the detail and considered 'this is how England's happiest spots should be painted . . .' The *Illustrated London News*,[14] in a long appreciative notice a month later, concentrating on the minute precision of landscape, again commented on the boy, 'beaming with health . . . he works with a will, and is not above his work, though there is a cast of thought in

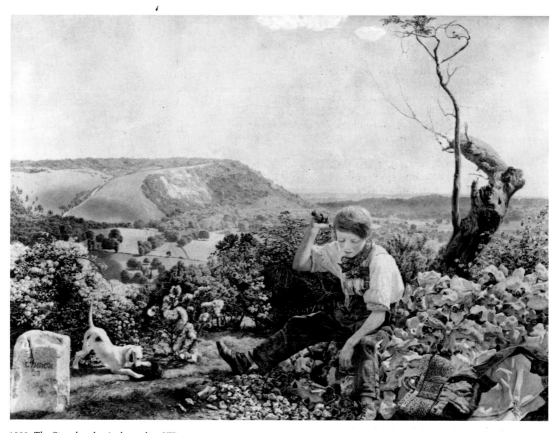

1632. *The Stonebreaker* (colour plate VII)

the expression which would indicate that he might one day be fit for better employment than is now allotted to him'. The textural treatment they thought was 'such as can hardly be surpassed'. All parts of foreground and background they thought 'equally remarkable for pains-taking detail and delicacy of finish . . .'. Ruskin in his *Academy Notes*[15] that year, calling in his introduction for a nobler choice of landscape subjects, admired both Wallis's and Brett's paintings for their pathetic qualities due to their Pre-Raphaelite rendering, '. . . one . . . of a boy hard at work on his heap in the morning, and the other of an old man dead on his heap at night'. While he considered Wallis's picture 'On the whole, to my mind, the picture of the year . . .', his comments on Brett's painting were confined exclusively to its detailed techni-que: 'This, after John Lewis's, is simply the most perfect piece of painting with respect to touch, in the Academy this year; in some points of precision it goes beyond anything the Pre-Raphaelites have done yet. I know of no such thistledown, no such chalk hills, and elm-trees, no such natural pieces of far away cloud in any of their works.

'The composition is palpably crude and wrong in many ways, especially in the awkward white cloud at the top; and the tone of the whole is a little too much as if some of the chalk of the flints had been mixed with all the colours. For all that, it is a marvellous picture, and may be examined inch by inch with delight; though nearly the last stone I should ever have thought of any one's sitting down to paint, would have been a chalk flint. If he can make so much of that, what will Mr Brett not make of mica slate and gneiss! If he can paint so lovely a distance from the Surrey downs and railway-traversed vales, what would he not make of the chestnut groves of the Val d'Aosta! . . .'

Staley suggests[16] that the alterations which appear in the clouds may be due to Ruskin's criticism. While in Switzerland the following year painting the *Val d'Aosta* (Sir Frank Cooper collection) very much under Rus-kin's personal influence, Brett wrote home advising his artist sister (Rosa Brett), and giving a description of his current technique which probably also applies to *The Stonebreaker*:[17]

'– as regards the blue I would use cobalt – write to Winsor he will send it by return of post. I am using the real ultramarine for mine, it is not bluer, but tenderer than cobalt but I dont think the difference is material. I dont like French blue for skies – except for a little stippling – find it too heavy and purple – I would not use Rowneys if I had any other – I told you to write to Winsor always when you wanted anything – I always stipple various

colours into my blue sky – a little – little-emerald – a little of blue etc. – but you should not trust to stippling or indeed any [?] after painting for *flatness* – I never can do any good by retouching – if it is not done right at first I take it out – whenever I do retouch, it is for colour not form, and consists of very minute bits fitted in – and as regards the mixing white with the colours – independently of tint, it makes the paints more manageable and I never think of "giving distance" by any dodge whatsoever, if you paint the things the right colour and put in only as much detail as you see they will do, and wont want any forcing back. Look at the real ones through a hole in a card as big as a nut to see what they are.'

Further on in his letter he added:

'About the sky. I have just got my sky in [in the Val d'Aosta]. The blue I put in with a sharp tool bouncing it down on its point perpendicularly, driving the paint into the grain, using no medium, (you hardly ever want medium if you finish at once) and laying the paint securely [or scumbly?]. You can get it beautifully flat this way. (Afterwards you can with your finest sable fill up any little holes), but after bouncing it in, I put it very delicately with the broadside of the brush held between thumb and finger [slight sketch follows] to make it lie down. The clouds I put in pretty much at once as I mean them to be. – you may depend all very good painting is done at once. I hope you have not left your grain too rough – that is very important. – Cobalt and yellow madder (deep) makes lovely cloud greys – also scarlet madder.'

Brett sold *The Stonebreaker* immediately: Ruskin wrote home to his father from Bellinzona, 22 June 1858, 'I am exceedingly glad Brett has sold his picture, for he is a fine fellow as well as a good painter . . .'.[18] The purchaser was Thomas Avison, a solicitor and Alderman of Liverpool.[19]

Five pen and ink studies are in the artist's family ownership:[20]
1. Boy seated on hillside in act of breaking stones, Box Hill outlined behind, milestone at left, signpost over hill at right, arched top indicated, 4¾ × 7½ in. Inscribed: *Aug 7/57* and at side: *The wilderness of this world* and *outside Eden.*
2. View towards Box Hill with milestone at left. 4¾ × 7½ in. Inscribed: *The wayside.*
3. Boy seated in pose close to picture. 4¾ × 7½ in. Inscribed on mount: *Edwin Brett sat for this figure Study for the figure in the 'Stonebreaker'.*
4. Boy seated in pose similar to picture, on a pile of stones with cap on head, holding sledge-hammer over shoulder 4½ × 4½ in. Inscribed: *Aug 13/57* and on mount: *Study for figure in the 'Stonebreaker' / Edwin Brett sat for this figure.*
5. Boy standing centre facing left wielding sledge-hammer over pile of stones, Box Hill outlined behind, signpost at right, arched top indicated. 4½ × 5¾ in. Items 2–5 in album (figs 9–12).

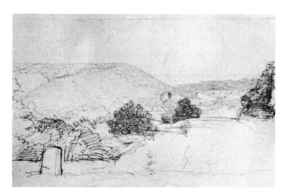

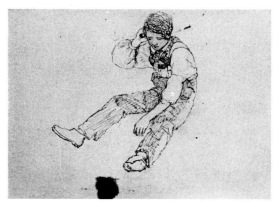

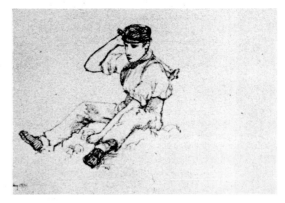

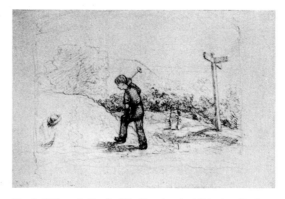

Figs 9–12 *Four studies for 'The Stonebreaker'*. Private collection

PROV: Thomas Avison (Fulwood Park, Liverpool), 1858; his sale Branch and Leete, Liverpool, 29.1.1878 (87), classified under watercolours; James Barrow by 1891; bequeathed by his widow, Mrs Sarah Barrow (Waterloo, near Liverpool), to the Walker Art Gallery, 1918.

EXH: Royal Academy 1858 (1089);[21] Liverpool Academy 1858 (135); Birmingham 1891 (216); Guildhall 1897 (146); Glasgow 1901; Tate Gallery 1923, *Pictures of the 1860 period* (94); Wembley *British Empire*, 1925 (W.27); Brussels 1929 (11); Royal Academy 1934, *British Art* (553); Birmingham 1937, *Victorian Pictures* (80); London 1937, *British Country Life* (388); Birmingham, Whitechapel and Tate, 1947 & 1948, *P.R.B.* (1); Port Sunlight 1948, *P.R.B.* (2); Royal Academy 1951, *First Hundred Years* (280); Nottingham 1959, *Victorian Painting* (4); Walker Art Gallery 1960, *Liverpool Academy, 150th Anniversary* (69).

1 Identified by David Cordingly, ' "The Stonebreaker"; an examination of the landscape in a painting by John Brett', *The Burlington Magazine*, March 1982, p.141.
2 Identified by department of botany, Liverpool Museum, 1970s.
3 Repr. Cordingly 1982, loc. cit.
4 Ibid.
5 Marcia Pointon, 'Geology and landscape painting in nineteenth century England', in *Images of the Earth*, British Society for the History of Science, 1979, cited by Cordingly 1982.
6 Brett exhibited a watercolour of a *Bullfinch* at Suffolk Street 1858 (820), and at the Liverpool Academy 1858 (604), price 10 gns.
7 See for example Staley 1973, pp.126–7, and a discussion of recent views in Cordingly 1982, p.145.
8 The influence of Ruskin through his writings and in person is discussed in Staley 1973, pp.125ff.; see also Cordingly in Tate Gallery 1984, *P.R.B.*, (79, 99).
9 Though the artist kept a diary there is none for this period (Cordingly 1982, p.145). See also M. S. H. Hickox, 'John Brett and the Rossettis', *Journal of Pre-Raphaelite Studies*, V, No.2, May 1985, p.108, where he suggests a link between its possible Christian interpretation and Brett's possible wish to impress Christina Rossetti, towards whom he appears to have had a leaning at this period.
10 *Illustrated London News*, 19 June 1858, p.614.
11 A detailed discussion of it by Robin Hamlyn is in Tate Gallery 1984, *P.R.B.* (92) repr. col.
12 Cordingly 1982, note 19, points out that they were both members of the Hogarth Club, founded March 1858. Also, Brett could have seen an engraving after Landseer's *Stonebreaker's Daughter*, 1830 (Victoria & Albert Museum): see Staley 1973, p.127. There are also William Henry Hunt, *The Stonebreaker*, watercolour, 1838 (private collection), and Courbet's *Stonebreaker* of 1850.
13 15 May 1858, p.629.
14 19 June 1858, p.614.
15 *Ruskin*, XIV, pp.153, 170–2.
16 Staley 1973, p.128.
17 From a copy made by a member of Brett's family, in family ownership. Quoted by courtesy of M. H. S. Hickox and the family.
18 *Ruskin*, XIV, p.171, note 3.
19 He is referred to in Brett's letter quoted above as the owner, evidently of this picture, when Brett was proposing to send several paintings to the Liverpool Academy. Avison had

purchased a landscape by Mark Anthony, another adherent of the circle, at the Liverpool Academy 1859, No.250 (Liverpool Academy Purchase Book).
20 Items 1, 2, 3 and 5 repr. Cordingly 1982, figs 21, 20, 22, 23; items 2–5, photographs Gallery files.
21 The artist's label on the back reads: *No. 1 'Stonebreaker' / John Brett / 34A Gloucester Road / Regents Park / London.*

759. *Rocks, Scilly*

Oil on canvas,[1] 35.8 × 61.2 cm (14⅛ × 24⅛ in)
Inscribed: *Scilly/July 7.73*

Close-up view in strong sunlight of the split granite rocks on a headland of the Scilly Isles. It illustrates the artist's continued interest in rock formation throughout his life, often, as here to a lesser extent, combined with study of the sea and sky which was the characteristic subject of his post-Pre-Raphaelite period. The rugged rock formations of the south-west coasts appear to have particularly fascinated him. He may have been on one of his yachting trips this year as he moved on to the mainland Cornish coast in September and October of the same year.[2]

It was Brett's mature practice to make sketches during the summer months on the spot, to be used as material for pictures afterwards painted in the studio (see No.2741 below).[3] On days of bad weather he would work on small finished pictures based on them. His chosen format, but not quite the case here, was of a width twice the height, and he stated that he only inscribed his sketches with place and date, reserving his signature for finished pictures. While No.759 is twice the size of the sketches referred to in note 2 and displays a degree of finish (though in a style already broader than his Pre-Raphaelite period), it presumably thus falls into the same category as a sketch on the spot.[4] A painting of *Summer Noon in the Scilly Isles* appeared at the Royal Academy the following year, but seems to have differed in its composition.[5]

PROV: The Rev. E. C. Dewick, who presented it to the Walker Art Gallery, 1919.

EXH: Bordeaux, 1977, *De Gainsborough à Bacon* (82) repr.

1 Canvas stamp of Winsor and Newton.
2 Two cliff scenes recorded are: *St Agnes' Bay, Cornwall*, inscribed Sept. 3'73 (Sotheby's Belgravia, 21.3.1972 (92) repr.), and *At Bude*, inscribed Oct. 14 '73 (Sotheby's Belgravia, 22.10.1974 (181) repr.); each 7 × 14 in.
3 His sketching practice and his attitude to it was discussed by him at length in his introduction to the catalogue of his work for the Fine Art Society, 1886, *Three Months on the Scottish coast, a series of Sketches and Pictures Painted during the summer of the present year, Accompanied by an explanatory essay by John Brett A.R.A.*, 1886.
4 His studio Logbook and summer diary were only recommenced in 1878 (artist's family ownership).
5 Described in *The Art Journal*, 1874, p.163.

2741. *Trevose Head*

Oil on canvas,[1] 107.3 × 214.5 cm (42½ × 84½ in)
Signed and dated: *John Brett 1897*

View looking towards the headland in the west across a bay, on the north coast of Cornwall to the west of Padstow.

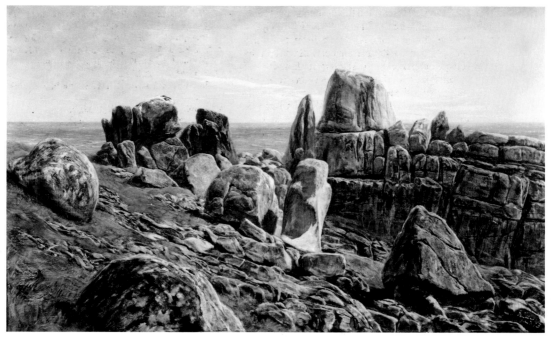

759. *Rocks, Scilly*

2741. *Trevose Head*

The Cornish coast was a favourite of the artist (see No.759 above). Various of his views of it also date from the 1890s. At the Royal Academy 1898, along with this picture, Brett showed two other views of the same area round Trevose Bay, where he had lodged between 27 July and 6 September, afterwards returning to London.[2] One of these, called *Where you had better not come ashore* (No.715, 7 × 14 in),[3] was a sketch which incorporates a

small portion of the same headland and may have been made use of for No.2741 as a preliminary study.

It was the artist's practice, as recorded by Beatrix Potter in 1883,[4] to make many small oil studies on the spot for the colour and to paint his pictures in the winter months 'chiefly from memory, though also assisted by photographs'; he was a keen photographer, she stated. She also recorded that he painted very fast, 'finishing a large pic-

ture in a few days'.[5] He affirmed this system in his 1886 exhibition catalogue for the Fine Art Society,[6] though making no mention of photography. There he stated his belief that 'until you can paint an object well without the model you cannot paint it at all, so that your finished picture, although done without reference to nature, should be more like the real scene than even your studies done on the spot'. He seems to have continued this practice for in 1889 Arthur Hughes reported meeting him when Brett was spending three months with his family at Padstow 'making beautiful studies about the coast among the ripples and rocks. He does one small one complete at a sitting on fine and good days – beautiful skies and lovely seas, and foreground of the pretty mermaid tresses colouring the pools or what not.'[7]

The present painting was begun in London in October 1897. Brett recorded in his studio Logbook[8] that he ordered a canvas 7 × 3½ feet from Winsor and Newton on 30 September 1897 and on 7 October 'began picture of "Trevose Head" on 7ft. canvas'. This view of the headland, recollected in the studio, is however identifiable only in general terms with the headland itself, while incorrect in the landscape details. It is not, apparently, possible to see the headland from this angle in relation to the coast.[9] The mood of the scene has taken the place of topographical accuracy.

At the Royal Academy the following year Brett was not happy about its position, 'hung next Herkomer's Scarlet picture [*The Guards' Cheer*, No.198] in the big room and utterly smashed'.[10] It was nevertheless sympathetically reviewed by *The Athenaeum*:[11] 'The brilliant illumination and able handling of a resplendent sea, the sunlit cliffs and slow-creeping land fog of *Trevose Head* (194) are in Mr Brett's best vein, and the sentiment of Cornish landscape is sympathetically conveyed.' It was then on offer at £525[12] but remained unsold and was sent to the Liverpool exhibition 1900, on the invitation of the committee to exhibit.[13] The price was then £315 but the exhibition committee negotiated its purchase (as was their practice) at a reduced price of £200 including copyright.[14]

PROV: Purchased from the artist at the Liverpool Autumn Exhibition, 1900, £200. Walker Art Gallery.
EXH: Royal Academy 1898 (194) repr.[15]; Walker Art Gallery 1900, *Liverpool Autumn Exhibition* (19).

1 Canvas stamp of Winsor and Newton. Label on frame of E. Banchet Paris, 20 Rue St Benoit, canvas maker.
2 Information here and below from Brett's studio Logbook kindly supplied by David Cordingly, 1981: Logbook JB 23, pp.40, 41 (artist's family ownership).
3 Repr. *Royal Academy Pictures* (Supplement, 'Magazine of Art'), 1898, p.69.
4 Leslie Linder, *The Journals of Beatrix Potter from 1881–1897*, 1966, p.65.
5 Ibid, p.58.
6 *Three Months on the Scottish coast, a series of Sketches and Pictures Painted during the summer of the present year, Accompanied by an explanatory essay by John Brett A.R.A.*, 1886.

7 W. E. Fredeman, 'A Pre-Raphaelite Gazette: The Penkhill Letters of Arthur Hughes to William Bell Scott and Alice Boyd, 1886–97', *Bulletin of the John Rylands Library*, Vol.49, Nos 2 and 50, No. 1, Spring and Autumn 1967. Reprint p.22: Arthur Hughes to W. B. Scott summer 1889.
8 Studio Logbook, JB 23, p.42.
9 Information from the staff of Padstow Public Library, Aug. 1984.
10 Studio Logbook, 29 April (1898), p.46.
11 *The Athenaeum*, 18 June 1898, p.797.
12 Studio Logbook, p.44.
13 Charles Dyall (Curator) to Brett, 5 Aug. 1900: '. . . The Committee would prefer one of your large works for the ensuing Exhibition. Failing that of course, they would be pleased to have one of the smaller pictures.' (Letterbook copies in Gallery files: Brett's letters in reply are missing)
14 Charles Dyall to Brett, 11, 16, 19 and 22 Nov., and 5 Dec. 1900, and 19 April 1901 (Letterbook copies, Gallery files); Brett's Studio Logbook, 15 Dec. (1900), noting receipt of cheque.
15 *Royal Academy Pictures* (Supplement 'Magazine of Art'), 1898, p.178.

Brown, Ford Madox (1821–93)

The only one of the circle with Continental training and experience. Born Calais 16 April 1821, the son of a half-pay ship's purser. His family moved to Belgium 1833–9 where he received a sound academic art training, first at Bruges under Albert Gregorius, then at Ghent under Pieter van Hansel (both pupils of David), and finally at the Antwerp Academy 1837–9 under the historical painter, Gustave, Baron Wappers. Married his cousin Elizabeth Bromley, 1840 and lived in Paris 1840–3, where studied Rembrandt and the Spanish masters (presumably the Louis Philippe Collection) in the Louvre and academic and Romantic contemporaries, Delacroix, Delaroche, Flandrin, etc. His early style was sombre and romantic with a developing concern for outdoor lighting effects. Settled in London 1844, and his style changed radically, partly under the discipline of designing cartoons for the Westminster Hall Competitions, and more particularly following his visit via Basle to Rome in 1845–6 (for his wife's health; she died 5 July 1846), when he saw the work of Holbein, the German Nazarenes and the Italian masters. He was already attempting a more formally composed and clear-cut realistic style with daylight effects and delicate fresco-like colouring, in subjects from early British history, when Rossetti applied to him in March 1848 for painting lessons. They became lifelong friends.

Though older, he sympathised closely with the new Pre-Raphaelite Brotherhood formed the following autumn, which paralleled his own ideas, though he was never a member. At first an adviser, at least to Rossetti, in turn he was influenced by them, trying out Millais' 'wet white' technique, employing their minute finish, turning to contemporary subjects, tackling landscape painting seriously, and like Millais and Hunt, brightening his colour as he looked more closely at nature out of doors.

While at first well received, his work gained little public recognition in the 1850s and the influential Ruskin was antagonistic. He led a retired and often despondent existence at Hampstead and Finchley. Married 1853 Emma Hill, whom he had known since about 1848, and who was often his model. She appears in his two greatest paintings, both begun 1852, *The Last of England* (Birmingham) and *Work* (Manchester). He ceased exhibiting at the Royal Academy after 1853 though he was awarded two prizes at Liverpool Academy 1856 and 1858 (he visited Liverpool September 1856, where he met local artists through their patron John Miller).

Helped organise the private Russell Place exhibition, 1857, the Hogarth Club, for the circle and their friends, 1858, and the USA touring exhibition, 1857–8.

In the late 1850s with an increase in patronage, he undertook much retouching of earlier work and some replicas. Around 1856–7 he took up designing furniture for himself and friends, perhaps inspired by the young William Morris, and in 1861 was a founder-member of the decorating firm of Morris, Marshall, Faulkner and Company, for which he designed some furniture and many stained-glass cartoons, until its re-arrangement as Morris and Co. in 1875. These last were influential on his later manner which saw a return to his earlier historical approach combined with a looser more decorative style in which his tendency to over-emphatic gesture and expression became increasingly characteristic. This later style found full vent after his long preoccupation with his one-man show in 1865. He moved to Fitzroy Square 1865, and a decade of prosperity and new patrons, usually owed to Rossetti, followed, but his style was not generally popular though he gained some notice on the Continent. He exhibited occasionally at the Dudley Gallery. His children Lucy, Catherine and Oliver were his pupils and studio assistants. In 1878 he was commissioned, largely through the influence of Frederic Shields, for the murals in Manchester Town Hall, with subjects from the history of Manchester; he lived in Manchester 1881–7 and these were his chief occupation until his death at his house in St Edmund's Terrace, Regent's Park, London 6 October 1893.

7804. *Millie Smith*

Oil on paper laid down on panel, 22.8 × 17.5 cm (9 × 6⅞ in)
Signed and dated: *F. Madox Brown 1846*

Amelia (Millie) Smith, later Mrs Bedwell, daughter of the artist's landlord in Wellington Terrace (Eastern Esplanade), Southend[1], where he stayed with his own small daughter Lucy for a time after his return to England from Rome following his first wife's death. The same child probably appears in the double portrait of a little girl, dated 1847, now at Manchester, which the artist records in his diary as 'the study of a little girl's head positioned in two views at Southend in '46, on a table napkin' (fig. 13).[2] Millie was about five in that year.[3] She might also be the model for the main head in *The Seraph's Watch* of 1846–7, which is alike, and which was probably begun at Southend.[4]

It is recorded in the family that her father Alfred Smith, who was described as a grocer in the 1851 census, made a 'hard-bake black rock (or toffee) with white nuts . . . (no connection with Southend rock)', and the artist 'made a great fuss of Millie and was "infatuated" with her'.[5]

The refreshing simplicity and directness of the portrait

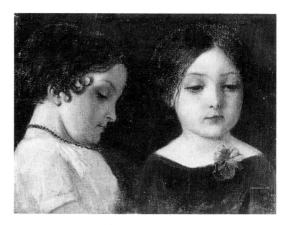

Fig.13 *Two studies of a little girl's head (Millie Smith)*. By permission of the City of Manchester Art Galleries

are indicative of the artist's change of manner following his trip to Rome. The clear pencil outline is visible under the paint. The frontal pose and close-up view is common to several of his paintings of small children, in particular *Lucy Madox Brown* of about 1848 (private collection) and *The English Boy*, 1859 (Manchester City Art Gallery);[6] and see No. 10504 below.

On a second visit to Southend twelve years later with his wife Emma, to finish a landscape sketch also begun there in 1846, Madox Brown saw this portrait again and wrote to his daughter Lucy from a different lodging: 'We are safe here in *one* room the place being very crowded & no larger as to houses than when *we* were here twelve years ago. We called first on Mr Smith & he sent us to the house where his two daughters let lodgins [sic] – The mother has been dead four years. I saw the one that used to play with you & the picture I painted of her. The latter I thought a terrible daub & as to the former she is still rather pretty but not so big as you, looks thin & Jewish about the nose otherwise like any other young servant girl . . .'[7]

PROV: H. Bedwell (1910); apparently given by the sitter to Mrs Hennis, Tunbridge Wells, a connection by marriage; thence to her niece, Mrs Bray; anon. sale Christie's 28.1.1972 (133), bt. Van Haeften; Richard Green, from whom bt. by the Walker Art Gallery, 1972.
EXH: Southend-on-Sea, 1910, *Royal Fête* (54).[8]

1 Information from Mrs Bray in letter to the compiler, 28 July 1972; and from L. Helliwell, Borough Librarian, Southend-on-Sea, in a letter 5 Oct. 1972.
2 Surtees, *Diary*, p.91.
3 Information from the 1851 census supplied by L. Helliwell, loc. cit.
4 See M. Bennett, 'Ford Madox Brown at Southend', *The Burlington Magazine*, Feb. 1973, pp.74–8 (portrait repr. fig. 1).
5 Mrs Bray, loc. cit., quoting Mrs Hennis.
6 Both repr. Tate Gallery 1984, *P.R.B.* (21, 111).

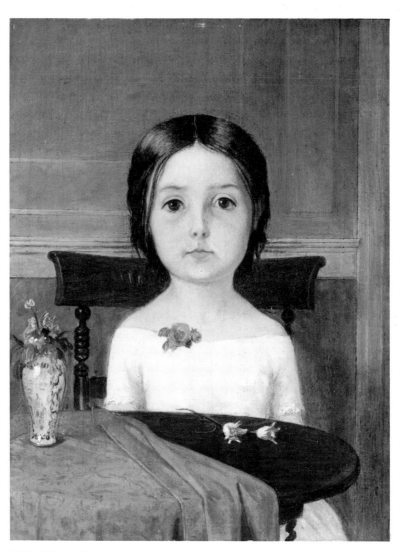

7804. *Millie Smith*

7 Undated letter from *Mrs Brooks, 2 West Cottages, Southend, Essex* (Angeli Papers, Special Collections, University of British Columbia Library, published Bennett, loc.cit.).
8 Label.

10504. *Lucy Madox Brown as a child*

Pencil, 13.5 × 16.3 cm (5⅜ × 6⅜ in)
Signed in monogram, dated and inscribed: *FMB/Dec 5/47*, *Lucy* and *To Cathy*

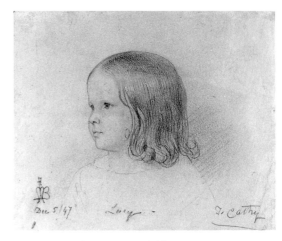

10504. *Lucy Madox Brown as a child*

Study of the artist's elder daughter Lucy (1843–94), drawn on a visit to her while she was living with her aunt Helen Bromley at the latter's school at Gravesend, during the time he lived in London alone after his first wife's death. He recorded this visit, which followed a trip first to his wife's grave at Highgate cemetery, in his diary for 4 and 5 December 1847:[1] '. . . drew a little head of my beautiful babe. It is to day 18 months since the death of my poor dear wife. These are thoughts that I must banish it unnerves me. I have dedicated the day to my child & the memory of her mother.'

At this period he was working on his large painting of *Chaucer* (Art Gallery of New South Wales, Sydney), and about to begin *Wycliffe* (Bradford Art Gallery). This drawing displays the same clear-cut pencilling as the studies for various heads in these works, which were the result of the new direction his style took after his Italian trip under the influence of Holbein and the Italian masters. It may have been used as a basis for the young prince in the *Chaucer*, though there the head is tilted rather more up.[2]

The artist made several studies of Lucy as a child, which have remained in family ownership. She married William Michael Rossetti, brother of Dante Gabriel, in 1874, and was herself an artist of some promise, exhibiting chiefly at the Dudley Gallery until her marriage.

PROV: On the evidence of the inscription, perhaps a wedding present from her father to Cathy Madox Brown, who married Franz Hueffer, 1872; by descent to Dr David Soskice; Sir Frank Soskice (Lord Stow Hill); Lady Stow Hill, from whom purchased by the Walker Art Gallery with Nos 10505–15 below, with the aid of a contribution from the National Art-Collections Fund, 1984.
EXH: Manchester 1911, *P.R.B.* (111).

1 Surtees, *Diary*, p.18.
2 He was drawing in this figure a little earlier, on 20 Nov. 1847 (Surtees, *Diary*, p.15), and the picture was not completed until 1851; repr. Liverpool and A.C. 1964, *F.M.B.* (11).

8296. *Sheet of studies for 'Wycliffe reading his Translation of the Bible to John of Gaunt'*:

(a) for the page holding books; (b) for his legs; (c) for the right hand of the Duchess; (d) for the clasped hands of her and her child; (e) for a length and section of carved stone or woodwork.
Pencil, 25 × 17.5 cm (9⅞ × 6⅞ in)
Signed and inscribed, probably at a later date: *FMB / Rom*
Verso: Outline of a casket and a tall beaker.

Study for details in the picture, now at Bradford (47 × 60½ in; fig. 14),[1] which was painted 1847–8 while

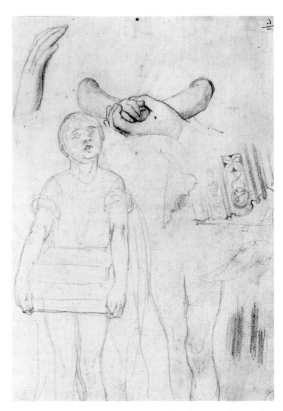

8296. *Sheet of studies for 'Wycliffe reading his Translation of the Bible to John of Gaunt'*

the artist's great subject of *Chaucer* was temporarily put on one side. Growing out of the Chaucer subject it likewise revealed both the artist's interest at this time in early English literature following the Houses of Parliament fresco competitions, and the influence on his style of Holbein and the Italian masters seen by him for the first

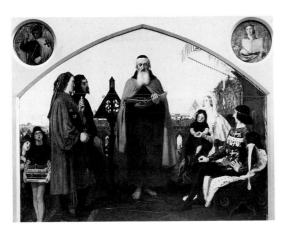

Fig.14 *Wycliffe reading his Translation of the Bible.* By permission of Bradford Art Galleries and Museums

time on his journey to Rome in 1845–6. The painting of *Wycliffe* was begun in London in November 1847[2] and the many pencil studies, now in Birmingham City Art Gallery,[3] are all dated London 1847 or 1848. The inscription on No. 8296 must be a mistaken recollection by the artist, who seems to have signed some of his sketches at a later date. He may have been confusing the page holding books here with one of the pages in the coloured study for *Chaucer* which was designed at Rome (Ashmolean Museum, Oxford).[4]

He recorded in his diary[5] that he made a drawing of the hand of his model, Mrs Yates, and her child, on 29 January 1848 and the hands of both were laid in on 31 January and 1 February. On 20 March he made a drawing of 'one of the pages', which was presumably this sketch, for on the following day he drew the page holding the books in on the canvas. He was at the same time planning a frame: the sketch of carving might be for the original frame he designed for the picture, later discarded, or an unused study for the balustrade.

PROV: Anon. sale Sotheby's, 13.1.1965 (31), bt. Bridges; anon. sale Sotheby's, 12.1.1966 (29), bt. L. T. Edwards; purchased from S. & K. Morris, Stratford-upon-Avon, by the Walker Art Gallery, 1972.

1 See Tate Gallery 1984, *P.R.B.* (8) repr.
2 Surtees, *Diary*, p.17.
3 City of Birmingham Museum and Art Gallery, *Catalogue of Drawings*, 1939, pp.38–41.
4 See Tate Gallery 1984, *P.R.B.* (6) repr. col.
5 Surtees, *Diary*, pp.27–8, 35.

LL 3638. *Windermere*
Oil on canvas, painted surface including the folded-over top and right edges, 17.5 × 49.2 cm (6⅞ × 19⅜ in); in oval flat 15.2 × 45.7 cm (6 × 18 in)
Signed and dated (along left bottom edge of mount):
F. MADOX BROWN WINDERMERE 1855
Frame: Narrow lozenge and circle repeat border with oval flat, gilt.

The painting is cut along the top and right edges and approximately ⅝ inch folded over the stretcher on these sides and tacked down. The bottom edge shows a narrow border of unpainted canvas with old tack holes and has evidently been raised on the stretcher, and the unpainted left edge has similarly been moved over to the right with a 2⅛ × ⅝ inch apex to the oval field abutting into it to the edge of the stretcher. The paint in this area is slightly different in colour and coarser in technique than the main field. Slight blue streaks of sky are visible in the folded-over edge to the overcast sky at top; the top left and right areas below the mount are yellowed, the discolouring possibly due to lack of light. There are areas of yellowish-green at bottom left and right below the mount, brighter and more translucent than the opaque bluish-green over-painting of the visible foreground, perhaps pointing to an initial intention to establish the rounded oblong shape of the other extant versions (see below). The hidden and folded right edge shows most of the cream-coloured cow, fully visible in the other extant versions and continues the trees and rising bank but with rather scumbled finish.

A view from the head of the lake near Waterhead, from a position above the Roman Fort. Brathay Neck runs down below an outcrop on the right with Scalehead Claife beyond. Holme Crag islet is off shore slightly to the left of centre in the lake and Bowness is in the far distance under Brant Fell.[1] The scene is little changed today.

This is the artist's second recorded landscape, begun 1848 on the spot and cut down and altered in 1854 and 1855. He visited the Lake District for a short walking tour with his friend and fellow artist Charles Lucy (1814–73) in September 1848, taking in the Manchester Institution exhibition on the way and the Liverpool Academy on the return journey. He painted this view between 25 and 30 September, 'six days at about four hours a day. Last day in the rain under an umbrella'.[2] (Lucy seems to have painted alongside him as he showed a painting in an exhibition of sketches in 1851 called 'Study from Nature looking down Lake Windermere from under Lough'.)[3]

Madox Brown took it up in his studio on 9 October and worked at the sky, but immediately afterwards turned to the production of a duplicate or 'finished' picture from it, having first, on 13 October, made a sketch in black and white (which unless it was the under-painting is untraced). This second oil was in turn put aside until March–April 1849 when it was sent in, unsuccessfully, for the Royal Academy: it is presumably the picture afterwards exhibited at the Royal Hibernian Academy 1850, and the British Institution 1851 (as 14 × 26 in, probably including the frame). He took up both versions in 1854 and at the same time made a lithograph, 'drawn from the original study' (example in private collection).[4] The finished oil was sold to his dealer D. T. White and passed to B. G. Windus of Tottenham; it was destroyed with the Morse collection, World War II. A later oil of 1859–61 on panel (4¾ × 10¾ in, formerly William Morris Gallery, Waltham Forest), closely reflects the lithograph of 1854, is of the same oblong shape with rounded corners and

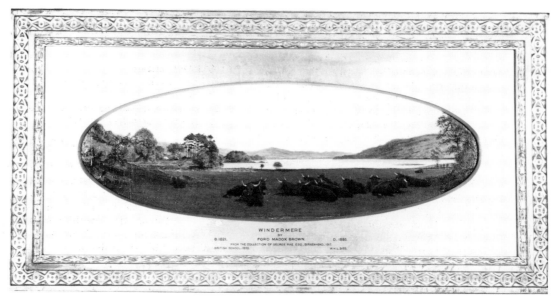

LL 3638. *Windermere* (colour plate VI)

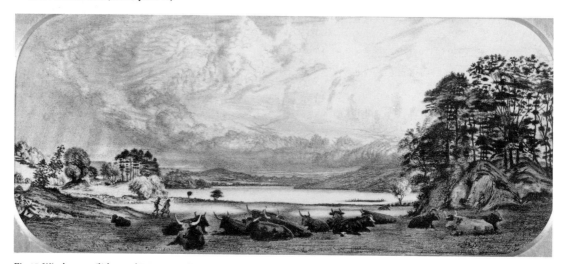

Fig.15 *Windermere* (lithograph). Private collection

has the same dominant storm clouds; its overwhelming meteorological interest was emphasised in the artist's note on it in his 1865 catalogue.[5] Both it and the lithograph (fig. 15) must reflect the artist's original concept for the sky of his composition, which is otherwise lost to us. Their high expanse of sky, curving mass of cloud and balanced composition, with trees and hillock at the right, indicates, as Staley suggests,[6] an initially romantic approach to stormy scenery well within the English landscape tradition. The alterations to No. LL 3638 in August 1854 to make a picture of it[7] and between March and July 1855 were radical and the result quite different.

In August 1854 he spent much time on it, worked 'at sky and all over', 'altered the trees at the right', and 'altered sky'.[8] In March 1855 he recorded his intention of cutting it down, 'like the other Windus has'.[9] It is undoubtedly cut down along the top and right-hand side and must originally have been much bigger. Much of the bank of trees, visible at the right in the other versions, is eliminated. The framemaker cut the oval mount wrong and Madox Brown was not sure whether to use it and had the stretcher cut smaller.[10] This error probably led to the shifting over of the canvas and the retouchings in the two points of the shallow pointed oval. He finished it in a long session on 21 July 1855 for the Manchester exhibition.[11] In his 1865 exhibition catalogue he makes it clear that it was a study from nature 'Made into a picture and the cattle added in 1854'.

Its simple lowering sky which takes the place of the busy cloudscape seen in the other extant versions, much more subtly reflects the wet weather which the artist encountered on his original trip. The narrow oval of the mount, of a type favoured by the artist in the early 1850s, creates a balance between the sky and the dense green foreground with shadowy cows at rest. Its tranquil mood is closer, as Staley points out,[12] to the small 'natural' landscapes of *The Brent at Hendon* and *Carrying Corn* (both Tate Gallery), which the repainting of 1854 just precedes in date.

PROV: Begun 1848, altered and completed 1854–5; given to J. P. Seddon in an exchange arrangement, about 1855–7;[13] Mrs Seddon by 1857 and in 1865; H. Virtue Tebbs, sold Christie's 10.3.1900 (38), bt. Rae £42; George Rae, and purchased from his executors by W. H. Lever (1st Viscount Leverhulme), February 1917,[14] and thence to the Lady Lever Art Gallery.

EXH: Royal Manchester Institution 1855 (470), 15 gns; Russell Place 1857, *P.R.B.* (9); Liverpool Academy 1857 (163); Piccadilly 1865, *F.M.B.* (5); Port Sunlight 1948, *P.R.B.* (10); Liverpool and A.C. 1964, *F.M.B.* (18); Sheffield 1968, *Victorian Painting* (164); Baden-Baden 1973–4, *Präraffaeliten* (19) repr. col.; Tate Gallery 1984, *P.R.B.* (13) repr.

1 The location pin-pointed for the compiler by M. A. E. Mortimer, Director of Studies, Brathay Centre for Exploration and Field Studies, Ambleside, in a letter 7 Jan. 1983.
2 Surtees, *Diary*, p.46.
3 *The Art Journal*, 1851, p.260.
4 Hueffer, p.92.
5 Piccadilly 1865, *F.M.B.* (25) as *Winandermere* (which is inscribed on the flat). It may possibly also have been, like the version now in Carlisle Art Gallery (4½ × 11 in, watercolour and bodycolour), painted over a print of the lithograph, used as a cartoon. Hueffer (p.92), states that only five proofs were taken of the lithograph, of which four were destroyed and the remaining one coloured for John Marshall, the surgeon (the Carlisle example), but this does not take into account the example which W. M. Rossetti had, now in a private collection.
6 Staley 1973, p.32: he suggests the influence of the artist's friend Mark Anthony on his early landscape style. John Linnell, whose work Madox Brown admired, may also be a source and Charles Lucy, who accompanied him on the 1848 trip, may have exerted an influence at this period. He could also have been conscious of views of the Lakes by, for example, D. C. Reed, whose etchings of 1840 (including *Windermere Evening*) were in the British Museum by 1842 (see Tate Gallery, *Illustrated Catalogue of Acquisitions 1976–8*, p.11); he visited the print shops on 8 Sep. just before the trip north. A more scientific interest in meteorology and atmosphere may have been induced by Professor Ansted's lectures on geology at the Society of British Artists, which he attended in Jan. and Feb. 1848 (Surtees, *Diary*, pp.27, 31). The first, on 'The Atmosphere' and 'Clouds' reviewed in the *Art Union* (pp.40, 84; and see also p.369), included a description of cloud types.
7 Surtees, *Diary*, p.82.
8 Ibid, pp.82, 83.
9 Ibid, p.125.
10 Ibid, p.134.
11 Ibid, p.145.

12 Staley 1973, p.33.
13 Hueffer, pp.97, 436.
14 Letters 16 and 27 Feb. 1917 (Gallery files).

10505. *Self-portrait*
Black chalk, on light brown paper, 25 × 23 cm (9⅞ × 9⅛ in)
Signed, dated and inscribed: *Ford Madox Brown etat 29. Sepr. 1850* and *retouched Octr./53*

The artist's second recorded self-portrait. In 1850 he had a studio in Newman Street and was completing his enormous *Chaucer* for the 1851 Royal Academy. Common to both is the clear-cut Continental realism derived in part from Holbein. At the period of the second date on the drawing, October 1853, he was finishing his landscape *An English Autumn Afternoon* (Birmingham City Art Gallery) in his landlady, Mrs Coates' house at Hampstead. During this period his concern with the role of the

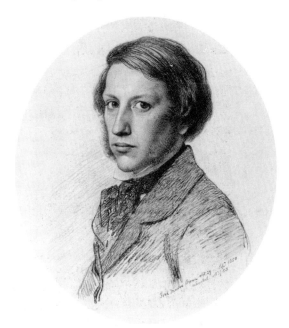

10505. *Self-portrait*

artist and with his own difficulties was finding expression in his choice of subject, *The Last of England* (see below), *Work* (Manchester City Art Gallery) and *St Ives, An.Dom 1636* (see *Cromwell on his Farm*, No. LL 3641 below); and the smouldering fortitude of his personality is in evidence in this searching study.

William Michael Rossetti described his appearance at the time of his first meeting with his brother Dante Gabriel:[1] 'He was a vigorous-looking man, with a face full of insight and purpose; thick straight brown hair, fair skin, well-coloured visage, bluish eyes, broad brow, square and rather high shoulders, slow and distinct articulation. His face was good-looking as well as fine; but less decidedly handsome, I think, than it became towards

the age of forty. As an old man . . . he had a grand patriar-chal aspect.'

His earliest self-portrait, a small oil, dates from about 1844 and passed to the Rossetti branch of his family (private collection). He introduced his own portrait into *The Last of England*, 1852–5 (Birmingham City Art Gallery), and he later, 1877, painted a larger self-portrait in oil which he gave to Theodore Watts-Dunton (now Fogg Art Museum, Harvard). His head also appears in two of his Manchester wall-paintings, in the background of the *Baptism of Edwin*, 1878–9, and as the Archbishop in the *Trial of Wycliffe*, 1884–6.

PROV: William Michael Rossetti (1896);[3] Mrs Catherine Hueffer, née Madox Brown (1897); by descent to Dr David and Juliet Soskice and thence to Sir Frank Soskice (Lord Stow Hill); Lady Stow Hill, and thence purchased with Nos 10504–15. 1984.[2]
EXH: Grafton Galleries 1897, *F.M.B.* (93); Manchester 1911, *P.R.B.* (115); Venice 1934, *Biennial*; Liverpool and A.C. 1964, *F.M.B.* (62) repr.; Tate Gallery 1984, *P.R.B.* (170) repr.

1 W. M. Rossetti 1895, I, p.118.
2 National Art-Collections Fund *Review*, 1985, p.128 repr.
3 Repr. Hueffer, fp. 67, as in his collection.

10506. *Study of Emma and Catherine for 'Pretty Baa Lambs'*

Black and sepia chalk, arched top, 21.3 × 17.2 cm (8½ × 6¾ in)

Pretty Baa Lambs (Birmingham; fig. 16), was the artist's first essay in painting a subject picture out of doors in strong sunlight. It dates from the summer of 1851 when he had taken a house for himself and Emma and their child Catherine at Stockwell, South London. He may have looked for guidance in his new project to Dutch and Flemish paintings, from which the Madonna and Child-like pose in this study and the detailed realism of the child's drapery seem to derive.

Emma was frequently his model. She first appears in a sketch dated *Xmas 48* (Birmingham), which was used for *Lear and Cordelia* (Tate Gallery); she posed for the Fair Maid of Kent in *Chaucer*, probably early in 1851. She appears during the 1850s in *The Last of England* (Birmingham) and *Work* (see No. 10511 below), while in later life her portrait can be recognised in various oils including *Cordelia's Portion* (No. LL 3640 below) and some of the Manchester wall paintings.

PROV: Dr David Soskice (1911); Sir Frank Soskice (Lord Stow Hill); Lady Stow Hill, and thence purchased with Nos 10504–15, 1984.[1]
EXH: ? Manchester 1911, *P.R.B.* (105).

1 National Art-Collections Fund *Review*, 1985, p.129 repr.

10533. *Waiting: An English Fireside of 1854–5*

Oil on oak panel, 30.5 × 20 cm (12 × 8 in)
Signed and dated: *F. Madox Brown/55*
Frame: A commercial gilt composition frame with deep concave rebate with an applied shallow floral scroll re-peat pattern and reeded front edges.[1]

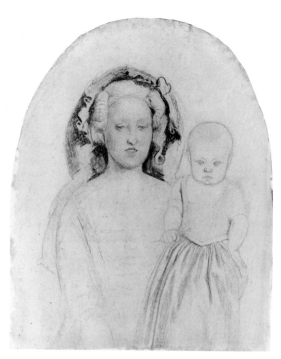

10506. *Study of Emma and Catherine for 'Pretty Baa Lambs'*

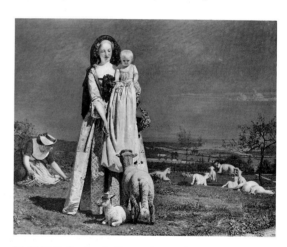

Fig.16 *Pretty Baa Lambs*. By permission of Birmingham Museums and Art Gallery

Begun as a study for a picture in the winter evenings of 1851–2 at the artist's new house at Stockwell, South London,[2] its domestic subject no doubt inspired by his life with Emma and their child Catherine. It can be seen as the private expression of the artist's conscious aware-ness at this time of the religious felicity of modern family life at the time he was painting the moving humility of Christ in his *Jesus washing Peter's Feet* (Tate Gallery).[3] It is his first modern subject.

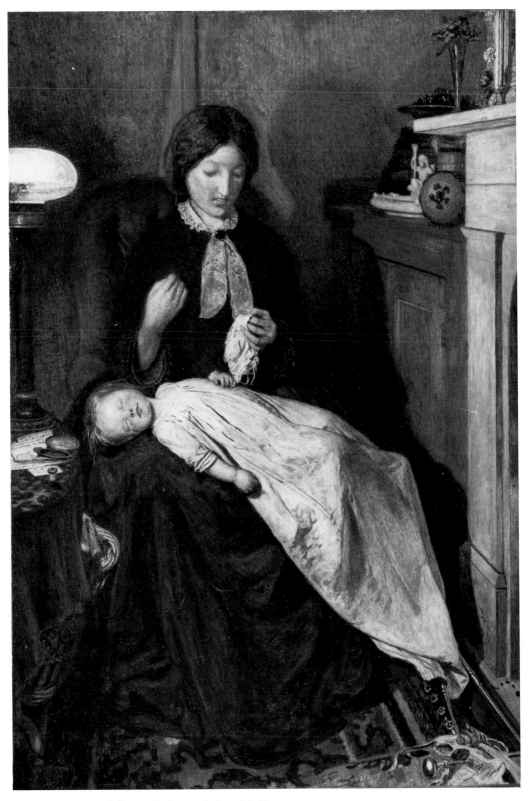

10533. *Waiting: An English Fireside of 1854–5* (colour plate V)

Its originality lies both in its wholly factual presentation of a modern domestic subject without the sentimental overtones more usual at this period,[4] and in its exploration of colour under artificial light. The young mother is seated in a very simple middle-class room, like a domestic madonna, with her child sleeping on her lap in an alarmingly realistic pose; she sews by the light of an oil lamp[5] as she waits for the return of her husband. Her work-bag lies on the Turkey carpet at her feet, by the fender with its fire-irons. The lamplight casts a cool illumination over the little group and fades into soft blurring shadows, while the fire throws a pink glow and a dancing live sparkle over the child's robe. The viewpoint is in intimate close-up as if the spectator, in place of the missing husband, were standing on the other side of the fireplace.

From it a finished version was painted between April and June 1852, but using a professional model, Miss Ryan, for the head; it was finished later at Hampstead, exhibited at the Royal Academy and Manchester in 1853, as *Waiting* and sold to his dealer, D. T. White, around July 1854, for £20 (private collection).[6] It differs in some of the details from No. 10533, including more elaborate carving to the chimney-piece, where drapery hides the top edge and the arched flat precludes the gilt mirror frame of No. 10533; there is a leather- rather than a velvet-covered chair and a patterned wallpaper, the mother has a plain collar and brooch, and a cotton reel is the only item on the table beneath the lamp. Both versions have similar objects on the cupboard, including an example of 'The Bride's Inkstand' in white pottery, which Howard Coutts has recently identified and pointed out may be a deliberate allusion to the theme of the picture.[7]

No. 10533 was taken up again for a day or two in August 1854, soon after the sale of the other version[8] and at a time when Madox Brown was also reconsidering pictures for entry to the Paris Universal exhibition.[9] He recorded on 20 August that he 'retouched with fine brush all the right-hand side of the picture which had been painted in coarsely by lamp light,' and the following day 'repainted the childs hands from the studie & the head from feeling'.[10] No drawing for this figure has reappeared. He did not like it and put it aside until inspiration came again.

He took it up again in December 1854, now calling it a 'duplicate,' for some retouching to the mother and child's heads and to the velvet chair but rubbed out the latter.[11] He gave it serious attention in January 1855 when it was accepted by the English committee for the Paris Universal Exhibition along with the *Chaucer* (Art Gallery of New South Wales, Sydney). He recorded, in various overlapping entries, that he first 'Scraped & pumisstoned it all over till it looks quite spoiled' (3 January), scraped it all over with a razor (Saturday, 6 January), and that it was 'Slow work retouching all over having scraped within a hairsbreadth of its existance' (9 January). On the same day he recorded its change of subject to a topical one of 'an officer's wife thinking of him at Sevastopol'.[12]

To retouch earlier works was characteristic of him at this period and here appears wholly consistent, with delicate small brush-strokes in evidence. Apart from the details he records, it is clear that there is some re-painting in the area of the green plate by the chimney-piece and its immediate background and on the cupboard. The scraping down seems to have been greatest at the left-hand side where the still-life details on the table were changed to fit the new theme, with the addition of a miniature of a soldier and a group of letters. He appears to have set them from life for painting.[13] He painted at the child's bed-gown, the chair, set his lay figure for the collar, brooch and wedding ring, painted at the mother's head and her hair from Emma, and later at the hands and her face and the cradle.[14] He put in about two days' work on the tablecloth which he altered again on 1 February[15] and touched at the head and face before sending the picture for a day to his dealer D. T. White in the unsuccessful hope of selling it.[16] By 1 March he recorded its new title of 'An English Fireside of 1854–5'[17] (but this was not used at Paris).[18] He decided that it was finished on 7 March but finding it faulty got Emma to sit again on 9 March and put it in its frame on Sunday 11 March.[19] The Paris exhibition opened in May.[20]

He afterwards sent it to the Liverpool exhibition and himself visited Liverpool late in September 1856. There he met John Miller, the considerable local collector and patron of Liverpool artists, who bought it.[21] He then referred to the child as a boy (his eldest son Oliver had been born on 20 January 1855 while he was finishing it), but he corrected this in a letter to his daughter Lucy long afterwards.[22]

PROV: Begun 1851–2, retouched 1854–5; sold to John Miller, Sep. 1856, £85; Peter Miller;[23] John Miller sale, Christie's 20–24.5.1858 (108), bt. in, and Branch and Leete, Liverpool, 4–6.5.1881 (261), bt. ?; J. K. Pyne, Manchester, by 1883[24] and by him sold to Henry Boddington of Manchester[25] before 1891; still with Boddington in 1909 and sold at the Leicester Galleries exhibition 1909 to Dr W. Wingate, £185.15.0, and thence by descent to Lady Southwell (d. 1985); purchased from her estate by the Walker Art Gallery, through Messrs Phillips, Son & Neale,[26] with the aid of the National Heritage Memorial Fund, the Victoria & Albert Museum Purchase Grant Fund, the Pilgrim Trust and Friends of Merseyside Museums and Art Galleries, 1985.

EXH: Paris Universal 1855, as *Waiting*; Liverpool Academy 1856 (270), as *An English Fireside in the Winter of 1854–5*; (?) Hogarth Club Jan. 1859; Royal Scottish Academy 1859 (624); Piccadilly 1865, *F.M.B.* (15); Birmingham 1891 (149); Grafton Galleries 1897, *F.M.B.* (40); Whitechapel Spring 1901 (299); Bradford 1904 (90); Leicester Galleries 1909, *F.M.B.* (1).

1 This must be the original frame; a printed cut-out fragment of a list on the back reads: *Brown J M* [sic] *7 Grove Villas, Church End, Finchley, Waiting By J M Brown*. What must be an earlier list, in the same format, of the British Section for the Paris Universal Exhibition, 1855, including only the *Chaucer*, is in the Victoria & Albert Museum Library, and a list of works with

contributors and titles for this section was published in *The Art Journal*, 1 April 1855, p.128. Madox Brown left Grove Villas in Sep. 1855.

2 Surtees, *Diary*, p.76.

3 At the same period Holman Hunt was painting *The Light of the World*, which was begun on the canvas 7 Nov. 1851 and uses the artificial light of a lantern out of doors by moonlight. (Madox Brown visited him and Millais at Worcester Park Farm on 9 Nov.). Hunt's material counterpart, *The Awakening Conscience*, in a modern interior setting dates from 1853 (see Tate Gallery 1984, *P.R.B.* (42, 57, 58).

4 For example, in domestic subjects by Charles Cope RA, at least one of whose works Madox Brown admired (in a letter to Lowes Dickinson referring to the 1851 Royal Academy: Hueffer, p.78).

5 Of the Sinumbra type; identified for the compiler by Jane Insley, Science Museum, in letter of 11 Feb. 1983.

6 Surtees, *Diary*, pp.78, 82. Exhibited most recently at Liverpool and A.C. 1964, *F.M.B.* (24); repr. Hunt 1905, I, p.279. Between Nov. and Dec. 1852 was sent on approval at the request of Francis McCracken of Belfast, to whom Holman Hunt had recommended it, but he found it too small for his eyesight. McCracken referred to it as the *English Fireside* (artist's family Papers).

7 *The Burlington Magazine*, May 1987, p.322. The inkstand was one of the Felix Summerly Art Manufactures, the enterprise of Henry Cole who was later to be anathematised by Madox Brown in his diary when he was trying to obtain a teaching post through Cole when the latter was Director of the Government Schools of Design. The marriage of Madox Brown and Emma, the model in No. 10533, took place in April 1853.

8 Surtees, *Diary*, pp.82, 84.

9 Including *Jesus washing Peter's Feet.*

10 Surtees, *Diary*, p.84.

11 Ibid, p.110, 17 Dec.

12 Ibid, pp.113, 114.

13 Ibid, p.114, 8 Jan.: '. . . set to work at the Part of the Little picture of waiting which I set & began last night . . . in the eveng placed the table lamp etc . . .'

14 Ibid, pp.116–21: 13, 16, 20, 21 Jan. and 1, 4 Feb.

15 Ibid, pp.115, ?8, 9 and 10 Jan.; p.121.

16 Ibid, p.122.

17 Ibid, p.124; but see note 6 for use of the title *English Fireside* in 1852.

18 See note 1.

19 Surtees, *Diary*, pp.125–7; see note 1 for frame.

20 *The Art Journal*, 1855, pp.165, 193; the reviewer recorded at length (pp.229–32) the French criticisms of the insular singularity of the English contributions.

21 Surtees, *Diary*, p.190.

22 13 March 1886 (Angeli Papers, Special Collections, University of British Columbia Library).

23 Lent by him to the 1865 exhibition; the extant copy of the Artist's Account Book II, p.54, lists later owners (artist's family Papers).

24 Letter to Lucy, 6 Sep. 1883 (Angeli Papers), when it had been rejected from the Manchester Art Gallery's first Autumn exhibition as painted too long before. A label on the back in the artist's hand reads: '*Waiting / Painted in 1853–55 / By Ford Madox Brown / 3 Addison Terrace / Victoria Park*'. This was the artist's residence in Manchester.

25 Account Book, loc. cit.

26 It appears in their sale catalogue, 19.11.1985 (182) repr. col.

10507. *Catherine Madox Brown as a child*

Coloured chalks and ink outline, on brown paper,

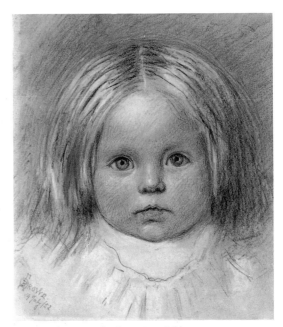

10507. *Catherine Madox Brown as a child*

19 × 16.5 cm (7½ × 6½ in)
Signed, with initials in monogram, and dated: *F M Brown/14 July/52*

Catherine (1850–1927), daughter of the artist and Emma, one and a half years of age in this lively portrait drawn in the summer of 1852 in a spontaneous technique. The artist recorded in his diary that he moved to Hampstead in June that year while Emma went to Dover for the summer.[1] He spent two months of the summer painting the background for *Work* in Heath Street, Hampstead, but does not record whether he broke off to visit Emma at Dover or whether she came back to London for this study of their child to be made in mid-July. It was perhaps begun earlier, before leaving Stockwell. Emma lived at Hendon and Highgate for a period before Madox Brown took their next proper home together in Grove Villas, Church End, Finchley. Cathy already figures in two other works, the baby in *Pretty Baa Lambs* (see No. 10506 above), and the baby lying on its mother's lap in *Waiting*, (No. 10533 above). She was the sitter in 1855 for the blond child eating an apple, in a similar head-on pose in *The Last of England* (Birmingham City Art Gallery). As a young woman she appears in *The Nosegay* (No. LL 3639 below), in a half-length pastel portrait (private collection), and probably in *Cordelia's Portion* (No. LL 3640 below).

Catherine also took up painting, helping her father as a studio assistant in the later 1860s and exhibiting at the Dudley Gallery, the Royal Academy and elsewhere until her marriage in 1872 to Franz Hueffer, the music critic (see No. 10513 below). Their eldest son, Ford, wrote the standard biography of his grandfather and subsequently became a noted novelist under a change of surname as Ford Madox Ford.

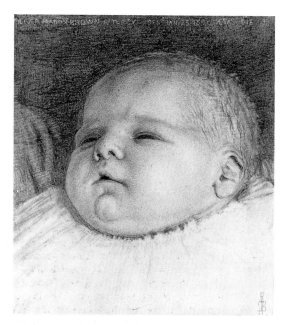

10508. *Oliver Madox Brown as a baby*

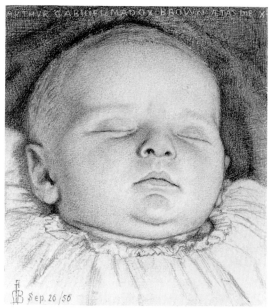

10509. *Arthur Gabriel Madox Brown as a baby*

PROV: By descent to Sir Frank Soskice (Lord Stow Hill); Lady Stow Hill, and thence purchased with Nos 10504–15, 1984.[2]

1 Surtees, *Diary*, p.78.
2 National Art-Collections Fund *Review*, 1985, p.130 repr.

10508. *Oliver Madox Brown as a baby*
Pencil, 15.8 × 14.2 cm (6¼ × 5⅝ in)
Signed in monogram, inscribed and dated: *FMB* and along top edge OLIVER MADOX-BROWN. PATER SV DESᵗ JAN 23 1855 AETAS DIES III

The first portrait of the artist's eldest son, at three days old.[1] Oliver was born on Saturday 20 January 1855. The diary records: 'This morning at ½ past 12 a.m. Dearest Emma was delivered of a son, my first. He is very red, a large nose, eyes & shape of face like a calmuck Tartar, shape of head like a Bosjeman . . .'[2] On 25 January[3] Madox Brown mentions working at his son's portrait from the Monday to Wednesday and concludes: 'drew at the boy without his cap & they said I had given him a cold (3 hours). Monday I began it. Worked at it with great care but I fear it is not worth anything (8 hours).' Finances and prospects were particularly unsatisfactory at this time and made the artist despondent.

Oliver (Nolly) was a precocious and promising child. He took up both painting and writing. He worked in his father's studio and exhibited from 1869, and published his first romance, *Gabriel Denver*, in 1873. He died of blood poisoning on 5 November 1874 in his twentieth year.[4]

Madox Brown made various studies of him as a child, the best-known being *The English Boy*, 1860 (Manchester City Art Gallery).

PROV: Mrs Catherine Hueffer (née Madox Brown); by descent to Sir Frank Soskice (Lord Stow Hill); Lady Stow Hill and thence purchased with Nos 10504–15, 1984.
EXH: Liverpool Academy 1858[5] (?599 or 601), as *Pencil Study of an Infant*; Piccadilly 1865, *F.M.B.* (72), as *Study of an Infant three days old* (1855); Grafton Galleries 1897, *F.M.B.* (91, 95, 98, or 101); Manchester 1911, *P.R.B.* (122).

1 Inscribed on label on back in the artist's hand: *My son Oliver Madox Brown aged 3 days 25 Jany./55/Ford Madox Brown 13 Fortess Terrace Kentish Town/London N W.*
2 Surtees, *Diary*, p.117.
3 Ibid, p.118–9.
4 John H. Ingram's *Oliver Madox Brown, A Biographical Sketch*, 1883, was published under the artist's eye.
5 Artist's Account Book II (copy), p.51 (artist's family Papers).

10509. *Arthur Gabriel Madox Brown as a baby*
Pencil, 15.5 × 14 cm (6⅛ × 5½ in)
Signed in monogram, dated and inscribed: *FMB Sep 26/56* and incised through pencil along top edge, ARTHUR GABRIEL MADOX BROWN AETAS DIES X

The design conforms with the earlier portrait of Oliver (No. 10508 above). The artist's younger son, born 16 September 1856. A drawing of him was being worked at between 17 and 19 September.[1] The *26* of the date on this drawing might be over a pencil 20(?) as the artist was in Liverpool on 26 September. The child died the following year, 21 July 1857, a week after his baptism, of 'inflamation of the brain'.[2] Madox Brown had to borrow from his new patron T. E. Plint to pay for the funeral.[3]

Madox Brown also drew him at ten weeks old (British Museum), used in *Take your Son, Sir* (Tate Gallery); in the week of his death (Norfolk Museum of Arts, Virginia) and in *Work* (see No. 10510 below).

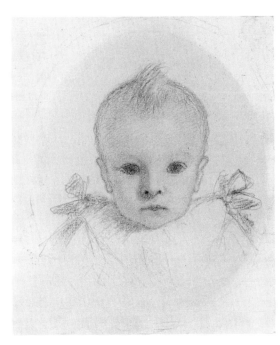

10510. *Arthur Gabriel Madox Brown as the baby in 'Work'*

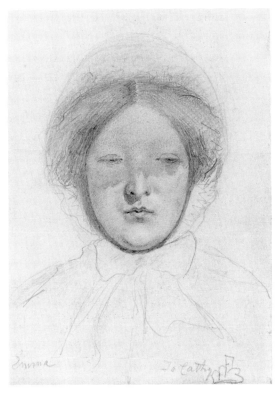

10511. *Study of Emma for 'Work'*

PROV: As No. 10508 above; Lady Stow Hill and thence purchased with Nos 10504–15, 1984.
EXH: Liverpool Academy 1858 (?601 or 599),[4] as *Pencil study of an Infant*; Piccadilly 1865, *F.M.B.* (73), as *Study of an Infant ten days old (1856)*; Grafton Galleries 1897, *F.M.B.* (91, 95, 98 or 101); Manchester 1911, *P.R.B.* (116).

1 Surtees, *Diary*, p.188.
2 W. D. Paden, 'The Ancestry and Families of Ford Madox Brown', *Bulletin of the John Rylands Library*, Vol.50, reprint p.134.
3 Surtees, *Diary*, p.198.
4 Artist's Account Book II (copy), p.51 (artist's family Papers).

10510. *Arthur Gabriel Madox Brown as the baby in 'Work'*

Coloured chalks, 12 × 9.8 cm (4¾ × 3⅞ in)

Immediately before the baby's death in July 1857, Madox Brown was employed on his new commission of *Work* (fig.17). He recorded that he 'drew in poor little Arthur's head for the baby & began painting it the day he was taken ill & had to rub out what I had done'.[1] The baby nevertheless appears in the painting similarly to this drawing, supported on the shoulder of his sister in the orphan family, in the centre foreground, but with his red shoulder ribbons changed to black. A similar portrait, oval with coloured background and red ribbons, passed to the Rossetti branch of the artist's family: it is inscribed with the name and death date: '. . . *July 21 57 From Memory*'.

PROV: As No. 10508 above; Lady Stow Hill and thence purchased with Nos 10504–15, 1984.[2]
EXH: ?Grafton Galleries 1897, *F.M.B.* (91, 95, 98 or 101); Liverpool and A.C. 1964, *F.M.B.* (69).

1 Surtees, *Diary*, p.198.
2 National Art-Collections Fund *Review* 1985, p.131 repr.

10511. *Study of Emma for 'Work'*

Pencil, 17.5 × 12.5 cm (6⅞ × 4⅞ in)
Signed in monogram and inscribed: *FMB // Emma* and possibly at a later date *To Cathy*

The culminating painting of Madox Brown's Pre-Raphaelite period was *Work* (now in Manchester City Art Gallery), which was begun at Hampstead in 1852 in high summer, and embodied his profound admiration of the writings of Thomas Carlyle, in this case his *Past and Present* through its presentation of work in all its forms.[1] Commissioned only in 1856 by the evangelical and philanthropic T. E. Plint of Leeds, it was finished with additional moral and religious overtones requested by the new patron, only in 1865.

This full-scale study of the artist's wife Emma, looking more mature in years and with a narrow high-fronted bonnet, must date from the later 1850s, certainly after the new commission. It is for the head of the young woman at the left of the picture holding a parasol and looking slightly down as she follows a safe foothold past the central group of navvies representing physical labour (fig.18). The artist described her role in his lengthy descriptive note on the picture[2] as one 'whose only busi-

Fig.17 *Work*. By permission of the City of Manchester Art Galleries

ness in life as yet is to dress and look beautiful for our benefit'. The fine pencilling captures the delicacy of her complexion and softness of her hair under the almost moving shadow thrown by the scalloped edge of her parasol.

The inscription *To Cathy* suggests that this may perhaps have been a wedding present to their daughter.

PROV: Mrs Catherine Hueffer; by descent to Sir Frank Soskice (Lord Stow Hill); Lady Stow Hill and thence purchased with Nos 10504–15, 1984.[3]
EXH: Liverpool and A.C. 1964, *F.M.B.* (68); Tate Gallery 1984, *P.R.B.* (182) repr.

1 See Julian Treuherz, *Pre-Raphaelite Paintings from the Manchester City Art Gallery*, 1980, pp.53–63, repr.; and Tate Gallery 1984, *P.R.B.* (88) repr. col.
2 His 1865 exhibition catalogue reprinted in Treuherz, loc. cit.
3 National Art-Collections Fund *Review* 1985, p.130 repr.

10503. *St Jerome with a Lion*
Chalk and ink outline, within traced arched panel, 31 × 14 cm (12¼ × 5½ in)

St Jerome (about 342–420), most learned of the four Latin Doctors of the Church, with his usual attributes. The book and cross represent his role as a commentator on the Scriptures, and author of the Vulgate. Anachronistically

Fig.18 *Work* (detail). By permission of the City of Manchester Art Galleries

10503. *St Jerome with a Lion*

Fig.19 Morris, Marshall, Faulkner and Company, pulpit, St Martin's Church, Scarborough. By permission of the Royal Commission on the Historical Monuments of England

he is depicted in cardinal's robes, as is customary in Renaissance pictures.

The artist records designs of a *St Jerome* and a *St John* 'for pulpit', under 25 August 1862.[1] These were for the pulpit of St Martin's Church, Scarborough (G. F. Bodley, 1861–2), where Morris, Marshall, Faulkner and Company undertook important stained glass and decorations as their second commission from this architect. As was already usual with the firm, various members contributed to the designs with Morris acting as overseer; Madox Brown also provided cartoons for some of the stained glass.[2]

The pulpit is of oblong format with two rows of four panels on the front, and shallow sides with two and four panels respectively (fig. 19). The front panels display figures of the four Evangelists above and the four Doctors of the Church below, after designs by Madox Brown and William Morris;[3] the pair of panels on the left side represents *The Annunciation*, after D. G. Rossetti, and the four on the right have decorative motifs.[4] *St Jerome*, after the present drawing, appears second from the right of the lower tier on the front, while *St John* (for which there is a drawing in the British Museum),[5] is top right. The figures are placed within identical painted and gilt gothic cusped arches with textured detailing; these match the outline border on the drawing, which was presumably supplied to the artist by the firm. Philip Webb, the architect and a member of the firm, decorated the panels and frame[6] and George Campfield, foreman, executed the paintings.[7]

A slight sketch of *St Jerome* in a different pose, standing to the left holding his hat and robes and looking down to the right at a lion, within the same traced border, is in the Houghton Album of sketches by the artist in the Ashmolean Museum, Oxford, initialled *FMB* and dated *70* (presumably added at a later date in mistaken recollection). The present design with its monumental solidity is more in keeping with the other three Doctors, who appear in bishop's robes. Neither of Madox Brown's designs, which were the second of the kind for the firm, seem to have been used again for other commissions.[8]

PROV: Probably artist's executors' sale (T. G. Wharton), 1
St Edmund's Terrace, Regent's Park, 29–31.5.1894 (265),
bt. Garnett, £2.2.6.; Mrs Catherine Hueffer by 1897, and
thence by descent; anon. sale Phillips, Son & Neale,
10.10.1984 (118), bt. in; purchased from a private owner
through Phillips, 1985.
EXH: Grafton Galleries 1897, F.M.B. (94).

1 Hueffer p. 445 (list).
2 Olivier Georges Destrée, 'Some notes on the Stained Glass
 Windows and Decorative Paintings of the Church of St
 Martin's-on-the-Hill, Scarborough', in The Savoy, Oct. 1896.
3 Ibid, p. 80.
4 Ibid, p. 79 and repr., pp. 78, 81.
5 Cat. No. 1894.6.12.9 (13½ × 7⅛ in), from the artist's executors'
 sale 29–31.5.1894, presumably lot 275, An Evangelist, bt. De-
 prez, 5 gns.
6 W. R. Lethaby, Philip Webb and his Work, 1935, p. 41. quoting
 Webb's account book with the firm, under 1862.
7 Destrée, op. cit., p. 80. The writer, after describing Rossetti's
 double panel at length, continues, 'the Evangelists, and espe-
 cially the St John, are remarkable; these eight panels are of a
 warm and rich colouring; they complete harmoniously the
 decoration of the pulpit, and contribute to make it one of the
 most precious ornaments of the church'. He also admired the
 two stained glass panels after designs by Madox Brown from
 the life of St Martin, but regretted 'not seeing other more
 important windows by Madox Brown in the same church'. He
 then went on to admire the two large Adam and Eve windows,
 in fact by Madox Brown, as 'the most beautiful and impressive
 windows in the church', but ascribed them to Rossetti.
8 Unlike the slightly earlier design for the panel of 'Architecture'
 in the King René's Honeymoon architect's cabinet for J. P.
 Seddon (Victoria & Albert Museum), which appears in several
 later forms.

LL 3639. The Nosegay (colour plate XIV)

LL 3639. *The Nosegay*

Watercolour, 23 × 15.8 cm (9⅛ × 6¼ in)
Signed in monogram and dated: *FMB 67*
Frame: Gilt oak, reeded with raised circles on the face
and squares at the corners; gilt oak flat with border of
engraved circles.

This is the finished sketch for a watercolour of 1865
(18¾ × 12¾ in, Oxford; fig. 20),[1] which was the first of
several commissions from Frederick Craven of Manches-
ter (see also *Cordelia's Portion*, No. LL 3640 below).
Craven had been introduced to D. G. Rossetti by Frederic
Shields of Manchester, and Rossetti in turn introduced
him to Madox Brown's work at the time of his one-man
1865 exhibition.[2] Craven collected chiefly watercolours
and wanted a companion to a study of a boy praying by
William Henry Hunt (1790–1864), who had died before
undertaking it himself. According to Rossetti,[3] it needed
to be 'a golden haired female party', the size 18½ × 12½
in upright, but Madox Brown was otherwise free as to
subject. Craven sent an outline of the Hunt to give the
scale of the head, and agreed to *The Nosegay* as the best of
several possibilities.[4] Madox Brown had commented in
his draft letter[5] making the suggestion that it was 'not yet
fixed in any way, I could make it accord without giving
up in the least my own thoughts'.

Craven's watercolour was painted from July to October
1865, with Cathy Madox Brown modelling the girl;[6] the
flowers were begun in July while in bloom.[7] It was

finished and sent off on 25 October and the night before
the artist noted in his diary spending two and a half hours
on the sketch.[8] T. H. McConnel of Manchester saw and
admired Craven's watercolour and asked the artist to
finish the small drawing for him in March 1867. He
acknowledged its receipt in April: '. . . it is a brilliant
cheerful drawing and will be satisfactory until I can get
some more important drawings from you'.[9]

It differs from the large watercolour in the arrangement
of the black apron, which is there pulled across to the
right (Craven had complained about this feature in his
watercolour and it may have been altered).[10] An outline
for the cat, for which a drawing is recorded on 29 Septem-
ber 1865,[11] is in the Houghton Album, Ashmolean
Museum, Oxford (7 × 6½ in; inscribed ?at a later date;
FMB 1855 [sic]).

PROV: Sold to T. H. McConnel of Manchester, £31.10.0.,
his sale Capes and Dunn, 30.7.1872 (244), bt–; ? J. Ken-
drick Pyne, 1897; George Moore, 1910.[12] Purchased
from the Leicester Galleries, by W. H. Lever (1st Viscount
Leverhulme), 1918,[13] and thence to the Lady Lever Art
Gallery.
EXH: ?Grafton Galleries 1897, F.M.B. (181) as pastel study;
?New Gallery 1910, 3rd Exhibition of Fair Women (180);
Port Sunlight 1948, P.R.B. (17); Empire Art Loans, Aus-
tralia and New Zealand, 1952–3, British Watercolours.

Fig.20 *The Nosegay*. By permission of the Visitors of the Ashmolean Museum, Oxford

1 Repr. Surtees, *Diary*, p.205.
2 Hueffer, p.207f.
3 Doughty and Wahl, II, No. 614: DGR to FMB, 26 June 1865.
4 Craven to FMB, 30 June, 2 July 1865: this and all subsequent references to Craven/FMB correspondence and FMB drafts are from the artist's family Papers.
5 1 July 1865: in which he dismissed as unsuitable 'The Flirt' (*Stages of Cruelty*), *At the Opera*, 'The First Born' (*Take your Son, Sir*), and *Rahab*, but then left open as a possibility 'The First Born'.
6 Surtees, *Diary*, pp.202ff. It was later on show with *The Coat of Many Colours* (No. 1633 below) in the artist's studio, 21 April 1866.
7 FMB to Rae, 25 July 1865 (Rae Papers, No 45, Lady Lever Art Gallery), excusing his delay over *Jacob*: 'I am interrupted from him owing to the necessity of painting some flowers from nature in a drawing which otherwise could not be done till they blossom again next year'.
8 Surtees, *Diary*, p.207.
9 J. A. McConnel to FMB, 8 March, 11 April 1867 (artist's family Papers).
10 Craven to FMB 24 April 1866 commented: 'It seems to me that the apron interferes with the breadth of the work'.
11 Surtees, *Diary*, p.204.
12 The provenance of the two versions is not clear.
13 Account dated 7 Jan. 1918 (Gallery files).

1633. *The Coat of Many Colours (Jacob and Joseph's Coat)*

Oil on canvas,[1] 108 × 103.2 cm (42½ × 40⅝ in)
Signed and dated: *F. MADOX BROWN*/66
Inscribed top of frame: THIS HAVE WE FOUND: KNOW NOW WHETHER IT BE THY SON'S COAT OR NO? (Genesis XXXVII, 32), possibly a later addition contemporary with the Walker Art Gallery inscription at bottom.
Frame: Gilt oak with close-stepped profile and 3-reeded border inset with medallions, circular on the sides and square at the corners (Madox Brown/Rossetti design).

The first oil version of a composition initially projected as one of three illustrations for Dalziel's prestigious illustrated Bible. Madox Brown received the commission from the brothers Dalziel in November 1863[2] and was quick to plan the development of his designs as paintings. *Dalziel's Bible Gallery* only finally appeared in 1881, with a selection of wood-engravings after many artists, headed by Frederic Leighton, but without text.[3] Madox Brown's several paintings after two of the subjects, *Jacob and Joseph's Coat* and *Elijah and the Widow's Son* date from the 1860s and 1870s.[4] This painting was commissioned by George Rae of Birkenhead in 1864 (see below), and its execution partially overlaps with that of the pen and ink drawing for Dalziels, though completed after it.

Madox Brown's approach to his subjects was essentially historical and factual with emphasis on visual accuracy. He relied on source books and the British Museum's collections as he had not, unlike Holman Hunt or Thomas Seddon, visited the Holy Land. He described his treatment of the drawings in the catalogue of his 1865 exhibition,[5] noting that he took his costumes from Assyrian and Egyptian sources, which, he stated, 'alone, it seems to me, should guide us in Biblical subjects'. The drawing (now British Museum, 8⅛ × 7⅞ in; fig. 21) was described in detail and is followed almost exactly in this painting:

'The brothers were at a distance from home, minding their herds and flocks, when Joseph was sold. Four of them are here represented as having come back with the coat. The cruel Simeon stands in the immediate foreground half out of the picture, he looks at his father guiltily and already prepared to bluster, though Jacob, all to his grief, sees no one and suspects no one. The leonine Judah just behind him, stands silently watching the effect of Levi's falsity and jeering levity on their father; Issachar the fool sucks the head of his shepherd's crook, and wonders at his father's despair. Benjamin sits next to his father, and with darkling countenance examines the ensanguined and torn garment. A sheep dog without much concern, sniffs the blood which he recognizes as not belonging to man.

'A grand-child of Jacob nestles up to him, having an instinctive dislike for her uncles. Jacob sits on a sort of dais raised round a spreading fig-tree. The ladder, which is introduced in a naturalistic way, is by convention the sign of Jacob, who, in his dream, saw angels ascending and descending by it.

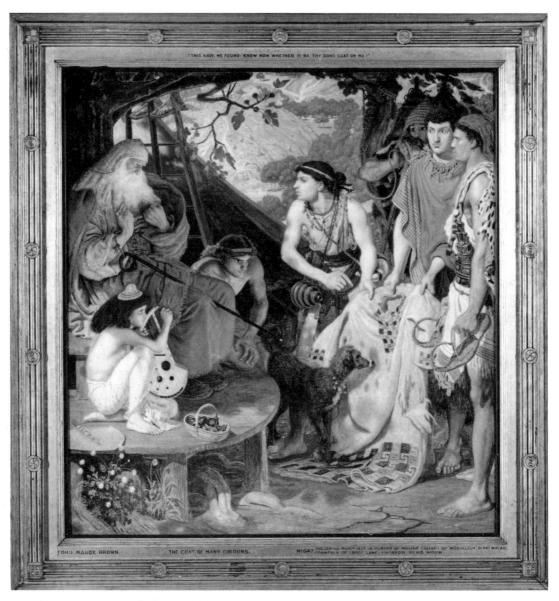

1633. *The Coat of Many Colours (Jacob and Joseph's Coat)*
(colour plate XIII)

'The background is taken from a drawing made by a friend in Palestine . . .'

To provide verisimilitude, as he was unable to paint before the motif, he introduced an accurate landscape background by copying part of a watercolour painted by his friend Seddon in Palestine in 1854. This has been identified by Staley[6] as *The Well of Enrogel* (Preston; fig. 22); it may have belonged to Madox Brown, who had helped Seddon with his paintings on his return to England, in 1855.[7] The landscape also appears in the pen drawing (British Museum), from which this oil varies in small details, having more foliage in the background and having transparent drapery on the seated child. The artist had tried out sketches of her with and without drapery on an initial pencil drawing (Birmingham; 788/06; fig. 23), and had intended to introduce transparent drapery in the pen drawing, but told his patron George Rae that he had found it too difficult on that scale; which form to follow in the oil was to be a matter for discussion between them (see below).[8] The colour range is of a hot muted tonality veering towards sand and brown, which was appropriate for the subject but which was also becoming more prominent in the artist's work from this period.

Fig.21 *The Coat of Many Colours* (pen drawing). By permission of the Trustees of the British Museum

Fig.23 *Sketch for 'The Coat of Many Colours'*. By permission of Birmingham Museums and Art Gallery

The Jacob subject is first noted in the artist's Account Book late in 1863 as designed at Kentish Town.[9] However, it has been suggested by Janet Haugaard[10] that the inception of the design may go back to 1855, which is the

Fig.22 Thomas Seddon, *The Well of Enrogel*. By kind permission of the Harris Museum and Art Gallery, Preston, Lancashire

date inscribed on the pencil sketch at Birmingham (which is the same size as the pen drawing). She suggests a connection with Rossetti in his plans, periodically from 1849, for an illustrated edition of Charles Wells' poetic drama *Joseph and his Brethren*, which proved abortive. Emulation of Rossetti's own design of *Joseph accused before Potiphar*,[11] of 1860, is certainly a possibility, though Madox Brown's own evolving style for stained-glass cartoons in the 1860s should also be remembered. For example, his St Oswald series, in particular *The Baptism* (see No. LL 3645 below), designed September 1864,[12] is supportive of a similar date for *Jacob and Joseph's Coat*. The inscription on the pencil sketch is most probably, in common with some other similar inscriptions, a later, forgetful, addition by the artist.[13]

This picture was chosen by George Rae from the list sent him at Christmas 1863,[14] but only finalised in March 1864[15] in response to a letter from Madox Brown[16] setting out his terms following a meeting between them and the sight by Rae of a sketch (presumably the Birmingham drawing cited above). Madox Brown's terms were: a price of 450 gns, excluding copyright, but only one ¼ size duplicate allowed; figures to be 3 ft high in a 3 ft 4 in × 3 ft canvas; to be completed in a year at the latest; he planned to execute a watercolour first as the sketch for it. The artist had mentioned in his letter, perhaps to ensure Rae's final agreement: 'I have begun the cartoon for it tonight & find the figures jolly big – the largest I have painted next the "Jesus & Peter" save "Chaucer".' This cartoon was 'not yet done with' in October when he had at last started the oil.[17] No trace remains of it. On 28 November[18] he sent a photograph of the Dalziel drawing with the comment that he had 'left the little grandchild naked . . . because the transparent drapery I meant to put upon her was too difficult to manage on that scale. Since doing it, however, all who have seen the drawing (ladies & all) are loud in their advice to keep it so in the large picture – however, we will talk this matter over when you come to London . . .'[19] In response Rae sent a first payment of

£100.[20] The picture is listed in the Account Book as begun in October 1864, when the Dalziel drawing was being finished, but it appears only to have really got going in the autumn of the following year, 1865, subsequent to his one-man exhibition.

Rae had by then already paid Madox Brown in full to help him tide over his exhibition,[21] and on 5 October 1865[22] the artist wrote to explain his delay over getting on: 'As to myself and "Jacob" I have ordered his frame if this is any evidence of progress – This I have been unable to do till the other day because I could not make quite sure of the sight measure of the picture, as there was a margin of canvas to suit the requirements of the composition . . . Five of the figures, the camel & all the background are now in, all indeed that is intricate or difficult except the little girl. One reason why I do not get on quite so fast as I reckoned is that I find in a work of this size the elaborate small drawing I made is of next to no use except as a previous study, I mean that though it has been of advantage to the work in helping to avoid errors, it is of no use to copy from. The flesh has all to be painted from nature & the draperies & accessories all to be placed again. The necklace for Levi I had to *manufacture* before I could paint it.'

Madox Brown had resumed his diary, in shortened form, in September 1865,[23] which cryptically records his work on the picture bit by bit, overlapping with work on *The Nosegay* (see No. LL 3639 above) and *Cordelia's Portion* (see No. LL 3640 below). He had already put in several days on it before his letter to Rae, mentioning in his diary work on the drapery of Judah, on Levi, making his necklace (20 September), and painting it in. He recorded a visit from Holman Hunt on 28 September, who probably then, airing his personal knowledge of the Near East, had carped on the introduction of the dog, the touch of which might be considered a defilement. Hunt wrote to him on October, retracting this statement and now citing Job XXX, 1, where 'dogs of my flock' were mentioned and stating also that he had, in Syria, himself '*seen* the dogs allowed to exercise their natural instincts as watchdogs . . .'[24] To this Madox Brown replied laconically, 'were I to have hunted it out, it would have necessitated my borrowing books which, having done with, I have sent back and forgotten . . .'[25] Rossetti during the summer or autumn had provided Madox Brown with the address of a mulatto who had a 'very fine head and figure', and offered an African carved stool and two African men's loose woollen robes for this picture.[26]

After a month's gap, work continued in late October and November, laying in the platform, the little girl,[27] Levi's scarf, and Jacob's dress. Then late in November and through into 1866 he painted at further details: the dog and sandals, Levi's horn, Issachar, Judah, Simeon, the tiger's skin and Joseph's coat again, etc. Rae called and saw it on 25 January 1866. The artist afterwards had a model for Simeon and later for Levi, on 5 February was 'out to Zoological after camel. Evening general effect.' He continued on various figures, worked at the landscape on 19 February and put in a final solid ten days' work before finishing on 19 April and holding a private view, with

The Nosegay, on 21 April.[28]

Rae acknowledged its receipt on 1 May 1866:[29] 'It is, if possible, finer than I thought it was. Mrs Rae is immensely pleased with it, as is everyone else who has seen it . . . In my judgement it is by far your greatest work thus far. In subdued splendour and subtlety of color, in dramatic pose, in drawing and in composition, in short, in everything that contributes to make a picture great I see absolutely nothing that could be amended, as far as my poor judgement gives me light . . . I trust and believe that it will be followed by a series of works equally great and I could also wish . . . that you will not think anything worth painting except out of the Bible or Shakespeare: for I consider these are virtually virgin ground as regards art . . .'

He lent it for the exhibition at Gambart's French Gallery in October 1866, where *The Athenaeum*[30] considered it 'the most original, one of the best painted and certainly the most paradoxical of pictures in the whole collection'. In a flattering but qualified notice the point was taken of the artist's search for truthfulness through the material available to him, 'to go further in this direction would involve residence in the East'. This approach was seen as the key to his treatment and execution: his 'very rare inventive faculties' and 'singular ability', and the 'quaintness and strangeness' of the picture. The colour, however, was not liked, '. . . Its treatment lacks breadth and repose; also that the subject, not being restful in its nature . . . may have indisposed the painter to let our eyes rest where no repose should be. If this is not part of the painter's policy, we are wrong. A certain horny yellowness offends us throughout the work.'

The Art Journal[31] while admitting that it 'bore incontestable marks of genius' and that his work 'merits attention as by a spell', nevertheless voiced a growing opinion of an inherent eccentricity and abnormality of style. The long descriptive notice ended: 'We cannot deny genius to this work. Yet why it should be quite so peculiar and repellent we cannot pretend to say. The picture is just one of those performances about which artists and *dilettanti* are likely to be intense one way or the other, either in the extreme of love or hate. As for the multitude we shall gratify the painter when we say that his picture is beyond them.'

The Contemporary Review[32] in 'Pictures of the Year' the following March, found the same 'defect of awkwardness in arrangement' as in his *Cordelia's Portion* (No. LL 3640 below), then on show at the Dudley Gallery, but was otherwise on the whole complimentary: 'The Jacob is a better figure than the Lear, and Benjamin is a great success, both in form and expression. Spectators may have some difficulty in making out the landscape background, which does not retire, but most nearly resembles a curtain of tapestry a few feet behind the figures. There is, however, much truth of rocky hill character in this landscape, and its various colour supplies an agreeable relief.'

Rae arranged for its return to the artist after the Leeds 1868 exhibition for a quarter-size replica (Museo de Arte, Ponce, Puerto Rico) to be made and for retouching. He

wrote on 13 September 1869:[33] 'I think the points you thought of retouching a little were the background, and the face of the lying knave, who is telling the story to the patriarch . . . the figure to the extreme right of the picture always struck me as capable of being rendered more *Oriental* in face. He has the bad luck to remind me of a prize fighting scoundrel I once saw . . .' He had commented about this figure in the drawing, in December 1864.

Madox Brown mentioned he was 'touching it and working at the small one', in a letter to Leathart at this time,[34] and wrote to Rae on 25 September 1869[35] that the present work was finished: 'I have done a good deal all over it besides doing what you suggested to the background and the figure of Simeon – the latter is I think *very* much improved and orientalised, and his hair dark.' Rae finally had it back on 7 October and was enthusiastic: 'I have not yet had a look at it in *good* daylight, but it strikes me to be wonderfully improved in unity and balance of tone . . . I hope you sold the small replica at a good price.'[36] However, while he kept his various paintings by Rossetti, Rae sold this picture in 1875.[37] It seems to have sustained some, unspecified, damage late in 1875.[38]

The small watercolour version, which may have been begun concurrently with the oil,[39] dated 1867 (12 × 12 in), was acquired by Frederick Leyland of Liverpool in 1867 and is now in the Tate Gallery. The child in it is in a loin cloth like the pen and ink drawing. The reduced oil version (21½ × 21½ in) of 1868–71,[40] blocked in by the artist's children, in particular Nolly,[41] was bought by William Brockbank of Manchester, 1871, and is now in the Museo de Arte, Ponce, Puerto Rico. The pencil sketch (paper 15 15/16 × 16 11/16 in; composition 8⅛ × 7⅞ in) at Birmingham (788/06) was probably from the artist's sale of 1894,[42] and the pen and ink drawing for the Dalziels (8⅛ × 7⅞ in) was acquired from the Dalziels in 1893 by the British Museum.

PROV: Commissioned by George Rae March 1864, 450 gns (£100 on acc. 10 Dec. 1864; £72.10.0, 15 Jan. 1865; £100 each at 1 March, 15 April and 15 May 1865); commenced Oct. 1864, completed April 1866; retouched 1869; sold by Rae to J. F. Hutton of Manchester autumn 1875 (Hutton planned to sell it 1879;[43] anon. sale Capes, Dunn & Co., 13.5.1890 (82), bt. Agnew £157.10.0; thence to William Coltart, 14 May 1890;[44] presented by his widow to the Walker Art Gallery, 1904.

EXH: Artist's Studio, 21 April 1866; Gambart, French Gallery, 1866–7, *Winter Exhibition*, as *The Coat of Many Colours*; Leeds 1868 (1345); Manchester 1878, *Art Treasures* (241) and 1887, *Jubilee* (270); Birmingham 1891 (165); Southport 1892, *Art Treasures* (79); Grafton Galleries 1897, *F.M.B.* (63), as *Jacob and Joseph's Coat*; Royal Academy Winter 1901 (106); Whitechapel 1901 (365), and 1905 (452); Hulme Hall, Port Sunlight 1902, *Coronation* (76); Port Sunlight 1948, *P.R.B.* (14); Liverpool and A.C. 1964, *F.M.B.* (40); Tate Gallery 1984, *P.R.B.* (129), repr. col.

1 Canvas stamp of Charles Roberson, Long Acre. A canvas 42 × 40½ in for the artist is listed under Oct. in Roberson & Co.'s Account Book for 1864 (Roberson Archives, Hamilton-Kerr Institute, University of Cambridge): information kindly supplied by Stephen Wildman.

2 Dalziel to FMB, 19 Nov. (?1863) and Nov. 1863 (artist's family Papers).

3 Dalziel, p. 237 f., 252–4.

4 The third subject, *Ehud and Eglon*, was never carried out as a painting. Madox Brown also planned a design for *Rahab and the Spies* which was not required by the Dalziels.

5 Nos 67–9 in the catalogue. The *Ehud* was a cartoon (Johannesburg Art Gallery,), the pen drawing only being executed late in 1865 (Victoria & Albert Museum).

6 Staley 1973, p. 43, pl. 52a (and oral opinion 1963/4).

7 A landscape by Seddon was lot 114 in the artist's executors' sale 29–31.5.1894, bt. Seddon.

8 FMB to Rae, 28 Nov. 1864 (Rae Papers No. 38, Lady Lever Art Gallery).

9 MS Account Book (copy by Hueffer), p. 84 (artist's family Papers).

10 For full discussion see Janet Haugaard, 'A Pre-Raphaelite Shibboleth: Joseph', *The Journal of Pre-Raphaelite Studies*, III, No. 1, 1982; and see Bennett in Tate Gallery 1984, *P.R.B.* (129).

11 Surtees 1971, *Rossetti*, No. 122; Haugaard, loc. cit. repr.

12 Hueffer, p. 446 (list).

13 Several sketches are dated either 1854 or 1855 and do not agree with what is known about the pictures concerned, e.g., sketch for *Walton-on-the-Naze* (private collection), sketch of old woman for *Work* (Tate Gallery), the outline for a cat in *The Nosegay*, No. LL 3639 above (Houghton Album, Ashmolean Museum, Oxford).

14 With letter 26 Dec. 1863 following some earlier discussion (Rae Papers No. 17).

15 14 March 1864 (artist's family Papers).

16 FMB to Rae, 9 March 1864 (Rae Papers No. 21).

17 FMB to Rae, 17 Oct. 1864 (Rae Papers No. 36).

18 Rae Papers No. 38.

19 A watercolour is listed by Hueffer (p. 440) as dating from 1866–7 (Tate Gallery); while it may have been started around 1864, it does not appear in the extant Account Book (copy) which ends late in 1864. In it the child is only in a loin cloth as in the pen and ink drawing.

20 9 Dec. 1864 (artist's family Papers); acknowledged in FMB to Rae, 10 Dec. 1864 (Rae Papers No. 39).

21 Rae to FMB, 4 Jan. 1865, enclosing four post-dated cheques, before he went abroad (artist's family Papers), and draft with Rae Papers.

22 Rae Papers No. 46, quoted in Hueffer, pp. 207–8.

23 Surtees, *Diary*, p. 202 f.

24 6 Dec. 1865, (artist's family Papers).

25 9 Oct. 1865 (Henry E. Huntington Library, San Marino, California).

26 Doughty and Wahl, II , Nos 628, 648.

27 He hired a lay figure of a child from Roberson & Co., 4–15 Nov. 1865 (Roberson Archives, loc. cit.).

28 John Gilbert saw it on this occasion and commented in his diary on its 'extraordinary ugliness' and the company's 'affected rapture' (private collection, from notes kindly supplied by Richard Ormond).

29 Artist's family Papers.

30 10 Nov. 1866, p. 612.

31 1 Dec. 1866, pp. 374–5.

32 2 March 1867, pp. 269–70.

33 Artist's family Papers.

34 21 Sep. 1869 (Leathart Papers, Special Collections, University of British Columbia Library).

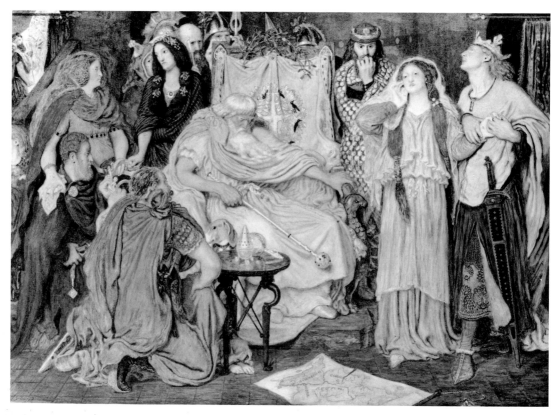

LL 3640. *Cordelia's Portion* (colour plate XII)

35 Rae Papers No. 82.
36 Artist's family Papers.
37 Noted in letters between Rae and the artist (Rae Papers and artist's family Papers).
38 FMB to Rae, 9 Oct. 1875 (Rae Papers No. 111).
39 See note 19.
40 *The Art Journal*, July 1871, p. 210.
41 FMB to F. Shields, 29 Jan. 1869 (Princeton University Library), and FMB to Lucy Madox Brown, 8 Sep. 1869 (Angeli Papers, Special Collections, University of British Columbia Library).
42 Presumably lot 202A: [First composition for] 'Coat of Many Colours', bt. Murray.
43 Rae to FMB (draft), 14 Feb. 1875, and FMB to Rae, 24 July 1879 (Rae Papers No. 115).
44 Agnew Picture Stock Book 5 (5645).

LL 3640. *Cordelia's Portion*

Watercolour, gouache and pastel, 70.5 × 107.3 cm
(29½ × 42½ in)
Signed in monogram and dated: *FMB 66–72*

Illustrating *King Lear*, Act I, scene 1, the moment when the King of France takes the disinherited Cordelia for his wife: *Lear*: 'Let it be so: thy truth, then, be thy dower . . . Cornwall and Albany with my two daughters' dowers, digest the third'.

This is the last of three paintings in which the artist sought to interpret aspects of the doomed conflict of Shakespeare's play, each of which grew out of the series of 'barbaric' pen and ink outline drawings illustrating *King Lear* which Madox Brown had designed at Paris in 1844 in emulation of French and Continental illustrators. The first painting, of *Cordelia at the Bedside of Lear*, in more tranquil mood, dates from 1848–9 (Tate Gallery). The second, *The Parting of Cordelia and her Sisters*, Madox Brown first carried out as an etching for *The Germ* in 1850, and afterwards produced a small oil sketch in 1854, which was carried no further (private collection, USA).[1] This present painting dates from the mid-1860s and in it the artist's mature 'sensuous'[2] style is fully developed. The linear patterning owes much to his designs for stained glass of the same decade, while the rich colouring and sensuous lyricism indicate his debt to Rossetti's sumptuous decorative paintings of this period, translated into Madox Brown's own essentially historical approach to subject.

The composition stems from two of the 1844 drawings (Manchester; figs 24, 25).[3] Similarly composed as a set stage-piece, viewed frontally, it translates the robust freedom of the drawings into a sinuous decorative linearism and bright local colour, in an encircling movement round Lear. He appears, shrunk exhausted into his throne, smouldering with passion, as the central pivot between the opposing factions of good and evil represented by his daughter Cordelia and her two sisters.

Fig.24 *Study for 'King Lear': Lear questioning Cordelia.* By permission of the Whitworth Art Gallery, University of Manchester

Fig.25 *Study for 'King Lear', Act I, scene 1.* By permission of the Whitworth Art Gallery, University of Manchester

The models have not been recorded, but characteristically of many of his paintings, his family and friends are evidently included: his daughter Cathy is almost certainly Cordelia, his wife Emma is the red-haired Goneril, and William Michael Rossetti appears at the left of the king's throne.

The subject first appears as a projected picture in the list sent to George Rae in December 1863, proposed with figures 3 ft high in a 52 × 40 in format, at 700 gns.[4] The 1844 series of drawings was exhibited at the artist's 1865 one-man show with the evident hope of a commission and in November of that year this subject, but on a smaller scale, was suggested in reply to Frederick Craven's request for a two-figure subject from Shakespeare as a companion to Rossetti's *Tibullus*, which was not yet begun:[5] after making various other suggestions in his (draft) letter, Madox Brown concluded that he had 'no distinct conception of a King Lear subject that would only have two figures and make a good upright. The one I most fancy for is the declaration scene in the first act with a dozen figures'. In the draft of a later letter[6] he particularised this as a subject he had 'long had in mind' and wished 'to do much larger, perhaps 25 × 33 in'.

Craven, still undecided, planned a visit in November and in reply to his letter of 9 November, the artist drafted his terms on the following day: 500 gns for a 32 × 25 in format or 350 gns for 22 × 16 in, copyright reserved. Craven had asked about frames in connection with both the *Nosegay* to match Rossetti's and this picture, and Madox Brown added: 'My framemaker is the same as Rossetti's and the pattern[s] he uses have been chiefly furnished by ourselves we have in fact altered the fashions in frames to a great extent . . .' On 18 November he recorded in his diary:[7] 'Craven called & commissioned me to paint a *King Lear*, a watercolour, for £525'. Rossetti would not finalise the size of his watercolour[8] and Craven agreed on 27 November to a 36 × 26 in format, which was in the event enlarged.

The subject was thought out later in November and the composition begun on 17 December 1865.[9] A cartoon was made for the design and probably begun first[10] though only mentioned specifically in the diary from 10 March 1866. He mentions working at the subject occasionally, chiefly in the evenings until with the completion and showing of the *Coat of Many Colours* (No. 1633 above) 21 April 1866, it becomes his chief work. The diary peters out in the following July. Craven sent payments at intervals at the artist's request, but wished to see the work before meeting the artist's request for a final £130 late in September 1866.[11] It was on show in Madox Brown's studio in mid-November[12] and Craven acknowledged its receipt on 23 November: 'Have just unpacked the drawing "Cordelia's Portion" and write a few lines to say how much I am pleased with it – the subject is finely conceived – broad in treatment and beautiful in colour – I thank you for making it for me with so much earnestness of purpose and for doing me so much justice'. Madox Brown sent him a copy of the sympathetic and descriptive review in *The Reader*[13] which in particular commented on the figure of Lear: 'This figure, indeed, is a noble creation, and would make or clench the fame of any man'. But Craven was soon picking faults, in particular what he called the 'modern French table' as an anachronism, asking if the dog was necessary and mentioned the odd semi-circular form behind Regan. He thanked the artist on 23 January 1867, before seeing it again, for his alterations.

On show at the Dudley Gallery early in 1867, it was demolished in *The Saturday Review:*[14]

'When foreigners interested in the fine arts do us the honour to visit our exhibitions, they find in them a class of productions elsewhere unknown, and which excite sensations of unlimited astonishment. Mr Ford Madox Brown is exactly the sort of painter to astonish a Frenchman. M. Taine[15] would regard his "Cordelia's Portion", in the Dudley Gallery, with mingled perplexity and abhorrence. The colour is splendid, but glaring in the extreme; the arrangement eccentric and ungraceful, the drawing positively bad. Some details – as, for example, the throne of Lear – are painted with great power; and though the violent colours everywhere fatigue the sense, there are passages of much delicacy and truth, and evi-

dences of poetical invention. That Mr. Madox Brown is an artist of real genius every good judge must be ready to admit, but his energy is not accompanied by moderation and good taste. M. Taine's feelings in the presence of such works as this are a matter of perfect indifference to us, and we by no means wish to imply that Mr Brown ought to abandon his way of painting in order to please philosophers; but it sometimes happens, as it certainly does in this instance, that considerable gifts are neutralized for the want of restraint; and though an artist need not defer to the opinions of others, he ought to be able to criticize himself. The eye of Lear, the arm of Regan, and the head of Cornwall are, as specimens of drawing and modelling, on the level of the work done by our uneducated female artists; and though the clothes are rich in colour, they show no human beings beneath them. There is an overcrowding and obtrusiveness of minor material which, though common in the school to which Mr Madox Brown belongs, is a fault and a hindrance. What is the use of the dog's paws under the table? The picture would have been better without them, and the dog's head does not easily explain itself; many spectators fail to see what it is.'

(The reviewer was kinder about *The Coat of Many Colours* No. 1633 above.)

In contrast, Ernest Chesneau writing in 1882 in a series of complimentary articles on Madox Brown in *L'Art*,[16] drew attention to his command of expression through both gesture and physiogomy so that each figure aspired to express, and with success, a certain character and state of mind. Chesneau was prepared to accept the artist's concern with the varieties of human expression, in which beauty was of no greater validity than ugliness or crudity.

Madox Brown appears to have retained it during 1867 and it may have again been retouched before September,[17] and a new frame was made for it to match *Tibullus* (the present one is presumably twentieth century) to please Craven.[18] In February 1868 it was again with the artist before going to the Leeds exhibition, when Craven asked him to look at certain points: Goneril's arms and Regan's neck. Madox Brown could not 'see anything to improve', but thought the 'junction of arm and body might be bettered'.[19] It was again with him about May 1872[20] when Craven asked for further alterations: 'I cannot but think it would be an advantage *to change* the colour of Goneril's girdle which I think takes *too much attention* – is there not rather too much red in the hair and face of the figure also. Indeed you spoke of reducing this when I called before. Albany's cheek is rather red too I fancy – however excuse my offering my suggestions.' It is not clear how much work was put into it at this date. It required minor restoration in 1883: 'the affected parts', Craven wrote, 25 September, 'seem to be Goneril's cheek and nose and Cordelia's hands . . .'

The cartoon of the same size, was taken up in 1868–9 for reproduction by the Autotype Company as Craven was reluctant to make his picture available yet again;[21] it was sold in 1875 to the artist's new acquaintance Charles

Rowley, picture dealer and philanthropist of Manchester,[22] and was probably the version shown in the exhibition of Les XX at Brussels in 1893 (now Manchester City Art Gallery).[23]

An oil version, 33 × 42 in, begun 1867, was finished for Albert Wood of Conway in 1875[24] (Southampton Art Gallery). A small oil, 22 × 30⅜ in (Fitzwilliam Museum, Cambridge), may date from around 1893[25] and have been in the executors' sale.[26] Each shows slight variations in drapery and details.

Henry James, in reviewing the 1897 Grafton Galleries exhibition of Madox Brown's work, which he considered, in contrast to Lord Leighton's memorial show at the Royal Academy, as an 'opportunity for poetic justice tragically missed', summed up this subject (the oil version was on show), as an example of the artist's paintings 'which have a little of everything, including beauty, but which are so crammed with independent meanings as rather to be particoloured maps than pictures of his subject. Everything in Madox Brown is almost geographically side by side – his method is as lateral as the chalk on the blackboard. This gives him, with all his abundance, an air of extraordinary, of *invraisemblable* innocence . . .'[27]

ENGRAVED: Autotype Company reproduction c.1870, 18 × 26½ in, and 8½ × 12½ in, after the cartoon (Manchester City Art Gallery).
PROV: Commissioned by Frederick Craven of Manchester, Nov. 1865, 500 gns; (£130 on a/c 22 Nov. 1865; £130 25 April, and (22) July 1866; final payment about Sep. 1866 unrecorded),[28] finished Nov. 1866; retouched 1867, 1872 and 1883; Craven sale Christie's, 18.5.1895 (45), bt. Rowley £210; Edgar Wood of Manchester by 1909; anon. sale Christie's 2.5.1924 (76), bt. Gooden & Fox, £609, for 1st Viscount Leverhulme; bt. from trustees of his estate by the trustees of the Lady Lever Art Gallery, 1925.
EXH: Artist's Studio, 37 Fitzroy Square, 19–21 Nov. 1866; Dudley Gallery, London 1867, 3rd Watercolour Exh. (249); Leeds, May–Oct. 1868 (234); Manchester 1909, *Manchester Academy Jubilee*; Manchester 1911, *P.R.B.* (89); Tate Gallery 1913, *P.R.B.* (10); Bath 1913; Birkenhead 1929; Port Sunlight 1948, *P.R.B.* (18); Belfast 1964, *Shakespeare in Pictures* (5); Tate Gallery 1984, *P.R.B.* (239) repr.

1 For a general discussion on this subject see Helen O. Borowitz, ' "King Lear" in the art of Ford Madox Brown', *Victorian Studies*, Spring 1978, pp.323–7; and see Tate Gallery 1984, *P.R.B.* (16).
2 Hueffer, p.416, note 1.
3 Catalogue, *The Pre-Raphaelites and their Associates in the Whitworth Art Gallery*, 1972, Nos 7 and 8 (8 repr. pl. 10).
4 Rae Papers (Lady Lever Art Gallery).
5 Surtees, 1971, No. 62 R.I.; Craven to FMB, 1 Nov. 1865; FMB to Craven n.d. (2 Nov.) 1865 (these and all subsequent references to Craven/FMB correspondence and FMB drafts are from the artist's family Papers).
6 6 Nov. 1865.
7 Surtees, *Diary*, p.209.
8 See Doughty and Wahl, II, No. 652; Surtees, loc. cit., 23 Nov. 1865.
9 Surtees, *Diary*, p.210.

10 Hueffer, p.207.

11 See note 28.

12 W. M. Rossetti 1903, p.198, quoting his own diary for 19 Nov. 1866.

13 *The Reader*, 1 Dec. 1866.

14 *The Saturday Review*, 2 March 1867.

15 Hippolyte Taine, the French critic, whose *Philosophie de l'art* was published in English in 1866. The reviewer is probably thinking of Taine's opinion on the distortion and blunting of optical sensibility in English painting and his comment that 'I do not believe that pictures so very disagreeable to look at have ever been painted. Impossible to imagine cruder effects, colour more brutal or exaggerated', etc., and giving as examples works by Millais, Holman Hunt etc. (Taine, *Notes sur L'Angleterre*, 1871 edition, p.353: from English translation in Edward Hymans, *Taine's Notes on England, 1860–1870*, 1957, p.263).

16 *L'Art, Revue Hebdomadaire Illustrée*, IV, 1882 (XXXI), p.103.

17 Craven to FMB, 20 Sep. and 11 Nov. on receipt.

18 Craven to FMB, 20 Aug., 4 and 20 Sep. 1867.

19 Craven to FMB, 27 Feb. and FMB (draft) to Craven 28 Feb. 1868.

20 Craven to FMB, 21 May (?) 1872.

21 FMB (draft) to Craven 11 Feb. and Craven to FMB 12 Feb. 1868; FMB (drafts) to E. Edwards (Autotype Company), 15 and 26 Feb. 1868, 12 (?) June 1869 (artist's family Papers).

22 Hueffer, p.302, quoting FMB to Rae 6 Feb. 1875 (Rae Papers No. 108); Rowley to FMB 16 Feb. 1875 (artist's family Papers).

23 See Bruce Laughton, 'The British and American Contribution to Les XX', *Apollo*, Nov. 1967, p.379: Julian Treuherz, *Pre-Raphaelite Paintings in the Manchester City Art Gallery*, 1980, p.112 repr.

24 FMB to Lucy Madox Brown n.d., ? Sep. 1868 (Angeli Papers, Special Collections, University of British Columbia Library); FMB to Leathart, 31 Dec. 1874 (Leathart Papers, loc. cit.); Hueffer, pp.300, 441 (list).

25 W. M. Rossetti MS Diary, 25 June, 13 July 1893 and 10 March 1894 (Angeli Papers), where he refers to the artist being at work on a watercolour (sic) duplicate.

26 Artist's executors' sale, 29–31.5.1894 (15), bt. Frazer, £73.10.0. The reproduction in the catalogue is probably from the Autotype.

27 *Harper's Weekly*, Feb. 1897, reprinted in R. Hart-Davis, *The Painter's Eye*, 1956 edition, p.250.

28 FMB (draft) to Craven, 17 Sep. 1866, asking for final payment of £130; Craven to FMB, 'Wednesday Night' (?19), and 20 Sep. 1866, wishing to see it first; Housekeeping Account Book (Walker Art Gallery).

10602. *Nehemiah*

Brown wash and pencil, 96.5 × 49.8 cm (38 × 19⅝ in)
Inscribed in the artist's hand: *This Cartoon is the property of the Artist F. Madox Brown; copyright for stained Glass only Granted to Morris* and with notes in another hand at top and bottom of figure: *tip of nimbus* and *toe*

Nehemiah (fifth century BC) was a minor prophet, writer of one of the books of the Old Testament. He persuaded his master, the Persian King, Artaxerxes I, to send him as governor to Judah, where he restored the walls of Jerusalem, protecting his Jewish flock by arms. He is presented with a trowel in his right hand and with his left resting on a sword.

The design for a stained-glass panel in the east Chancel window of the church of St John the Baptist, Tuebrook, Liverpool (G. F. Bodley, 1868–71), which was executed

10602. *Nehemiah*

by Morris, Marshall, Faulkner and Company, and one of three windows by them in the church.[1] The cartoon dates from 1868[2] and was not used elsewhere. The window is made up of two tiers each with five single figures, designed by various members of the firm including two by Madox Brown. Both of these appear in the top row, a *Noah* at top left (dating from 1864, and used extensively elsewhere), and *Nehemiah* in the fourth panel.

Bodley had been the first to commission the Morris firm for stained glass, in 1862 (see also No. 10503, *St Jerome*, above). Their work here forms part of the sumptuous interior to Bodley's restrained exterior design.

PROV: Morris and Company (1911);[3] perhaps in their dispersal sale 1940; anon. sale Christie's, 28.4.1987 (233),

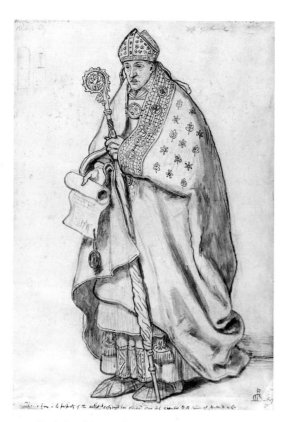

3182. *Hugh de Balsham, Bishop of Ely*

repr., bt. Agnew for the Walker Art Gallery.
EXH: Manchester 1911, *P.R.B.* (3).[4]

1 A. C. Sewter, II, 1975, pp.117–18, 309.
2 Hueffer, p. 446 (list).
3 Evidently not returned to the artist, who retained the majority of his cartoons (not listed in the house sale after his death, May 1894). A Morris and Company label on the back of the frame has *No. 14* added in ink.
4 Label on frame back.

3182. *Hugh de Balsham, Bishop of Ely*
Brown wash with charcoal, 55.4 × 37.8 cm
(21¾ × 14⅞ in)
Signed in monogram and dated: *FMB – 69*
Inscribed, top in pencil: *Hugh de Balsham/Bishop of Ely*, and bottom (in the artist's hand) *This cartoon is the property of the artist; copyright for stained glass only granted to the firm of M.M.F. and Co.* The firm's number (?)*FP 322*, partly cut off, is at top right with a pencil note below: *top of head*

Morris, Marshall, Faulkner and Company were commissioned to provide decorative tiles and stained glass for the Hall and Combination Room at Peterhouse, Cambridge, where extensive restoration was being carried out by George Gilbert Scott, 1868–70.[1] Both Edward Burne-Jones and Ford Madox Brown designed figures for the stained glass.[2] Madox Brown executed four small figures,

1869–74, for paired windows in the Combination Room: Spenser and Milton, and Edward I and Hugh de Balsham, the present cartoon.[3] In 1870–71 he also executed seven further figures on a larger scale of great scholars for the Hall bay window, and these included a further Hugo de Balsham, 1871, in different pose and costume (frontal, in grey habit, holding a model of the college).[4]

Hugh de Balsham (d.1286), Bishop of Ely and founder of Peterhouse during the reign of Edward I, here appears in canonicals with crozier and scroll with a seal. At the top left of the paper is a slight outline of a two-light window with the right-hand one marked for a panel, and this figure is set on the right as indicated. The scale of the windows, where the figures appear against a field of diamond quarries, is similar, the patterning on the cope, however, is altered.

Like all Madox Brown's designs for stained glass the drawing displays strong characterisation and rhythmic movement. The artist set down his ideal views in the cartoon section of his 1865 exhibition catalogue:[5]

'With its heavy lead-lines, surrounding every part (and no stained glass can be rational or good art, without strong lead-lines), stained glass does not admit of refined drawing; or else it is thrown away upon it. What it does admit of, and above all things imperatively requires, is, fine colour; and what it *can* admit of, and does very much require also, is *invention, expression*, and *good dramatic action*. For this reason, work by the greatest historical artists is not thrown away upon stained glass windows, because though high finish of execution is superfluous and against the spirit of this beautiful decorative art, yet, as expression and action can be conveyed in a few strokes equally as in the most elaborate art, on this side therefore, stained glass rises again to the epic height . . .'

The colour was selected by Morris from the glass itself.

REPR: H. Rathbone, *Cartoons of Ford Madox Brown*, 1895, p.16.
PROV: Artist's executors' sale (T. G. Wharton), 1 St Edmund's Terrace, Regent's Park, 29–31.5.1894 (267) as *Bishop of Ely*, bt. Shields, £4.4.0.,[6] acting for the subscribers to the fund for purchasing and presenting cartoons to principal Galleries, and presented to the Walker Art Gallery, 1894.

1 Fitzwilliam Museum, Cambridge, *Morris and Company in Cambridge*, exhibition catalogue by Duncan Robinson and Stephen Wildman, 1980, pp.44–8.
2 A. C. Sewter, I, 1974, pls 225–41; II, 1975, pp.44–6.
3 Hueffer, p.446 (list): *Edward I* and *Bishop of Ely*, 1869; *Young Milton* and *Spenser*, late in 1872. A. C. Sewter, I, pls 325, 326. The cartoons for the *Young Milton, Edward Spenser*, and *Edward I* were also in the artist's executors' sale, loc. cit., the first two as lot 238 and the latter lot 246, all bought Harold Rathbone. The first two Rathbone reproduced in his *Cartoons of Ford Madox Brown*, 1895, p.16 (and thence repr. A. C. Sewter, I, pl. 462). The *Young Milton*, dated 1874, is now at Birmingham (1951/34). *Edward I* (which was also designed in a larger version for a window in the Hall, 1871, and that cartoon was bought at the sale by the Westminster Technical Institute), must be that included in a list of ten designs Rath-

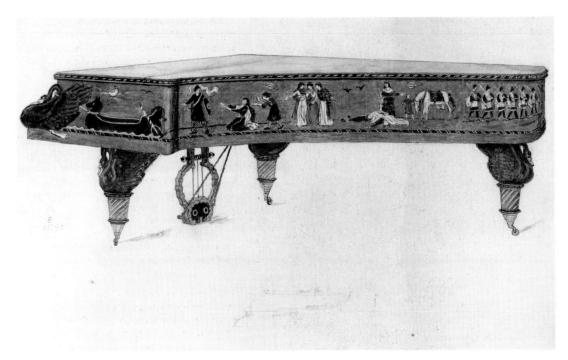

10513. *Design for a 'Lohengrin' Piano*

bone bought for the Liverpool University College School of Architecture and Applied Art under R. Anning Bell (Liverpool Corporation Technical Instruction Committee Minutes, 10 April 1896, Liverpool Record Office). They cannot now be found at the University School of Architecture and may have gone astray when the Art Department was discontinued in 1905 and amalgamated with Liverpool School of Art, Mount Street. They are not traceable in the latter institution either. Some of them were reproduced in Rathbone's *Cartoons* loc. cit. (pls 4, 6, 9, 13 and 15, and thence repr. A. C. Sewter). They were listed as follows:

	Price
Flagellation	£6.6.0. (not identified in sale, unless unmarked lot 315)
Miraculous draught of Fishes	£3.13.6. (lot 235)
St Luke (in fact St Mark)	£1.2.6. (lot 269)
Peada, King of Kent	£5.5.0. (lot 236)
Edward I	£3.15.0. (lot 246)
Elkanah and Doves	£5.5.0. (lot 303)
John the Baptist	£3.13.6. (lot 239)
Simeon	£7.17.6. (lot 297)
David and Goliath	£4.14.6. (lot 271)
Noah	£3.0.0. (lot 279 at £1.1.0.)

(prices in all cases, except, possibly the first, and the last item, match those in a marked copy of the catalogue in the artist's family, giving purchasers). See also No. 4006 below, *St Jude*, note 2.

4 Hueffer, p.446 (list) under May 1871. A. C. Sewter, I, p.331; the cartoon is untraced. A yet further *Hugh de Balsham* was designed by Edward Burne-Jones for one of the other windows in the Hall, for which Madox Brown also supplied twelve more figure designs.
5 Piccadilly, 1865, *F.M.B.*, p.23. For a full discussion of Madox Brown's cartoons, see A. C. Sewter, I, pp.48–72.
6 Marked copy in artist's family.

10513. *Design for a 'Lohengrin' Piano*
Black and sepia wash, 28.5 × 49 cm (11¼ × 19¼ in)
Signed in monogram and dated: *FMB–73*

Episodes from the opera appear along the sides; a black swan forms the head of each leg and supports either end of the keyboard. Below the design a pencil diagram gives the overall measurements (about 8 ft 2 in × 4 ft 6 in along the straight sides). Hueffer states[1] that it was intended to be executed in inlaid ebony and ivory but proved too expensive.

It was most probably designed for Franz Hueffer (1845–89), the music critic, who had married Catherine Madox Brown in September 1872. *The Times*, on which he was music critic, in its obituary on him commented:[2] 'A great admirer of Richard Wagner, Dr Hueffer was perhaps the first in England to recognise his merit and to advocate his claims. *Richard Wagner and the Music of the Future* appeared in 1874,[3] when Wagner was little appreciated in this country . . .' Two scores of 'Lohengrin' were published in 1873[4] and the Wagner Society was founded and held its first season of concerts that year, when excerpts from 'Lohengrin' were included in its repertoire well before this and other Wagner operas had received performances in England.[5]

REPR: *The Artist*, May 1898, p.44, 'Madox Brown's Designs for Furniture'.
PROV: Mrs Catherine Hueffer (née Madox Brown); by descent to Sir Frank Soskice (Lord Stow Hill); Lady Stow Hill, from whom purchased, with Nos 10504–15, with the aid of a contribution from the National Art-

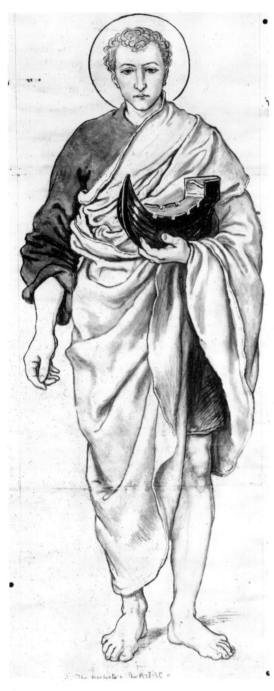

4006. *St Jude*

Collections Fund, 1984.

EXH: Grafton Galleries 1897, *F.M.B.* (188).

1 Hueffer, p.282.
2 *The Times*, 21 Jan. 1889, p.9.
3 Reviewed in *The Athenaeum*, 24 Jan. 1874, p.132.
4 Reviewed in *The Athenaeum*, 1 March 1873, p.287.

5 *The Athenaeum*, 1 March 1873, p.288; 17 May, p.639, etc. The latter report commented: 'The re-demands rapturously insisted upon by the large audience assembled in St James's Hall, an audience the artistic element of which was most remarkable, for the 'Lohengrin' instrumental items seemed to be the key to public opinion here as regards Herr Wagner's music.'

4006. *St Jude*

Charcoal and wash, 136.8 × 52.6 cm (53⅞ × 20¾ in)
Inscribed: *Jude* and *The Property of the Artist*

St Jude the Apostle, traditionally brother of James, Apostle and fisherman. He is said to have been martyred in Persia with St Simon.

Design for a panel in a stained-glass window by Morris, Marshall, Faulkner and Company for Llandaff Cathedral, 1874. Four new designs by Madox Brown were used in this three-light window containing three full-length Apostles, each with a panel subject below, and with three angels holding scrolls in the tracery above.[1] *St Simon* (left) and *St Jude* (right), both by Madox Brown, flank *St Peter* by Edward Burne-Jones; with below, *The Miraculous draught of Fishes* and *St Paul's Shipwreck* flanking the re-used subject of *Christ Walking on the Waters* of 1864, all by Madox Brown.[2] Both Apostles by Madox Brown are similarly frontal and barefoot, in simple robes as fishermen. Their draperies, characteristically, are employed to add movement and solidity to the figures within the limitations of decorative patterning.

PROV: Artist's executors' sale (T. G. Wharton), 1 St Edmund's Terrace, Regent's Park, 29–31.5.1894 (304), bt. Shields, £7.7.0,[3] acting for the subscribers to the fund for purchasing and presenting cartoons to principal Galleries, and presented to the Walker Art Gallery, 1894.

1 Hueffer, p.447 lists the four new subjects under April 1874. A. C. Sewter, I, 1974, pl.463; II, 1975, pp.120–1. The firm had already executed other windows in the Cathedral from 1866, for which three of Madox Brown's cartoons, previously used for Bradford, had been employed.
2 The cartoon for *St Simon* is at Birmingham (A. C. Sewter 1974, I, pl.464); *Christ Walking on the Waters* belongs to a descendant of the artist (ibid, pl.246); *St Paul's Shipwreck* belonged in 1896 to Charles Rowley of Manchester (lent Arts and Crafts Exhibition Society, 1896, No. 411); *The Miraculous draught of Fishes*, bought at the artists's executors' sale, loc. cit., by Harold Rathbone, was included in his list of purchases for Liverpool University College School of Architecture and Applied Art, 1896 (see No. 3182 above, note 3), and has not reappeared.
3 Marked copy in artist's family.

LL 3641. *Cromwell on his Farm*

Oil on canvas, arched top, 143 × 104.3 cm (56¼ × 41 in)
Signed in monogram and dated: *FMB 74*
Inscribed on gold flat: (left) LORD, HOW LONG WILT THOU HIDE THYSELF – FOREVER? AND SHALL THY WRATH BURN LIKE FIRE?; (right) LIVING NEITHER IN ANY CONSIDERABLE HEIGHT, NOR YET IN OBSCURITY, I DID ENDEAVOUR TO DISCHARGE THE DUTY OF AN HONEST MAN
Frame: Of the 'Lely', seventeenth-century, type, having a curved border with fields at the corners and centre sides with shallow carved plant forms; gilt oak with plain gilt oak flat.[1]

The quotations are, respectively, from Psalm 89, verse 45, as given in the Book of Common Prayer,[2] close to the 'Great' Bible text, 1539, and from Cromwell's Speech of 12 September 1654.[3] They repeat the MS label on the back in the artist's hand and are given in the catalogue on the picture's first exhibition at the Royal Manchester Institution, 1874.

Cromwell has come to a halt on his old pale horse[4] in a country lane with a view of the church of Huntingdon in the distance over the river Ouse; his wife with their child observe him from the terrace of their house. He clutches an oak sapling in place of his forgotten whip, symbol of moral or physical strength and of future power.[5] With one hand he keeps the place in his Book of Common

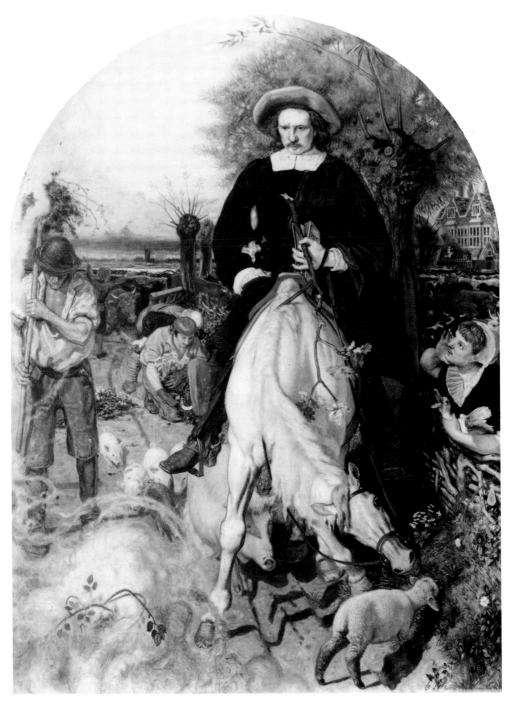

LL 3641. *Cromwell on his Farm* (colour plate XV)

Prayer, from which he has just read the passage in Psalm 89, verse 45, quoted above. Deep in meditation he gazes into the wreathed smoke and flames of the bonfire made by the labourers clearing and mending the hedgerow, perhaps contemplating the future obscured in mist while the dead wood of the past is destroyed. He is quite unconscious of the chaos and noise around him caused by the escaping pigs and cattle, and the maidservant clutching a squawking duck crying to him over the hedge that his dinner waits. His browsing old horse (close in composition to Delacroix' *The Capture of Constantinople by the Crusaders*, Louvre, in reverse), and the lamb nearby, are heedless likewise.[5]

The composition follows, with only slight developments, a small watercolour of *St Ives*, dating from 1853–6, which had been designed with an oil painting in mind (17½ × 9¼ in, Manchester; fig. 26).[6] While living in isolation and mental unrest at Hampstead in 1852–3, Madox Brown began his three greatest paintings, *The Last of England*, *English Autumn Afternoon* and *Work*. Like the last of these, this design also stems from the writings of Thomas Carlyle, in this case *Cromwell's Letters and Speeches* (1845, a 3rd edition was published 1849). Hueffer suggests[7] that Madox Brown saw a parallel to his own situation at that time with that of Cromwell during the latter's retirement from the political scene to his country estate during the early 1630s after the dissolution of Parliament. Carlyle wrote of Cromwell at St Ives in 1636: 'A studious imagination may sufficiently construct the figure of his equable life in those years. Diligent grass-farming; mowing, milking, cattle-marketing; add "hypochondria", fits of the blackness of darkness, with glances of the brightness of Heaven; prayer, religious reading and meditation; household epochs, joys and cares:- we have a solid substantial inoffensive Farmer of St Ives, hoping to walk with integrity and humble decent diligence through this world . . .'[8] In the Speeches he transcribes, Cromwell makes specific reference to reading from the Psalms.[9] Subjects from Cromwell's life were popular with other painters at the time including Madox Brown's friend Charles Lucy of whose works in this line he was aware.[10]

The artist found in Psalm 89 an appropriate parallel to Cromwell's situation,[11] and the composition is woven round Carlyle's descriptions of the neighbourhood of Huntingdon and St Ives, which the artist visited in June 1856 after taking up his sketch earlier that year.[12] Soon after, his dealer, D. T. White, advised him not to make a picture of it[13] and he disposed of the watercolour.[14] However, he had some hope of a commission in 1859 from James Leathart and again from him early in 1865, when it was discussed in terms of life-size figures.[15] In 1873 when this oil of more acceptable scale was commissioned by William Brockbank of Manchester,[16] the watercolour was borrowed back.[17]

The composition was probably first blocked out in a full-scale cartoon as was now Madox Brown's normal practice (a cartoon on brown paper, finished in watercolour later, is now in the Johannesburg Art Gallery). Rossetti, in writing on 6 April to congratulate him on his

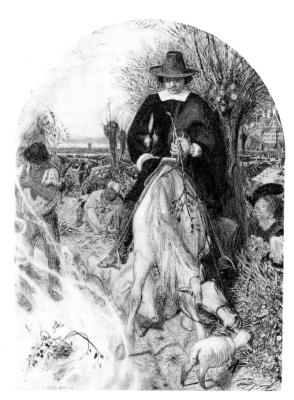

Fig.26 *St Ives (Cromwell on his Farm)*. By permission of the Whitworth Art Gallery, University of Manchester

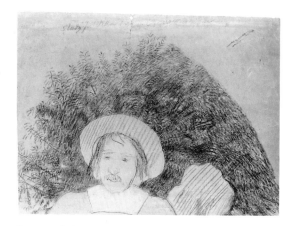

Fig.27 *Study for 'Cromwell on his Farm'* (Houghton Album). By permission of the Visitors of the Ashmolean Museum, Oxford

recent commission, commented: 'If I were you I should certainly do away with Cromwell's hat, and so give the subject a less quaint and more dignified aspect; but indeed I dare say you propose altering it in several respects.'[18] The hat is changed from the high crowned shape of the watercolour to a slouch beaver in the oil, and is also so in the cartoon and in a rough chalk study of this fragment of the picture (Oxford, Houghton Album, folio 5; fig. 27). Thus, Cromwell's face, now illuminated in-

stead of half in shadow, becomes more clearly the focal point of the painting. Other differences from the watercolour are the serving wench at the right who replaces a yokel and the workman behind the horse who looks up instead of down. The colouring is in the muted earthy range of the artist's later manner.[19]

The canvas was worked on during June 1873 while staying in similar countryside with Rossetti at Kelmscott Manor, Oxfordshire. Madox Brown mentioned in a letter to Rae[20] that '. . . the lamb is settled and the horse fairly started, but the pigs puzzle me – they are all perversely *black* in this country and I want white ones'. Rossetti wrote to his brother William in July[21] that Madox Brown 'has begun putting in the material straight from Nature, with great vigour and fine tone, and I would almost say that it promises to be his very best picture'. To Brown himself he was equally complimentary:[22] 'Your picture of *Cromwell* shows that, working direct from nature, you are capable of making an advance in execution on anything you have yet done, and I think if you now do this kind of work for a while, there is a very good chance of its opening some eyes which are shut at present.' The artist asked for a loan from Rae to help him to proceed exclusively on this work,[23] 'the picture' he wrote on 23 August, 'ought to be finished in about 6 or 7 weeks when I shall get 400£ . . . but I want money & do not wish to leave off the picture'. Rae obliged.[24] In October he informed Frederic Shields at Manchester:[25] 'I am getting on with Cromwell now solidly – all of him done but one hand'. *The Athenaeum* in February 1874[26] announced that it was far advanced and Brockbank sent a cheque for £100 and asked to see it.[27] By 19 March the artist could write to Shields[28] that it was going to Brockbank 'on Monday, and has become perhaps my finest work. Mum about hand to patron'. Delay in finishing had been caused by an attack of gout. Brockbank acknowledged it on 1 April:[29] 'the only part which puzzles me is the lamb, *has* it a meaning? I think I can make out your intentions in all the rest'.

Whilst it was on public exhibition in Manchester, F. J. Shields expounded at length on it to the Manchester Literary Club in November 1874,[30] making a comparison with the sensuousness of a Fantin-Latour still life to the advantage of the *Cromwell*, '. . . For the thought rules here, and the execution is subordinated to it; not slighted, but ruled into service to the nobler part . . .'[31]

It was exhibited with *Haidee and Don Juan* in Bond Street, winter 1876–7, when F. G. Stephens in *The Athenaeum*[32] thought it of 'immeasureably higher quality' than the other, and noted that 'the composition of the subject is first-rate in power and pathos, and is a fine and complete picture, except where a little attention might complete the drawing'. *The Art Journal*[33] commented on its 'thoughtful composition' and thought both pictures 'grand works'.

PROV: Commissioned by William Brockbank, Manchester, March-April 1873, £400; finished 1874; Brockbank sale Christie's 27.2.1897 (73), bt. Garnett, £168; Oliver Brockbank, 1897; purchased from Fine Art Society by W. H. Lever (1st Viscount Leverhulme) 16 Oct. 1899, 200 gns,[34] and thence to the Lady Lever Art Gallery.

EXH: Royal Manchester Institution 1874 (73); Deschamp's Gallery, Bond Street, 1876/7, *Winter Exhibition* (16); Manchester 1887, *Jubilee* (63); Arts and Crafts Exhibition Society 1896 (408); Grafton Galleries 1897, *F.M.B.* (62); Whitechapel 1901 (226); Hulme Hall, Port Sunlight 1902, *Autumn* (179); Manchester 1911, *P.R.B.* (51); CEMA, 1943, *The English* (14); Port Sunlight 1948, *P.R.B.* (21); Liverpool and A. C. 1964, *F.M.B.* (42).

1 Repeated for the frame of the cartoon at Johannesburg Art Gallery; the designer uncertain.
2 Pointed out to the compiler by Jillian Barry, Johannesburg, in letter of 23 April 1977.
3 Thomas Carlyle, *Oliver Cromwell's Letters and Speeches with Elucidation, 1845* (1857 edition, III, p.41).
4 Surtees, *Diary*, p.226 (fragment).
5 Some of the symbolism is described by F. J. Shields, 'On Two Pictures by Mr Madox Brown', *Transactions of the Manchester Literary Club, Vol. 1, Session 1874–5*, 1875, pp.48–50 (read on 23 Nov. 1874). An extensive description by Forbes Robertson is quoted by Hueffer, pp.290–2.
6 This watercolour was exhibited at the Liverpool Academy 1857 as *St Ives, An. Dom. 1635* and with the quotation from Psalm 89, verse 45. It was subsequently exhibited at the artist's 1865 show with the date advanced to 1636 and with a brief explanation: 'This is a first sketch for a picture, not yet painted, of Oliver Cromwell on his farm. At this date, 1636, when Cromwell was engaged in cattle farming, the electrical unease of nerves which is felt by nations prior to the bursting of the psychological storm, seems to have produced in him a state of exalted religious fervour mingled with hypochondria, now, owing to the "Letters and Speeches", pretty generally understood. In my composition the farmer is intended to foreshadow the king, and everything is significant or emblematic; but as I hope yet to produce this subject in large, I will not further describe the present sketch.' A slight pencil sketch for it is in the Tate Gallery.
7 Hueffer, p.94.
8 Carlyle, op. cit. (1857 edition, I, p.53).
9 Ibid, III, p.193, 17 Sep. 1656.
10 Surtees, *Diary*, pp.59, 153.
11 See note 6.
12 Surtees, *Diary*, pp.176–7.
13 Ibid, p.178.
14 Hueffer, p.97.
15 Leathart to FMB, 29 Oct. 1859, 11 Jan. 1865 (artist's family Papers); FMB to Leathart, 13 Jan. 1865 (Leathart Papers, Special Collections, University of British Columbia Library).
16 Probably introduced by Frederic Shields, then still living at Manchester. His first purchase had been in the previous year of a small oil version of the *Coat of Many Colours* (Museo de Arte, Ponce, Puerto Rico). Madox Brown wrote to Shields on 6 April announcing the present commission, in which guineas was changed to pounds and commented: '. . . Have you been talking to him since your return and so hastened his return here? In such case how much have I to thank you!' (E. Mills, *Life and Letters of Frederic Shields*, 1912, p.158).
17 FMB to Lucy Madox Brown, 11 June 1873 (Angeli Papers, Special Collections, University of British Columbia Library).
18 Doughty and Wahl, III, No. 1326.
19 In his letter to Lucy, loc. cit., Madox Brown commented on the watercolour: 'It does look crude – you would not believe how much'.
20 Rae Papers, No. 93, 27 June 1873 (Lady Lever Art Gallery).

21 Doughty and Wahl, III, No. 1366, 10 July 1873.
22 Ibid, No. 1391, 26 Aug. 1873.
23 Rae Papers, No. 94.
24 Acknowledged in FMB to Rae 31 Aug. 1873, Rae Papers, No. 96.
25 23 Oct. 1873 (Angeli Papers).
26 *The Athenaeum*, 14 Feb. 1874, p.233.
27 Letter 15 Feb. 1874 (artist's family Papers).
28 Angeli Papers.
29 Artist's family Papers.
30 F. J. Shields, loc. cit.
31 His views on the subject in art were not shared by at least one member of his audience, Walter Tomlinson, who read a 'Commentary on the Foregoing' on 30 Nov. (*Transactions*, op. cit., pp.50–1): '. . . Through the whole of these notes there seems on the part of Mr Shields an effort, and an earnest one, to assume such an exceptional position to all acknowledged precedent that, were we to put ourselves under his guidance in art matters, we must not only unlearn all our lessons from the great men of old, but unfeel all our instinctive love of beauty and harmony . . . I would fain recall Mr Shields' attention to the simplest and first requirements of art expression. . .'.
32 *The Athenaeum*, 11 Nov. 1876, p.631.
33 *The Art Journal*, 1877, p.15.
34 Account, 16 Oct. 1899 (Gallery files).

Brown, Ford Madox, studio of

LL 3645. *The Baptism of St Oswald*
Watercolour,[1] with gilt nimbus, 56 × 51 cm (22 × 20⅛ in)

Oswald of Northumbria, king and martyr (about 605 – died 642), after regaining his kingdom from the Welsh king Caedwalla, introduced Christian missionaries into Northumbria, led by his friend St Aidan.

Madox Brown executed six cartoons for stained-glass panels illustrating the life of St Oswald, 1864–5, for his firm of Morris, Marshall, Faulkner and Company, to be placed in the east tower window of St Oswald's Church, Durham. These cartoons are now in the Victoria & Albert Museum (figs 28, 29).[2] The cartoon for the *Baptism* (fig. 28), executed September 1864,[3] measures 18⅝ × 18⅞ in, with which No. LL 3645 corresponds in size and closely follows in detail and textures, except for the elimination of two soldier onlookers from the bottom right and the introduction of a more youthful beardless head for the priest.

Harold Rathbone suggested, when he sold this drawing, that it was 'apparently a replica . . . probably laid in by one of his daughters, Cathy née Madox Brown'.[4] Cathy certainly did 'some preliminary work' on the very competent watercolour version of *The Last of England* (Tate Gallery) in 1866.[5] The present item may have been an early exercise of hers touched on and completed by her father. It appears of a rather higher quality than either of the two, admittedly unfinished, replicas (No. LL 3646 and No. 10512 below), of which the watercolour is perhaps more certainly by her. This may be due to Ford Madox Brown's overseeing and finishing. He saw his cartoons as raw material for possible paintings and his children were working in his studio in the 1860s. These three items may have been undertaken with the hopes of a patron which came to nothing.

In 1878 he began his first cartoon for the commission for wall paintings in Manchester Town Hall and took up the second subject of the *Baptism of Edwin* first (fig. 30). This was, as he informed his co-artist Frederic Shields, 'because it comes readily to my hand, having done the sort of thing before'.[6] The composition is an expansion of this design taking into account the different format and scale, with a similar baptism at its left.[7]

PROV: Possibly artist's executors' sale (Wharton), 29–31.5.1894 (281 or 282: where in a copy of the catalogue 'Moses' and 'Zachariah' are deleted by hand and 'unfinished painting the Baptism' and 'do do' added in MS); bt. Rathbone £3.0.0. and £6.0.0;[8] Harold Rathbone, who sold it from the exhibition at the Bluecoat School, Liverpool to W. H. Lever (1st Viscount Leverhulme), May 1916, £30; thence to the Lady Lever Art Gallery.
EXH: Bluecoat School, Liverpool, 1916; Port Sunlight 1948, *P.R.B.* (12); British-China Friendship Association, China and East Berlin, 1963, *British Watercolour Paintings during three Centuries* (104).

1 Stretched over wooden panel; artist's colourman label of Charles Roberson, 99 Long Acre.

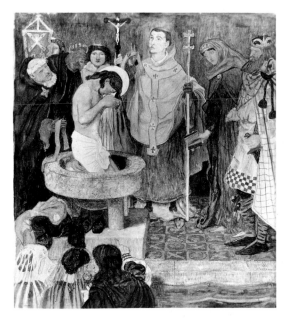

LL 3645. *The Baptism of St Oswald*

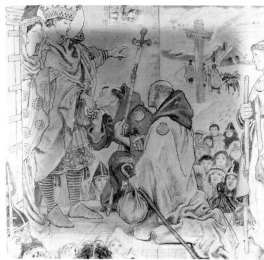

Fig.29 *St Oswald receiving St Aidan* (cartoon for stained glass). By courtesy of the Board of Trustees of the Victoria & Albert Museum

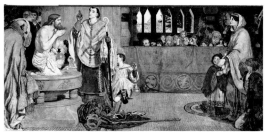

Fig.30 *The Baptism of Edwin* (Manchester Town Hall). By permission of Manchester City Council

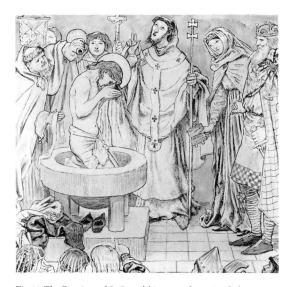

Fig.28 *The Baptism of St Oswald* (cartoon for stained glass). By courtesy of the Board of Trustees of the Victoria & Albert Museum

7 The six cartoons for the life of St Oswald, which were first exhibited at the artist's 1865 show (Nos 76–81), while the stained glass was in train, would then have been again with him from the Morris firm, returned on the break-up of Morris, Marshall, Faulkner and Company in 1874, if not earlier. The cartoons appeared in the artist's executors' sale in 1894 (loc. cit.) (242), bt. South Kensington Museum, £43.

8 Artist's family Papers. A chalked '*281*' is recorded on the back of No. LL 3645. It should be noted, however, that Rathbone also appears according to the Lady Lever Art Gallery files to have acquired at least a *Zachariah* (repr. *Cartoons of Ford Madox Brown*, 1895, p.16, pl.5), now at Birmingham.

LL 3646. *St Oswald receiving St Aidan (St Oswald sending Missionaries into Scotland)*

Oil on canvas, unfinished, 56.5 × 52 cm (22¼ × 20¼ in)

Carried to a fairly advanced state but with bare canvas centre bottom, where faint pencil outline is visible, and green underpainting for the flesh tints left for some of the heads. Less competent than No. LL 3645 above and likely to be by one of the artist's children or a pupil, carried out either as an exercise or for a commission which fell through.

2 Nos 231, 231b-e, 1894; E. 1853–1910: A. C. Sewter, I, 1974, pls 209–11; II, 1975, p.65.
3 Hueffer, p.446 (list).
4 Note to Lever, 1 May 1916 (Gallery files).
5 W. M. Rossetti 1903, p.199, quoting his own diary for 11 Dec. 1866.
6 Letter, 19 July 1878 (Angeli Papers, Special Collections, University of British Columbia Library), published in Ernestine Mills, *The Life and Letters of Frederic Shields*, 1912, p.231.

PROV: See No. LL 3645 above. Harold Rathbone certainly by 1911, and sold to W. H. Lever (1st Viscount Leverhulme), 1915, £30; thence to the Lady Lever Art Gallery.
EXH: Manchester 1911 (57); Tate Gallery 1913, *P.R.B.* (6); Bath 1913, *P.R.B.*; Port Sunlight 1948, *P.R.B.* (13).

10512. *St Oswald receiving St Aidan (St Oswald sending Missionaries into Scotland)*
Watercolour over outline, unfinished,[1] 55.6 × 51 cm (21⁷⁄₈ × 20 in)

The same composition as the preceding.

PROV: By descent to Sir Frank Soskice (Lord Stow Hill); Lady Stow Hill, from whom purchased, with Nos 10504–15, with the aid of a contribution from the National Art-Collections Fund, 1984.

1 Label on solid-backed stretcher of Charles Roberson, Long Acre.

Brown, Ford Madox, circle of

10515. *Study of hawthorn berries and of leaves*
Oil on ?tobacco box lid, 12.4 × 21.7 cm (4⁷⁄₈ × 8½ in)

This freely treated study is perhaps too fluid in style for the artist himself, and might be the work of a friend provided for an unidentified use in one of his pictures, or simply as a gift.

PROV: Sir Frank Soskice (Lord Stow Hill); Lady Stow Hill, from whom purchased with Nos 10504–14, with the aid of a contribution from the National Art-Collections Fund, 1984.

LL 3646. *St Oswald receiving St Aidan (St Oswald sending Missionaries into Scotland)*

10512. *St Oswald receiving St Aidan (St Oswald sending Missionaries into Scotland)*

10515. *Study of hawthorn berries and of leaves*

10519. The Footpath Way

Brown, Ford Madox, after

10519. *The Footpath Way*

Line reproduction, proof, 4.7 × 4.7 cm (1⅞ × 1⅞ in)
Inscribed on scroll: *A merry heart/goes all the day/*
EDWARD: GARNETT/your sad tires/in a mile-o; and on the
signpost: *NO WAY*[1]

One of the artist's few ventures into book illustration.
Designed for the young Edward Garnett (1868–1937), son
of the artist's friend and near neighbour in St Edmund's
Terrace, Dr Richard Garnett, Keeper of Printed Books at
the British Museum. Edward Garnett, who entered the
publishing world to become a noted publisher's reader,
in 1889, the year of his marriage, made his first and only
venture into publishing with his sister-in-law Grace
Black's *A Beggar and other Fantasies*, for which this was
used on the title page. He also occasionally used it as a
book-plate in his own books.[2] The original pen and ink
drawing (2⅜ × 2⅜ in), belongs to the Garnett family[3] and
a slight pencil drawing (2 × 2¼ in), is in the Ashmolean
Museum, Oxford (Houghton Album, folio 18).

PROV: Edward Garnett and by descent to his great-
grandson, Oliver Garnett, who presented it to the Walker
Art Gallery, 1985.

1 The title and quotation from Autolycus' exit song in *The Win-
ter's Tale*, Act IV, scene 2.
2 George Jefferson, *Edward Garnett, A Life in Literature*, 1982,
p.299, note 38; Hueffer, pp.385, 444 (list); letters to the com-
piler from David Garnett, 31 Jan. 1974, and Oliver Garnett,
17 May 1985. Garnett afterwards persuaded his firm, Unwin's,
to publish Ford Madox Hueffer's first book of fairy stories, *The
Brown Owl*, 1891, with illustrations by Ford Madox Brown.
3 Exhibited Arts and Crafts Exhibition Society, 1896 (363) as
The Footpath Way.

Dyce, William (1806–64)

Of an earlier generation than the Pre-Raphaelite Brotherhood, whose work he partially anticipates and who influenced his style in the 1850s. Born Aberdeen, 19 September 1806, son of a physician and educated at the Marischal College. Initially an Episcopalian, he became a devout High Churchman and also developed a broad and cultivated interest in the arts and sciences, like the 'complete man' of the Renaissance whom he admired. Initially self-taught as an artist, after brief probationership at the Royal Academy Schools, he went to Rome 1825–6 and for a longer period 1827–8 where he laid the foundation of his style. He initially studied Titian, Poussin and Raphael, and at an early date met Overbeck and the German Nazarenes at Rome, whose work in fresco showed a similar deep religious attitude to his, as modern followers of the Renaissance. At Edinburgh in the 1830s, religious subjects not answering, he gained a reputation for spirited portraits and attempted history painting; elected ARSA 1835. He turned to early church music and became spokesman on industrial design and the reform of art training; was appointed Superintendent of the Government Schools of Design, 1838–43. This limited his painting but his expert knowledge of fresco and first-hand awareness of Continental trends led to his patronage by the Prince Consort and his early commission for frescoes for the new Houses of Parliament, 1845. Elected ARA 1844, following the success of his severely dramatic 'Nazarene' *Joash shooting the arrow of Deliverance* (Hamburg, Kunsthalle); Royal Academician 1847. Married Jane Brand, nineteen years of age, in 1850. Lived in London from 1837 and at Leigham Court Road, Streatham from 1856.

He was on the hanging committee when Millais' *Isabella* and Holman Hunt's *Rienzi* were hung as pendants, 1849, and initiated Ruskin's critical and favourable examination of Millais' *Carpenter's Shop*, Royal Academy 1850. He provided Hunt with copying and restoration work in 1850, when he was in need of financial aid, and probably influenced his development. In the later 1850s, Dyce returned to easel painting and again concerned himself with outdoor naturalism, attempted in youth, using now a Pre-Raphaelite technique and displaying a passion for natural detail, in historical, contemporary and biblical subjects, heralded by the brilliant *Titian's first essay in Colour*, Royal Academy 1856 (Aberdeen), admired by Ruskin. In colour his effects became increasingly muted and tended sometimes to a bleached appearance, which was in his own day associated with photography. He became an honorary member of the Hogarth Club, 1859. His use of landscape can be seen as expressive of the immensity of geological time and the isolation of man, and links his scientific and artistic interests with his religious beliefs. Died London following periods of illness preventing the completion of his frescoes on Arthurian themes, 15 February 1864.

221. *The Garden of Gethsemane*
Oil on mill-board,[1] 41.8 × 31.2 cm (16¼ × 12⅜ in)

The view is of a glen below stark hills at twilight, with a new moon and the evening star above. Dominating the landscape, Christ, a luminous small figure in his blue robe, turns, absorbed in thought, away from the rocky path which leads through a half-open gate towards dark woods.

This can be grouped with a series of subject paintings employing landscapes, which Dyce produced towards the later 1850s, off-setting the large-scale and burdensome problems of his House of Lords frescoes. They have the minute precision of the Pre-Raphaelite technique and challenge contemporary photography for their super-reality and sense of place. Their subjects, whether historical, contemporary or biblical, seem to have the same pervading quietude and sense of time stood still.[2] It is possible that in them Dyce sought to prove to such critics of his earlier 'Nazarene' style as Ruskin, that he was fully able to employ the natural vision and geological accuracy which Ruskin advocated, to express profound thought.[3]

Marcia Pointon argues convincingly[4] that in those of these late landscapes which embody biblical subject matter (*The Good Shepherd*, Royal Academy 1859; *David as a Youth*, about 1859; *The Man of Sorrows*, Royal Academy 1860; *Christ and the Woman of Samaria*, 1860), Dyce was deliberately setting out to represent the scriptures as a contemporary problem by representing them in a concrete, familiar environment which provided emotional and symbolical emphasis. They were not to be viewed simply as literal transcripts of nature nor as landscape divorced from the figures within them, though no doubt the outcome of sketches made on holiday trips to Wales and Scotland which Dyce had planned to put to good use.[5] This overlays Staley's suggestion[6] that some can be seen as 'literal views of highland scenery into which biblical personages had strayed'.

Staley[7] parallels *Gethsemane* with the artist's small twilight *Flight into Egypt* in its similar tenderness and harmony of mood, distinctive from the literalness of the late 1850s landscapes, and for which he argues a date variously in the later 1840s[8] or early 1850s.[9] A similar atmosphere also pervades the small upright *John leading the Virgin from the Tomb* (ex Handley Read collection), which may date from 1851. While all three are fairly close in size, though not in figure scale, both the others are more fluid in technique than *Gethsemane* which seems reasonably to come closer to the works of the later 1850s in its detailed style, recognisable landscape and conscious geological detail: Pointon suggests a likely dating of 1857–60.[10]

It should be noted that like the much larger *Pegwell Bay* (1858–60, Tate Gallery) with its strange comet-lit sky, it is concerned with a particular light effect. In its type of Christ, it perhaps comes closest, though totally different in scale, to the dreamily gentle figure in the large *Good Shepherd* (Royal Academy 1859: Little Budworth Church, presently on loan to the Manchester City Art Gallery).[11] The tiny scale of Christ's figure is, never-

221. *The Garden of Gethsemane* (colour plate I)

theless, unique in the paintings cited and its proportions are oddly tall for its setting; also the landscape can in no way be seen as a garden or cultivated enclosure. Staley's contention that the figures come later certainly appears borne out here. It seems a likely hypothesis that Dyce, in choosing to paint this view of a glen at twilight on one of his country holidays, had in mind its possibilities for this particular subject: the time of day, the emotional appropriateness of the dark enclosing hills, the rocky path leading into the unknown and the waxing moon, which can be seen both as heralding Christianity as well as a reminder of the recurrent human predicament, all combine in an entirely appropriate if wholly original concept of this passage of the Scriptures.

PROV: John Farnworth, of Woolton, Liverpool;[12] executors' sale Christie's (483B),[13] 18.5.1874 (100), bt. Agnew £577.10.0; thence to Albert Grant, 6 June 1874;[14] his sale, Christie's (910E),[15] 27.4.1877 (86), bt. Agnew £388.10.0; thence sold to George Holt, Liverpool, 12 March 1878,[16] £420;[17] by descent to his daughter Emma Holt, who bequeathed it to Liverpool, 1944. Sudley Art Gallery, Liverpool.

EXH: Liverpool 1874, *Agnew's Exchange Galleries* (7); Manchester 1887, *Jubilee* (760); Glasgow 1901 (4); Whitechapel 1905 (305); Edinburgh 1908; Glasgow 1911 (127); Wembley 1924; National Gallery, 1945, *Some Acquisitions of the Walker Art Gallery, Liverpool, 1935–1945* (21); Royal Academy 1962, *Primitives to Picasso* (196); Aberdeen and Agnew 1964, *William Dyce, R.A.* (32) repr.; Ottawa 1965, *Paintings and Drawings by Victorian Artists in England* (31).

1 Label for Rowney's mill-board.
2 See Pointon 1979, pp.156f., 171f.
3 See Vaughan 1979, pp.95–6.
4 See Pointon 1979, pp.162–3 and figs 85, 68, 71, 81; and Marcia Pointon, 'William Dyce as a Painter of Biblical Subjects', *The Art Bulletin*, 1976, passim.
5 See Pointon 1979, p.156, and Staley 1973, p.166, quoting a letter from Dyce mentioning trips to Ramsgate 1858, Arran 1859, and Wales 1860. Dyce also visited Wales in Sep. 1861 (his letter to W. G. Herbert, dealer, Liverpool, in Holt Papers, Walker Art Gallery).
6 See Allen Staley, 'William Dyce and Outdoor Naturalism', *The Burlington Magazine*, Nov. 1963, p.474, and Staley 1973, p.165, discussing them primarily as landscapes.
7 Staley 1973, p.163 and pl.91a.
8 Ibid.
9 Staley 1963, loc. cit.
10 See Pointon's discussion of this picture, 1976, loc. cit., p.262, and 1979, pp.163–4.
11 Pointon 1979, fig. 85.
12 John Farnworth (1809–69), timber merchant and active Wesleyan; Mayor of Liverpool, 1865–6. In his executors' sale was also Holman Hunt's *Past and Present*, 1868–9 (Aberdeen), a prayer scene, and Millais' *Gambler's Wife*, Royal Academy 1869. A possible source for his acquisition of the Dyce may have been through W. G. Herbert, a dealer of Liverpool and brother of the artist J. R. Herbert. The dealer was certainly in correspondence with Dyce in 1861 when Dyce wrote to him, on 16 Sep., while at Capel Curig, North Wales, recording towards the end of a month's trip that there might not be time for them to meet and that he had 'not done much –though have picked up some *notions*' (Holt Papers, cited in note 5). The provenance of this letter is unknown: Holt was himself buying from Herbert in the 1870s and may have got it from him (see Sudley Catalogue, 1971, p.36).
13 Christie's stamp on back.
14 Agnew's Picture Stock Book, 1874–9, No. 8763.
15 Christie's stamp on back.
16 Agnew's Picture Stock Book, 1874–9, No. 171.
17 Invoice, Midsummer 1874 for 12 March, Holt Papers.

Hughes, Arthur (1832–1915)

Born London 27 January 1832. A few years younger than the painters of the Pre-Raphaelite Brotherhood, he studied at the School of Design at Somerset House under Alfred Stevens, and afterwards at the Royal Academy Schools. He was entered as a student in the School of Painting, 17 December 1847, in the same year as the sculptor Alexander Munro (*q.v.*), with whom he shared a studio at 6 Upper Belgrave Place between about 1852 and 1858. He first exhibited at the Royal Academy 1849 and came under Pre-Raphaelite influence through reading Munro's copy of their journal, *The Germ*, 1850. That year through Munro he met Rossetti and Madox Brown and, on the exhibition of both their next Royal Academy pictures, of *Ophelia*, in 1852, he met Millais to whom he sat for the cavalier in the *Proscribed Royalist*, 1852/3. Millais' themes of lovers may have influenced his own subsequent choice of subjects which were usually of romantic love, often overlaid with grief. His *April Love* (Tate Gallery) at the 1856 Royal Academy gained Ruskin's appreciative support and was bought by William Morris. With the latter and other youthful artists he assisted Rossetti with the Arthurian wall decorations to the Oxford Union, 1857. He became a member of the Hogarth Club, 1858. Married Tryphena Foord 1855. Moved out of London to Surrey and ultimately to Kew. A man of modest and retiring character, he remained in the background of the circle. His pictures in the 1850s and early 1860s had an intense emotional lyricism expressed through a brilliant palette dependent on greens and lavenders, but in later years his sensitivity fell away into a romantic genre. From 1854 he took up book illustration through which he produced his finest work of later years, to the poems of William Allingham and Christina Rossetti and particularly to the children's stories of George MacDonald. T. E. Plint and J. H. Trist were among his best early patrons. Some of his later recollections of the Pre-Raphaelite circle during the 1850s appear in various of the biographies, but no biography of the artist himself was ever undertaken. Both his sons, Godfrey and Arthur Foord, and his nephew Edward Robert Hughes, were artists. Died at Kew Green, 23 December 1915.

LL3642. *A Music Party*
Oil on canvas, 58 × 76 cm (22⅞ × 30 in)
Signed and dated: ARTHUR HUGHES 1864

Exhibited at the Royal Academy 1864 and subsequently at the Liverpool Academy with a quotation in the catalogue from Keats' *Ode On a Grecian Urn*:

LL 3642. *A Music Party*

Heard melodies are sweet, but those unheard
Are sweeter * * * * *
Not to the sensual ear, but more endear'd
Pipe to the spirit ditties of no tone.

The essentially lyrical intensity of Hughes' vision took
on a more sentimental quality in the 1860s, with themes
frequently suggested by, and developed from, some
favourite line of poetry. Here music is more particularly
his theme, with the lines of Keats' poem used to evoke a
mood of wistful nostalgia and perhaps suggesting the
transience of youth and departed friends, fleeting like the
notes of music.

He uses elements of architecture, costume and rich
colouring inspired by his trip to Venice in 1862 and
suggesting also the influence of Rossetti's later style.
Behind the woman playing her lute and her young com-
panions absorbed in their thoughts, is a view across the
Lagoon through the carved arches of a balcony, over a
Venetian fishing smack lying below, to a church on an
island in the distance. Studio props include the embroid-
ered hanging and the child's embroidered kaftan which
appear also in the nearly contemporary family portrait,
set on a Venetian balcony, of Mrs Leathart and her three
children (Leathart family.)[1] The lute, which Robin Gib-
son points out[2] is an anachronistic harp-lute, popular in
the early nineteenth century, appears in earlier paintings
including *The Rift within the Lute*, Royal Academy 1862
(Carlisle City Art Gallery). The model for the woman
appears again in an almost identical dress in a single
figure picture, *Madeleine* (Carlisle City Art Gallery).[3]
According to Lewis Carroll, the two children were drawn
from the artist's own children 'Trotty' and Agnes.[4] The
man might be Hughes himself, whose hair style was very
similar.[5]

Reviewers commented chiefly on the artist's senti-
ment. *The Times*[6] described it as a '. . . scene in Venice,
and a happy young father among his children hears the
artless melody of his happy home, while his fair young
wife strikes her lute. Delicacy, approaching dangerously
near to sickliness sometimes, is the very element in
which Mr Hughes charms and works. His colour is ex-
quisite in refinement but prone to run riot in purples.
This year he has been striving against this tendency, and
has never before painted pictures in which the beauty
and refinement were so little marred by his besetting
purple . . .'. *The Art Journal*[7] assessed his emergence
from Pre-Raphaelitism and considered his contributions
that year, '. . . each and all poetic and refined in concep-
tion, and singularly sensitive to delicate and harmonious
modulations of colour. The figures, however, are lacking
in manly vigour; they want the stamina and robustness
which the greatest masters have shown not to be incom-
patible with beauty.'

PROV: George Rae[8] before 1868; bought from the trustees
of his estate by W. H. Lever (1st Viscount Leverhulme),
1917, thence to the Lady Lever Art Gallery.
EXH: Royal Academy 1864 (64); Liverpool Academy 1864
(149); Leeds 1868 (1327); Edinburgh 1886 (900); Port
Sunlight 1948, *P.R.B.* (111); Sheffield 1968, *Victorian*

Paintings, 1837–1890 (103); Cardiff and Leighton House,
1971, *Arthur Hughes* (13).

1 Repr. *The Burlington Magazine*, Nov. 1963, p.493.
2 'Arthur Hughes: Arthurian and related subjects of the early
 1860s', *The Burlington Magazine*, 1970, p.455, and figs 31, 32.
3 Repr. Cardiff/Leighton House Catalogue, 1971, No. 14.
4 Roger Lancelyn Green (edit.) *The Diaries of Lewis Carroll*,
 1953, I, p.212, entry for 2 April 1864.
5 See Lewis Carroll's photograph of Hughes and Agnes, repr.
 Tate Gallery 1984, *P.R.B..*, p.32.
6 *The Times*, 30 April 1864.
7 *The Art Journal*, 1864, p.161.
8 Privately printed *Catalogue of Mr George Rae's Pictures*
 (about 1900), No. 35. Listed also are four other paintings by
 Hughes: No. 36 *Female Head*, Nos 50 and 82 two *Sir Galahads*
 (see No. 2936 below), and No. 51 *Good Night*. Rae also owned
 at one period *In the Grass* (*The Athenaeum*, 9 Oct. 1875, p.482).

2935. 'As You Like It'

Triptych, oil on canvas,[1] centre 71 × 99 cm; wings each
71 × 45.8 cm. (28 × 39 in; 28 × 18 in)
Signed and dated on right-hand panel: ARTHUR HUGHES.
72–3
Frame: Gilt with border in relief of overlapping vine
leaves in random pattern, and plain gilt flat.

Scenes from Shakespeare's play, in the Forest of Arden.
In the left panel Touchstone and Audrey are seated be-
neath a tree, courting, while goats graze in the under-
growth around them (Act III, scene 3). In the centre panel
Orlando bends to attend to Adam, whom he has just set
down, while in the background the exiled Duke is seated
with his courtiers beneath a great tree by a stream, about
to dine, and Amiens plays his lute and sings his song (Act
II, scenes 6–7). At the right Rosalind, dressed as a youth,
has come upon her name inscribed on a tree in a birch
glade; deer are in the distance and at the right lies the
copy of Orlando's lines to her, half visible: '[From the
east to western] Ind, [No] jewel is [like] Rosalind. [Her]
worth, being [mount]ed on ye wind, [Throu]gh all ye
world-bears Rosalind. All ye pictures fairest lin'd Are but
black to Rosalind.' (Act III, scene 2)

It was in progress in February 1872 according to *The
Athenaeum*,[2] where it was stated that the artist wished to
illustrate the lines from Amiens' song in Shakespeare's
play (Act II, scene 7); these appear with it in the Royal
Academy catalogue that year:

Blow, blow, thou winter wind,
Thou art not so unkind
 As man's ingratitude;
Thy tooth is not so keen,
Because thou art not seen,
 Although thy breath be rude.
Heigh-ho! sing heigh-ho! unto the green holly;
Most friendship is feigning, most loving mere folly.
 Then heigh-ho, the holly!
 This life is most jolly.

The *Art Journal*[3] reviewer considered that it 'must be
regarded as a vehicle for a display of sylvan scenery, for
after all, the persons enact parts secondary to those of the
trees and the foliage . . . there is no look of action to

2935. *'As You Like It'*

concentrate the interest. As a representation of the forest glade, it is very masterly, and it would seem that this has been the painter's utmost ambition.' This emphasis on the landscape was a characteristic of the artist and a continuance on a less intense level of the brilliantly colouristic and poetic landscape backgrounds of the 1850s; its romantic presentation of many facets of love is also a characteristic theme of his work.[4]

An oil study (14 × 22½ in) of the same landscape as that in the background of the central panel, with Jaques reclining beneath the great tree and a deer at the left was on the art market 1982, as *The Forest of Arden: Jaques and the Stag*[5] (possibly Liverpool Autumn Exhibition 1875 (407) as *Jaques in the Forest*, £45). A picture of the same title as No. 2935 was the last item in the MS catalogue of J. H. Trist of Brighton, a patron of Hughes, listed as bought May 1884 for £63[6] (Christie's 9.4.1892, lot 71, bt. Leggatt).

PROV: Bequeathed by Joshua Sing of Liverpool, 1908.[7]
EXH: Royal Academy 1872 (489–91); *Liverpool Autumn Exhibition* 1873 (223), as *The Love making of Orlando and Touchstone*, price £262.10.0; Whitechapel, Winter 1908; Walker Art Gallery 1908, *Liverpool Autumn Exhibition* (1005) repr.; Whitechapel 1910 (94); Bradford 1925; Arts Council, Swansea and Aberystwyth 1955; Nottingham 1961, *Shakespeare in Art* (68).

1 Canvas stamp of Charles Roberson, Long Acre, on back of centre and right-hand canvas. The centre canvas and frame are marked by two parallel curved lines, still visible after restoration and relining. The frame of a pattern often used by Hughes.
2 *The Athenaeum*, 24 Feb. 1872, p.248.
3 *The Art Journal*, 1872, p.183.
4 For an assessment of Hughes' landscapes see Robin Gibson, 'Arthur Hughes: Arthurian and related subjects of the early 1860s,' *The Burlington Magazine*, 1970, p.451f.
5 Christie's sale, 4.6.1982 (12) repr.
6 Tate Gallery archives.
7 Joshua Sing JP, senior partner in Powell and Sing, leather factors, Liverpool, and concerned with education in Liverpool.

2936. *Sir Galahad – The Quest of the Holy Grail*
Oil on canvas, 113 × 167.6 cm (44½ × 66 in)
Signed: ARTHUR HUGHES

The knight, on a white horse, rides up a steep pathway in a mountainous landscape towards a bridge over a rocky stream at the right. Three angels, one holding the glowing Grail, the others swinging censers, hover over him in a starlit sky. Exhibited first in 1870 at the Royal Academy, and secondly in 1872 at Liverpool, with a quotation in the catalogue from the last lines of Tennyson's *Sir Galahad* (first published 1842):

The clouds are broken in the sky,
 And thro' the mountain-walls,
A rolling organ-harmony
 Swells up, and shakes and falls.
Then move the trees, the copses nod,
 Wings flutter, voices hover clear:
'Oh just and faithful knight of God!
 Ride on: the prize is near.'
So pass I hostel, hall, and grange;
 By bridge and ford, by park and pale,
All-arm'd I ride, whate'er betide,
 Until I find the holy Grail.[1]

The artist had previously found inspiration in Arthurian legend and Tennyson's poetry.[2] Characteristically, he employs a real landscape, based on Ashness Bridge near Derwentwater, as the setting for his poetically visionary subject. He recollected it long afterwards, in a letter of 1892 to Alice Boyd of Penkhill in which he included a sketch of the view over the bridge:[3] 'It was delightful to revisit . . . the old landscape in Cumberland that provoked me long ago to paint Galahad, and it looked better than ever. I wonder if you know that walk from Keswick, along the Derwent Water first, then up to the left to Ashness and its little bridge.' The composition builds on more than one thread of Tennyson's poem without being a straight illustration of it. A finished sketch (11 × 16 in)

2936. *Sir Galahad – The Quest of the Holy Grail*

formerly in the George Rae collection and likely to be for this picture, was listed in Rae's catalogue with earlier lines in the poem,[4] which are also suggested here:

A gentle sound, an awful sight!
 Three angels bear the holy Grail
With folded feet, in stoles of white,
 On sleeping wings they sail.

A picture of a similar subject but with the knight riding to the left led by three angels walking before him is also recorded,[5] and may be earlier in date. Lewis Carroll noted[6] that a Sir Galahad was in progress in June 1866 and not finished in April 1867, which might be a reference to No. 2936. The publication of Tennyson's *The Holy Grail* poem late in 1869[7] may have been the incentive to the artist to exhibit his theme from the earlier poem the following season.

It is possible that alterations were made between the first and second exhibition of this picture as the pose of the knight, unless misread by the reviewer, does not seem to correspond exactly with the notice in *The Athenaeum* on its appearance at the 1870 Royal Academy. It was generally noticed in the reviews. *The Athenaeum*[8] considered it as a 'picture of a fine class . . . The laureate's hero riding by night near a torrent, which courses down a valley among trees. The angels of the Holy Grail, swinging censers, approach the knight, their garments streaming, their faces indicated by pure passion, with an

intensely pathetic and elevated action the rider salutes the appearances, presses his hands upon his armed breast, rises and bends forward in his saddle – an attitude which is deeply expressive of reverence and joy. This figure is one of the best illustrations of the Spirit of its subject which we know; it is graceful and noble; those of the angels are still more so; the horse is capitally designed and admirably executed. Nor is the charm of the background inferior to that which is so finely given to the figures; it is perfectly suited to the subject, a rocky dell, with many windings, slopes that are clad in wind oppressed pines, the rocky bed of the stream, far off, the mountain tops catch a mysterious light and palely shine.' *The Times*[9] was more critical, considering both it and *Endymion* in the same exhibition not up to earlier paintings of legendary lore while having 'a delicate and feminine beauty of their own'. 'The figure of the pure knight', it commented, '. . . is very purely and nobly conceived, if not very powerfully painted, and in the true spirit of the legend. But is the vision what Tennyson's lines suggest! Are not these angels at once too near the earth and the knight to whom they appear. The landscape, again, above all the foreground – a causeway over a mere, fenced in with spiky stones – looks to us uncomfortable and poor, without being weird or suggesting desolation, difficulty, or danger . . .'. *The Saturday Review*[10] followed on: 'Mr Arthur Hughes is a painter of poetic gifts, and yet he does not so much create afresh as carry out ideas which others

have conceived. Neither does he always possess the power needed to cast poetic thought into pictorial form. Thus ''Sir Galahad'' (324) is a thought feebly carried out; it is at once painstaking and timid. And yet the artist throws angels boldly into the sky as if strong in the belief of a world of spirits; he takes, indeed, the mind pleasantly away into realms of fancy.'

PROV: Probably George Rae;[11] presented to the Walker Art Gallery by Mrs Alexander M. Synge, 1925.
EXH: Royal Academy 1870 (324); *Liverpool Autumn Exhibition*, 1872 (136), £200.

1 The artist's MS label is on the back, giving this quotation.
2 See Robin Gibson, 'Arthur Hughes: Arthurian and related subjects of the early 1860s', *The Burlington Magazine*, 1970, pp.451–6.
3 Published in William E. Fredeman, 'A Pre-Raphaelite Gazette: The Penkhill Letters of Arthur Hughes to William Bell Scott and Alice Boyd, 1886–97,' *Bulletin of the John Rylands Library*, Vol. 49, No. 2, and Vol. 50, No. 1, 1967, reprint, p.39.
4 Privately printed *Catalogue of Mr. George Rae's Pictures* (about 1900), No. 50, thence in his house sale (E. Owen), 28.6.1917 (1695).
5 Christie's sale 9.6.1961 (178), 35 × 52 in (photograph Gallery files); it employs a similar landscape background to *The Knight of the Sun*, 1860 (repr. Gibson op. cit. 1970).
6 Roger Lancelyn Green (edit.), *The Diaries of Lewis Carroll*, 1953, I, pp.244, 245.
7 Pointed out by R. D. Altick, *Paintings from Books*, 1985, p.456, fig. 345.
8 *The Athenaeum*, 21 May 1870, p.681–2.
9 *The Times*, 30 May 1870, p.6.
10 *The Saturday Review*, 4 June 1870, p.739.
11 Presumably Rae *Catalogue*, No. 82, without any quotation.

5234. *The Demon Lover*

Sepia wash, 25.9 × 18.9 cm (10³⁄₁₆ × 7⁷⁄₁₆ in)
Signed in monogram: *AH*
Inscribed: *to W. Ralph Hall Caine from Arthur Hughes*
(the initials *W* and the *all* of Hall added)

Illustrating the old ballad of the dead sailor returning to claim his former sweetheart, who has married after his death at sea. She leaves her husband and children for him but their ghostly ship is wrecked. The scene shows him tapping on the window when she is alone with her child while her husband is away from home:

But, whilst that he was gone away,
 A spirit in the night
Came to the window of his wife
 And did her sorely fright.

Which spirit spoke like to a man,
 And unto her did say,
'My dear and only love' quoth he,
'Prepare and come away'.

Miss Baily, who worked for the first owner, stated that it was for a poem by Hall Caine, the novelist's brother.[1] It was perhaps intended for an anthology.[2]

PROV: Given by the artist to William Ralph Hall Caine (1865–1939), who bequeathed it to his nurse Miss Bertha Baily; presented by her to the Walker Art Gallery, 1960.

5234. *The Demon Lover*

1 In a letter to the Gallery, 1 Oct. 1960. The brothers were natives of Liverpool where they both began their careers in journalism.
2 He published *The Children's Hour*, 1907, with illustrations by several artists.

Hunt, William Holman (1827–1910)

Born Cheapside, London 2 April 1827, son of a warehouse manager, who discouraged his interest in painting as a career and put him to work as a clerk in the City at the age of twelve. Received some painting lessons and painted portraits with success, which resulted in his taking up art at sixteen. He entered the Royal Academy Schools as a probationer in July and registered as a student on 18 December 1844; there he met Millais and later Rossetti. He read avidly and became critical of the conventions of current art. The sight of Ruskin's *Modern Painters* in 1847 was fundamental to the crystallisation of his ideas and the foundation of his determination to go back to the careful study of nature and to bring a serious and thoughtful approach to subject matter, fired by the example of the early masters as graphically described by Ruskin. 'The determination to save one's self and art must be made in youth', he recorded as his statement to Millais whom he imbued with his crusading spirit, and afterwards discussed with the more imaginative Rossetti. They together formed the core of the Pre-Raphaelite Brotherhood, which they founded in the autumn of 1848 with four other members, Frederic George Stephens (introduced by Hunt), James Collinson, William Michael Rossetti and Thomas Woolner (q.v.). Visited Paris and Belgium with Rossetti autumn 1849.

Hunt had begun exhibiting at the Royal Academy in 1846. He chose religious, Shakespearian or contemporary subjects with strong moral themes. Always less dextrous than Millais, who helped him to secure patrons, he struggled for income and recognition; he gained the £50 Liverpool Academy prize 1852 and by 1854 achieved security with the sale to Thomas Combe of Oxford of *The Light of the World* (Keble College, Oxford), which was to become the most famous nineteenth-century religious painting. He then realised his ambition of visiting the Holy Land to paint biblical subjects on the spot at a period when it was possible still to experience an unspoilt environment. In Egypt and Palestine 1854–6, painting *The Scapegoat*, his masterpiece (Royal Academy 1856; No. LL 3623 below), and *The Finding of the Saviour in the Temple* (Birmingham), finished and exhibited 1860; its sale established his reputation. He also painted in watercolour, chiefly landscapes, often with religious overtones, designed some book illustrations and flirted with furniture design. Shared studio at 49 Claverton Street with Mike Halliday and Martineau (q.v.) and took 1 Tor Villa, Campden Hill 1857–66. Exhibited with the Pre-Raphaelite Brotherhood at Russell Place 1857 and became a member of the Hogarth Club, 1858. He held a one-man show at 16 Hanover Street 1864–5. His later work was larger in scale and broader in technique. He remained outside the Royal Academy and showed his major works individually, exhibiting also at the Grosvenor Gallery, the Old Watercolour Society, etc., as well as at the Liverpool Autumn Exhibition. He was isolated from contemporary trends by further sojourns abroad: Italy 1866–7, after his marriage to Fanny Waugh (d.1866) and 1868; Palestine 1868–72, painting *The Shadow of Death* (Manchester); again there 1875–7, after marrying Edith Waugh, painting *The Triumph of the Innocents* (No. 2115 below) and Italy, Greece and Palestine 1892. He thus became chiefly noted for his iconographically original religious paintings. The determination to give his imaginative conception the most realistic, detailed and elaborate form was central to his purpose and limited his output. He also experimented with differing light effects and made a critical study of pigments to ensure permanency.

He became spokesman of the Pre-Raphaelite Brotherhood after Rossetti's death with the idea of upholding Millais' and more particularly his own role in its foundation, to refute Rossetti's following; published an extensive autobiography 1905. Major exhibitions of his work were held in 1886 and 1906–7. His eyesight deteriorated around 1900 and his late work was completed by assistants. Was awarded OM and DCL Oxford 1905. Lived at Draycott Lodge, Fulham from 1881 and at Melbury Road, Kensington from 1903. Died London 7 September 1910 and was buried in St Paul's Cathedral.

1635. *The Flight of Madeline and Porphyro during the drunkenness attending the revelry (The Eve of St Agnes)*
Oil on mahogany panel,[1] 25.2 × 35.5 cm (9^{15}/$_{16}$ × 14 in)
Signed, with initials in monogram, and dated: *W holman hunt. 1847–57*
Frame: Commercial gilt wood and composition with slightly concave field and formalised five-point leaf in alternating repeat pattern within a ribbon scroll.

A small version of the artist's first important picture which was exhibited at the Royal Academy in 1848 and is now in the Guildhall Art Gallery (30½ × 44½ in; fig. 31).[2] The episode illustrated, from the penultimate stanza of Keats' poem 'The Eve of St Agnes', was quoted in the catalogue:

They glide, like phantoms, into the wide hall.
Like phantoms, to the iron porch they glide,
Where lay the Porter, in uneasy sprawl,
With huge empty flagon by his side:
The wakeful bloodhound rose, and shook his hide
But his sagacious eye an inmate owns;
By one, and one, the bolts full easy slide:-
The chains lie silent on the footworn stones:
The key turns, and the door upon its hinges groans.

In his memoirs Hunt makes a point of his discovery of the poems of Keats, which he thought he was one of the first to illustrate in painting. His enthusiasm brought him into close contact with Rossetti on the exhibition of this subject and he also succeeded in converting Millais (see *Isabella*, No. 1637 below).[3] He first read the poems sometime in 1847 and at about the same period read parts of Ruskin's controversial *Modern Painters* (perhaps Vol. I, published in 1843, and certainly Vol. II, published in 1846),[4] which presented the Old Masters with a fresh eye and advocated a return to nature. Hunt must have found in Keats a wealth of romantic detail, the perfect vehicle in which to experiment with his newly formulated ideas.

I William Dyce, *The Garden of Gethsemane* (No.221)

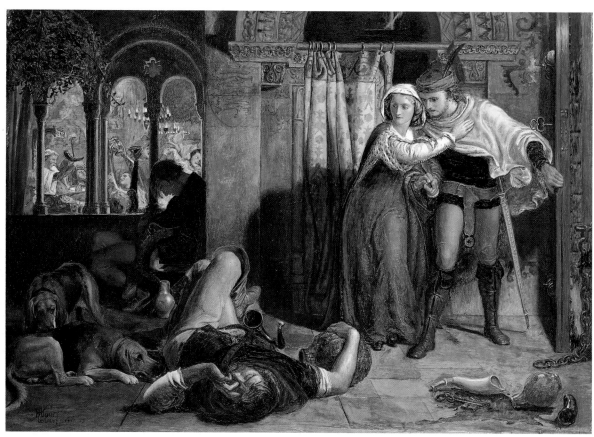

II William Holman Hunt, *The Flight of Madeline and Porphyro during the drunkenness attending the revelry (The Eve of St Agnes)* (No.1635)

III John Everett Millais, *Isabella* (No.1637)

IV John Everett Millais, *Ferdinand lured by Ariel* (No.273)

V Ford Madox Brown, *Waiting: An English Fireside of 1854–5* (No.10533)

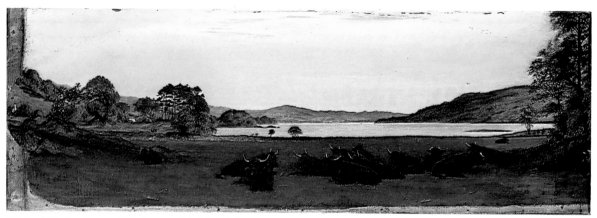

VI Ford Madox Brown, *Windermere* (No.LL 3638)

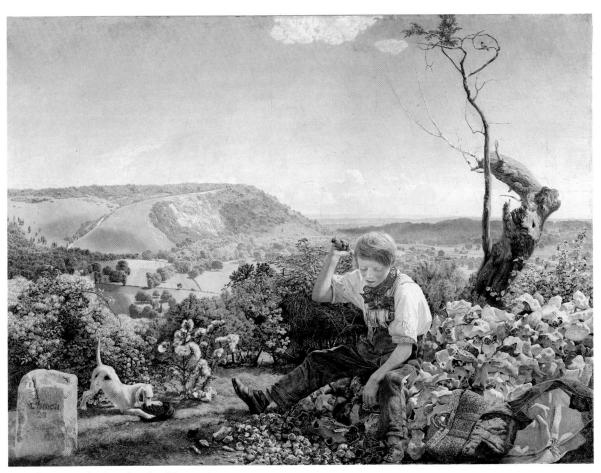

VII John Brett, *The Stonebreaker* (No.1632)

VIII John Everett Millais, *Spring (Apple Blossoms)* (No.LL 3624)

IX John Everett Millais, *The Black Brunswickers* (No.LL 3643)

X William Holman Hunt, *The Haunt of the Gazelle* (No.980)

XI William Holman Hunt, *The Scapegoat* (No.LL 3623)

XII Ford Madox Brown, *Cordelia's Portion* (No.LL 3640)

XIII Ford Madox Brown, *The Coat of Many Colours (Jacob and Joseph's Coat)* (No.1633)

XIV Ford Madox Brown, *The Nosegay* (No.LL 3639)

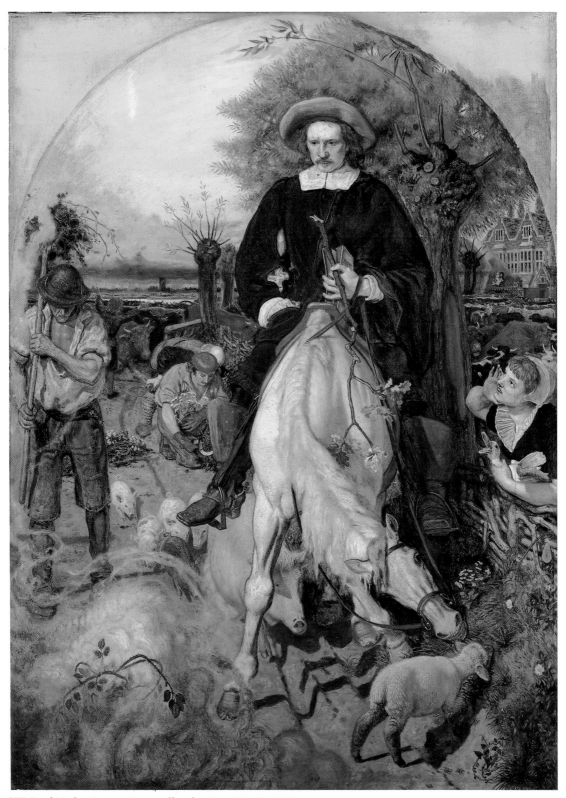

XV Ford Madox Brown, *Cromwell on his Farm* (No.LL 3641)

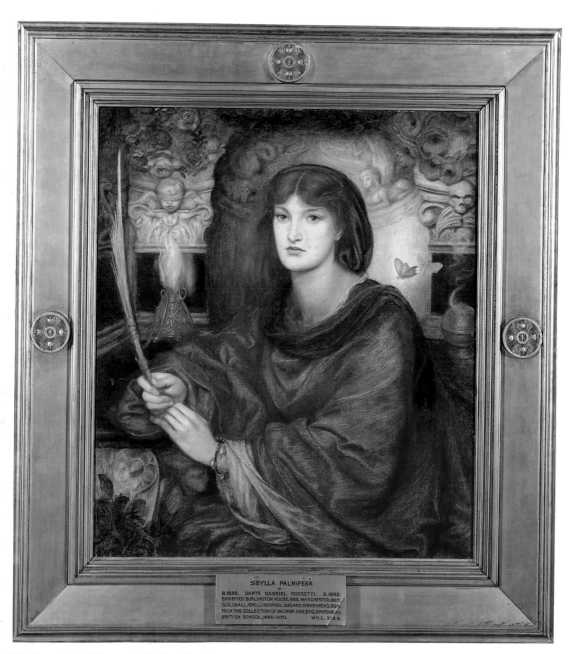

XVI Dante Gabriel Rossetti, *Sibylla Palmifera* (No.LL 3628)

XVII John Everett Millais, *Vanessa* (No.272)

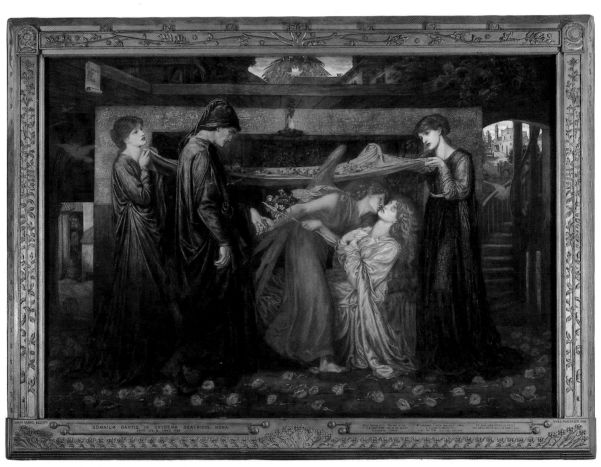

XVIII Dante Gabriel Rossetti, *Dante's Dream* (No.3091)

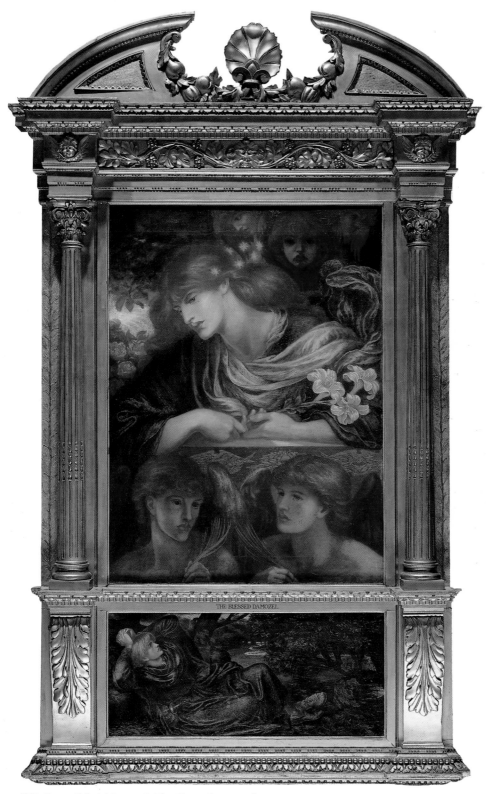

XIX Dante Gabriel Rossetti, *The Blessed Damozel* (No.LL 3148)

XX John Everett Millais, *An Idyll of 1745* (No.LL 3618)

XXI John Everett Millais, *A Dream of the Past: Sir Isumbras at the Ford* (No.LL 3625)

XXII John Everett Millais, *Landscape, Hampstead* (No.271)

XXIII John Everett Millais, *Lingering Autumn* (No.LL 3137)

XXIV William Holman Hunt, *The Triumph of the Innocents* (No.2115)

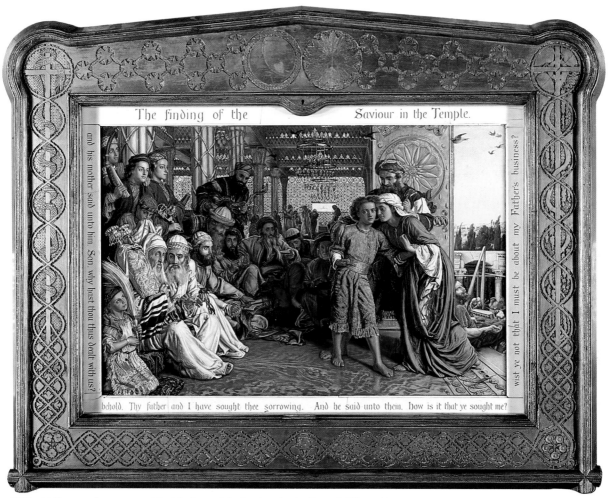

The finding of the Saviour in the Temple.

and his mother said unto him, Son, why hast thou thus dealt with us?

wist ye not that I must be about my Father's business?

behold, Thy father and I have sought thee sorrowing. And he said unto them, How is it that ye sought me?

XXV William Holman Hunt, *The Finding of the Saviour in the Temple* (No.246)

XXVI William Holman Hunt, *Sheet of studies for 'May Morning on Magdalen Tower'* (No.10537)

XXVII William Holman Hunt, *May Morning on Magdalen Tower* (No.LL 3599)

XXVIII William Holman Hunt, *Harold Rathbone* (No.1636)

XXIX John Everett Millais, *Alfred, Lord Tennyson* (No.LL 3613)

XXX John Everett Millais, *Little Speedwell's Darling Blue* (No.LL 3620)

XXXI John Everett Millais, *The Nest* (No.LL 3141)

XXXII Frederick Sandys, *Helen of Troy* (No.2633)

In this subject, which seems to have been his first choice from Keats' poetry, he saw the illustration of his own deeply-held principle of 'the sacredness of honest responsible love and the weakness of proud intemperance.'[5] The interior architectural setting and artificial lighting gave him the opportunity to try out his developing theories of going closer to nature in every detail and trying out unusual light effects. Compositionally, he experimented with vigorous movement and problems of recession and foreshortening. It has been pointed out[6] that Hunt's composition incorporates more than one phase of the poem: the revellers are still feasting in the inner hall, with Lord Maurice, 'not a whit more tame for his grey hairs',[7] in their midst. This provides an element of contrast between noise and silence, movement and stillness, light and shadow, as well as revel and intemperance opposed to innocence and youthful purity. To attain this purpose, the artist has developed a type of compositional formula present in particular in much German outline illustration of the previous decades: Judith Bronkhurst[8] suggests a debt to Retzsch's outlines to *Faust*; K. F. Lessing might be another source.[9]

The large painting was begun on 5 February 1848 and completed by April for the Royal Academy sending-in day. It was painted largely by candlelight and was the artist's first completed attempt at painting without 'dead colouring', or underpainting, and with clear form and colour.[10] This small painting Hunt himself variously described as an original study or 'original sketch' taken up and finished in the late 1850s,[11] as a sketch[12] and as an original picture derived from the outline drawing[13] (see below). Besides the outline drawing for the composition

an undoubted oil sketch, for the left-hand half of the composition, on a stone coloured ground, was certainly made.[14] No. 1635 is on a white ground, which Judith Bronkhurst points out[15] was only used by Hunt later, in his strictly Pre-Raphaelite period. The colour generally, which is brighter all over than the original picture, reflects the more vivid palette of the artist subsequent to his journey to Palestine and the Near East. While it is possible that this may overlay some initial early sketch, the work as a whole is likely to be virtually all of the later date inscribed on it. Hunt has nevertheless preserved all the spontaneity of a first concept. Various minor details have been altered or elaborated: the chair at the left has a curved arm instead of being straight-sided; the horn on the floor differs; the carving and decorations round the arch are more pronounced.

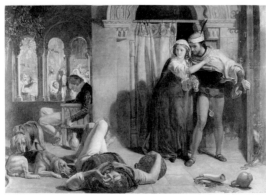

Top: 1635. *The Flight of Madeline and Porphyro during the drunkenness attending the revelry (The Eve of St Agnes)* (colour plate II)
Bottom: Fig.31 *The Eve of St Agnes.* By permission of the Guildhall Art Gallery

Hunt's own comments on it reflect the attitude towards replicas or versions as opposed to sketches which he wished to record for posterity in his autobiography as against his actual practice or desire to accommodate his patrons in the 1850s. On his return from the Near East in February 1856 he was mainly concerned to complete his large *Finding of the Saviour in the Temple* (see No. 246 below). To provide ready money, he turned to what he called in *Pre-Raphaelitism . . .*[16] 'pot-boilers'. He wrote there: 'At that time picture-dealers told me that there was a great demand for replicas of works of mine exhibited years ago, which when they first appeared had been much abused; I therefore took up the original studies of these, and elaborated them into finished pictures. These works escaped the diatribes of the critics which always met any works incorporating a perfectly new idea, and thus timid purchasers were not frightened. I first took up an original sketch for "The Eve of St Agnes", which was sold to Mr Peter [in fact John] Miller of Liverpool.' In August 1857 he had written to his friend John Lucas Tupper that he had given up his big picture for three months and 'since then have been working like a slave at a sketch of the Light of the World and another of the old Eve of St Agnes. I have now nearly got them finished and shall hope to sell them altho' I have no knowledge of the chance. With the money they bring I shall have to support myself . . . In a week I hope to settle the business of one of the sketches . . .'[17]

He had at an earlier date promised a small picture to John Miller of Liverpool,[18] and Miller received a note from him about it around March 1857.[19] Miller, in May 1857, wrote to Ford Madox Brown that he had seen the work (presumably this picture) at Hunt's rooms and was 'perfectly satisfied with it as the fulfilment of an old commission,[20] but having heard nothing further, and speculating that Hunt might prefer to paint something else for him, he asked Madox Brown (who was then helping to organise the American exhibition of Pre-Raphaelite and associate artists), to mention the matter to Hunt. By whatever means, matters were arranged satisfactorily and Miller wrote again on 29 August: 'Mr Hunt's little picture of the Eve of St Agnes, which I am glad to know you admire, goes to the American Exhibition, first paying us a visit for a day and I expect it here tomorrow – it is the fulfilment of a very old commission.'[21] At some stage in his negotiations with Hunt, Miller must have queried its status which Hunt explained when he wrote to him: 'Indeed it is an original picture, rather than a sketch of the work I did ten years ago, for nothing but the main design is derived from that, and this is much added to – and I have carried it out with so much desire to do better justice to it than circumstances and my feeble power would allow in the first instance that I can say that the result should be satisfactory'.[22]

Besides the studies noted above are several sketches and studies for the figures (all formerly artist's family collection);[23] some slight studies are on the same sheets as studies for *Woodstock*, Royal Academy 1847, and *Christ and the Two Marys* (see No. 10534 below). Two

studies of bloodhounds in differing poses, perhaps connected with this subject and also with *Woodstock*, were on the art market, 1971 and 1981.[24]

PROV: Sold to John Miller, Liverpool, August 1857; his son Peter Miller in 1861; Mrs R. A. Munn, daughter of John Miller, in 1868; John Miller executors' sale, Branch and Leete, Liverpool, 6.5.1881 (271); Miss M. E. Munn, who bequeathed it to the Walker Art Gallery, 1948.

EXH: USA 1857–8, *American Exhibition of British Art*, New York (90), Boston (107), and Philadelphia (31); probably *Liverpool Academy*, 1858 (193); (?)Hogarth Club, January 1859;[25] Royal Scottish Academy 1859 (625), as a watercolour; Liverpool Institute, 1861, *Loan Exhibition* (81); Leeds 1868 (1381); Bradford 1870 (7); Wrexham 1878 (460); Whitechapel 1905 (491); Walker Art Gallery 1907, *Hunt* (71); Manchester 1911, *P.R.B.* (225); Tate Gallery 1913, *P.R.B.* (29); Birmingham 1947, *P.R.B.* (31); Port Sunlight 1948, *P.R.B.* (113); Liverpool and V.&A. 1969, *Hunt* (11) repr.

1 With label and incised stamp of Charles Roberson, 51 Long Acre.
2 Repr. Hunt 1905, I, fp.98; Tate Gallery 1984, *P.R.B.* (9) repr. col.
3 Hunt 1886, pp.478–9; Hunt 1905, I, pp.79–80, 105–6. It should be noted that a subject from Keats' poem was, for example, exhibited at the Royal Academy 1842, No. 408, *Porphyro discovered in the Hall of Madeline*, by Charles Hutton Lear.
4 Hunt 1886, p.478: after mentioning a picture never finished (i.e., *Christ and the Two Marys*, 1847), and this subject, he read *Modern Painters* 'before I had begun either of these pictures'. See also Hunt 1905, I, pp.90–1, where he appears specifically to be referring to Vol. II (Part III, Section II, Chapter III, 17, etc.).
5 Hunt 1905, I, p.85. He also made a drawing illustrating Lorenzo in the warehouse, 1849, from the poem of 'Isabella and the Pot of Basil' (Louvre), and in 1866–7 an oil of *Isabella and the Pot of Basil* (Laing Art Gallery, Newcastle upon Tyne).
6 Graham Parry, 'The Pre-Raphaelite Image: Style and Subject', *Proceedings of the Leeds Philosophical and Literary Society*, XVII, part I, p.12; and Judith Bronkhurst in Tate Gallery 1984, *P.R.B.* (9).
7 Keats, stanza XII.
8 Bronkhurst, loc. cit.
9 As a forerunner of the type, see Karl Friedrich Lessing's drawing of a similar subject, *Walter and Hildegunde stealing from the Palace*, 1831 (Cincinnati Art Museum, 1972, *Drawings of Karl Friedrich Lessing*, No. 1882/49 repr.); there are similarities notably in the principal figures, in the sprawling man asleep in a chair and in the type of romanesque architectural setting. This drawing does not, however, appear to have been engraved.
10 Hunt 1886, pp.476–8.
11 Hunt 1905, II, p.95.
12 Letter to J. L. Tupper quoted in text: see note 17.
13 Letter to John Miller quoted in text: see note 22.
14 Exhibited Liverpool 1969, *Hunt*, Nos 10 and 94 (repr.). Burt Collection, sold Sotheby's 10.10.1985 (8, 9) repr.
15 To the compiler, Sep. 1986, and in her forthcoming catalogue raisonné.
16 Hunt 1905, II, p.95.
17 Letter, 11 Aug. 1857 (Henry E. Huntington Library, San Mari-

10534. *Sheet of figures and compositional studies . . . (recto)*

no, California), published James H. Coombs et al. edit., *A Pre-Raphaelite Friendship, The Correspondence of William Holman Hunt and John Lucas Tupper*, 1986, No. 22, p.50. On the status of the former picture and F. G. Stephens' work on it see J. Maas, *Holman Hunt and the Light of the World*, 1984, pp.50–4.

18 Noted by John Miller in letter to Ford Madox Brown, 15 May 1857 (artist's family Papers). The commission may have dated initially from 1852 when Hunt gained the Liverpool Academy prize or from 1856 when Miller apparently acquired Hunt's *The Haunted Manor* (Tate Gallery), which he gave that year to Mrs Wilson of Liverpool (Miller to FMB, 17 May 1857, loc. cit.).

19 Mentioned in Miller to FMB, 15 March 1857 (loc. cit.)

20 Miller to FMB, 15 May 1857 (loc. cit.).

21 Loc. cit.

22 Copy of an extract of a letter from Hunt to Miller forwarded by J. Miller Munn to E. R. Dibdin, Walker Art Gallery, in a covering letter of 21 Jan. 1907 (Gallery files).

23 Walker Art Gallery 1969, *Hunt*, Nos 90–4; see Burt Collection sale Sotheby's, 10.10.1985, lots 2, 3, 5, 7–10 (reprs.).

24 Forbes Magazine Collection, and Sotheby's Belgravia, 23.3.1981.

25 Miller to FMB, 21, 25 Dec. 1858 (loc. cit.), wrote that he would be delighted to lend it to the Hogarth Club.

10534. *Sheet of figures and compositional studies connected with 'Dr Rochecliffe performing Divine Service in the cottage of Joceline Joliffe at Woodstock', 'Christ and the Two Marys', the 'Eve of St Agnes' and other subjects*

Pencil, with one figure outlined in red chalk, 34 × 48.3 cm (13⅜ × 19 in)

Inscribed: (recto) *Christ & the two Maries*; (verso) *The Eve of St Agnes*, both by (?) Gladys Holman Hunt, and *108 High Holborn* and *J. Key his dog* in the artist's hand

One of several sheets of studies[1] made around 1847–8 showing the artist's method of working out his ideas for his first three major paintings. A slight composition at centre left, recto, has been identified by Bronkhurst[2] as an early idea for the first of the group, illustrating Scott's *Woodstock*, Chapter XIII (Royal Academy 1847: private collection),[3] which was a subject Hunt thought popular and likely to sell as well as being a 'due exercise in serious inventiveness'.[4] It shows the preacher standing at the left facing Sir Henry Lee, seated at the right, facing front. A profile head of an elderly man, bottom right verso, sideways on, may be for Lee's head, which appears

10534. *Sheet of figures and compositional studies . . . (verso)*

rather more three-quarters in the painting, where all the poses were changed.

The pose of the woman kneeling next to Lee, while it might be for his daughter, who appears differently in the painting, is more probably an earlier idea for Mary Magdalene in *Christ and the two Marys* (begun 1847 and left uncompleted until the late 1890s; Art Gallery of South Australia, Adelaide).[5] Through many trial poses on this sheet this figure evolves, as Bronkhurst points out,[6] from a pose of supplication to one of resignation. Closest to the final pose is that just left of centre, recto, outlined in an oval, with a profile study for the head immediately below it. A highly worked profile portrait of a bearded Christ is centre right, verso, sideways on. Hunt had difficulty with Christ's figure for this, his first religious painting. He was trying to find some treatment which would make un-affected people, 'see this Christ with something of the surprise that the Maries themselves felt on meeting Him as One who has come out of the grave'.[7] This approach of realistic immediacy was to be the foundation of his subsequent career. Dissatisfied here, he had altered this figure and soon after put the picture aside with the Christ only sketched in and took it up again only in the 1890s; the Christ finally appears in a three-quarters view.

At top and bottom right, recto, and chiefly top, verso, are several thumb-nail sketches for the composition of the *Eve of St Agnes* (see No. 1635 above). In the other

sketches cited an upright format was tried for the composition, but here the final format is indicated with the lovers to the right but with Madeline still on the right of Porphyro, an arrangement reversed in the picture. There are several variations for the porter 'in uneasy sprawl', and dogs are indicated. The inscription 'J. Key his dog' must refer to the artist's fellow student who sat for the figure of the sleeping page: he perhaps provided a dog at this stage, though the bloodhounds in the picture were lent by John Blount Price.[8] At centre left, verso, is a small study of the head of a bearded man, profile to right, for one of the revellers seen through the arcade, presumably 'Lord Maurice', and figure studies round this may also be for the revellers.

At the top of the sheet, recto, and bottom left, verso, are group studies for unidentified compositions. Bronkhurst suggests[9] that the slight study lower left centre, recto, may be for *Ginevra* ('One step to the death bed'), a drawing of 1848.[10]

The inscription '108 High Holborn' is the address of the house to which Hunt's parents moved about 1847 to give him space for a studio.[11]

PROV: By descent in the artist's family to Mrs Elizabeth Burt, sold Sotheby's, 10.10.1985 (3), bt. Agnew for the Walker Art Gallery, purchased with Nos 10535–7 with the aid of contributions from the National Art-Collections Fund, the Victoria & Albert Museum Grant

Fund and the Friends of Merseyside Museums and Art Galleries.

EXH: Liverpool and V. & A. 1969, *Hunt* (91).

1 Others were in the Burt Collection, sold Sotheby's, 10.10.1985 (2, 4 and 7). (Liverpool and V. & A. 1969, *Hunt*, Nos 88, 90, 92).
2 Sotheby's sale, loc. cit. under lot 3.
3 Reproduced Sotheby's sale, 15.10.1969 (73) and *Liverpool Bulletin* 1969, *Hunt*, fig. 18.
4 Hunt 1905, I, p. 64.
5 Liverpool and V. & A. 1969, *Hunt* (8) repr.
6 Loc. cit.
7 Hunt 1905, I, p. 85.
8 Ibid, p. 98.
9 Loc. cit.
10 Liverpool and V. & A. 1969, *Hunt* (99, 100).
11 Hunt 1905, I, p. 64.

980. *The Haunt of the Gazelle*

Watercolour, 14.5 × 20.1 cm (5¾ × 8¼ in)
Signed with initials in monogram and dated: *Whh 54*

The artist arrived at Cairo early in February 1854[1] to join Thomas Seddon, as his first stopping-off point en route for the Holy Land. At Cairo he was intrigued by the colourful contemporary scenes in the streets which he saw as a last reflection of ancient times, and began a series of watercolours ostensibly 'to make the records of ancient history clearer'.[2]

He was concerned not to fall into the trap of becoming a mere topographical artist and wrote to Millais that 'the country offers nothing with more than antiquarian interest as landscape' but, nevertheless, admitted that the 'desert is beautiful'.[3] He encamped with Seddon near the Sphinx at Gizeh outside Cairo at intervals between February and early May, when they left for Palestine.[4] While there he began several watercolours, which included No. 980, *Back of the Sphinx* (Harris Museum and Art Gallery, Preston), the *Great Pyramid* (private collection), and *The Wilderness of Gizeh* (art market 1971).[5] The latter, like No. 980, shows gazelles, but seen at a distance in a vast expanse of desert and foothills.[6]

In No. 980 a Dorcas gazelle[7] is at rest by a pool, with a long strip of higher ground in the distance and further stretches of water visible. It must pre-date, at least in conception, the total drying-up of the inundations of the Nile which, according to Seddon's account,[8] was well advanced by mid-April. The Sphinx watercolour was planned to be continued with a visit to the pyramids site from 13 April,[9] and No. 980 may have been similarly treated. Judith Bronkhurst points out that it is from the same sketch-book as drawings of fellahin which are dated 'April'.[10] Hunt mentions finishing watercolours on his trip down the Nile in May.[11] Compositionally, No. 980 is echoed in the format of *The Scapegoat* (No. LL 3623 below)[12] designed later at Jerusalem but here the image is one of gentle repose.

It must have remained with the artist until after its exhibition in 1889. In that year at the Old Watercolour Society, over thirty years after its being painted, *The Athenaeum* commented on the vividness of its colour,

980. *The Haunt of the Gazelle* (colour plate X)

but considered it a slight work: (the gazelle) 'lies couched in a resplendent landscape. The firmness of Mr Hunt's draughtmanship is somewhat exaggerated, there is not a trace of sentiment, and the drawing is hard, yet without the least crudity of modelling or colour. On the whole the drawing is very pretty, but, even as a study of a beautiful animal, was hardly worthy to occupy so much of the time of an artist of renown'.[13]

PROV: With Harold Rathbone by 1906, and probably acquired from the artist c.1889–92 either by him or his father, Alderman P. H. Rathbone (Chairman of the Arts Sub-Committee and art collector);[14] Alderman John Lea, post-1913 and before 1922, among a group of items for consideration by the Gallery, under Lea's Will, January 1927, but not chosen;[15] Mrs Elias, niece of John Lea, who acquired it from his house sale Feb. 1927;[16] bequeathed by her to the Walker Art Gallery, 1952.

EXH: Old Watercolour Society, Winter 1889 (308); Manchester 1906, *Hunt* (75); Liverpool 1907, *Hunt* (55); Manchester 1911, *P.R.B.* (292); Tate Gallery 1913, *P.R.B.* (7); Bath 1913 (56); Walker Art Gallery 1922, *Liverpool Autumn Exhibition* (245); Liverpool and V. & A. 1969, *Hunt* (135) repr.; Royal Academy 1984, *The Orientalists* (71) repr. col.

1 Seddon, 1859 edition, p.43, letter of 11 Feb. 1854.
2 Hunt 1905, I, p.377.
3 Ibid, p.380.
4 He was there for a week at the end of February, planned a week there after 12 March and was there again the eve before Good Friday (14 April), into early May (Seddon, 1859 edition, p.71; Mary Lutyens, 'Letters of . . . Millais . . . and . . . Holman Hunt . . . in the Huntington Library . . .,' *44th Volume of the Walpole Society 1972–4*, 1974, p.55, quoting letter to Rossetti of 12 March; Hunt 1905, I, p.384).
5 See Liverpool and V. & A. 1969, *Hunt* (133, 134) repr.
6 Hunt 1905, I, repr. p.390.
7 Identified by Clem Fisher, Liverpool Museum.
8 Seddon, 1859 edition, p.71: in letter dated 'Good Friday evening' (14 April in 1854), Seddon wrote that he could no longer get wildfowl for the pot as the ponds were drying up and the ground already turning to dust.
9 Ibid, and see Judith Bronkhurst in Royal Academy catalogue 1984, *The Orientalists*, No. 69.

10 Ibid, No. 71.

11 Hunt 1905, I, p.391. It should also be noted that he mentions finishing two Eastern watercolours in a letter to F. Palgrave, 5 April 1866 (Burt Collection, sold Sotheby's 15.12.1970, part of lot 890). In a later letter, 24 July 1866 (loc. cit.), he mentions 30gns as the highest he could get 'for the Fawns Head'. The watercolour, the *Wilderness of Gizeh*, is dated *1854–66*.

12 Noted by Frank Milner, *Pre-Raphaelites on Merseyside*, Walker Art Gallery Education Service publications, 1982; and Judith Bronkhurst, loc. cit., No. 71.

13 *The Athenaeum*, 7 Dec. 1889, p.787; quoted in the Old Watercolour Society Club, *Thirteenth Annual Volume, 1935–6*, 1936, p.29.

14 See the portrait of Harold Rathbone (No. 1636 below), note 6.

15 Documents in Gallery files.

16 Label on the back: no sale catalogue has been traced.

LL 3623. *The Scapegoat*

Oil on canvas,[1] 87 × 139.8 cm (34¼ × 55 in)
Signed, dated and inscribed: OOSDOOM DEAD SEA/ 18 WHH 54
Inscribed on frame: (top) *Surely he hath borne our Griefs, and carried our Sorrows / yet we did esteem him stricken smitten of GOD and afflicted* [Isaiah, LIII, 4]; (bottom) *And the Goat shall bear upon him all their // THE SCAPEGOAT // Iniquities unto a Land not inhabited* [Leviticus XVI, 22]
Frame: Gilt wood with wide plain convex field having shallow flat carved motifs at the centre of each side: (top) seven stars in a cusped field; (bottom) the seven-branched candlestick within double circles of the (?) Torah; (left side) dove with olive branch in a trefoil; (right side) the heartsease flower within a cross; designed by the artist.[2]

One of the most telling religious images created in the nineteenth century. The concentrated meaning and forceful brilliance of its representation of the Scapegoat as a type of Christ taking on the sins of the world, in a setting encapsulating the most memorable of biblical landscapes in the most desolate part of the Holy Land on the shores of the Dead Sea, were little comprehended and received with hostility on the picture's first exhibition.

Begun on the spot, 17 November 1854,[3] and finished at Jerusalem in June 1855,[4] the picture was exhibited at the Royal Academy of 1856 with the following entry in the catalogue:

'The Scapegoat – See *Leviticus*, xvi

'The scene was painted at Oosdoom, on the margin of the salt-encrusted shallows of the Dead Sea. The mountains beyond are those of Edom.

'While the ceremonies of the day of atonement were in progress in the Temple, after the lots had been cast which had devoted one of the two goats for the Lord, and while it was being sacrificed as a burnt offering, the congregation present manifested their impatience by calling upon the priest to hasten the departure of the scapegoat, and afterwards by following the beast as he was led away by the man appointed, to a cliff about ten miles from Jerusalem; tormenting it by the way, and shouting, "Hasten, carry away our sins." It is recorded that, on many occasions, the poor beast sprang over the precipice, and there

perished; but that oft-times it turned aside, to be hooted and driven away by every "Israelite who met it, until it had reached a land not inhabited". A fillet of scarlet was bound about its horns, in the belief that, if the propitiation were accepted, the scarlet would become white (in accordance with the promise in Isaiah: "Though your sins be as scarlet, they shall be as white as snow : though they be red like crimson, they shall be as wool."). In order to ascertain the change of colour, in case the scapegoat could not be traced, a portion of the scarlet wool was preserved on a stone, and carefully watched by priests in the Temple. – See *The Talmud*.'

The subject was considered while Hunt was studying sources for the ceremonies of Jewish worship,[5] and was taken up when models proved impossible to obtain for the *Finding of the Saviour in the Temple* (see No. 246 below). With the parallels he found in Leviticus and Isaiah for the scapegoat as a type of Christ, he combined passages referring to the red fillet borne on the brow, taken from the Talmud, or rather, as Judith Bronkhurst suggests,[6] transcriptions from it in John Lightfoot's *The Temple Service as it Stood in the Dayes of Our Saviour* (1649). Jeremy Maas has pointed out[7] that a wood-engraving of a scapegoat with other sacrificial animals, is in Hunt's Bible from his father's library. If he was consciously aware of this, it might have suggested to him his idea of offering the subject to Landseer,[8] but he realised the importance of painting it in an appropriate setting in the Holy Land. He purchased a rare white goat at Jerusalem[9] and his mature conception was certainly in his mind by mid-July 1854. Bronkhurst quotes from a letter to his patron Thomas Combe at Oxford of his surprise that it had not already been done as a subject: 'The scapegoat in the wilderness by the Dead Sea somewhere with the mark of the bloody hands on the head.'[10]

The setting he chose of the desolate shore of the Dead Sea is fundamental to his conception. His attitude appears clearly in a letter to Combe of the following year: 'How curious that an etching of the scapegoat should have been made since the subject as I believe has never been done before. I dont care for anything that could be designed in England as the interest of the illustration depends upon the locality so much'.[11] Bronkhurst points out[12] that his choice of location was probably inspired by his reading at this time of Félicien de Saulcy's *Narrative of a journey round the Dead Sea and in the Bible Lands in 1850 and 1851* (English translation 1853), with its identification of the site of Sodom as Kharbet Esdoon on the southern reaches and the description of the dramatic effects over the mountains and the sea. He had also, no doubt, been just as impressed as his companion Thomas Seddon on their first sight of the Dead Sea from the Mount of Olives the day following their arrival at Jerusalem in June 1854, lying in misty distance under the brilliant sunset colours of the mountains,[13] (Hunt first recorded this distant view, at Siloam near Jerusalem probably about September 1854).[14] His appetite to visit and record this unfrequented and infamous site of Biblical wrath was probably only whetted by the dangers then

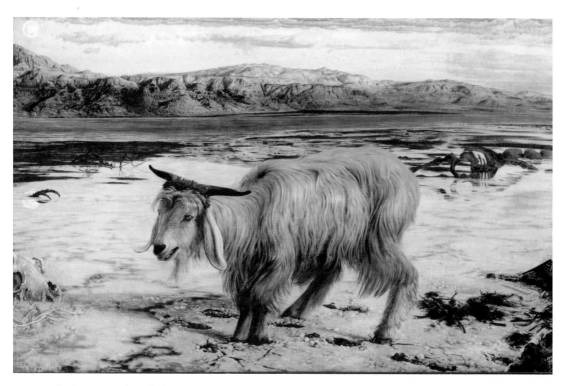

LL 3623. *The Scapegoat* (colour plate XI)

Fig.32 *The Scapegoat.* By permission of the City of Manchester Art Galleries

pertaining to travellers during the insurrections among the fellahin.

He made two visits to the southern shore. The first reconnaissance was in the already cooler month of October,[15] intending it to be, as he stated in his autobiography,[16] near the Day of Atonement (2 October in 1854), but in fact rather later in the month. On this occasion he visited Oosdoom with a companion, William Beamont, on 25 October and on the return ascent from Engedi began a study of 'the glowing hues of the evening landscape', as Beamont recorded:[17] this was

probably the beginnings of the smaller version now in the Manchester City Art Gallery (fig. 32).[18]

He began his second journey, without European companions, on 13 November,[19] taking the white goat with him to determine its pose on the spot. He painted at Oosdoom between 17 and 26 November,[20] a much shorter period than he had wished for, and in his Journal of the visit recorded much of his work and the impression he sought to record:[21]

'The mountains lie afar beautiful as precious stones but anear they are dry and scorched, the rose color is the burnt ashes of the grate, the golden plain is the salt and naked sand. The Sea is heaven's own blue like a diamond more lovely in a king's diadem than in the mines of the Indes but as it gushes up through the broken ice like salt on the beach, it is black, full of asphalte scum – and in the hand slimy, and smarting as a sting – no one can stand and say it is not accursed of God'.

He took up a position slightly different to the sketch and appears to have painted the view from more than one point. He worked at the background, correcting at sunset the colour of each portion completed. A blank space would be left for the goat: slight pencil sketches of it (Nos 10535–6 below), presumably date from this time and also a pencil study of the mountains.[22] He was unable to finish his work on the spot but determined to continue at Jerusalem. He wrote to Seddon in mid-December:[23] 'I am humbled you see in having to do my Dead Sea work almost entirely without Nature. I painted the Mountains,

the Sea and some of the foreground, but the other, the sky etc. I have to do from the top of [Dr] Sim's house'. This work appears to have been undertaken in January 1855[24] and after the snow was over[25] from 19 March when he found the wrong sort of clouds.[26] The white goat having died on the return journey, he had difficulty in finding another, making do with a brown-faced goat[27] until a third, white, she-goat was obtained.[28] His Diary[29] for a period from 12 February records the day by day painting, the animal standing in a tray of salt and mud brought back in part from Oosdoom. He adjusted the pose to suggest greater weakness (12 February), and placed the scarlet fillet about the horns to suggest the Crown of Thorns (14 February).

There was still much to be done to the rest of the picture: he mentions working at the skeleton of the camel (the beast of burden), early in March, from one obtained near Jerusalem;[30] designing the frame during February and sending its sketch off to Combe for execution on February 26;[31] mentions his use of emerald instead of a colour containing cadmium for the marshy water (24 March); work again on the clouds in early April (after which a section of the diary until October is missing). The skull of a Sinaitic ibex was lent him by Dr Sim.[32] The full moon rising in the east casts a halo behind its horns which may signify the companion sacrificial goat of the Day of Atonement;[33] the whitened olive branch and the skull of another goat lying on the edge of the shore at the left may indicate the repeated shouldering of sin and its expiation in a continuous process. The rainbow which Hunt and Beamont had observed on their first visit and which he had tried out on the smaller canvas along with a brown goat,[34] and which is faintly visible on the sketch of the goat (No. 10535 below), was omitted from No. LL 3623, giving a starker image and preserving the idea of the unsullied whiteness of the dying goat as symbol of Christ. The picture was not completed by Easter (8 April), and too late to send in for the 1855 Royal Academy. It was finally sent off in June 1855.[35] Some further work was done on it before the 1856 sending-in day in London.[36]

The frame designed by the artist was to be made by Joseph Green, the London framemaker;[37] the motifs provide the message of hope[38] with Christian forgiveness overlaying the Jewish scheme of atonement.

In September, by which time the picture had arrived at Combe's house at Oxford, Hunt sent off a description,[39] again placing great emphasis on the setting:

'. . . the mountains on which you are looking are part of the Moab range of Mountains which bound the Jordan and Dead Sea plain on the East, and which connect the low plain still lower with the Red Sea by bordering all the intermediate level in the same uniform chain, the extreme distance of sea in the picture is the Southern end of the Dead Sea and the part of the mountains represented is therefore Edom and perhaps in part Moab seen from the shore of Oosdoom, a ruined isolated barren Mountain thought by most people to be the site of ancient Sodom as well from the nature as from its Arabic name (this of

course is behind me and the spectator). There is no imagination in the presence of the skeletons I have represented the shore teams with them . . . you know an old myth that no birds fly over the Dead Sea many people have gloried in disputing this assertion yet in a degree it is true . . . the corpses are thus left to flies who clean them leaving the skeleton in the most complete state until the winter rains swell the sea up to the line of drift you see at the right of the picture behind the goat the trunks of trees are all brought there in this way, and left on the sinking of the waters which forms the marsh encrusted with salt which is the white ground of the picture. For an account of the manner in which the goat was treated I must refer you to the Talmud which is my authority for the Scarlet wool on his head which seem[s] to have been the key to the passage in Isaiah, "though your sins be as scarlet etc. etc." for they watched this or a part of the wool which they retained in hopes that in turning white they would receive a sign of forgiveness.'

Combe offered it on the artist's behalf to interested patrons in the year before its exhibition, but it was considered painful in subject and untypical of the artist.[40] Hunt states that carping comments had already been made, through returning travellers, as to its not being entirely painted on the spot.[41] Millais privately pronounced against it.[42] Nevertheless, at the Royal Academy, hung on the line,[43] it was, as a realistic and detailed presentation of a religious image, the centre of attention[44] and attracted wide comment in the press, chiefly of a puzzled and antagonistic kind. Hunt admits that he had 'over-counted on the picture's intelligibility'.[45]

The reviews, copiously quoted by Hunt,[46] took common issue against the idea of using a goat as a religious symbol. *The Times* considered the work 'disappointing although there is no doubt much power in it. The distance is given well, and the colour is very good, the mountains are most lovingly painted; in the eye of the scapegoat, too, as it comes to drink of the waters of the Dead Sea, there is a profound feeling, but altogether the scene is not impressive, and were it not for the title annexed it would be difficult to divine the nature of the subject.' W. M. Rossetti in a more sympathetic descriptive note[47] considered it solemn and impressive but again doubted whether without a key it conveyed 'a symbol unmistakeably defined'. *The Athenaeum* again laid emphasis on the goat: 'a picture from which much has been expected, not merely from the original feeling of the painter, but from its being a Scripture subject, and one the scene of which is laid in a spot of prophetic and awful desolation, where it was actually painted. It was one of Wilkie's theories that Scripture scenes should be painted in the Holy Land, a theory which Raphael and some others are quite sufficient to disprove . . . The question is simply this, here is a dying goat which as a mere goat has no more interest for us than the sheep that furnished our yesterday's dinner; but it is a type of the Saviour, says Mr Hunt, and quotes the Talmud. Here we join issue, for it is impossible to paint a goat, though its

eyes were upturned with human passion, that could explain any allegory or human type. The picture, allowing this then, may be called a solemn, sternly painted representation of a grand historical scene (predominant colours purple and yellow), with an appropriate animal in the foreground. We shudder, however, in anticipation of the dreamy fantasies and the deep allegories which will be deduced from this figure of a goat in difficulties . . .' Ruskin gave it the longest notice in his *Academy Notes* of 1856:[48] 'This singular picture, though in many respects faithful, and in some wholly a failure, is yet the one, of all the gallery which should furnish us with most food for thought . . .' He admired the determination and strength of heart needed to choose to paint that polluted and decaying atmosphere: 'Of all the scenes in the Holy Land, there are none whose present aspect tends so distinctly to confirm the statements of Scripture, as this condemned shore'. He reasoned that the unfamiliarity of its imagery and subject deserved the patience of inquiry to match the resolve of the artist: 'Now, we cannot, I think, esteem too highly, or receive too gratefully, the temper and the toil which have produced this picture for us. Consider for a little while the feelings involved in its conception and the self-denial and resolve needed for its execution . . .' 'But', he comments, '. . . this picture indicates a danger to our students of a kind hitherto unknown in any of our school; the danger of a too great intensity of feeling, making them forget the requirements of painting as an *art*. This picture, regarded merely as a landscape, or as a composition, is a total failure. The mind of the painter has been so excited by the circumstances of the scene, that, like a youth expressing his earnest feeling by feeble verse . . . Mr Hunt has been blinded by his intense sentiment to the real weakness of the pictorial expression; and in his earnest desire to paint the Scapegoat, has forgotten to ask himself first, whether he could paint a goat at all.' He considered the artist had failed in the distant mountains, thought the goat placed so exactly centrally looked like a signboard, and in a note questioned (as he was to do with Millais' *Sir Isumbras*, No. LL 3625 below), the accuracy of the water being brighter than the sky.[49]

Ford Madox Brown in his diary for 19 May[50] presented the most painterly and perceptive assessment. While deprecating the hard colour and shortcomings of the centralised composition he considered that it 'requires to be seen to be believed in & only then can it be understood how by the might of genius out of an old goat & some saline incrustations can be made one of the most tragic & impressive works in the annals of art'. Hunt felt that Ruskin's strictures had held back its sale,[51] but it was sold by July 1856 according to Madox Brown, to the dealer D. T. White for 450 gns on an eight months bill.[52] It was acquired by B. G. Windus of Tottenham, who also bought the smaller version.

ENGRAVED: Charles Mottram. Publication registered by H. Graves & Co, 29 November 1861 (36¼ × 24½ in).[53]
PROV: Bought by B. G. Windus, ?through D. T. White, dealer, 450 gns, including copyright; his sale Christie's,

19.7.1862 (56), bt. Agnew £489.10.0; John Heugh, sold Christie's, 10.5.1878 (208), bt. Agnew £504, and thence sold to Sir Thomas Fairbairn 8 May 1878;[54] Fairbairn sale Christie's 7.5.1887 (143) bt. Agnew £1,417.10.0 and thence sold to Cuthbert Quilter 10 May 1887;[55] Quilter sale Christie's 9.7.1909 (59), bt. in at £2,940, and 22.6.1923 (154), bt. Gooden & Fox, £4,830 for 1st Viscount Leverhulme (£4,950);[56] thence to the Lady Lever Art Gallery.
EXH: Royal Academy 1856 (398);[57] Liverpool Academy 1856 (44);[58] Fine Art Society, 1886 *Hunt* (20); Birmingham 1891 (174); Guildhall 1895 (44); West Ham 1898; Whitechapel 1905 (427); Leicester Galleries, 1906, *Hunt* (22), and Spring 1907 (82); Manchester 1906, *Hunt* (15); Walker Art Gallery 1907, *Hunt* (49); Rome 1911 (39) repr.; Walker Art Gallery 1923, *Liverpool Autumn Exhibition* (1001); Royal Academy 1934, *British Art* (552); Toronto 1936; Birmingham 1947, *P.R.B.* (42) repr.; Whitechapel 1948, *P.R.B.* (39); Manchester 1948, *P.R.B.* (12); Royal Academy 1951–2, *First Hundred Years* (274); Sheffield 1952, *P.R.B.*; Australian State Galleries 1962, *P.R.B.* (38) repr., pl.6; Christie's 1967, *Bicentenary Exhibition* (19); Royal Academy 1968–9, *Bicentenary Exhibition* (375); Liverpool and V. & A. 1969, *Hunt* (33) repr.; Paris 1972, *P.R.B.* (145); Whitechapel 1972, *P.R.B.* (25).

1 Not relined: canvas mounted on panelled stretcher.
2 See note 37.
3 MS Journal of an *Account of a second journey to the southern end of the Dead Sea by way of Hebron* (the main part John Rylands University Library of Manchester Eng. MS 1210; and a centre fragment Bodleian Library, Oxford in MS Eng. Lett. c. 296), quoted by Judith Bronkhurst in part under No. 84 in Tate Gallery 1984, *P.R.B.*, and extensively in *Pre-Raphaelite Papers*, 1984, ' "An interesting series of adventures to look back upon": William Holman Hunt's visit to the Dead Sea in November 1854'; Hunt 1886, p.829; Hunt 1905, I, pp.446–7.
4 Hunt to Thomas Combe about June 1855 (John Rylands Library, Eng. MS 1213).
5 Hunt 1886 and 1905, loc. cit.
6 Tate Gallery 1984, *P.R.B.* (84), mentioning commentaries by Lightfoot and others which were available to him in a missionary's library at Jerusalem, and II, p.109.
7 Jeremy Maas, *Holman Hunt and the Light of the World*, 1984, pp.82–3 repr.
8 Hunt 1905, I, p.447; and see Staley 1973, pp.66–7 for a discussion of Landseer's influence.
9 In his Journal (see Nos 10535–6 below) he states that he bought it in the spring, but he only arrived in Jerusalem on 3 June 1854 (Seddon, 1859 edition, pp.83,90).
10 Hunt to Combe, 10 July 1854 (Bodleian Library, Oxford, MS Eng. Lett. c. 296, fols. 36–7), quoted by Bronkhurst, Tate Gallery 1984, *P.R.B.* (84), where she discusses his biblical and other sources at length.
11 Hunt to Combe, 31 March 1855 (John Rylands Library); see Staley 1973, pp.67–8 for a discussion of the significance of the landscape. The importance of this trip to Hunt is confirmed by his detailed Journal, loc. cit., and Diary undertaken on his return to Jerusalem (also John Rylands Library, Eng. MS 1211). T. S. R. Boase has pointed out that Hunt was not the first to paint in oil on the shore of the Dead Sea. Alphonse Montfort (1802–84) painted there in the 1820s ('Biblical Illus-

tration in Nineteenth Century English Art', *Journal of the Warburg and Courtauld Institutes*, Vol. 29, 1966, p.349ff.).

12 Tate Gallery 1984, *P.R.B.* (84), referring to a letter of Hunt to Millais, 10–12 Nov. 1854 (British Library); de Saulcy, I, p.456f.; see also note 17.

13 Seddon, 1859 edition, p.92: '. . . In the afternoon we walked up to the top of the Mount of Olives, whence you overlook the whole city, and, also to the east, the Dead Sea, which is really only fifteen miles off, and which looks quite close. This is one of the most impressive views in the world, and if I have time I will certainly paint it, but I fear that I shall not be able. On the top of the Mount of Olives are gardens, and corn-fields stretch down its sides, but all beyond seems perfectly barren rock and mountains. The Dead Sea seemed motionless, and of a blue so deep, that no water that I have seen can compare with it. The range of mountains beyond is forty or fifty miles off, and a thin veil of mist seemed spread between us and them over the sea, through which they appeared aerial and unreal; and, as the sun sinks, the projections become rose-coloured, and the chasms a deep violet, yet still misty. When the sun left them, the hazy air above them became a singular green colour, and the sky over rosy red, gradually melting into the blue . . .' This impression is repeated in different words in Seddon's letter to his sister, 14 July 1854 (Seddon Papers, deposit, John Rylands Library), where he adds: 'I wish I could paint a large picture of them but I cannot'. See also Hunt 1905, I, p.403: '. . . I walked about the walls and up the Mount of Olives, from the top of which the view was wild, barren, and diaphanous, like a vision of the surface of the moon'.

14 City Museum and Art Gallery, Birmingham No. 13/48 (exhibited Liverpool and V. & A. 1969, *Hunt* (163), repr. Staley 1973, pl.30b.).

15 Hunt to Combe, 13 Sep. 1854 (Bodleian Library, MS Eng. Lett. c. 296, fol. 44), quoted by Bronkhurst, loc. cit., mentioning awaiting cooler weather for his visit.

16 Hunt 1905, I, p.447. He may also have postponed his departure until after Thomas Seddon left Palestine hurriedly on 19 Oct. (Seddon, 1859 edition, p.129; Hunt 1905, I, pp.447–8).

17 W. Beamont, *A Diary of a Journey to the East, in the Autumn of 1854*, 1856, II, p.78; Hunt 1905, I, p.456. Beamont, II, p.43, echoes de Saulcy's dramatic description of a rainbow effect in a storm over the mountains and sea, which they similarly witnessed: '. . . a lofty and most perfect rainbow, with one foot upon Usdam, and the other upon Kerak, spanned the wide but desolate space of intervening sea and land – the symbol of God's covenant of mercy above the most memorable scene of his wrath'. This was an effect which Hunt tried out in the smaller version (Manchester; fig. 32).

18 Tate Gallery 1984, *P.R.B.* (84) repr. col.

19 Hunt 1905, I, p.463.

20 Journal, loc. cit., giving days of the week but no dates. He camped in the Wady Zoara and descended each day to the margin of the sea in the plain (see copy of letter from Hunt to Thomas Seddon, 3 Dec. 1853 and Hunt to Seddon, 16 Dec. 1854, John Rylands Library, published in George Landow, 'William Holman Hunt's Letters to Thomas Seddon' *Bulletin of the John Rylands University Library of Manchester*, Vol.66, No. 1, Autumn 1983, letters 8, 9). See also Hunt 1887, passim and Hunt 1905, I, p.472f. for further descriptions of his second visit.

21 John Rylands Library; the quotation published in Staley 1973, p.68; and more fully in Bronkhurst, 'An interesting series of adventures . . .', loc. cit., p.120.

22 Exhibited Liverpool and V. & A. 1969, *Hunt* (163).

23 Hunt to Seddon 16 Dec. 1854 (Landow, op. cit., No. 9; published with the permission of the Editor): he had strongly

advised Seddon to finish his landscapes from nature on the spot before leaving Palestine and was now himself unable to adhere to this principle.

24 Hunt to Seddon, 31 Jan. 1855 (Landow, op. cit., No. 10).

25 Hunt 1905, II, p.1.

26 MS Diary, commencing 12 Feb. 1855, Hunt to Combe, 31 March 1854 (John Rylands Library, Eng. MSS 1211,1213).

27 Hunt to Seddon, 31 Jan. 1855 (Landow, op. cit., No. 10).

28 MS Diary, 15 Feb. 1855 (loc. cit.).

29 Ibid.

30 Hunt 1905, II, p.2.

31 MS Diary, loc. cit., and see note 37.

32 Hunt 1905, I, pp.442, 466; II, p.11; Bronkhurst, Tate Gallery 1984, *P.R.B.* (84). Hunt had seen ibex in the vicinity of the Dead Sea on his second visit.

33 Bronkhurst, loc. cit.

34 Draft letter to (C. Morland) Agnew, early 1906 (John Rylands Library), and see note 17; published Bronkhurst, loc. cit.

35 Hunt to Combe c. 15 June 1855 (John Rylands Library); Hunt 1905, II, p.15.

36 Hunt to Lear, 13 April 1856 (John Rylands Library).

37 In letters to Combe, 11 and 25 Feb. 1855 (Bodleian Library, MS Eng. Lett. c. 296, fols. 54, 56–7), Hunt cited Green, the framemaker. He had found it difficult to design the frame and in order to get the work started quickly, at a time when he was still hoping to get the picture to the 1855 Royal Academy, sent a rough sketch with silk threads for the size measurement, but in his second letter he included further outlines of motifs to be incorporated: a cross of circles with a heartsease, which he asked Combe to complete from a real flower and leaves, and the dove with olive leaves for which he had not been able 'to find nature for here' (the sketches are no longer with the letters). Joseph Green, carver and gilder, is listed at 14 Charles Street, Middlesex (Hospital) until 1870. Madox Brown and Rossetti also used him.

38 Discussed by Lynn Roberts, 'English Picture Frames: The Pre-Raphaelites', *The International Journal of Museum Management and Curatorship IV*, No.2, June 1985, pp.165–6.

39 Hunt to Combe, 7 Sep. 1855 (John Rylands Library); and see Hunt 1905, II, pp.108–10.

40 Hunt 1905, II, pp.12, 94; and Hunt to Lear, 13 April 1856, loc. cit.

41 Hunt 1887, pp.213–14; Hunt 1905, I, pp.509–10.

42 Millais to Effie, 'Sunday evening' (about April 1856), and 5 May 1856 (Henry E. Huntington Library, San Marino, California); 5 April (1856) (Pierpont Morgan Library, New York).

43 Hunt 1905, II, p.113.

44 Ibid, p.110.

45 Ibid, p.108.

46 *The Times*, 3 and 5 May 1856, *The Athenaeum*, 10 May 1856, pp.589–90, *The Art Journal*, 1856, p.170.

47 Republished in W. M. Rossetti, *Fine Art, Chiefly Contemporary, Notices Reprinted, with Revisions*, 1867, pp.243–4.

48 Ruskin, XIV, pp.61–3.

49 See Hunt and Ruskin's letters in George Landow, ' "Your Good Influence on me": The Correspondence of John Ruskin and William Holman Hunt', *Bulletin of the John Rylands University Library of Manchester*, Vol.59, Nos 1 & 2, 1976–7, reprint pp.29–31; and see Landow, *William Holman Hunt and Typological Symbolism*, 1979, p.103f.

50 Surtees, *Diary*, p.174.

51 Landow, *Bulletin* article, loc. cit.

52 Surtees, *Diary*, p.181. Hunt may have received only £400, the difference perhaps going to the dealer: Hunt's letter to Thomas Combe, June 1855 (John Rylands Library) fixes the asking price at £400, and he repeats this figure to Ernest

10535. *Study for the goat in 'The Scapegoat'*

Chesneau, 16 March 1882 (G. Landow, ' "As Unreserved as a Studio Chat": Holman Hunt's letters to Ernest Chesneau', *The Huntington Library Quarterly*, August 1975, p.360; and Mary Lutyens, *44th Volume of the Walpole Society, 1972–1974*, 1974, p.77); but in Hunt to Lear, 13 April 1856 (John Rylands Library), the asking price is mentioned as 450 gns. See also Hunt 1887, p.219, stating it was sold for 400 gns, including copyright, and Hunt 1905, II, pp.121–2, indicating that B.G. Windus offered the artist 450 gns to include copyright.

53 *An Alphabetical list of prints declared at the Printseller's Association*, 1892, I, p.336: 200 artist's proofs at 10 gns; 25 presentation proofs; 50 India proofs before letters and 50 plain at 5 gns; unspecified number of prints at 3 gns.

54 Agnew Picture Stock Book 3, No. 584.

55 Agnew Picture Stock Book 5, No. 4449.

56 Invoice Gallery files.

57 The artist's MS label is on the back of the frame: *No. 1 The Scapegoat / W. Holman Hunt / 49 Claverton Terrace / Lupus Street / Pimlico.*

58 Liverpool reviewers followed the lead of the unsympathetic London critics. *The Courier* (17 Sep. 1856), in an opening notice mentioned it very much in passing: 'After "The Scapegoat", which violently excites the risibility of every one who enters, the most singularly absurd picture is Mr T. B. Seddon's "Valley of Jehosephat" . . . Verily these gentlemen have given us new lessons in *oriental tinting*'. *The Mercury* (27 Oct. 1856); after demolishing the prize picture (Ford Madox Brown's *Jesus washing Peter's Feet*), added: 'Here is another unfortunate subject, having a world of labour expended over nothing that interests or gratifies the taste of the beholder. The goat itself is a wonderful example of manipula-

tion, but without any interest either as a subject for a picture, as a specimen of its kind, or as an elucidation of any fact or tale of historic interest. The mountains are exceedingly fine, and powerfully painted, the colouring being most rich and beautiful; but nothing can make amends for the miserable animal that occupies the centre of the picture. Indeed, it and all the accessories are suggestive of anything but pleasant feelings, and we confess we should not like such a picture in our dwelling to contemplate, and therefore pass hastily by to more congenial subjects.'

10535. *Study for the goat in 'The Scapegoat'*
Pencil, 14 × 22 cm (5¼ × 8⅝ in)
Inscribed: *Khorosaffe*
Verso: sketch of a (?) gorge below indented skyline

10536. *Two studies for the goat in 'The Scapegoat'*
Recto and verso, pencil, 14 × 22 cm (5⅝ × 8¾ in)
Recto faintly inscribed: at right on drawing, *greener darker than* and near this in right-hand margin *salt*; below this in right-hand margin, *white cloud reflected/much brighter than salt*; and in another hand (? Edith Holman Hunt's), *Scapegoat* and *WHH*

Hunt made his second trip to the Dead Sea in November 1854 to paint the desolate landscape and took with him his precious white goat. In the Journal he kept during his days there he recorded its falling ill on the return journey: 'I bought it in the spring and have kept it ever since for my model for this picture, & brought it with me here that I might study his pecularities on the spot & under the

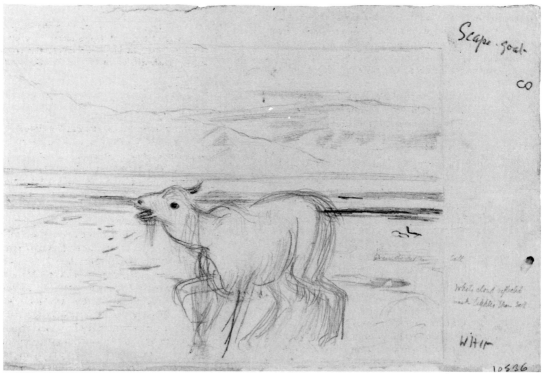

10536. *Two studies for the goat in 'The Scapegoat'* (verso and recto)

circumstances – as far as might be – which I have chosen for the subject'.[1] This is his only reference to it here, but in his later published accounts, when he was concerned to emphasise the amount of work done on the canvas at the actual location, he expanded his story. He recorded[2] hurrying on the day of his arrival (17 November) with his Arab guard Soleiman, down the gorge to the plain and over two miles (of disagreeable ground)[3] to the sea shore, carting his canvas strapped to a donkey and taking the goat with them. Having decided upon the exact spot, he got Soleiman to lead the animal about for him[4] to 'study the goat's manner of walking over the insecure ground, noting the while the tone he assumed'.[5] In the first published account he mentions sketching in the goat on the canvas,[6] but in his manuscript Journal he only records being unable to adapt, on this first day, the design he took with him to the place he had now chosen:[7] this design was probably the beginning of the smaller oil (Manchester; fig. 32), started on his earlier visit from a different place on the coast.[8] No further mention is made of the goat while he was painting on the shore.

These three sketches of the goat, in particular No. 10536 (recto), are likely to have been made on this first reconnaissance trip, rather than up at the camp,[9] firmly to establish its position in the composition, where blank canvas would be left. No. 10535 (recto) is a rapidly treated sketch: the goat stands much as in the final pose chosen for the canvas, but with its head up, bleating (this was reconsidered at Jerusalem). It is, however, viewed from below and well to the right of the lightly indicated line of hills, which barely rise above its back and stretch well to the left (about one third of the sketch is overlaid with instructions to the mounter for a smaller, lined-in format).[10] The sketch, verso, though difficult to read, may be of part of the gorge between the high ground and the plain.

In No. 10536 (recto)[11] the goat is set centrally, as in the picture, but still partly overlaying the sea and mountains. The forelegs are sketched in more than one position. The artist is particularly concerned here with observing the light effects in the water in his note at the side: 'white cloud reflected/much brighter than salt.' Another pencil sketch exists with colour notes, of the Dead Sea from the Western Shore looking towards Moab,[12] which might also date from the first day's work.

No. 10536 (verso)[13] is probably the basis for the ultimate composition and has a light line drawn round it, probably this time by the artist. It is more carefully worked-out though with a slightly more frontal pose to the head (still raised). Its body no longer impinges on the sea. To the right is the faint double arc of a rainbow. A note dictated by Holman Hunt long afterwards states 'Before my return to Oosdoom I made the rainbow experiment on the small picture'.[14] At the time of his second visit he probably planned to adhere to this in his large oil. Its final omission, Bronkhurst suggests, was probably that it, together with the olive branch at the left, 'introduced too optimistic a note into a scene of desolation'.[15]

The only sketch of the goat to which the artist refers is

one he mentions executing as the goat lay dying on the return journey,[16] which was of its head.[17] This has not re-appeared.

PROV: The artist and by descent to Gladys Holman Hunt, Mrs Michael Joseph; thence by descent to Mrs Elizabeth Burt, sold Sotheby's 10.10.1985 (32); bt. by the Walker Art Gallery with the aid of contributions from the Victoria & Albert Museum Purchase Grant Fund, the National Art-Collections Fund and the Friends of Merseyside Museums and Art Galleries.
EXH: Tate Gallery, 1923, Pictures of the Sixties Period (287); Birmingham 1947, P.R.B. (157); Liverpool and V. & A. 1969, Hunt (166–7).

1 Journal, 27 Nov. 1854, loc. cit. published in Bronkhurst, 'An interesting series of adventures. . .', Pre-Raphaelite Papers, 1984, pp.123–4.
2 Hunt 1887, pp.29–30.
3 Journal: Bronkhurst, loc. cit.
4 Hunt 1905, I, p.473.
5 Hunt 1887, p.30.
6 Hunt 1886, p.830.
7 Journal (Bodleian fragment, loc. cit.); Bronkhurst, op. cit., p.120.
8 W. Beamont, Diary of a Journey to the East in the Autumn of 1854, 1856, II, p.78; Hunt 1905, I, p.456f.: see Bronkhurst, Tate Gallery 1984, P.R.B. (84).
9 The latter suggested as a possibility by Bronkhurst, 'An Interesting series of adventures . . .', loc. cit., p.123.
10 Reproduced in this format, Hunt 1913, I, p.336 (bottom); Bronkhurst, op. cit., fig. 53.
11 Bronkhurst, op. cit., fig. 51.
12 Liverpool 1969, Hunt (165) verso; Bronkhurst, op. cit., p.120.
13 Repr. Hunt 1913, I, p.336 (top); Bronkhurst, op. cit., fig. 52.
14 Draft on a letter of 31 Jan. 1906 from C. Morland Agnew to the artist, published in full, Bronkhurst, Tate Gallery 1984, P.R.B. (84), p.154.
15 Bronkhurst, loc. cit.
16 Hunt 1887, p.207.
17 Hunt 1905, I, p.497.

246. The Finding of the Saviour in the Temple
Oil on canvas, 45.5 × 70.2 cm (17⅞ × 27⅝ in)
Signed in monogram and dated: Whh 62
Inscribed on the brazen door within the picture with a double inscription in Hebrew and in Latin, from Malachi, III, 1: ET STATIM VENIET AD TEMPLUM SUUM DOMINATOR QUEM VOS QUAERITIS (And the Lord, whom ye seek, shall suddenly come to his Temple).[1]
Inscribed on ivory flat of frame: The finding of the Saviour in the Temple/ and his mother said unto him, Son, why hast thou thus dealt with us?/ behold Thy father and I have sought thee sorrowing. And he said unto them, How is it that ye sought me?/ wist ye not that I must be about my Father's business? (Luke, II, 48–9).[2]
Frame: Gilt wood with shallow pointed top and semi-circular top corners, with ribbed borders and wide flat field with shallow carved symbolic motifs in a decorative patterning (see text) and inner ivory flat with gilt lettering; designed by the artist.

The small version of the picture which was Hunt's prime occupation in Jerusalem 1854–5, where it was begun

246. *The Finding of the Saviour in the Temple* (colour plate XXV)

from native models, but only completed in London from English sources in 1860 (now Birmingham, 33 × 55½ in; fig. 33).[3]

This was the second of five major subjects illustrating or pre-figuring the life and teaching of Christ which were to form the keynote of the artist's career.[4] Hunt had sketched the idea on his trip down the Nile from Cairo on his way to the Holy Land during May 1854,[5] and had certainly finally determined to carry it out as his new picture by early July.[6] Having already experienced difficulties at Cairo, he deliberately chose a subject requiring chiefly old men as models rather than unsophisticated and superstitious youths, and containing only one female figure.[7] The Temple site itself at Jerusalem, though then inaccessible to Gentiles, may also have been a factor in his choice of this theme of Christ's first step into adult responsibility.

Hunt studied sources for ceremonial and setting in the Old and New Testaments, the Talmud, and Josephus,[8] and also consulted the works of Joseph Lightfoot[9] which provide details of ceremonial and a draft plan of the Temple. The diversity of his sources no doubt determined him to 'reject tradition, religious as well as artistic, not convincingly true', and to plot an independent course.[10] His theme emphasises the confrontation of the Old and the New Dispensations.[11] The scene is set in the outer court of the Temple where it was the custom of the Elders to instruct the people. Innumerable details

and incidents pre-figure the life of Christ. Mary and Joseph enter from the south where, beyond the outer court, the hills in the east around Mount Scopas and the Mount of Olives are visible. In the court men are examining a stone intended for the 'head-stone of the corner', and a blind beggar asks for alms. In the background of the richly jewelled interior a lamb has just been bought from a vendor to be given in sacrifice and doves are being chased away. An ear of corn, signifying 'first fruits' has fallen from Mary's gown at the entrance. The semi-circle of Rabbis of varying semitic type, display degrees of credulity and superstition. The Chief Rabbi at the left is represented as blind and imbecilic; he holds the Torah, or Rolls of the Law. Another has a phylactery tied to his forehead, when custom required it only at the time of prayer. A third makes a point as he unrolls a scroll of the Prophecies. Christ, who has just risen from the circle, is girding up his large belt as a sign of his readiness to depart on his mission.[12]

Continual difficulties over models delayed the completion of the large picture but it would appear that all but one or two of the Rabbis, as well as Joseph, were completed at Jerusalem[13] and the artist was able to sketch the view towards the Mount of Olives from the dome of the Mosque As Sakreh in October 1855, immediately before his final departure.[14] In London, Mary was painted from Mrs Frederic Mocatta[15] and Christ, according to Stephens,[16] from a pupil at one of the Jewish

Fig.33 *The Finding of the Saviour in the Temple.* By permission of Birmingham Museums and Art Gallery

schools, while a later source identified him as Cyril Flower[17] (see No. 537 below). The novel interior, designed by the artist, was finished from the Alhambra Court at the Crystal Palace at Sydenham.[18] The costumes discarded the blanket drapery of tradition for current Syrian dress.[19] It was completed finally in 1860 and sold to Ernest Gambart, the foremost dealer in London, for £5,500 to include copyright.[20]

This version was taken up after completion of the larger picture. The artist called it an 'original study' which 'had yet only some experimental parts painted on the canvas'.[21] During the exhibition of the large picture by Gambart in 1861 the artist was at the gallery before opening hours preparing a tracing for the engraver,[22] and the large picture was withdrawn for a period in August 1861 for a chalk copy to be made for the engraver (see No. 4001 below).[23] This painting was perhaps taken up at that period while the large work was available from which to copy. In spite of the date on it, it was probably not completed until 1865 (the artist was occupied on several other pictures during this period as well as exhibition commitments). It appears reasonably to be the version referred to in Hunt's letters in that year: early in July 1865 he wrote to his friend J. L. Tupper that he had been 'working at my principal task the sketch of the Temple Picture. I hoped by a spurt to get it done without getting very far into the season but I was disappointed in this. . .'.[24] In August he was expecting Gambart to bring a

'rich purchaser of pictures here to tempt him with the sketch. . .'.[25] This client may have been Samuel Mendel of Manchester (although he usually bought through Agnew), who certainly acquired No. 246. By 18 August Hunt could write to F. G. Stephens that he had 'at last finished the Temple sketch and got some tin'.[26]

Unlike such finished sketches as *Rienzi* (art market 1984) or *The Two Gentlemen of Verona* (private collection), which preserve the impression of the artist's first idea, this painting is in the same category as the small version of *The Hireling Shepherd* (Makins collection) and *The Light of the World* (Manchester City Art Gallery; begun by F. G. Stephens),[27] which in spite of variations in the details are virtually reduced replicas. In No. 246, the artist introduced slight differences in the details and the colour. There is, too, one fewer column, which affects the perspective in the centre, and a coarser distant screen; while the man lighting the lamp in the left background of the large picture is lacking. The variations both relieved the monotony of copying for the artist and may also have been introduced to comply with copyright requirements by Gambart.

The frame is a reduced replica of that designed by the artist early in 1859 when he had been able to take up the large picture in earnest.[28] It incorporates, on one side, the cross-staff with the brazen serpent, representing the old Law of Moses and the sacrifice or substitution of an animal; on the other a cross with thorns and a garland of

flowers, to express the new Law; in the centre a sun in full glory with the moon eclipsed, supported by many stars; at the foot a diaper of heartsease, symbolising peace, and daisies, symbolising eternity, devotion and universality.[29]

The large painting was exhibited with outstanding success in Bond Street and afterwards toured the country. An engraving was published in 1867 (see No. 4001 below). A pamphlet by F. G. Stephens was published to accompany the exhibition, providing a lengthy description and publishing the innumerable reviews. Both the characterisation of the group of Rabbis and the gentle passion of the Holy Family were admired. *The Athenaeum*, 21 April 1860, emphasised the Englishness and Protestantism[30] of the subject and pinpointed its prismatic qualities: 'Intensity and luminous strength of colour so characterise this picture that at the very first glance we are struck with these qualities, that alone give novelty and power enough to distinguish it from the generality of works of art. . .'. The *Manchester Guardian*, 24 April 1863, summed up its impact: 'No picture of such extraordinary elaboration has been seen in our day . . . Draperies, architecture, heads, and hands, are wrought to a point of complete imitative finish . . . this picture is replete with meaning, from the foreground to the remotest distance . . . There are symbols everywhere, from the stray ear of corn, the nearest of the foreground, which indicates the feast of first-fruits, to the money-changer and the man who sells animals for the sacrifice, in the extreme distance. Nay the symbols have overflowed the picture, and expanded themselves all over the frame . . .'

Hunt's text to the original key plate to Blanchard's engraving (see No. 4001 below) follows fig. 34.

PROV: ? Sold through Gambart to Samuel Mendel,[31] Manley Hall, Manchester;[32] bt. from him by Agnew, 22.9.1873 (Mendel Cat. No. 180); and sold to Albert Grant, 8 Dec. 1873;[33] Grant sale Christie's, 28.4.1877 (169), bt. Agnew £1,417.10.0; thence sold to John Graham, 14 May 1877;[34] Graham sale Christie's, 30.4.1887 (71), bt. Agnew £1,260, for George Holt, 12 May 1887, £1,386;[35] by descent to Miss Emma Holt, who bequeathed it to Liverpool, 1944.[36] Sudley Art Gallery.

EXH: Glasgow 1878 (95)[37] Fine Art Society 1886, *Hunt* (19); Glasgow 1888 (49), and 1901 (405); Liverpool 1896 (9); Hull 1901; Walker Art Gallery 1904, *Liverpool Autumn Exhibition* (1167), and 1933 (50); Manchester 1904, *Ruskin*; Whitechapel 1905 (346); Leicester Galleries 1906, *Hunt* (28); Manchester 1906, *Hunt* (16); Walker Art Gallery 1907, *Hunt* (62); Newcastle 1907; Liverpool Academy 1910; Rome 1911 (38); Bradford 1925; National Gallery, 1945, *Some Acquisitions of the Walker Art Gallery, Liverpool, 1935–1945* (22); Port Sunlight 1948, *P.R.B.* (118); Liverpool and V. & A. 1969, *Hunt* (32).

1 Detailed in artist's note 27 to key plate to the engraving.

2 This is a shorter version of the text used on the flat of the large version and on the frame of the engraving (see No. 4001 below).

3 Birmingham *Catalogue of Paintings*, 1960, pp.78–9; exhibited Tate Gallery 1984, *P.R.B.* (85) repr., with catalogue entry by Judith Bronkhurst with detailed discussion.

4 *The Light of the World*, 1851–3 (Keble College, Oxford); this subject: *The Scapegoat* (No. LL 3623 above); *The Shadow of Death*, 1869–73 (Manchester City Art Gallery); *The Triumph of the Innocents*, 1876–87 (No. 2115 below).

5 Hunt 1905, I, pp.391, 395.

6 Hunt letter to Thomas Combe, 10 July 1854 (Bodleian Library, Oxford: MS Eng. Lett. c. 296), cited by Bronkhurst, loc. cit.

7 Hunt to Combe, 29 July 1854 (Bodleian Library, loc. cit.); F. G. Stephens 1860, p.40.

8 Hunt 1905, I, p.406.

9 Ibid, p.408; first discussed by Judith Bronkhurst in Tate Gallery, 1984, *P.R.B.* (85), p.158; Joseph Lightfoot, *The Temple Service as it Stood in the Days of our Saviour*, 1649, and *The Temple: especially as it Stood in the Days of our Saviour*, 1650 (both contained in *The Works of Joseph Lightfoot*, 1684).

10 Hunt 1905, I, pp.406, 408.

11 See Judith Bronkhurst, loc. cit., for very full discussion. F. G. Stephens 1860, p.63f. describes the roles of the Rabbis at length.

12 From the detailed description in F. G. Stephens 1860, pp.58–60.

13 Ibid, p.46; Hunt 1887, p.218.

14 Hunt 1905, II, pp.4–7, 37–8; MS Journal (John Rylands University Library of Manchester).

15 Judith Bronkhurst, loc. cit., quoting Derek Hudson, . . . *The Life and Diaries of Arthur J. Munby, 1828–1901*, 1972, p.66, diary for 1 July 1860.

16 F. G. Stephens 1860, p.51.

17 Judith Bronkhurst, loc. cit., quoting William Callow, *An Autobiography*, 1908, p.118.

18 Hunt to Edward Lear, 31 Dec. 1856 (John Rylands Library).

19 F. G. Stephens 1860, p.62.

20 Hunt 1905, II, pp.190, 192; Jeremy Maas, *Gambart, Prince of the Victorian Art World*, 1975, p.114f.

21 Hunt 1905, II, p.237.

22 Ibid, pp.193–4.

23 *The Athenaeum*, 24 Aug. 1861, p.256.

24 Hunt to Tupper, 3 July 1865 (Henry E. Huntington Library, San Marino, California), in James H. Coombs et al, edit., *A Pre-Raphaelite Friendship, The Correspondence of William Holman Hunt and John Lucas Tupper*, 1986, No. 49, p.75.

25 Hunt to Charles Howell, 8 Aug. 1865 (Henry E. Huntington Library, San Marino, California), in Mary Lutyens, 'Letters from Sir John Everett Millais . . . and William Holman Hunt . . . in the Henry E. Huntington Library, San Marino, California, *44th Volume of The Walpole Society, 1972–1974*, 1974, p.67.

26 Bodleian Library (MS Don. e. 66 fol. 128).

27 J. Maas, *Holman Hunt and The Light of the World*, 1984, p.50, quoting Stephens's own statement.

28 Hunt to Combe, 26 Feb. 1859, when it was nearly finished (Bodleian Library, loc. cit.) Hunt 1905, II, p.185.

29 F. G. Stephens 1860, pp.78–9.

30 Echoing F. G. Stephens 1860, pp.61–2, 71, etc.

31 See note 25.

32 Noted in his collection in *The Art Journal*, 1870, p.209.

33 Agnew Picture Stock Book 2, No. 8060.

34 Ibid Book 3, No. 210.

35 Ibid Book 3, No. 4411; invoice Feb. 1888 for 12 May 1877 (Gallery files).

36 See Walker Art Gallery catalogue, *Sudley: The Emma Holt Collection*, 1971.

37 Lent Agnew.

Fig.34 Key to *The Finding of the Saviour in the Temple*

KEY PLATE/to/HOLMAN HUNT'S PICTURE OF THE 'FINDING OF THE SAVIOUR IN THE TEMPLE'/LONDON: PUBLISHED BY E. GAMBART & CO., 1, KING STREET ST. JAMES'S SQUARE

No. 1. – The Torah or Pentateuch, written on parchment, which is wound on two rollers, surmounted by No. 2.

No. 2. – The Crown of the Law, silver ornaments with little bells suspended by small chains, copied from those in use in the Synagogue in Jerusalem.

No. 3. – A mystic figure, called the Shield of David, composed of a series of triangles described by one continuous line, worked on the cover protecting the Rolls of the Law.

No. 4. – Phylactery – called by modern Jews the Tephillin – the texts (which are from Exodus xiii., 2–10, 11–17, Deuteronomy, vi., 4–9, 13–22) are written on four strips of parchment doubled up and inclosed in the case, which is made of calf-skin and painted black. The *shin* is made with four arms: on the opposite side would be the same letter with but three, the usual number of limbs. The four Matriarchs (Sarah, Rebecca, Leah, and Rachel) are typified by the one with that number of arms, while the three Patriarchs (Abraham, Isaac, and Jacob) are typified by the other. By making the Phylactery within broad, the case was correspondingly increased in size. Those represented in the Picture are not copied from the very largest in use in this day, although they are three times larger than many worn. The fourth figure, from the left-hand of the Picture, has his bound upon the head as it is worn. A second Phylactery, without any letter on the exterior, is bound upon the arm opposite to the heart; in the present day, the Phylactery is worn only during prayer.

No. 5. – A whisk, made of dried palm-leaves, used to drive away flies and fan the air. In the Assyrian marbles, the kings and priests have attendants fanning them with this instrument. In one case, it is represented in use to protect offerings upon an altar.

No. 6. – The Veil of the Torah, which is kissed by the members of a congregation to mark their reverence for the Rolls of the Law to which it is attached.

No. 7. – A Sistrum: musical instrument represented in the ancient Egyptian paintings; two specimens in nearly a perfect state are preserved in the British Museum; they were made of bronze, and when shaken they produced a jingling noise. The Egyptians regarded them as peculiarly honourable instruments, to be used only in sacred services, and by persons of noble birth.

No. 8. – A Harp carried on the shoulders, frequently represented in Egyptian paintings. An example of this, also in a good state of preservation, exists in the British Museum.

No. 9. – Another Harp, from Assyrian sculptures.

No. 10. – A Roll of a single Book. The Books of the Prophets alone are written on separate rolls.

No. 11. – Another Book of the Prophets – of the least expensive kind – being unmounted.

No. 12. – An Abbia; a cloak used by all the poorer natives of Syria. It is represented as pressed flat on the ground to indicate that the Saviour has been sitting upon it.

No. 13. – An Ink-Horn and Pen-case combined. Thus worn by clerks and scribes of any kind in the present day.

No. 14. – A Decanter of Wine: the shape taken from an ancient Egyptian specimen.

No. 15. – A Tazza of glass or crystal, inclined slightly on one side, and thus arrested by the holder when in the act of forming a libation. The modern Jews in their Synagogue at Jerusalem invariably observe this custom ere drinking.

No. 16. – A Girl shaking her Scarf to frighten away the Doves. The roof of the Holy of Holies was covered with sharp golden spikes to prevent birds from settling upon it.

No. 17. – A Priest preceding a young Man and his Wife, who have purchased a lamb for sacrifice to redeem their first born.

No. 18. – A Seller of Animals for Sacrifice.

537. *Study for the heads of Christ and Mary in 'The Finding of the Saviour in the Temple'*

No. 19. – A Money Changer, in the act of weighing money, as is their custom in the East.

No. 20. – A Building on Mount Acra: a hill of considerable elevation in this direction.

No. 21. – A Leathern Girdle, loosened by means of a strap and buckle in front, on resting from a journey by the wearer, and tightened as a preparation for exertion of any kind.

No. 22. – A Purple Robe, called a 'kaftan' in modern Arabic, of cotton on a padded lining, which makes the folds fuller than they would otherwise be; copied from a kind worn by the class of mechanics; it is shortened, however, and the fringe is added to make it better fulfil the conditions of a Jewish dress in a simple manner. The ribbon of blue is bound upon the dress above the fringe, so as best to prevent the robe from being torn, which seems to have been its natural office.

No. 23. – Figs threaded on a string, as carried by travellers.

No. 24. – The long fringe to the girdle, which is of woollen stuff.

No. 25. – Shoes of a shape worn by women. Joseph's sandals, not seen, but indicated by the thongs. The precincts of the Temple were not entered with covered feet; but it is assumed that the richer people retained the under sock, worn within the shoe, as the Mahomedans do under similar circumstances in the present day.

No. 26. – An ornamental design, twenty-four flowers (twelve in full development, and twelve in bud), composed of the papyrus blossom, as conventionalised by Egyptian art. Although parchment and skins were used for writing upon, the paper prepared by the Egyptians from this plant was employed so generally that its native name 'byblos,' has been transmitted to the whole of the modern world, with but little variation, as the name of '*The Book*.'

No. 27. – A double inscription in Hebrew and Latin, from Malachi, Chap. iii., v. 1: 'And the Lord, whom ye seek, shall suddenly come to his Temple.' A license has been taken in thus inscribing this text, but one which, it is hoped, demands but little indulgence, seeing that, without doubt, the whole of the Jewish world at that time were dwelling upon the hope of the Messenger coming to them during the existence of this particular Temple. For the employment of the two languages, or rather of the Gentile one, which might be objected to, it is necessary to call attention to the fact that the inscription is upon a door which shuts the court of the Gentiles, and that it would therefore be desirable to have it in a language known to the strangers, as well as the Children of Israel. In proof that at this time it was customary to consider this need, it may be adduced, that between the first and second cloisters of the Temple, there was a 'partition, declaring the law of purity, some in Greek and some in Roman letters;' to which Titus alludes during the siege, when reproaching the Jews for their rebellion, as engraved upon 'in Greek and in your own letters;' and also that the inscription upon the cross was in the three languages.

No. 28. – The ridge of hill to the north-east of Jerusalem, between Scopus and the Mount of Olives.

No. 29. – The north-eastern angle of the Court of the Gentiles. The restoration of the Temple, commenced by Herod the Great sixteen years before the birth of Christ, was going on during the

whole course of the Saviour's lifetime. 'Forty and six years was this Temple in building,' the Jews said, at the commencement of his ministration; it was not completed until the time of Herod Agrippa. The pillars of coloured marble are still to be seen built into the wall of Jerusalem on its eastern side.

W. HOLMAN HUNT

537. *Study for the heads of Christ and Mary in 'The Finding of the Saviour in the Temple'*

Charcoal, chalk and watercolour, 26.3 × 36.7 cm (10⅜ × 14⁹⁄₁₆ in)
Inscribed and dated: *W H H/1858*
Frame: Gilt oak, reeded border with raised circles on the face and at the corners, flat field with engraved circles.[1]

In the early pencil sketch for the Holy Family[2] made in the Near East, the artist sketched in alternative positions for the relationship between Christ and the Virgin, but concentrated in the study made at Jerusalem from a Jewish youth and Jewish woman (Fitzwilliam Museum, Cambridge)[3] in giving the child's head the slightly higher position as the dominant character. However, in his full-length study of the Holy Family made in London in 1856 (Tate Gallery No. 5276), the Virgin's head is placed slightly higher than the Christ's and she takes on a more motherly role, with Christ looking down. The present highly finished drawing, which is close to the oil painting and on the same scale as the large picture, follows this arrangement except that the Christ child once again, like the early drawing, looks up dreamily into the distance, conscious of his future role.

On the back of No. 537 is attached a letter dated from the artist's house at 18 Melbury Road, Kensington, 17 June 1908, in Edith Holman Hunt's hand, acting as his secretary: 'Mr Holman Hunt wishes to say that the charcoal drawing was a preparatory design for the Temple picture.'[4] Hunt was only able to give his full attention to the completion of the large oil painting from late in 1859.[5]

The model for the Virgin is recorded in the contemporary diary of Arthur Munby[6] as Mrs Mocatta (Mary Ada, daughter of F. D. Goldsmid, and wife of Frederic Mocatta, 1828–1905, who had assisted Holman Hunt in the difficult task of obtaining models in Jerusalem).[7] The Christ, whom Munby thought was from a Christian boy in London, perhaps a son of Thoby Prinsep, was elsewhere identified as Cyril Flower[8] (later Lord Battersea, 1843–1907).

No. 537 was recommended to the last owners by Whitworth Wallis of the Birmingham City Art Gallery, who was unable to buy it for his gallery. He wrote that he considered the 'Virgin's head of ineffable sweetness'.[9]

PROV: Sir James Knowles, sold Christie's 28.5.1908 (311), bt. Brown & Phillips, £24.3.0; A. E. Pritchard, Birmingham, sold 31.7.1909 to the Misses Helen C. and Ethel M. Colman, and bequeathed by the latter to the Walker Art Gallery, 1949.
EXH: Liverpool and V. & A. 1969, *Hunt* (157); Dusseldorf 1982, *Bilder sind Nicht Verboten*, Christian and Jewish Art (67) repr.

1 The frame of a type designed by Madox Brown and D. G. Rossetti, might be of late date, as the mounting certainly must date after 1909 for the Misses Colman (framemaker's label on back of T. A. Mase, Rembrandt House, Norwich).
2 Liverpool and V. & A. 1969, *Hunt* (154): Burt Collection, sold Sotheby's, 10.10.1985 (21) repr.
3 Liverpool, loc. cit. (152); repr. Hunt 1905, II, p.27.
4 The lettering on the mount, incorporating this, presumably post-dates this letter: see note 1.
5 Hunt 1905, II, pp.184–5; and see Bronkhurst in Tate Gallery 1984, *P.R.B.*(85), p.159.
6 Derek Hudson, *Munby: Man of Two Worlds, The Life and Diaries of Arthur J. Munby 1828–1901*, 1972, p.66, diary for 1 July 1860, noting a conversation with the artist, quoted by Bronkhurst, loc. cit.
7 Hunt 1905, II, pp.4, 16.
8 H. M. Cundall, edit., *William Callow, An Autobiography*, 1908, p.18, quoted by Bronkhurst, loc. cit. In the 1860s Callow knew the Anthony Rothschilds, whose daughter Cyril Flower married.
9 Whitworth Wallis to Miss H. C. Colman, 23 July 1909 (copy Gallery files).

1251. *Edward Lear*

Crayon and chalk, 61.3 × 48.8 cm (24⅛ × 19¼ in)
Signed in monogram and dated: *Whh/Nov 7 1857*

Edward Lear (1812–88), artist and author, composer of limericks and nonsense verse. He began his career as a zoological draughtsman and was fortunate to find an early patron and friend in the 13th Earl of Derby, who initially engaged him to draw for publication the parrots in the menagerie at Knowsley. Lear published his first *Book of Nonsense*, designed for the children and grandchildren of his patron, in 1846. His health necessitated wintering abroad; he produced a large series of watercolour views of his travels in Mediterranean countries and published several travel books.[1]

He first met Holman Hunt in 1852 through Robert Martineau (q.v. and see No. 2443 below). From Hunt, Lear sought advice on translating his watercolour views into oil paintings and under Hunt's guidance painted appropriate elements direct from similar English scenery.[2] In return he taught Hunt Italian and provided some groundwork in culture and social polish.[3] Lear came to consider himself a follower or 'child' of Pre-Raphaelitism and of Hunt, whom he addressed as his 'parent' or 'daddy'. They exchanged a lifelong correspondence.

Lear's first trip to Egypt overlapped with Hunt's but he was not able to accompany Hunt to the Holy Land as he had wished and his subsequent foreign trips meant that they could not meet again until the summer of 1857. This portrait, showing Lear at forty-five years of age in that year, is dated shortly before another of his trips abroad for the winter. It was presumably intended to hang with other of Hunt's portrait drawings of his artist friends in the house Hunt had recently taken, 1 Tor Villa, Campden Hill. It was seen by G. P. Boyce, the watercolourist (q.v.), hanging in the dining-room there in June 1858.[4] It appears in the background of a sketch[5] (fig. 35) Hunt made of himself with a visitor and one of his own

1251. *Edward Lear*

Fig.35 Sketches in a letter to Edward Lear, 7 November 1859. By permission of the copyright holders and the John Rylands University Library of Manchester

recently designed Egyptian chairs, in one of his letters to Lear, dated similarly to this portrait, 7 November, but of two years later, 1859 (when both artists were in England).

PROV: Presented by William Holman Hunt, with No. 2443 below, to the Walker Art Gallery, 1907, 'as a mark to the City of Liverpool, of my gratitude to the Academy, then the sole representative of the City's Art, for its award to me on two occasions of the annual prize, a benefit not to myself alone but to our whole then struggling Body'.[6]
EXH: Walker Art Gallery 1907, *Hunt* (122); Glasgow 1907, *Hunt* (48); Birmingham 1947, *P.R.B.* (159); Port Sunlight 1948, *P.R.B.* (116); Russell Cotes Museum, Bournemouth, 1951, *P.R.B.* (106); Arts Council 1958, *Edward Lear* (128); Liverpool and V. & A. 1969, *Hunt* (194); Walker Art Gallery 1975, *Edward Lear and Knowsley* (2); Royal Academy 1985, *Edward Lear 1812–1888* (104) repr.

1 Hunt 1905, I, pp.328–36 (repr.); Angus Davidson, *Edward Lear: Landscape Painter and Nonsense Poet*, 1938, pp.76–82, 103; Vivien Noakes, *Edward Lear*, 1968, pp.111–13, and Royal Academy 1985 catalogue cited above giving extensive bibliography.
2 In the collection is one of several watercolour studies of *The Quarries of Syracuse* which was carried out as a large oil under Hunt's direction in 1852 at Fairlight near Hastings.
3 Hunt expressed his thanks in a letter dated 24 April (year unspecified) from Tor Villa; after looking through drafts of his own early letters: 'reminds me of how much I am indebted to you for the amount of culture that I have got since the time I first met you – so accept my best thanks and believe me that I shall always be most grateful for every candid caution against persistence in mistakes that you may make to me.' (Hunt Papers, John Rylands University Library of Manchester, Eng. MS 1214/40, partly quoted in Noakes, op. cit, p.113.
4 Surtees, *Boyce Diaries* 1980, entry for 10 June 1858: '. . . in the dining-room were three of Hunt's fine eastern drawings and a chalk head by him of Lear'. At Hunt's later house, Draycott Lodge, it also hung in the dining-room (Hunt to unnamed

2443. *Robert Braithwaite Martineau*

correspondent, presumably Lear, undated but mid-1880s, John Rylands University Library of Manchester, Eng. MS 1216/27).
5 John Rylands Library, Eng. Msc. 1214/28.
6 The artist to the Gallery Committee, undated, late Feb. 1907 (Gallery files), published in the *Annual Report* for 1907, p.97.

2443. *Robert Braithwaite Martineau*
Crayon and chalk, 76.4 × 53.4 cm (30 × 21 in)
Signed in monogram and dated: *18 Whh 60* underlined by an arrow

The artist R. B. Martineau (1826–69) q.v., a pupil of Holman Hunt's 1851–2. He shared Hunt's studio for a time and worked under his influence until his marriage in 1865.[1] Hunt visited his family at Fairlight Lodge, near Hastings, on several painting trips in the 1850s[2] and they both painted from the young model, Miriam Wilkinson, around 1859.[3]

This portrait of him in 1860 at thirty-four years, like that of Edward Lear (No. 1251 above), remained with the artist, who no doubt wished for a record of his artist friends to display in his house.[4] Martineau was also painted by Ford Madox Brown as the gentleman on horseback in *Work* (Manchester City Art Gallery).

PROV: Presented by William Holman Hunt, with No. 1251 above, to the Walker Art Gallery, 1907.
EXH: Walker Art Gallery 1907, *Hunt* (118); Glasgow 1907,

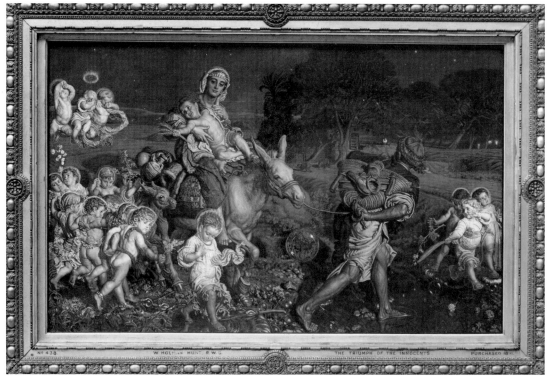

2115. *The Triumph of the Innocents* (colour plate XXIV)

Hunt (61); Brook Street Gallery 1922, *Martineau* (23); Birmingham 1947, *P.R.B.* (160); Port Sunlight 1948, *P.R.B.* (177); Liverpool and V. & A. 1967, *Hunt* (201), pl.73.

1 Hunt 1905, I, pp.302, 309, 320; II, pp.85–6, 243, 308–9 (repr.).
2 Ibid, I, p.330 and see Judith Bronkhurst in Tate Gallery 1984, *P.R.B.* (52, 102).
3 *The Schoolgirl's Hymn* by Holman Hunt (Ashmolean Museum, Oxford), and *The Pet of the Brood* by Martineau (Sotheby's, Belgravia, sale 25.3.1975 (58 repr.).
4 In the mid-1880s it hung in the entrance hall at Draycott Lodge (Hunt to ?Edward Lear, undated, John Rylands University Library of Manchester, Eng. MS 1216/27).

2115. *The Triumph of the Innocents*[1]
Oil on canvas, 157.5 × 247.7 cm (62 × 97½ in)
Signed in monogram and dated: *76 Whh 87*
Frame: carved/gilt wood and gesso, with an outer border having a repeat pattern in relief of stylised pomegranates, lilies and leaf forms, with inner borders of leaves and egg and dart, and with a medallion at the centre of each side, three with lily or bell-type flower heads and that at the centre bottom having a leaf motif; designed by the artist (see text).

A quotation from Matthew II, 13–18 headed the detailed description in the pamphlet accompanying the exhibition of the subject in 1884 and 1891:

'Behold, the angel of the Lord appeareth to Joseph in a dream, saying, Arise, and take the young child and his mother, and flee into Egypt, and be thou there until I bring thee word: for Herod will seek the young child to destroy him. When he arose, he took the young child and his mother by night, and departed into Egypt: and was there till the death of Herod: that it might be fulfilled which was spoken of the Lord by the prophet, saying, Out of Egypt have I called my son. Then Herod, when he saw that he was mocked of the wise men, was exceeding wroth, and sent forth, and slew all the children that were in Bethlehem, and in all the coasts thereof, from two years old and under, according to the time which he had diligently inquired of the wise men. Then was fulfilled that which was spoken by Jeremy the prophet, saying. In Rama was there a voice heard, lamentation, and weeping, and great mourning, Rachel weeping for her children, and would not be comforted, because they are not.'

The Holy Family are shown on their flight from Bethlehem at night across the Philistine plain towards Egypt; accompanying them are the spirits of the Holy Innocents, to whose presence the Christ Child draws his mother's attention. The artist's intention was to produce an original composition and a realistic immediacy of presentation, imbued with religious atmosphere through the mysterious and supernatural lighting. In line with *The*

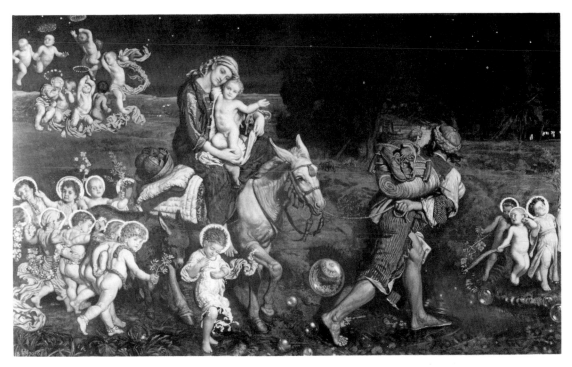

Fig.36 *The Triumph of the Innocents*. By permission of the Fogg
Art Museum, Harvard University, Cambridge, Massachusetts

Scapegoat (No. LL 3623 above), and the more recent
Shadow of Death (Manchester City Art Gallery), it
illustrates his lifelong aim to re-interpret the Scriptures
and revitalise their imagery for a contemporary audi-
ence.[2] Embodied in his conception is the impact upon
him of his direct confrontation with Italian art, more par-
ticularly of the High Renaissance, during his visits to
Italy between 1865 and 1869, combined with his con-
sidered observation of the contemporary life and
atmosphere of Palestine itself.

A subject of the Flight into Egypt had been first
considered by him in 1865–9 as part of an abortive
scheme for wall-decorations for the church of St Michael
and All Saints, Cambridge, for his friend the rector, the
Rev. W. J. Beamont.[3] While at Florence 1868–9, Hunt
discovered that his first idea, presenting the Holy Family
at rest on the flight with Joseph striking a light and St
Michael and his legions on guard with child angels
presenting food, was anticipated in a small painting by
Annibale Carracci in the Uffizi.[4] (This picture was
presumably No. 350, *Repose on the Flight into Egypt*,
later in the Pitti Palace, and now in the Palatine Gallery,
Florence, as Bolognese School;[5] in it angels and floating
putti assist St Joseph to drag down a palm branch for its
dates; it is a variant of a well-known type illustrating an
incident in the Pseudo Matthew and in the Golden

Legend.)[6] It is not certain that Hunt ever made a drawing
and Beamont's death put an end to the commission.

Nevertheless, having moved on to Jerusalem in August
1869, Hunt reconsidered the subject while beginning his
Shadow of Death. In order to retain his own first concept
of the angel figures he reconsidered St Matthew's Gospel
for its description of the Flight and the Massacre of the
Innocents (II, 13–18, quoted above) and changed his
theme to introduce the Innocents, similarly floating in
company with the Holy Family and presented in various
states of awareness of their recent fate.[7] Traditional forms
of the Flight into Egypt and the Rest on the Flight still
make up the core of his idea, which embodies a charac-
teristic night scene, figures crossing water, a pale-
coloured ass, while the Innocents replace angels hover-
ing and strewing flowers.[8] A slight pencil sketch (art
market)[9] shows a first idea with the Virgin apparently
riding, and the composition appears in the oil study
(29¾ × 49⁷⁄₁₆ in, Fogg Art Museum; fig. 36),[10] from
which the present picture was to be the ultimate outcome.

His choice of a night scene would, at this date, also act
as a counterpoise to the bright sunlight of the *Shadow
of Death*, following the pattern of earlier work of using
a variety of light effects. His choice may perhaps
have also been influenced by his admiration for the
Tintorettos in the Scuola di San Rocco, at Venice, which

Fig.37 *Sketch of a water-wheel*. By permission of Northampton Museums and Art Gallery

he saw in July 1869 in company with Ruskin.[11] Ruskin's comments on the *Annunciation* in *Modern Painters* had inspired Hunt's first youth: the same picture certainly inspired the symbolism in his *Shadow of Death*. Titian's *Bacchus and Ariadne* (National Gallery, London), which he copied as a youth, has been suggested[12] as a source for the diagonal processional composition, in reverse, with backward looking figure. The solidly treated Innocents seem to reflect sculptural sources, in particular the continuous procession of putti dancing and strewing flowers in Donatello's *Cantoria*, of which the panels were transferred from the Uffizi to the Museo Nazionale at Florence towards 1870.[13] Duquesnoy's flying putti relief in the Filomarini Chapel at SS. Apostoli, Naples, might also be reflected: Hunt visited Naples and Ravello during July 1868.[14] The Virgin and Child in the oil study show a more formal Italianate concept, while in the present picture, begun several years later, they develop a liveliness and immediacy which was perhaps due to the artist's observation of his own wife and children (see Nos 6595–6, 7242 below).

In February 1870 he visited the Philistine plain to find a landscape, and at Gaza found a 'handsome group of trees over a water-wheel', which he painted on the small canvas by moonlight.[15] Gaza was at an appropriate distance for such a night journey from Bethlehem towards Egypt (see the artist's comments quoted below). The oil study forms the basis for the composition of the present large picture, with some variations in the details, particularly the number of Innocents and the pose of the Virgin and Child. The study was left behind at Jerusalem in 1872 and the present oil was begun on Hunt's third visit to Palestine, 1876–8.[16] The study was itself worked on concurrently and only finished in 1903.

Hunt arrived at Jerusalem with his second wife Edith towards the end of December 1875.[17] Due to the late forwarding and the delay of his painting materials in transit and the poor state of materials left behind at Jerusalem, he bought linen locally. This material, while proving adequate to stretch for a smaller canvas,[18] was to prove disastrously faulty for a picture of this size. He had a few pigments still usable from his earlier stay, chiefly umbers and ochre,[19] and acquired at least flake white locally.[20] It is possible that his work was confined to the preparation of the canvas and blocking-in and possibly the children round the edges[21] when his cases began to arrive, one from Rowney early in February with damaged contents including canvas, and a monster case forwarded by F. G. Stephens, off-loaded by Hunt at Jaffa only on 13 March 1876; he appears to have tried to get canvas from Rowney's even later.[22] Whatever stage it may have reached at this time, his decision that his work was too far advanced to begin again on new canvas,[23] was to lead to years of trouble.

From Jaffa in March he undertook a second expedition to the Philistine plain, south-east through Ramleh, now finding an appropriate view including a stream and distant view of the mountains inland and a village with fig trees near 'Shama', presumably Jamina (or Jebna), on the Wady Rubin.[24] This was further north than the direct route between Bethlehem and Gaza towards Egypt, approximated to on his earlier trip, but it embraced Rama mentioned by the prophet, and was perhaps chosen for a better chance of finding flowing water. He presumably worked on the oil study on this occasion and a pencil sketch of a water-wheel, seen from a different angle to the painting, has the date 1876 added (10 × 13 in, Northampton; fig. 37).

From 1876–7, at Jerusalem chiefly, date many studies for the figures which are concerned with exactitude in local detail, characterisation of the Virgin herself and a development of a more lifelike pose for the Christ Child in line with the lively movements of the Innocents. A silverpoint study for Joseph (19 × 11½ in, British Museum; fig. 38),[25] incorporates careful observation of his carpentry tools and straw bag as well as a very exact study of his backward-looking pose. A variant drapery study was also made.[26] He took care to make a study from a Mecca donkey (Northampton; 19½ × 13⅜ in; fig. 39), and a study for the foal of an ass (Mecca breed) is recorded.[27] A finished pastel of Edith's head, dated April 1876,[28] may have been connected with the almost profile pose of the Virgin in the oil study, but the final more frontal view appears in a study, more appropriately, of a Syrian woman, dated July 1876 (see No. 2444 below for discussion), and is indicated in various studies developing the pose of the Christ Child in its mother's arms (see Nos 6595–6, 7242 below). There are also sketches for the dogs in the background (private collections),[29] studies for the symbolic bubble with the woman fleeing from a dragon, in the Fogg Art Museum, with studies and off-takes of the Christ Child and children[30] (8 × 10¾ in; fig. 40, and on the art market).[31] Hunt mentioned in a letter to J. L. Tupper drawing naked child models who would soon be unable to sit in the expected cold weather, 1876, and a study of the child walking by the ass at the

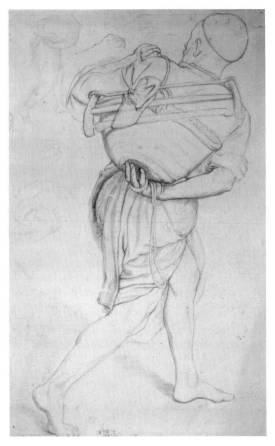

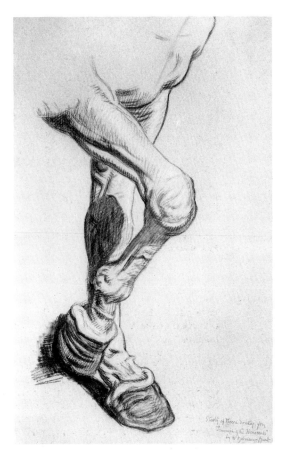

Fig.38 *Study for Joseph for 'The Triumph of the Innocents'.* By permission of the Trustees of the British Museum

Fig.39 *Study from a Mecca donkey.* By permission of Northampton Museums and Art Gallery

centre foreground is dated that year (art market).[32]

His work on the canvas, on which his problems had already begun, is recorded in letters to his wife at Jaffa, May–June 1877.[33] He records early in May restraining the canvas to eliminate unevenness after scraping down unspecified parts. He had previously thought of giving it up.[34] His child models (he mentions to his wife, variously, Gemila, Bint Elias, Miriam Harbrom, Ibrahim Hasboun, Hasboun's boy, little Georgey and Bint Katarina), drew his complaint that 'to have a picture with so many children in it in a country where there is no kind of discipline for and control of children is, there can be no doubt, a tremendous task. . . .' On that day, 23 May, he began from Bint Katarina, who had a good head, 'the uplifted arm of the little girl clapping her hands behind the donkey mare and I feel pretty secure that in this at least I advanced the picture which is a needfully comfortable [?] reflection after having appeared to stand still for a little while. . . .' On 28 May he reported to Edith more cheerfully that he was 'bent upon finishing all the left hand group of children then going to the right afterwards to the floating group at the back and then to the Saviour

every days work will now I trust tell for I think all is now prepared for finishing. . . .' He was soon hoping to calculate the weeks needed to finish, perhaps by the end of July. He worked at the background, was planning to have a model for the Saviour and the area round the Virgin and Child now faced him again, on what was to prove a most faulty area of canvas.[35]

On 23 January 1878 he reported to his friend, J. L. Tupper[36] that during a period of illness and working under pressure he had painted a great part all wrong in effect which had meant a restart with a new ground: it was not yet complete. This may be connected with his decision at some stage to add supernatural light to the 'uncheckered moonlight' of the oil study, to the children, to convey 'the impression of their celestial nature'.[37] Intensified moonlight proved on experiment to resemble warm sunlight. This effect embraces these figures in distinction to the cool moonlight of the general lighting.

He had first put off returning to England, but was back in London by April 1878, and the picture had arrived by May; during the year much was scraped out, it was less advanced than when he came back and the struggle with

Fig.40 *Study of bubbles for 'The Triumph of the Innocents'*. By permission of the Fogg Art Museum, Harvard University, Cambridge, Massachusetts

the 'blistered and twisted canvas' continued; by October he was seriously thinking of having a copy made on new 6 ft canvas specially ordered.[38] The pattern of restoration work was repeated during 1879 (and other work intervened),[39] but in July 1879 he advised Tupper that the picture was at a point to show, 'when I do such a subject or composition again I shall take great pains to model the whole thing in clay or wax to have the whole light and shade true in the round [?] and to have the ground plan made out that the place of each head and its size may be settled without abstruse calculation'.[40] Around September 1879, he showed it to W. B. Richmond and Richard Doyle,[41] and on 31 December to William Bell Scott. Scott recorded[42] that in spite of its incomplete state he found 'something exceedingly charming in this rhythmic accompaniment of the Flight, in this very vividly and solidly painted troop of bright creatures wreathed with flowers. . . .'; he likened them to the amorini in examples by the old masters. In response to his criticism of inconsistencies in the supernatural lighting, Hunt made the point to him[43] that he wished 'to avoid positively declaring them to be more than a vision to the Virgin conjured up by her maternal love for her

own child. . . . These develop in solidity and brightness by degrees. . . . The division of the two – the natural and the supernatural illumination – cannot be avoided, but when the picture is completed, I think the light on the duller parts will be more ethereal in effect. . .' According to Scott,[44] Hunt thought himself at this time in the midst of his struggles, opposed by supernatural forces. W. M. Rossetti recorded[45] that the picture was all got in and approaching completion when he saw it in company with Millais on 25 April 1880.

Nevertheless, the relining of the picture on his return to London and again later on the advice of Millais[46] did not eradicate the faults and caused further delay, exacerbated by illness.[47] Other work was undertaken,[48] and finally a replica was begun, according to Farrar,[49] on 1 January 1883. This was virtually completed late in 1884.[50] The faulty area of canvas round the Virgin and Child in No. 2115 was cut out and it was being relined between October and December 1883 by Reeves.[51] The insertion, about 23 × 17½ in, can just be made out. It was finally completed in 1887,[52] making use of the replica.[53] The paint is thickly applied in some of the heads, in particular, those of the Virgin and Child and the blond

Fig.41 *The Triumph of the Innocents*. By permission of the
Trustees of the Tate Gallery

child at the head of the procession, giving an effect close
to low relief.

The frame, for which there is a study for a medallion
and part of the repeat pattern[54] incorporates pomegran-
ates, which symbolise the Resurrection and the blood of
Christ, and lilies, the emblem of purity and of the Virgin.
The design distantly reflects the type of carving Hunt
would be familiar with in the Near East (he made many
studies of both classical and oriental types).[55] A study of
putti dragging a sphere and two others holding a cross, on
the back of an envelope postmarked 10 January 1885,
may be a rejected idea.[56]

The replica (now Tate Gallery, 61½ × 100 in; fig. 41),
with similar painting technique, differs slightly in colour
and minor details. In particular, the child leading the
procession of Innocents takes on the role of an acolyte
and holds a censer. It was exhibited alone at the Fine Art
Society, Bond Street from February 1885 in a similar
frame[57] and was reproduced in photogravure.[58] George
Lillie Craik negotiated terms for the artist which were
initially to include £3,500 for No. 2115 in a package
deal.[59]

For the exhibition of the replica and later for the
exhibition of No. 2115 at Liverpool in 1890, Hunt
produced a pamphlet, minutely explaining every
feature.[60] The *Epitome* reads:

'The flight into Egypt I have assumed to have occurred
about sixteen months after the birth of Jesus. Guided by
Christian tradition, and holding the birth of our Lord to

have taken place in December, it follows that the period
which I have assigned to the Flight into Egypt is the
second April in His life.

'During the spring-time, rich in flowers and first-fruits,
the HOLY TRAVELLERS are represented as passing across the
Philistine plain on the road to Gaza at a distance of about
thirty miles from their point of departure. The night is far
spent. While the declining moon sheds its last rays on the
natural objects in the picture, unearthly light reveals the
embodied spirits of the martyred Innocents advancing in
procession.

'The Virgin is seated on a she-ass of the breed now
known as the Mecca race, and the foal follows its mother,
as is seen to this day in the East. Signal fires – still lit in
Syria in time of trouble – are burning on the slope looking
down from the tableland. St Joseph is watching these
fires intent on discovering any signs that may present
themselves of a movement of soldiery upon the road. Of
the trees that enrich the landscape, the nearest ones
shelter a waterwheel used for the irrigation of the land.
The more remote group clusters round a village, with its
few huts visible by the lights that burn within. Having
left the colder climate of the high country, then thickly
populated and well cultivated, the fugitives have des-
cended into the rich and more balmy atmosphere of the
plain. As they advance nearer and nearer to a place of
safety they feel the blessed relief of a sense of peace after
disturbance and terror.

'Conscious of the divine mercy, the heart of Mary
rejoicing over her rescued son, feels compassion for the

murdered Innocents, and for the childless mothers less happy and less honoured than herself. It is at this moment, when the Virgin has been replacing the garments in which the infant has been hurriedly wrapped at the time of escape from Bethlehem, that Jesus recognises the spirits of the slain Innocents, his little neighbours of Bethlehem, children like Himself. They reveal the signs of their martyrdom. Garlanded for the sacrifice, bearing branches and blossoms of trees, they progressively mark their understanding of the glory of their service. An infant spirit isolated in wonder, finds no mark of harm where the sword wounded him, permitted to appear on his glorified body. Behind in the air are the babes as yet hardly awakened to the new life. In differing revelations of sorrow they show the influence of earthly terror and suffering still impressed upon them. Towards the front are other spirits of children triumphing in completer knowledge of their service. One of them in priestly office leads the band. Those who follow cast down their tokens of martyrdom in the path of their recognised Lord. Others encircle the travel-worn foal, wearily following its mother, and so bring it up to the onward group. The shallow stream over which the procession passes, reflecting the quiet beauty of the night sky, is unruffled except by the steps of Joseph. The flood upon which the spiritual children advance forms a contrast to this, by being in motion. The living fountains of water – the streams of eternal life – furnish this, mystically portrayed as ever rolling onward. Instead of being dissipated in natural vapour, the play of its wavelets takes the form of airy globes which image the Jewish belief in the Millennium that is to follow the advent of the Messiah.'

In the detailed description which follows, Hunt describes the meaning of the 'airy globes', drawing on both Genesis and Revelation:

'The stream is portrayed, as ever rolling onward and breaking – where it might if real water be dissipated in vapour – into magnified globes which image the thoughts rife in that age in the minds of pious Jews, particularly of those in great tribulation, of the millennium which was to be the mature outcome of the advent of the Messiah. The promises to the Patriarchs are progressive as is all the teaching of Revelation. The dream at Bethel first clearly speaks of the union of Earth and Heaven [Genesis XXVIII, 12f.]. This was the dawn of the exaltation of the Jewish faith, and accordingly the large orb reflects dimly the Patriarch asleep with a twofold ladder or pathway up and down, which is traversed by the servants of God. The intention is to combine with the first beautiful dream of the Patriarch other ideas of Messiah's reign which harmonise with this, and which were developed later. Heaven is indicated by the adoration by the elders of the spotless Lamb and the broken-heartedness of those who turn towards Heaven is illustrated by the fallen penitent, by the young child, while the tree of life in the midst bears the fruit for the healing of the nations.'

Ruskin had already seen the picture in an unfinished state in 1882 and in a lecture at Oxford in March 1883, he declared that on completion 'it will, both in reality and in esteem, be the greatest religious painting of our time'.[61] Claude Philips, in the *Gazette des Beaux-Arts*,[62] questioned the validity of this claim. While acknowledging the original inspiration of the awakening infants and the individual conception of the composition, he found it difficult to call it a religious work, it was a fantasy embroidering a religious theme. While it was worthy of attentive study, if, as Ruskin claimed, it was supreme in religious art of the era, one must acknowledge that the age itself, in this respect, was more fallible than one would suppose.

F. G. Stephens, no longer on friendly terms with Hunt, concentrated in the *Portfolio*[63] on what he considered the inconsistency in Hunt's interpretation. After discussing the artist's own description, he commented: 'The reader will guess that here are mysteries indeed, such as art seldom ventures to deal with and less often succeeds with. The living fountains, as depicted here, fail altogether in being mysterious, much less spiritual. They are apparently gelid sheets and curving planes of an unknown ice-like substance; and the "airy globes" of the artist and author are more substantial than bubbles. . . . In the strange mixture of the real and unreal in Mr Hunt's production more than one observer has noticed that which is akin to Albert Dürer's somewhat contradictory ideas of design. An attempt to represent the unseen by substantial means and all too faithful methods . . . is, to say the least, heavily handicapped against itself. In this respect the picture fails completely, not, of course, through any defect of skill, studies, or power on the part of the artist, but simply because he has employed methods which could not succeed.'

No. 2115 was invited to be shown at the Liverpool Autumn Exhibition, 1890 by P. H. Rathbone, chairman of the Exhibitions Sub-Committee.[64] His son Harold (see No. 1636 below), organised a subscription.[65] The picture was shown on its own after the Autumn exhibition at an entrance fee of 1 shilling[66] towards the fund which raised £2,016.[67] Hunt's initial price had been 5,500 gns, which he reduced first to £4,000[68] and ultimately to £3,500, of which the Corporation contributed £1,500. The protracted negotiations were finalised only in August 1891 after Holman Hunt had agreed.[69] He proposed to touch and varnish the picture and planned a visit to do this in October 1896.[70]

The Athenaeum had supported the purchase in an article in February 1891,[71] first pointing out its defects: 'It is alleged, and not without some justice, that the face of the principal figure is uncomely and deficient in spirituality, while the attitude of Joseph, though appropriate and expressive, is uncouth'. Nevertheless, however, it was considered that: 'The merits of Mr Hunt's picture are the high poetry of its conception, the originality and beauty of its effect, the splendour of the idea . . . the impressive pathos of the landscape, and the unsurpassed technique of what, with all its shortcomings, is a magnificent instance of the more serious art of the nineteenth century'.

PROV: Purchased from the artist by the Walker Art Gallery, £3,516, with the aid of contributions from private sources organised by Harold Rathbone, 1891.

EXH: Walker Art Gallery 1890, *Liverpool Autumn Exhibition* (918); Walker Art Gallery 1907, *Hunt* (6); Glasgow 1907, *Hunt* (10); Royal Scottish Academy, 1909; Australian State Galleries 1962, *Pre-Raphaelite Art* (42); Liverpool and V. & A. 1969, *Hunt* (52) repr.

1 On panelled stretcher.
2 See Herbert Sussman, 'Hunt, Ruskin and the Scapegoat', *Victorian Studies*, XII, No. 1, 1968, pp.83–90.
3 Hunt 1905, II, pp.251–2, 257.
4 Ibid, pp.257, 317.
5 *Galleria Pitti in Firenze*, 1937, p.91; and see E. Borea; *Pittori Bolognesi del Seicento nelle Gallerie di Firenze* (Florence, 1975), No. 22: information from Dr Serena Padovani, vice-direttore, Palatine Gallery, Florence).
6 Louis Réau, *Iconographie de l'Art Chrétien*, 1957, III, p.273f.
7 Hunt 1905, II, p.298.
8 See Réau, loc. cit., and Gertrud Schiller (Janet Seligman, trans.), *Iconography of Christian Art*, 1971, p.122. Ruskin in his lecture in 1883 (see note 61) referred to the type ministered to by attendant angels.
9 Burt Collection, sold Sotheby's, 10.10.1985 (55) repr.
10 Hunt 1905, II, repr. fp. 327; Fogg Art Museum, Harvard, *Paintings and Drawings of the Pre-Raphaelites and their Circle*, 1946, No. 48, repr.
11 Hunt 1905, II, p.259–62: Hunt was at Venice July 1869. George Landow points out that Ruskin's comments in *Modern Painters*, 'demonstrated to Hunt and his friends the possibility of reconciling elaborate symbolism with a detailed realism' ('There began a great talking about the fine arts', in Joseph L. Altholz, edit., *The Mind and Art of Victorian England*, 1976, p.192, note 61). Hunt was negotiating the purchase of a 'Tintoretto' for himself through his friend J. W. Bunney at Florence, in Dec. 1876 and Jan. 1877 (see *Liverpool Bulletin* 1969, pp.43–5 for his letters to Bunney).
12 Kathryn A. Smith, 'The Post-Raphaelite Sources of Pre-Raphaelite Painting', *Journal of Pre-Raphaelite Studies*, V, No. 2, May 1985, p.45. Hunt's copy after Titian, was sold Christie's, 19.5.1978(156) repr.
13 H. W. Janson, *The Sculpture of Donatello*, 1957, I, pls 163–78; II, pp.122–3: the *Cantoria* was reconstructed in the 1880s–1890s, and then moved to the Museo dell'Opera del Duomo. The review by Claude Philips in the *Gazette des Beaux-Arts*, May 1885, pp.460–1, commented that the children brought to mind Donatello's dancing angels at Prato (see Janson, op. cit., I, pls 158–61; II, pp.112f.).
14 Hunt 1905, II, p.257; and see Bennett in *Liverpool Bulletin*, loc. cit. pp.41–2, citing the diary of J. W. Bunney, 14 July 1868 and Hunt's letter to him mentioning visiting several, unspecified, churches in Naples.
15 Hunt 1905, II, pp.298–9; with reproduction of a drawing by Hunt of himself at work on a small canvas at night, dated 17–18 Feb. 1870, from a letter to his son Cyril.
16 Ibid, II, p.317: he had expected to be absent from Palestine only a few months.
17 Hunt to F. G. Stephens, 30 Dec. 1875 (Bodleian Library, Oxford; MS Don. e.67, fol. 188): recording their landing on 'Monday' (i.e. 27 Dec.).
18 Hunt 1905, II, p.321: *The Ship* (Tate Gallery), signed and dated 1875.
19 *Liverpool Bulletin* 1969, p.45: Hunt to J. W. Bunney, 27 Jan. 1876.

20 Hunt 1905, II, p.321.
21 Ibid.
22 Hunt to F. G. Stephens, 8 Feb. 1876, recording the damage to the contents in Rowney's case, and a (?) later undated fragment stating that he had sent to Rowney's for a roll of canvas to be forwarded in a tin container and mentioning other cases still expected (Bodleian Library, MS Don. e.67, fol, 195, 210); Hunt to Edith, from Jaffa, 13 March 1876 (John Rylands University Library of Manchester, MS Lett. 1215, with other letters cited in the text). His predicament and frustration through lack of communication at such a distance was recorded in a letter to his artist friend J. W. Bunney, then in Italy, February 1876 (quoted in *Liverpool Bulletin* 1969, p.45): '. . . I write thus early again in the hope that I may obtain colors from the store we discovered at Venice because I can't obtain my cases containing pigments from England and by some curious whim of Fortune and perhaps of my good old – but somewhat touchy, friend, Stephens I cannot obtain any sort of news of them. . . . I am actually at a stand still and must be until new colors arrive since all my finer materials left here three years ago are destroyed by damp and time. . . .'
23 Hunt 1905, II, pp.322, 324.
24 Hunt 1905, II, pp.321, 324; and undated letter to Edith (loc. cit.), from 'Schaama', mentioning Ramla etc.
25 Hunt 1905, II, p.323 repr.
26 Liverpool and V. & A. 1969, *Hunt* (247), and Burt Collection, sold Sotheby's, 10.10.1985 (76); in both cases mis-identified as drapery for *The Lady of Shalott*.
27 Exhibited Old Watercolour Society, Winter 1886 (291).
28 Burt Collection, sold Sotheby's, 10.10.1985 (63) repr.
29 Photographs Witt Library and Gallery files; Hunt, II, p.329 repr.
30 Fogg Art Museum, *Catalogue of Paintings and Drawings of the Pre-Raphaelites and their Circle*, 1946(49, 50).
31 Christie's, 16.10.1981(24) repr.
32 Hunt to J. L. Tupper, 28 Dec. 1876 (Henry E. Huntington Library, San Marino, California, with others to him cited in text), published James H. Coombs, George Landow et al, edit., *A Pre-Raphaelite Friendship: The Correspondence of William Holman Hunt and John Lucas Tupper*, 1986, No. 118, p.213; the drawing exh. Peter Nahum, London, *Master Drawings of the Nineteenth and Twentieth Centuries* (Catalogue by Christopher Newall), (autumn) 1985, No. 39.
33 Loc. cit.
34 Hunt to Tupper, 15 July 1877, loc. cit.; Coombs op. cit., No. 119, p.223.
35 Hunt letters to Edith, loc. cit.
36 Loc. cit.: Coombs, op. cit., No. 122, p.238.
37 Hunt 1905, II, p.324.
38 Hunt to Tupper, 3 April, 8 May, 5 July, 14 Aug., 30 Oct. 1878 and in letters to him June–Oct. of that year, loc. cit.: Coombs, op. cit., No. 123, p.239; No. 127, p.244; No. 130, p.250; No.133, p.254; No. 138, p.260. From Aug. 1878 he was working at the Trafalgar Studios, Chelsea.
39 Hunt to Tupper, 11 March and 21 April 1879, loc. cit.; Coombs, op. cit., No. 142, p.267 and No.147, p.275. Other work included *The Ship* (Tate Gallery) and see note 48.
40 Hunt to Tupper, 3 July 1879, loc. cit.: Coombs, op. cit., No. 157, p.287. This was in line with his comment to Tupper the previous year (20 June 1878), that he would like to do something in sculpture. He was then thinking of Watts' statue of *Hugh Lupus*, 1876–83 and Leighton's recent work. He had himself modelled a head of Christ while at Jerusalem on his second trip.
41 Hunt to Tupper, Sunday Sep. 1879, loc. cit.: Coombs, op. cit., No. 164, p.292. He had invited Millais to come in a letter of 16

Aug. (Pierpont Morgan Library, New York), but he was leaving town.

42 W. Bell Scott, II, pp.225–6, 229.
43 Ibid, p.229.
44 Ibid, pp.229–31.
45 MS Diary (Angeli Papers, Special Collections, University of British Columbia Library).
46 Hunt 1905, II, pp.331, 339.
47 Ibid, pp.338, 340–1.
48 Portraits in the next decade included *Cyril Holman Hunt*, signed and dated 1880, *Professor Owen*, signed and dated 1881, *Dante Gabriel Rossetti*, post-1882, *Hilary, The Tracer*, signed and dated 1886, *Sorrow*, signed and dated 1889, *The Bride of Bethlehem* and *Amaryllis*.
49 A Meynell and F. W. Farrar, 'William Holman Hunt, his Life and Work', *The Art Journal*, Special Number, Nov. 1893, p.19.
50 Hunt to George Lillie Craik (John Rylands University Library of Manchester with other letters to him cited below) 5 Dec. 1884, relaying Millais' comment that 'at last it is finished'. However, Hunt was still working on it when writing to Craik, 28 Jan. 1885, loc. cit.
51 Hunt 1905, II, pp.342–3; Hunt to Millais, 13 Nov. 1883 and 2 Jan. 1884 (Pierpont Morgan Library). He refers also (25 Jan., loc. cit.) to Joseph Jopling, Millais' protégé, wanting employment such as tracing work on the patch. The cut-out fragment was retained by the artist at least that year (Hunt to Craik, 22 Nov. 1884, loc. cit.).
52 Hunt to Edith, 24 Aug. 1887, loc. cit.: it would take him another two days. He was thinking of sending it to an exhibition at Melbourne (ibid and Hunt to Millais, 7 Aug. 1887, Pierpont Morgan Library).
53 Hunt to Craik, 16 Jan. 1885, loc. cit.
54 In an album from the artist, sold Christie's, 18.11.1980 (72): photograph Witt Library and Gallery files.
55 Examples in the same album and in the Burt Collection, sold Sotheby's, 10.10.1985 (67, 74).
56 Burt Collection, sold Sotheby's, 10.10.1985 (61) repr.: not, as suggested by an inscription, for the frame of *The Miracle of the Holy Fire*.
57 Hunt informed Craik, 3 Nov. 1884, loc. cit. that he was planning to put the replica in its frame and on 13 Feb. 1885, wrote to him that the frame was due to go to the Fine Art Society the following day.
58 Print declared by the Fine Art Society at the Printsellers Association, 11 Jan. 1887: 300 Artist's proofs at 10 gns; 25 presentation proofs; 200 lettered proofs at 5 gns; and prints at 2 gns.
59 Hunt to Craik, 13 Oct. 1884, with other correspondence, loc. cit. He signed an agreement in mid-Feb. 1885, to do with the exhibition (Fine Art Society Directors Meeting Minutes, 11 and 25 Feb. 1885). He was encouraged not to exhibit No.2115, when finished, with the replica, as he himself wished. Hunt later sold the replica in the 1890s to J. T. Middlemore of Birmingham (Hunt 1905, II, p.382).
60 The Walker Art Gallery pamphlet, *The Triumph of the Innocents* by *William Holman Hunt*, Liverpool 1891, contains also 'Opinions and comments of artists and critics' on its proposed purchase by Liverpool Corporation. The need to provide a gloss to his work, rather than to depend upon understanding critics such as Ruskin, had led to the biographical pamphlet written by F. G. Stephens under Hunt's eye, 1860, at the time of the exhibition of *The Finding of the Saviour in the Temple*, which incorporated an extensive description and many reviews. This was followed by the epitome to the engraved plate, 1867 (see No. 246 above, fig.

34), the pamphlet for the *Shadow of Death*, 1874, and later by a pamphlet for *May Morning on Magdalen Tower* (No. LL 3599 below), and explanations of other pictures (Hunt 1913 edition, II, p.401f).
61 Ruskin, XXXIII, p.277, pl.xxxiii; XXXVII p.404.
62 *Gazette des Beaux-Arts*, 2nd series, XXXI, May 1885, pp.460–1, 'Correspondence d'Angleterre'.
63 *The Portfolio*, 1885, p.80. Their friendship had ended around 1880 after previous coolness.
64 Noted by Charles Dyall, curator, to Hunt, 26 May 1890 (copybook Gallery files).
65 Harold Rathbone sent a copy of a paper advocating its purchase, untraced, to Hunt (acknowledged in Hunt to Rathbone, 28 Dec. 1890, Liverpool University Library Special Collections, MS 13.1(28)).
66 Minutes, Arts and Exhibitions Sub-Committee, 19 April 1891 (Gallery files). The artist agreed to this in a letter to Dyall, 15 April 1891 (Gallery files).
67 A leaflet dated 4 Dec. 1891 published subscriptions which, from all sources, amounted to £2,019.7.10 (copy Gallery files).
68 Copy of Hunt letter to Harold Rathbone, 25 May 1891 (Gallery files).
69 Hunt to P. H. Rathbone, 30 July 1891 and Minutes, loc. cit., 17 Aug. 1891 (Gallery files).
70 Hunt to P. H. Rathbone, loc. cit, and to Charles Dyall, 9 Oct. 1896 (Gallery files). Hunt had carefully sent a small bottle of varnish in 1891 and wrote to Dyall from Italy on 10 Dec. 1891, that he considered this would be adequate with the addition of 'one tablespoonful of the purest rectified spirits of Turpentine . . . thus making it more limpid'. He planned, however, to have a reserve bottle, procured from Messrs Blockx, fils, Antwerp, 'Its recommendation is that it is a clear and delicate preparation of Amber with which of older and stronger character the picture was painted . . .'.
71 *The Athenaeum*, 21 Feb. 1891, p.257.

6595. *Study for the Christ Child in the Virgin's arms for 'The Triumph of the Innocents'*
with related slight sketches
Pen and black chalk, 50.3 × 35.5 cm (19¾ × 13⅞ in)
Signed, dated and inscribed: *W. Holman Hunt//June 1876//(?)Whihan kishen naham*

6596. *Study for the Christ Child in the Virgin's arms for 'The Triumph of the Innocents'*
with related sketches of his legs
Red and black chalk, 38 × 54.1 cm (15 × 21⅜ in)
Signed and dated: *W. Holman Hunt 1876*

Two of a sequence of studies dated 1876,[1] in which the pose of the Christ Child is freed from the precedent of the Italian Renaissance and developed into one of greater movement and, by degrees, greater horizontality. Finally rejected is the upright more formal pose indicated in the slight pencil sketch of the Holy Family,[2] which probably shows the artist's initial idea and is the basis for the oil sketch (Fogg Art Museum, Harvard). The studies, made from young models obtained at Jerusalem,[3] take full advantage of the natural wriggling and posturing of a baby secure in its mother's lap, but aware of outside happenings. The second of these two drawings comes close to the ultimate pose used in the large oil, finalised in No. 7242 below, with the child's legs tucked under and

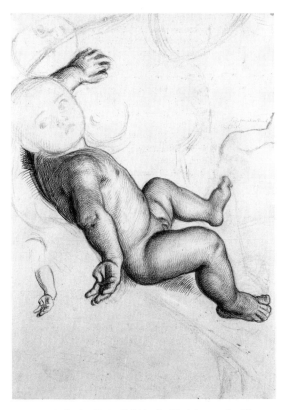

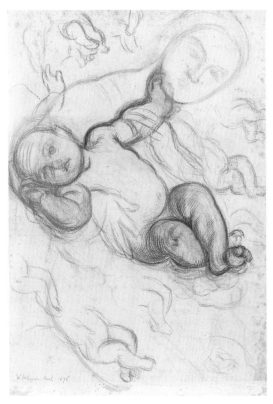

6595. *Study for the Christ Child in the Virgin's arms for 'The Triumph of the Innocents'*

6596. *Study for the Christ Child in the Virgin's arms for 'The Triumph of the Innocents'*

his left hand touching his mother's face to attract her attention to the accompanying spirits. The pose effectively strengthens both the visual and symbolic link between the Christ Child and the band of Innocents.

It is possible that the artist's problems with the defective canvas in this area may have contributed to his final choice for this pose, which moves the child over to the left instead of to the right of the Virgin as in the pencil and oil sketches.

PROV: H. C. Green, sold Sotheby's, 16.4.1962 (71), bt. A. Matthews, No. 6595 to C. Powney; purchased separately by the Walker Art Gallery, 1967.
EXH: Liverpool and V. & A. 1969, *Hunt* (228 repr., and 229).

1 Two others exhibited Liverpool and V. & A. 1969, *Hunt* (226, 227), and subsequently Sotheby's sale, 16.11.1976 (230) repr.; the former dated 19 June, 1876; the latter is now in the Tate Gallery. A sketch of the Virgin and Child in the Pollitt Album, Christie's sale, 17.6.1970 (17, part), can be linked with the first of this series as probably the first move towards a livelier pose with the child standing to the left.
2 Burt Collection, sold Sotheby's, 10.10.1985 (55) repr.
3 Hunt's own first child Gladys by his second wife Edith, was born at Jerusalem in Sep. 1876. In 1877 he was using native models for the children in the oil (letters to Edith at Jaffa, May–June 1877, John Rylands University Library of Manchester).

2444. *Nijmi, a Bethlehemite Woman, study for 'The Triumph of the Innocents'*
Coloured chalks, 54.6 × 38 cm (21½ × 15 in)
Signed with monogram, inscribed and dated: *Nijmi, a Bethlehemite* and *Whh / Aug 11.77*
Frame: gilt oak with reeded and medallion border and flat of Rossetti/Madox Brown type.

A partially erased label on the backboard, signed by the artist and inscribed Draycott Lodge, Fulham,[1] reads: '. . . in preparation for the *Triumph of the Innocents* . . . Bethlehemite woman in 1877'.

In the same manner as he employed with the posing of the Christ Child, the artist developed the final pose and character of the Virgin's head through intermediate stages from an initial inclined almost profile view, indicated in the first slight compositional sketch (cited under Nos 2115, 6595–6 above),[2] through to the final almost full-face with the head slightly bent and the eyes looking down over the Child. He clearly wished, after his marriage in 1875, to present his wife Edith as the Virgin with, ultimately, their son Hilary (born 1879) as the Christ Child (see No. 7242 below), but at the same time to ensure the correct Jewish characteristics.

He would appear to have turned again to the central group in the oil painting fairly late in his stay at

2444. *Nijmi, a Bethlemite Woman, study for 'The Triumph of the Innocents'*

Fig.42 *Study of a Syrian woman.* Photograph by permission of Messrs Phillips

Jerusalem and he states that he attempted various postures on his canvas to avoid the irregularities which were particularly trying in this area.[3] This may have influenced the ultimate pose of both figures. The present study, appropriately from a woman of Bethlehem, comes close to the final pose though with more lowered eyes and with a different, presumably everyday rather than bridal, head-dress. It takes a central position in a sequence of drawings which can be related to the picture. Two of earlier date are a crayon study of a young Syrian woman, dated 2 July 1876 (fig. 42),[4] and a silverpoint portrait of Edith, dated July 1877 (fig. 43).[5] Both of these have a slightly more inclined head with the eyes looking up. Later is a study of Edith made in London, 1880,[6] which is almost exactly followed in the large oil. Linked with the group is the small oil of the *Bride of Bethlehem* (19½ × 18 in, on loan to the Fitzwilliam Museum, Cambridge), which combines the ultimate pose of the head with the initial upward-glancing eyes, and with the bridal costume close to that of the picture.[7]

The present drawing was admired at its exhibition in the winter of 1879–80 as 'a learned and vigorous specimen of fine modelling'.[8]

PROV: Joseph Ruston, of Lincoln, sold Christie's 21.6.1912 (16), bt. Willis £37.15.0; presented to the Walker Art

Gallery by Alderman John Lea, June 1912.
EXH: Old Watercolour Society, Winter 1879 (104).

1 The artist moved to this address in 1881.
2 Burt Collection, sold Sotheby's, 10.10.1985 (55) repr. Similarities to this pose can be seen in Hunt's first recorded chalk study of Edith after their marriage, dated April 1876 at Jerusalem (same sale, lot 63, thence Colnaghi, *English Drawings and Watercolours*, April–May 1986, No. 63 repr.).
3 Hunt 1905, II, pp.329–30; Hunt letters to Edith at Jaffa, May–June 1877 (John Rylands University Library of Manchester, Eng. MS 1215).
4 Repr. *Magazine of Art*, 1894, p.98, when also in the Ruston collection: sold Phillips, 24.11.1980 (141).
5 Hunt 1905, II, p.317 repr.: sold Sotheby's, 6.10.1980 (18) repr.
6 Christie's sale, 14.10.1969 (171) repr.
7 Hunt 1905, II, repr. fp. 22: Fine Art Society 1886, *Hunt* (28), where it is described as a preliminary study connected with the painting of the Virgin's head. Note also Hunt to G. L. Craik, 22 Nov. 1884 (John Rylands Library), where he comments that it should be offered to any purchaser of the main picture.
8 *The Athenaeum*, 13 Dec. 1879, p.769.

7242. *Study for the Christ Child for 'The Triumph of the Innocents'*

Red and black chalk, heightened with white, 48.2 × 61 cm (19 × 24 in)
Signed in monogram, dated and inscribed: *18 Whh 79 // Drawn from H.L.H. For his Mother*

Fig.43 *Silverpoint study of Edith Holman Hunt.* Photograph by permission of Messrs Sotheby

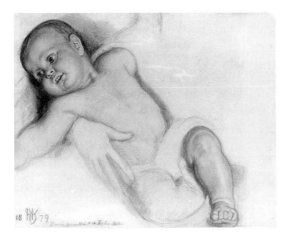

7242. *Study for the Christ Child for 'The Triumph of the Innocents'*

Study of Hilary Lushington Hunt,[1] the artist's son by his second wife Edith. He was born in London, 6 May 1879. This pose, with the child leaning over his mother's arm and gesturing towards the spirits of the Innocents, is that finally used in the large painting.

PROV: Mrs Holman Hunt; a note on the back states: '*Hilary /study for/Innocents/Jane Lushington/Hilary's godmother/belongs to him*', and in another hand '*given to me by my husband/some years ago/1943*'; acquired in London by Miss Dorothy Colles about 1959–60, sold Sotheby's, 6.11.1969 (60), bt. Colnaghi for the Walker Art Gallery.

EXH: Liverpool and V. & A. 1969, *Hunt* (235).

1 Repr. (detail), A. Meynell and F. W. Farrar, 'W. Holman Hunt, his Life and Work', *The Art Journal*, Special Number, 1893, p.20.

LL 3599. *May Morning on Magdalen Tower*

Oil on canvas,[1] 154.5 × 200 cm (60¾ × 78¾ in)
Signed in monogram and dated: *18 Whh 90*
Frame: copper repoussé, designed by the artist and executed by the Guild of Handicrafts (see text).

The historical background was described in the pamphlet accompanying the picture's first exhibition.[2] The custom of greeting the sun on May morning from a high place was thought to be a relic of Druidical worship. The May morning service on Magdalen Tower was itself of ancient origin and was first noted by Anthony Wood (flourished 1632–95): 'the choral ministers of Magdalen College do, according to ancient custom, salute Flora every year on the first of May, at four o'clock in the morning, with vocal music of several parts which, having been sometimes well performed, hath given great satisfaction to the neighbourhood and auditors below.' Dr J. R. Bloxam (1807–91), who saved the ceremony from near extinction in the 1840s, introduced the present form when the *Hymnus Eucharisticus*, with words by Dr Thomas Smith, Fellow of Magdalen 1663–92, and with music by Dr Benjamin Roberts, organist 1664–85, is sung facing towards the rising sun.[3]

The artist's presentation was not fundamentally realist in content. His ambition, he wrote a little later,[4] was not to make a prosaically exact representation but 'rather to represent the spirit of a beautiful, primitive, and in a large sense eternal service, which has only been in part restored on the tower, even to the floral fulness of three centuries since, but which still carries evidence in it of the origin of our race and thoughts in the same cradle with the early Persians. This was the kernel of the scene which I had to extract . . .' He presents the singers in isolation, with the many spectators usually present on the tower and the rail separating them eliminated: the onlooker takes their place. Prominent figures from the college and associated with the service have been introduced together with a Parsee, a sun worshipper, for which there was a precedent.[5] The boys are not all from the college choir but chosen for their looks (see list below). Many floral tributes have been added, chiefly tulips, hyacinths, lilies, imperial martagons and fritillaries,[6] and the William III silver monteith belonging to the college.[7] The lily held by the centre choirboy is the emblem of St Mary the Virgin and St Mary Magdalen to whom the college is dedicated. Through the parapet are glimpses across the High over the Botanical Gardens to Christ Church meadows and the river. Rooks and

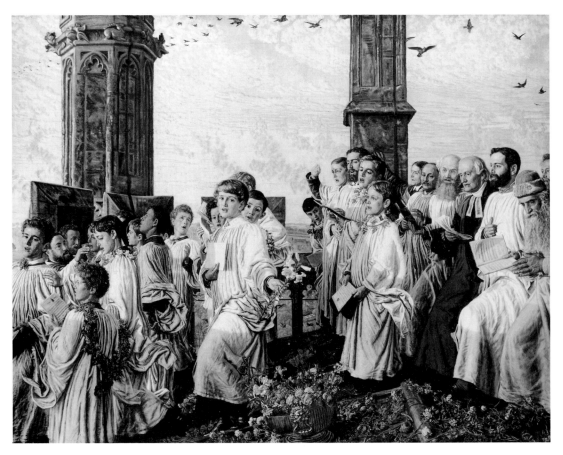

LL 3599. *May Morning on Magdalen Tower* (colour plate XXVII)

jackdaws swerve away from their usual perch on the tower.

The subject had long been in Hunt's mind[8] but his Eastern expeditions had prevented its execution. When well started on the picture he commented, January 1889,[9] that it 'delighted me thirty years or more since', and he was afraid that it might have been 'snapped up, as interesting ideas will be . . .'. Farrar in 1891,[10] presumably quoting him, pinpoints the date to 1851. This was the year of Hunt's first visit to Oxford to Thomas Combe, the purchaser of his *Converted British Family sheltering a Christian Missionary from the Persecution of the Druids* (Royal Academy 1850; Ashmolean Museum, Oxford). He enjoyed the Christmas festivities including those in Magdalen Hall[11] and apparently met Dr Bloxam and talked about it to him.[12] Dr Bloxam was at the centre of the High Church movement at Oxford, to which Combe adhered, and had instituted the Christmas Eve entertainment with carol singing by the choir boys.[13] It is possible that the idea might at this early date, when the revival was comparatively recent, have been considered as an appropriate pendant to the Druids picture.

In the later 1880s, released from the trauma of *The*

Fig.44 *Study from the Cantoria of Luca della Robbia*. Private collection; photograph Courtauld Institute of Art

Triumph of the Innocents (No. 2115 above) and following the successful exhibition of his works at the Fine Art Society in 1886, where the *Druids* picture was included, Hunt turned to a number of his early designs of various kinds for new paintings.[14] His now first-hand knowledge

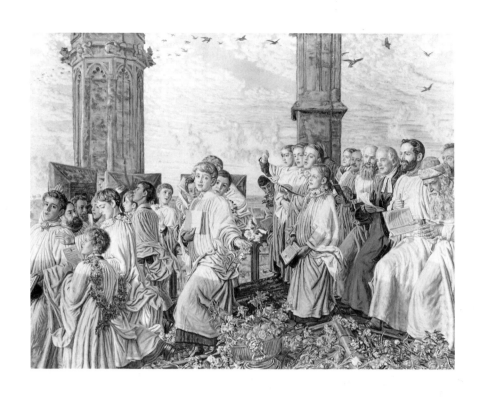

Fig.45 *May Morning on Magdalen Tower.* By permission of
Birmingham Museums and Art Gallery

of Italian Renaissance art, already drawn upon in the
Triumph, may have linked in his mind his early idea for
this subject with the application of elements of the Luca
della Robbia *Cantoria* in Florence, with its carved panels
of youthful music-making figures illustrating Psalms 148
and 149. The blocking-in of the close mass of figures, the
linear wind-blown drapery and the humanising touches
of the heads glancing over each other's shoulders and the
lively inattentive children can be compared. Sketch
outlines by Hunt of two of the panels, players on the
psaltery and boys singing from a scroll (both private
collections; fig. 44), presumably date from his stays in
Florence between 1866 and 1869 (when the panels and
parts of the *Cantoria* would have been on view in the
courtyard of the Museo Nazionale), or they could be from
the plaster casts purchased by the Victoria & Albert
Museum, 1877.[15] Psalm 148 seems reflected in this
picture and its frame (see below), here in particular
'Praise ye from the heavens: praise him in the heights',
etc.

That Hunt was here planning a contemporary religious
subject which might have popular appeal is borne out by
a letter of this time to his friend Edward Clodd, a writer

on religion and ethics, referring to opposition to his
mystic subjects. He counted this as one 'without offence
in it . . . and the public may even look at my pictures with
more toleration, and it may, while satisfying me as a
subject of the matter of fact kind, bring much needed grist
to the mill . . .'.[16] His use of light, as always in his major
works, is fundamental to his conception, providing a
spiritual interpretation of his presentation of innocent
youth in joyful song at rosy dawn. Landow[17] discusses
his idea of spiritual illumination, particularly in his late
paintings of the 1890s, of which this can be seen as an
example in modern dress. Like the *Triumph*, it combines
the real and the imaginative.

Hunt's decision to paint this subject appears to have
been quite sudden.[18] He visited Oxford to view the
ceremony in 1888, taking a sketch-block with him to the
top of the tower and making observations but not,
according to the President's record of the occasion,[19]
making any sketch at that time. He spent several weeks
working on the tower from 4 a.m. on the small canvas
(15⁵⁄₁₆ × 19¼ in, Birmingham; fig. 45).[20] The watercolour
study of architectural details (No. 10537 below), may
date from this time. He was hoping in June soon to begin

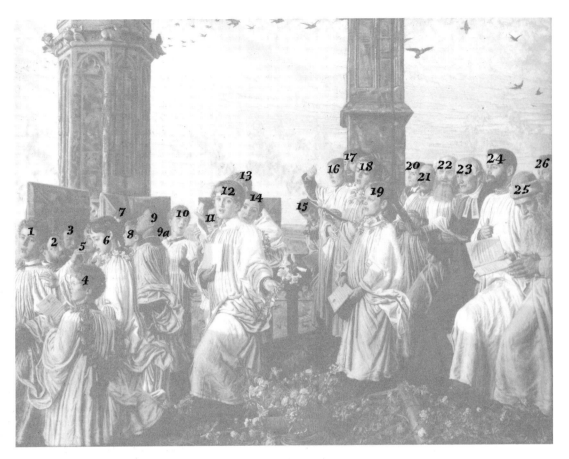

Fig.46 Key to *May Morning on Magdalen Tower*

on the figures[21] and back in London in August, was hoping 'to get the little picture ready for transference to the big canvas – and to have the studies drawn for each figure . . .', and he had 'young Sidney' for two drawings for 'the' chorister (untraced).[22] He chose a small chorister to sit[23] and had to depend on Westminster Abbey choir as the St Paul's choir boys were away until September.[24] He certainly watched the latter at practice, though he did not sketch from them.[25] He asked for the eldest son of the Rye family to sit (No. 1 on key).[26] A chalk portrait study of Dr Bloxam ($7\frac{1}{4} \times 9\frac{1}{8}$ in) is in the Ashmolean Museum;[27] a life drawing from a model ($18\frac{1}{2} \times 12\frac{1}{4}$ in), for the figure of the President, and a study of a lily, differing from that held by the chorister, were in a private collection.[28]

He was back in Oxford in December, now with the large canvas, for which the President made available a studio in the new buildings at Magdalen.[29] There he soon afterwards wrote to his wife,[30] 'There is now manifest a strong feeling against my picture because I have filled up so many places and cannot put Oxford or Magdalen notables for the figures, not only that, the [illegible] fellows are decidedly offended that – [deleted: ?Dr Bloxam] figures prominently and – [deleted: ?Dr Varley Roberts] in consequence of this and the obscure

place as it seems now in the composition which he is to occupy is disposed to refuse to sit altogether, and although I have called twice on the President he has not been [here] at all. I have also found that the people not connected with Magdalen look down upon the ceremony and refuse to think it worthy of a picture at all. So you see I have fallen into a thorough hornet's nest of difficulty. The way I meet it, is by ignoring it altogether.' He added that Varley Roberts wanted all his boys painted with good likenesses, and that there was an objection to Dr Bloxam. Hunt chose 'a delightful small fellow called Williams' (No. 14) from the choir but thought others had no chins; he sketched in Mr Bramley that day and found a very handsome Oxford boy at the school, not a chorister, whom he hoped to use later (probably No. 12). His immediate plans[31] were to stick at painting the boys before they went down on 26 December, to come up again in the New Year to 'finish the men and a few objects of still life', to include the huge silver bowl, not yet seen, for flowers, and to paint jackdaws.

He was again at Oxford after the Christmas break and various of the Fellows were painted or completed at that time.[32] All have musical associations. Dr Bloxam, instrumental in preserving the ceremony, is centrally

placed among the row of Fellows (No. 23), though he was then no longer living in Oxford. The Rev. H. R. Bramley, mentioned above (No. 22), stands on his far side and was no doubt chosen as another early Magdalen Tractarian: he recollected ruefully that he 'had to stand for an hour on a plank posing for it'.[33] He was also connected with the next figure, Sir John Stainer (No. 21), in a joint publication of carols. The last in the row, Dr Burdon-Sanderson (No. 20), was keenly interested in music and had been a choral singer.[34] Behind them is glimpsed Sir Walter Parratt (No. 26), at that time the College Organist. The President (No. 24), who had held a little aloof,[35] Hunt hoped to introduce before he returned to London at the end of January 1889.[36] Hunt wanted another sitter (name deleted in his letter to Edith)[37] whom he thought good-looking from a photograph but was short in stature: he wanted a tall man 'looking over at the same piece of music, for this I must paint him first'. This figure may have been that of Mr Garland (No. 17). He found that Varley Roberts was unhappy about the small position he took (No. 2), as he considered himself to be the principal figure and there was in reality a good deal of space between him and the boys.[38] At some date Hunt cut back the curly hair of the choirboy at the extreme left (No. 1), to give more room for Dr Roberts's face, for which he obtained a photograph to assist him, in April 1889, in London.[39] The Parsons boy (No. 18), was apparently to be completed in London;[40] this was perhaps to fit him in between No. 17 and Hilary Holman Hunt (No. 19). Hunt planned to go up the tower on 26 January[41] and the President recorded his departure on January 29:[42] 'Mr Holman Hunt the Artist who had been painting a picture representing the May Morning function on Magdalen Tower in College for some weeks left Oxford today taking the picture with him to London – where he intends to finish it and exhibit it in the Spring'.

The chief figures were identified in the press at the time of the picture's exhibition, 1891,[43] but only a few of the choristers. A key plate in the Gallery (see fig. 46), probably an off-print of the one referred to at the time of the publication of the photogravure, 1893,[44] similarly does not identify all the boys. Seventeen choristers are visible (three only partly shown), together with one adult, who in the small oil at Birmingham is also replaced by a boy chorister (there were only sixteen boy choristers at Magdalen).[45] Seven of the boys are identified as boys from the choir. The list below, numbering from the left, follows the key with later identifications and biographical details added:[46]

1 James Rye. Perhaps the Scholar of Balliol and Arnold Prizeman (born 1871), eldest son of Walter Rye.[47]
2 Dr (John Varley) Roberts, Choir-master. (1841–1920), Organist and Director of the Choir at Magdalen, 1882–1918.
3 (Rev. William Edward) Sherwood, School Master. (1851–1927), Headmaster of Magdalen College School, 1888–1900.
4 Basil Napier (foreground, wearing leaf garland). (1879–1900), a grandson of Lord Napier and Ettrick.

5 (William Harold) Ferguson, chorister.
6 Paul Haas. Son of the pianist, Madame Haas.
7 (F.) Barton, chorister (top of head of dark hair). This seems to be a slip. The widow of F. Barton in 1951[48] identified him as No. 11 (in the present numbering), but No. 8 or No. 10, both unidentified, might be alternatives.
8 Unidentified (profile to left). See No. 7 for possible identification.
9 Robert Collier, chorister.
9a Unidentified (back of head and ear only).
10 Unidentified (full face, glancing backward). See No. 7 for possible identification.
11 Claude Napier. (1880–1946), a grandson of Lord Napier and Ettrick.
12 Unidentified (foreground, holding lily). This may be the handsome boy, from the school but not a chorister, mentioned above. More recently identified variously, as David Steele,[49] as Raymond Egerton-Smith,[50] and, most probably, as Stuart Lloyd Richards, who was a pupil at Magdalen College School and not a regular member of the choir.[51]
13 Not identified (top of curly head only). Later identified[52] as Philip Wiggins, and chosen because of his large head.
14 (T.S.B.) Williams, chorister (looking at spectator). This must be the delightful small chorister Hunt mentions. A later suggestion was a Mr De la Mare.[53]
15 Harold Alexander, chorister. A grandson of Dr Alexander (1799–1845), first bishop of Jerusalem.[54]
16 William Edgar Stainer, chorister (right arm raised against the sunlight). Son of Sir John Stainer, No. 21.
17 Mr (Charles Thomas) Garland, chorister.[55]
18 (H.B.) Parsons, chorister.
19 Hilary Lushington Holman Hunt. (1879–1949), younger son of the artist.
20 Dr (later Sir) John Scott Burdon-Sanderson. (1828–1905), Fellow of Magdalen and first Waynflete Professor of Physiology; later Regius Professor of Medicine.
21 Sir John Stainer. (1840–1901), Professor of Music at Oxford and Honorary Fellow of Magdalen.
22 Rev. Henry Ramsden Bramley. (1833–1917), Fellow of Magdalen.
23 Dr John Rouse Bloxam. (1807–91), historian and some-time Fellow of Magdalen; Vicar of Upper Beeding from 1862; he was no longer in Oxford and died before the exhibition of the painting.
24 The President of Magdalen, Sir Herbert Warren (1853–1903).
25 Mr Cama, Parsee of India. A merchant.[56]
26 Dr (later Sir) Walter Parratt. (1841–1924), Honorary Fellow of Magdalen and Organist; later Professor of Music at Oxford.

The copper frame designed by the artist, like other earlier examples, enhances and elaborates upon the subject of the picture. It was executed by the Guild of Handicrafts, established by C. R. Ashbee in 1888, and finished by May 1889 when Hunt expressed his satisfaction with the adventure into this material. He was pleased also with

the inner flat supporting the canvas, but thought the lower border, to which he had given insufficient care in his design, too unsymmetrical.[57] He gave Spielmann[58] its meaning: 'the sun arises animate, inanimate creation is awakened to joyous life', and Farrar[59] presumably quotes his description: 'On the lower edge is the rising sun. On either side, the fish which gambol in the water, and the frogs leaping in the stream, indicate the glad renewal of morning life. Lilies and wild briar-roses twine about the sides of the picture, enwreathed on one side by convolvulus – a most suitable emblem here, both from its name of 'morning glory', and from its habit of unfolding at dawn and closing later in the day. At the top of the frame is a lark, shaking its wings for the first morning flight and morning song, before the crescent moon has set. At each corner there is a bird's nest, at one of which the male bird is ready to take its turn beside the eggs, while in the other the parents are feeding their callow brood.' The fleecy clouds at the top echo those in the picture and the copper itself contributes its rosy glow to the dawning sunlight. A band of five-point stars forms an outer border. The design in conception can be seen as developing ideas from Psalm 148: 'Praise ye him, sun and moon: praise him, all ye stars of light . . . creeping things, and flying fowl' etc., or the comparable morning prayer *Benedicite Omnia Opera*. Elements of the scroll patterning of the plants on the side panels, together with the lark spreading its wings at the top, distantly reflect the casing of Ghiberti's *Gates of Paradise* to the Baptistry, Florence (of which an electrotype was purchased by the Victoria & Albert Museum, 1867).[60] The more formal arrangement of the rose heads in the top border may owe their inception to a drawing by Hunt of roses in a frieze from a source at Christchurch, Hampshire; a sheet of sketches connected with their final design also exists.[61]

Millais came to see the picture at Hunt's request, in August 1890, when it was just finished, and was politely enthusiastic.[62] Hunt had to organise its exhibition himself,[63] which opened in May 1891 in Bond Street.

It was now more than forty years since Hunt had come to the forefront of British painting. The reviews in a variety of journals,[64] were chiefly descriptive and appreciative of the religious overtones in a modern setting, while some were conscious of a hard technique or wooden effect, and aware of a distinctness from current trends. *The Daily Telegraph*[65] provided a reasoned descriptive assessment and commented on the one hand that: 'There are to be found here both the earnestness of devotional feeling, sometimes verging on asceticism, which so strongly marks the conception and the conduct of his work, and the astonishing skilfulness of execution long since attained by the painter. . . . The microscopic attention to details, the unerring touch, the loving appreciation of floral beauty, the exquisite perception of colour are all here . . .'. On the other hand, the reviewer emphasised the many peculiarities which others also criticised in his work: ' . . . an inveterate hardness and dryness of manner, a seeming oblivion of the infinite reflections and refractions of light, and a systematic ignoring of the mobility of atmospheric effect . . . motion

seems absent . . . It is as though on the mind of the painter had been impressed a kind of instantaneous photograph of the scene which he was to depict, and he had worked out that impression on canvas without deviating one iota from the scheme which had originally presented itself to him.' The *Magazine of Art*,[66] while conscious of a characteristically heavy execution and too much detail, nevertheless thought that 'It is interesting to be reminded by the present work that Mr Holman Hunt treats sunlight and shadow from a standpoint approaching that of the modern French *luministes*, although his technical method is of course absolutely different from, and opposed to theirs'. *The Athenaeum*[67] (F. G. Stephens) provided a carefully diluted praise: the picture 'proves itself intensely brilliant, strong, and pure in its lighting and coloration; energetic, spirited, and original in design and composition . . .'; some figures were thought beautiful, others uncouth; the effect of dawn on the surplices was considered splendid and the sky glorious, 'there are some points of colour in the picture which cannot be admired too much. On the whole, the merits of this extraordinary example outweigh immeasurably its eccentricities . . .'; by and large it was a masterpiece and 'with all its shortcomings, an honour to our time'.

D. S. MacColl, the advocate of the more recent theories of the New English Art Club, while acknowledging the merits of its inventive grouping, refuted *The Athenaeum*'s points of praise in an article in *The Spectator*.[68] He considered that the colour could not be admired at all; that the picture's merits could only be retained by 'steadily thinking away its colour and all the qualities of the medium of oil-paint in which it is expressed'. He could only think of it as a design or drawing in black and white.[69] He was prepared to accept the fanciful in it, the subject was 'to some extent a representation of a nineteenth-century cult', but he wished to consider the painting 'as a picture', and how it agreed with the Pre-Raphaelite formula of 'Truth to Nature', on which Hunt had taken a stand. MacColl considered him to have had 'the theorist's fanaticism for the fact without having much more than Rossetti, the gift for rendering it . . . he has laboured in his painting to convey the "truth", the fact, and has only succeeded in spoiling his work as a decoration. The *Magdalen Tower* confronts us, displeasing as an arrangement in decorative colour, but also completely inadmissible as a statement of the facts of natural colour. These facts include the fact of atmosphere, and for Mr Hunt that does not seem to exist. Of what avail, then, is it to climb for days to see the sunrise on Magdalen Tower, if you cannot see it when you are there? Better to be absolutely conventional, than to render sunlight on faces with the effect of unpleasant colours smeared upon tin; for the pleasure of quality is as much wanting in this painting as the pleasure of colour.'

Archdeacon Farrar, in his long and adulatory article in the *Contemporary Review*,[70] focused attention on the artist's fundamentally religious viewpoint, by then so rare in contemporary painting:

'Mr Holman Hunt deserves the honour and gratitude of

his country, and of the age, for the lofty purpose which has animated his entire career . . . The noble work . . . though it might seem less directly religious than those which were devoted to the illustration of great thoughts and scenes of Holy Scripture, is in reality a religious picture, and that in the highest sense. And in the element of simple loveliness the artist has never surpassed this last and enchanting production of his artistic imagination . . .

'He has, indeed, chosen for illustration a scene of contemporary life but one which constitutes in itself a peaceful idyl of beauty and innocence, linked by tradition with far antiquity, and involving an act of worship performed under conditions of unique freshness, interest, and simplicity. Into this picture he has concentrated the conception of spring with its loveliest flowers, and the rosy dawn of sunrise, and innocent boyhood, and holy worship . . .

'The actual scene is indeed idealised, and rightly idealised. It is only of recent years that the old ceremony has been restored to its right significance. Within living memory it used to be a dreary survival vulgarised by irreverence, and emptied of all its meaning. The choir-lads, we are informed,[71] used in former days to sing the hymn with their caps on, and in their ordinary dress, and in the most perfunctory manner . . . The restoration of the May-dawn service to its true dignity was due to Dr Bloxam, and the late venerable President of Magdalen College, Dr Routh. They laid down three rules:- That the choristers should wear their surplices; that they should uncover their heads at the beginning of their *Hymnus Eucharisticus*; and that they should turn towards the East to face the rising sun . . .

'There is not a touch of false sentiment about it. Its elements of beauty are undegraded by a single taint of morbid ecclesiasticism, and the whole effect of the picture is healthy and ennobling . . .'

He hoped that it would be bought for the nation. It remained, however, with the artist, who subsequently exhibited it at Oxford in the autumn and at Liverpool in 1893.[72]

Studies have been cited in the text. A copy of the choirboy holding a lily, No. 12, was on the art market 1969.[73] The small oil was itself being completed 'with some last touches' in June 1893.[74]

ENGRAVED: Photogravure, Berlin Photographic Company.
PROV: The artist; Mrs Holman Hunt,[75] sold Christie's (517CY), 18.7.1919 (146), bt. Gooden & Fox for W. H. Lever (1st Viscount Leverhulme), (1,900 gns, plus commission) £2,194;[76] thence to the Lady Lever Art Gallery.
EXH: Gainsborough Galleries, 25 Old Bond Street, 9 May–1 Aug. 1891;[77] Ryman Gallery, High Street, Oxford, Nov. 1891;[78] Walker Art Gallery, July 1893 and *Liverpool Autumn Exhibition*, 1893 (1016); Guildhall 1897 (135); Leicester Galleries 1906, *Hunt* (29); Manchester 1906, *Hunt* (34); Walker Art Gallery 1907, *Hunt* (11); and *Liverpool Autumn Exhibition* 1922 (430); Port Sunlight 1948, *P.R.B.* (121); Liverpool and V. & A. 1969, *Hunt* (59) repr.

1 Double canvas. Label on stretcher of Charles Roberson, 99 Long Acre, *Drawing Materials*, addressed to W. Holman Hunt, Draycott Lodge, Fulham.

2 *May Morning, Magdalen Tower*, Oxford, painted by Mr W. Holman Hunt, Gainsborough Galleries, 25 Old Bond Street, May 1891, by 'Magdalenensis' and quoting a sketch of its history by Dr Bloxam (MS, never published).

3 T. S. R. Boase, 'An Oxford College and the Gothic Revival,' *Journal of the Warburg and Courtauld Institutes*, Vol. 18, 1955, p.179, comments, 'it was a simple but lasting meeting of mediaevalism and Tractarianism'.

4 Statement in his letter to *Pall Mall Gazette*, 4 Nov. 1891 (the artist's press-cuttings book, Gallery files), while the picture was on exhibition at Oxford and refuting the reviewer's implication that he had hoped the college would buy it. Hunt reiterated that his interpretation was 'rather abstract than of prosaic fact' in a letter explaining the exclusions and eliminations, to Mr and Mrs Barrow Cadbury, donors of the oil study to Birmingham City Art Gallery (Birmingham, *Catalogue of Paintings*, 1960, pp.79–80).

5 *John Bull*, 16 May 1891, commented, from information no doubt supplied by Holman Hunt: 'Since the establishment of the Indian Institute at Oxford, a Parsee member of it has actually been present on one occasion at this ceremony. Doubtless the painter has seized on the incident to remind us that the instinct of worship is common in all religions. But some people will be disposed to question the propriety of introducing into the representation of an act of Christian worship this figure of one who is, after all, engaged in adoring the creature rather than the Creator.'

6 F. W. Farrar, 'Mr Holman Hunt's May-Day, Magdalen Tower', *Contemporary Review*, CIX 1891, pp.814–8.

7 H. C. Moffat, *Old Oxford Plate*, 1906, pl.III: E. A. Jones, *Catalogue of Plate of Magdalen College, Oxford*, 1950, p.30, pl.6, No.1.

8 *Pall Mall Budget*, 21 May 1891 (press-cuttings book); Hunt 1905, II, pp.377–8.

9 Hunt to M. Spielmann (editor of the *Magazine of Art*), 23 Jan. 1889 (John Rylands University Library of Manchester, Eng. MS 1294, with other letters to Spielmann cited below).

10 Farrar, op. cit., p.815.

11 Hunt 1905, I, p.311.

12 *Oxford Magazine*, 30 May 1906, p.409: Hunt to the President of Magdalen (pointed out by Judith Bronkhurst, in Tate Gallery 1984, *P.R.B.*, p.106).

13 R. D. Middleton, *Magdalen Studies*, 1936, p.48.

14 Including the *Lady of Shalott* (Wadsworth Athenaeum, Hartford, Connecticut), the large *Light of the World* (St Paul's Cathedral), and the early unfinished *Christ and the Two Marys* (Art Gallery of Southern Australia, Adelaide).

15 Judith Bronkhurst, in letter to the compiler of 2 April 1987, dates the drawings to Hunt's period in Florence (both ex Pollitt collection, sold Christie's, 18.11.1980 (72): 13¼ × 16⁵⁄₁₆ in and 10⅛ × 7¾ in). See also J. Pope-Hennessy, *Luca della Robbia*, 1980, p.226 and pl.1: in 1883 the carvings were transferred to the new Museo dell'Opera del Duomo; the *Cantoria* was reconstructed in the 1890s.

16 Edward Clodd, *Memories*, 1916, p.203, quoting a letter from Hunt at Oxford, 10 June 1888. Hunt was making a comparison in particular, with the *Lady of Shalott*. The overriding religious elements of the subject appear, however, to have been stressed in, for example, its exhibition at Liverpool in July 1893 when the picture was supported not only by the oil sketch (Birmingham), but also by the artist's several recent designs for Sir Edwin Arnold's *Light of the World*, 1893 (*Liverpool Daily Post*, 10 July 1893, press-cuttings book).

17 George Landow, 'Shadows cast by *The Light of the World*: William Holman Hunt's Religious Paintings, 1893–1905', *Art Bulletin*, Sep. 1983, p.471f.; and see also his *William Holman Hunt and Typological Symbolism*, 1979, p.139.

18 *Oxford Magazine*, loc. cit.: 'my work [abroad] and what it entailed on my return kept me engaged till 1889 [sic], when in the spring I suddenly resolved to free myself from other work and then come up to study the subject . . .'. Hunt confused the year which should read 1888.

19 President's Note Book, 1 May 1888 (Magdalen College): extracts supplied to the compiler Jan. 1969 by the President's secretary.

20 Hunt 1905, II, p.378; Clodd, loc. cit. For the small oil see Birmingham City Art Gallery, *Catalogue of Paintings* 1962, pp.79–80 (137/07), and Liverpool and V. & A. 1969, *Hunt* (60).

21 Clodd, loc. cit.

22 Hunt to Edith Holman Hunt, 3 Aug. 1888 (John Rylands Library, Eng. MS 1215, with the other letters to Edith, cited below).

23 Ibid.

24 Ibid and Hunt to Edith, 9 Aug. 1888.

25 Copy of his letter of thanks to the Rev. W. Russell, 7 July 1891, supplied to the Lady Lever Art Gallery, 11 June 1957.

26 Hunt to Edith 20 Aug. 1888.

27 Liverpool and V. & A. 1969, *Hunt* (249); Ashmolean Museum, *Report of the Visitors*, 1969–70, p.31.

28 Burt collection, photographs Gallery files: the former was in the Sotheby sale, 10.10.1985 (68, part).

29 Hunt 1905, II, p.378.

30 Hunt to Edith, 12 Dec. 1888.

31 Hunt to Edith, 16 Dec. 1888.

32 Hunt to Spielmann, 23 Jan. 1889.

33 Middleton, loc. cit., p.280.

34 Lady Burdon-Sanderson, *Sir John Burdon Sanderson: a memoir . . .*, 1911, pp.17, 163.

35 Hunt to Edith, 13 Jan. 1889 (mis-dated 1888).

36 Hunt to Edith, 8 and 13 Jan. 1889.

37 Hunt to Edith, 13 Jan.

38 Ibid.

39 Hunt to Mrs Roberts, 27 April 1889 (sitter's family ownership): see *Liverpool Bulletin*, 1969, p.48, repr. of photograph.

40 Hunt to Edith, 'Sunday night'.

41 Hunt to Edith, 25 Jan. 1889.

42 President's Note Book, loc. cit.

43 Hunt gives the identities of most of the adults in an undated letter to Spielmann, c. August 1889 (John Rylands Library). *John Bull*, 6 May 1891 (press-cuttings book), confirms the identities of Nos 2, 3, 17, 20–26 (the adults). Farrar, *Contemporary Review*, 1891, p.817, also identifies some of the boys: he confirms Nos 2, 3, 4, 6, ?11 ('face in shadow' in second row), ?15 (who 'looks round with a certain expression of *espièglerie*', and identified as a grandson of Dr Alexander, first bishop of Jerusalem), 16, 17, 19, 22–25. He notes that the boy close by Dr Roberts is 'a kinsman of General Gordon'. This is presumably No. 1, John Rye. Farrar, however, mis-identifies Sir John Stainer, undoubtedly No. 21, as the last figure standing behind in shadow, i.e., No. 26.

44 *Liverpool Courier*, 8 July 1893 (press-cuttings book): No. 12 and No. 19 (Hilary Holman Hunt) are specified by number.

45 J. R. Bloxam, *A Register . . . of Saint Mary Magdalen College, Oxford*, I, 1853, p.i.

46 A revised list, numbering from the right, appears in H. T. Kirby, 'May Morning on Magdalen Tower,' *Country Life*, 27 April 1951. It re-identifies some of the figures with the aid of information supplied by H. B. Parsons (No. 18) and Philip

Taylor, Choir-master and Organist of Magdalen College, Oxford. Other suggestions have been made by correspondents to the Lady Lever Art Gallery and to the compiler.

47 A. C. Fox-Davies, *Armorial Families*, II (1970 edition). An alternative might be a son of William Brenchley Rye, Keeper of Printed Books at the British Museum.

48 *Country Life*, 6 July 1951, correcting Kirby, loc. cit: should be No. 16 in his list, not 26.

49 By his friend Mr Lawman, who had visited the Lady Lever Art Gallery with him (note of 1951 on Kirby's article in Lady Lever Art Gallery files).

50 Added on a copy of the key at uncertain date and without source (Lady Lever Art Gallery files).

51 Major John G. Bill to the compiler and to the Lady Lever Art Gallery, 16 July 1969 (Gallery files) giving his mother's identification: the sitter, grandfather of the writer and later a Lt Colonel, was the son of the Rev. E. T. Richards of Farlington, Hampshire; Dr Bloxam was a friend of the family.

52 Kirby, loc. cit.

53 Mr M. H. Phillips to Lady Lever Art Gallery, 10 Oct. 1944 (note of 1951 in Lady Lever Art Gallery files).

54 Farrar, loc. cit. More recent notes in the Gallery list this boy as the 'nephew' of General Gordon.

55 His Christian names provided by the sitter's daughter, Mrs Nicholson, on her visit to the Gallery, 2 June 1987, to see the painting for the first time, following her own 100th birthday in April 1987: her father had been at York Minster before moving to Magdalen.

56 Identified by Hunt in note to Spielmann, cited in note 43. Also identified by name in *The Observer*, 10 July 1891. Farrar, loc. cit., notes that this visitor 'may readily be supposed to be a member of the Indian Institute at Oxford'. See also note 5.

57 Hunt to Mr Hubbard, Guild of Handicrafts, 19 May 1889 (Victoria & Albert Museum Library). The copper frame is mounted on a wood core.

58 Undated letter, about Aug. 1889, cited above. He also repeated his dissatisfaction with 'one part of the lower angle.'

59 Loc. cit., p.818.

60 For his early copying from this door as a student see Hunt 1905, I, p.106. The small oil (Birmingham) also has a copper frame, circular in form, with an outer frame of flower scrolls and an inner flat of radiating flames and arrow-heads overlaid with four cartouches inscribed: MAY MORNING / MAGDALEN TOWER // AND FYRY PHEBUS RYSETH UP SO BRIGHT / THAT ALL THE ORIENT LAUGHETH AT THE LIGHTE (from Chaucer's 'Knight's Tale'). Both are reproduced in A. Meynell and F. W. Farrar, 'William Holman Hunt, his Life and Work,' *The Art Journal*, Special Number, 1893, pp.24, 27: the large picture was then in the studio. O. Von Schleinitz, *William Holman Hunt*, 1907, p.122, shows the latter free-standing in a dining-room at Draycott Lodge. See also Lynn Roberts, 'Nineteenth Century English Picture Frames, I The Pre-Raphaelites', *The International Journal of Museum Management and Curatorship*, 4, 1985, pp.169–70, citing a review of it.

61 Respectively: Burt Collection, sold Sotheby's, 10.10.1985 (75, part); and in an album from the artist's family, sold Christie's 18.11.1980 (72); photographs in Gallery files.

62 Hunt to Millais, and to Mary Millais, 23 and 30 July 1890 (Pierpont Morgan Library, New York); Hunt to Edith, 3 Aug. 1890 (John Rylands Library): 'He seemed much surprised at the cloisters and said but its a tremendous work and no one could do it without giving it enormous time I call it all beautiful excellent couldnt be better old fellow. The light is so good with the horizontal shadows and the sky is delightful and all those old fellows now they are as good as Holbein every bit, better.' Arthur Hughes also made a kindly comment

10537. *Sheet of studies for 'May Morning on Magdalen Tower'*
(colour plate XXVI)

in a letter at Whitsun to Alice Boyd after a Private View at
Hunt's house: he thought it 'more true to nature than most of
his later work' and admired the sky 'very Hunty', 'It is a
difficult picture to have done, and I hope it very much will be
a success to him.' (W. E. Fredeman, 'The Penkhill letters of
Arthur Hughes to William Bell Scott and Alice Boyd,
1886–97,' *Bulletin of the John Rylands Library* Vol.49, No. 2,
1967, and Vol.50, No. 1, 1967, reprint p.31; published with
permission of the Editor).

63 Hunt to Spielmann, 6 May 1891.

64 Press-cuttings book cited, from the artist's family (Gallery
files). Included are reviews from the following: *Daily
Graphic*, 9 May 1891; *Observer, Lloyds Weekly*, 10 May;
Telegraph, Daily News, Pall Mall Gazette, Scottish Reader, 11
May; *Times*, 12 May; *Christian World*, 14 May; *Black and
White, Athenaeum, John Bull*, 16 May; *Truth, World*, 20 May;
Pall Mall Budget, 21 May; *Academy, Lady's Pictorial, Specta-
tor*, 23 May; *National Observer*, 6 June, etc.

65 *The Daily Telegraph*, 11 May 1891.

66 *Magazine of Art*, June 1891, p.xxxiv.

67 *The Athenaeum*, 16 May 1891.

68 *The Spectator*, 23 May 1891.

69 MacColl was presumably thinking of the proposed reproduc-
tion by photogravure announced in the pamphlet accom-
panying the exhibition. He also took issue with the artist's
advocacy for a national school of art to the exclusion of
modern French, or Dutch, influence.

70 Loc. cit. *The National Observer*, 6 June 1891, under the title of
'Unpretentious Advertisement', took up arms against this

review and called Archdeacon Farrar 'our puff-master-in-
chief'. They commented: 'And you see within the "symbolic
frame" a sorry outcome of perverted endeavour. Ill-drawn
forms, inharmonious colour, clumsy composition, dry, tight,
handling, brush-work without character, a surface licked up
and tickled out of all semblance of paint – these are the
qualities over which you are asked to slobber . . .'.

71 Pamphlet (see note 2).

72 It was initially offered for the Liverpool Autumn Exhibition,
1892, but Hunt's wish to advertise the photogravure was not
acceptable. The following year it was arranged to have a
special exhibition July–Aug. in the Fountain Room (Room 5),
when other works, including the small oil which Hunt was
then finishing, were included. This was on the understanding
that the picture remained at the Walker Art Gallery for the
Autumn Exhibition, 1893 (correspondence Gallery files).

73 Information from D. M. Archer; photograph Gallery files.

74 Hunt to Charles Dyall, Curator, Walker Art Gallery, 12 June
1893 (Gallery files).

75 Offered for sale to Lord Leverhulme April 1919, on a basis of
the artist's original price of 5,000 gns (correspondence Lady
Lever Art Gallery files).

76 Invoice July 1919 (Lady Lever Art Gallery files).

77 Press cuttings and annotated copies of the pamphlet in Lady
Lever Art Gallery files.

78 Pamphlet (Gallery files) and review *Oxford Times*, 7 Nov.
1891 (press-cuttings book).

10537. Sheet of Studies for 'May Morning on Magdalen Tower'

Watercolour and pencil over grey wash, 25.3 × 35.4 cm (10 × 13¹⁵/₁₆ in)
Inscribed: *From Magdalen Tower / WHH* and *WHH*; and with extensive notes by the artist: [top left] *horizontal line inclining / towards middle of tower,* [top centre] *here higher than at / Eastern fellow,* [centre left] *if roof be not seen the horizon is less than / halfway up to top of parapet // Quatrefoil at Eastern walls / not dark in shadows except / where smoked inside (?) and somewhat / less dark only in outside forms / Joins of stone shown by moss / growth above and below / line;* [centre] (?) *Grains,* [right] *Depth of quatrefoil / t . . [? tint] of parapet . . .* [rest obliterated], [bottom left] *Water / ducks*

Studies made on the tower, probably at an early stage of Hunt's first visit to Oxford in the summer of 1888. The watercolour sketches of views through the balustrade are about half the scale of the large oil. The slight sketch of distance, top left, appears at the left of the picture; the view across a duck pond in the Botanical Gardens, bottom left, is visible between the first and second row of singers and the double arcade, centre, with view across the High and with the distant Thames indicated above, is repeated in the centre of the painting. The pencil study, top right, is for the carved crown of the pinnacle at the south-east corner of the tower, at the left of the painting. Slight studies of birds in flight are below this.

PROV: By descent in the artist's family to Mrs Elizabeth Burt, sold Sotheby's 10.10.1985 (72), repr. col., and bt. Agnew for the Walker Art Gallery; purchased, with Nos 10534–6, with the aid of contributions from the National Art-Collections Fund, the Victoria & Albert Museum Grant Fund and the Friends of Merseyside Museums and Art Galleries.
EXH: Victoria & Albert Museum and Walker Art Gallery 1969, *Hunt*, (250).

1636. Harold Rathbone

Oil on oak panel,[1] 23.1 × 17.8 cm (9⅛ × 7 in)
Signed in monogram and dated, on a shield: *9 Whh 3*
Frame: Tortoise-shell and ebony.

Harold Steward Rathbone (1858–1929), Liverpool artist, poet and pottery designer; a son of Alderman Philip H. Rathbone of the eminent merchant family. The sitter was trained at Heatherley's School, the Slade and was a pupil of Ford Madox Brown for at least three years around 1882–3 while the latter was painting his Manchester Town Hall wall decorations.[2] He later studied in Paris and travelled in Italy, and was a founder of the Della Robbia Pottery Company, Birkenhead, 1894, and its Art Director until its closure in 1906. He subsequently lived at Llandudno and finally retired to the Isle of Man.[3]

He used to accompany his father, Chairman of the Arts Sub-Committee, on his trips round the artists' studios in London when pictures were being requested for the Liverpool Autumn Exhibition. He may have met Hunt on such an occasion or at the Art Congress in Liverpool,

1636. *Harold Rathbone* (colour plate XXVIII)

1888, when Hunt stayed with the George Holts at Sudley.[4] They were in correspondence and personal contact from late in 1890 when the sitter organised the public subscription to buy Hunt's *The Triumph of the Innocents* (No. 2115 above).[5] This portrait may have been the outcome of that, but it is not certain whether it was a commission by P. H. Rathbone or the sitter, or a gift of the artist.[6] Harold Rathbone also owned Hunt's *Haunt of the Gazelle* (No. 980 above).

This portrait, which shows the sitter with dark brown hair and beard and wearing a brown velvet jacket and red bow tie, and set against a green background, closely resembles contemporary studio photographs of him.[7] While more informal in pose it embodies the same immediacy as Hunt's portrait head of D. G. Rossetti (Birmingham) of 1883[8] (itself based on a drawing of 1850s), and it equally stresses the character of the sitter, in this case the dreamer.

When exhibited at the New Gallery, 1894, *The Athenaeum*[9] considered it a 'hard, yet brilliant, solid and vivacious portrait . . .', while *The Artist*[10] commented: 'Funny, but dont escape being vulgar'.

PROV: Perhaps P. H. Rathbone (died 1895); Mrs P. H. Rathbone, 1896 (died 1905); the sitter by 1906 and until after 1911[11]; Alderman John Lea, before 1922, who bequeathed it to the Walker Art Gallery, 1927.
EXH: New Gallery 1894 (234); Walker Art Gallery 1894, *Liverpool Autumn Exhibition* (1190); Liverpool Domes-

tic Mission 1896 (14); Manchester 1906, *Hunt* (38); Walker Art Gallery 1907, *Hunt* (40); Glasgow 1907, *Hunt* (23); Manchester 1911, *P.R.B.* (218); Walker Art Gallery 1922, *Liverpool Autumn Exhibition* (45), as 'A Portrait'; Cumner Art Gallery, Jacksonville, Florida 1965, *Artists of Victoria's England* (31); Liverpool and V. & A. 1969, *Hunt* (61) repr.

1 Part of a plank, cut off irregularly at bottom edge after the application of a white ground, but before painting.
2 Madox Brown painted him as John of Gaunt in the *Trial of Wycliffe*, 1884, and Humphrey Chetham in *Chetham's Life Dream*, about 1886.
3 See Walker Art Gallery catalogue, *Merseyside Painters, People and Places*, 1978, I, pp.127, 175–6; II, p.275 repr.; and Williamson Art Gallery, Birkenhead catalogue, *The Della Robbia Pottery, Birkenhead, 1894–1906, An Interim Report*, 1980–1.
4 Hunt correspondence with his hosts, Holt Papers, Gallery files.
5 Hunt to H. Rathbone, 28 Dec. 1890, Liverpool University Library, MS 13.1 (28); ditto 25 May 1891 (Gallery files).
6 Hunt implies in his letter of 25 May 1891 that he 'cannot ignore or be unrecognisant of your favourable personal feeling in reserve but for the present I have to concern myself with the business aspect of the question . . .'. The portrait might, thus, be an acknowledgment of Harold Rathbone's initiative but not necessarily so. Certainly Hunt wrote to Harold, 28 April 1894 (Fogg Art Museum, Harvard) indicating that he would withdraw the portrait from the New Gallery if it was not hung on the line. However, all P. H. Rathbone's pictures passed to his wife for her lifetime and she is recorded as the owner in 1896; and moreover Harold was almost certainly financially very dependent on his father (information of P. H. Rathbone's Will and the 1894 letter kindly supplied by Judith Bronkhurst, 26 Nov. 1983).
7 Example Gallery files.
8 See Liverpool and V. & A. 1969, *Hunt* (56) repr.
9 *The Athenaeum*, 23 June 1894, p.810.
10 *The Artist*, May 1894, p.149.
11 There was a sale at his residence in Port St Mary, Isle of Man (F. D. Johnson, auctioneers), 19.2.1923, but no copy of the catalogue has been traced (information from A. M. Cubbon, The Manx Museum, 14 Aug. 1972).

Hunt, William Holman, after

Blanchard, Thomas Marie Auguste (1819–98)
4001. *The Finding of the Saviour in the Temple*

Line engraving on laid india paper, image: 39.2 × 64.7 cm (15^{7}⁄₁₆ × 25^{7}⁄₁₆ in)
Signed, in pencil: *W. Holman Hunt* and *Aug. Blanchard*
Lettered: London, *Published August 1st 1867, by E. Gambart & Co. No. 1 Kings Street St. James //* and Printsellers' Association stamp (*FHD*)[1]
Frame: A simplified version of the design by the artist for the oil painting, adapted by F. G. Stephens (see text); and lettered in gold on its gilt-edged white slip: [top] *The Finding of the Saviour in the Temple*; [left] *And when they found him not, they turned back again to Jerusalem / seeking him. And after three days they found him in the Temple*; [bottom] *And when they saw him, they were amazed; and his mother said unto him, Son, why hast thou thus dealt with us, behold, thy father and I have sought thee sorrowing. / And he said unto them, how is it that ye sought me? wist ye not that I must be about my Father's business?*; [right] *And he went with them, and came to Nazareth, and was subject unto them; but his mother kept all these sayings in her heart* (Luke II, 45–6, 48–9, 51).[2]

Gambart the dealer, as purchaser of *The Finding of the Saviour in the Temple* (Birmingham City Art Gallery) from the artist at £5,500 including copyright, was well able to recoup the enormous price both by exhibition entrance fees and by its engraving.[3] It was already on show at his German Gallery, New Bond Street, when negotiations were completed in May 1860;[4] a tracing was prepared by Hunt[5] and a black chalk drawing of the same size as the original was already underway by Morelli before November.[6] The picture was withdrawn from exhibition for a period in August 1861 so that Morelli might complete it under the artist's eye[7] and it was finished by January 1863.[8] Gambart proposed in a memorandum to the publisher Pennell of 12 November 1860 to have the engraving made entirely from this drawing, overseen by the artist, leaving the picture free to be exhibited about the country; the engraving, by Blanchard, Morelli or the like, he expected to cost 2,000 gns; he proposed to print between 1,000 and 2,000 artist's proofs at 15 gns, 1,000 proofs before letters at 12 gns, 1,000 proofs at 8 gns and possibly 10,000 prints at 5 gns; and he hoped the orders would reach 50,000 gns in four years.[9] Auguste Blanchard was chosen for the engraver[10] and the print was registered 2 June 1863.[11] It was not completed until 1867. 'There was still a touch or two to be given to the plate' when Hunt visited Gambart and Blanchard at Paris on his way back from Italy in September 1867.[12] On 2 November *The Athenaeum*[13] announced that it would shortly be published and on 19 November Hunt informed Gambart that he would call on him, in London, to sign proofs.[14]

The frame, a plaster version of the elaborate original designed by Hunt, is an unusual feature, probably

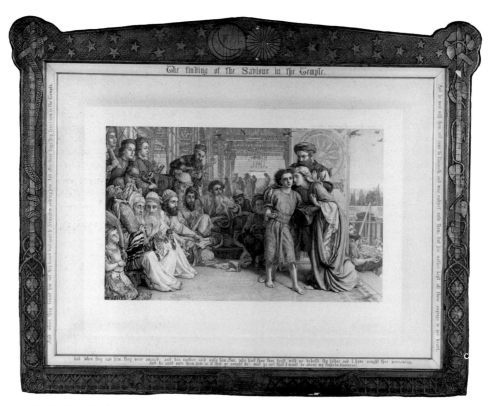

The finding of The Saviour in The Temple.

4001. *The Finding of the Saviour in the Temple*

masterminded by Gambart. Hunt seems to have had doubts about not having a simple frame. Writing to his friend J. L. Tupper at Florence, late in 1867,[15] he commented: 'although the very elaborate one adapted from the frame of the picture by Stephens really looks well much beyond my expectation, for it seemed it must be too heavy for the subject as given in the print without color'. It varies slightly from the original, in particular in the lower border where here is a row of papyrus flowers, two stars, and three circlets of the waning and rising moon.

The engraving was well received. *The Art Journal*[16] commented that 'The French engraver . . . has established his claim to a first position among the artists of Europe; his reputation was previously high; by this, his latest work, he has increased it. Those who are accustomed to mellow richness in engraving, may possibly complain of a certain hardness in the style; but the character of the picture is well preserved . . . The print, whether regarded merely as a work of Art, or accepted as an illustration of the earliest impressive incident in the life of our Lord, will be universally accepted as an acquisition of rare value, destined to occupy the place of honour in tens of thousands of homes where Art is loved, and the Christian faith venerated.'

The reviewer noted that the artist had published a key 'in which he explains his motives and notes his authorities'. See text following fig. 34 (No. 246 above).

PROV: Presented by Mrs Margaret Harvey, 1878.
EXH: Arts Council 1978 (Leeds, Leicester, Bristol and Royal Academy), *Great Victorian Pictures* (24) repr.

1 See note 11. See also E. Morris, *Foreign Catalogue* (Text), 1977, Walker Art Gallery, p.360.
2 Following the full inscription on the frame of the large picture.
3 Discussed at length by J. Maas, *Gambart, Prince of the Victorian Art World*, 1975, p.114f.
4 Ibid, p.120.
5 Hunt 1905, II, pp.193–4.
6 Maas, op. cit., p.131. *The Athenaeum*, 31 Jan. 1863, p.157.
7 *The Athenaeum*, 24 Aug. 1861, p.256.
8 Ibid, 31 Jan. 1863, p.157.
9 Maas, op. cit., pp.131–2, quoting original memoranda (Gillot Papers).
10 *The Athenaeum*, 24 Aug. 1861, p.256.
11 *An alphabetical list of engravings declared at the Printsellers' Association*, 1892, p.123.
12 Hunt to J. W. Bunney, 30 Sep. 1867 (private collection); see Bennett, *Liverpool Bulletin*, 1969, p.35.
13 *The Athenaeum*, 2 Nov. 1867, p.579, quoted by Maas, op. cit., p.205.
14 Maas, op. cit., p.206 (letter in John Rylands University Library of Manchester, MS 1268).
15 Hunt to Tupper, 19 Dec. 1867 (Henry E. Huntington Library, San Marino, California): J. H. Coombs et al, edit., *A Pre-Raphaelite Friendship. The Correspondence of William Holman Hunt and John Lucas Tupper*, 1986, No.54, p.81.
16 *The Art Journal*, 1868, p.100.

Inchbold, John William (1830–88)

Landscape painter working under Pre-Raphaelite influence in the 1850s but returning to an increasingly more fluid manner, particularly in watercolour, in later life. Born Leeds, 29 August 1830, son of a newspaper proprietor. Trained in London as a lithographic draughtsman with Day and Haghe, studied watercolour under Louis Haghe, and was apparently in the Royal Academy Schools, though not registered there. Exhibited at Suffolk Street 1849 and 1850, at the Royal Academy from 1851, at the Liverpool Academy from 1853 and occasionally at Manchester. By 1852 he knew the Pre-Raphaelite circle, perhaps through the Rossettis, and later was a friend of the poet Swinburne. Exhibited with the Pre-Raphaelite Brotherhood at Russell Place, 1857 and became a member of the Hogarth Club, 1859. Ruskin's attempts to influence his style in the painting of Alpine views in Switzerland in the later 1850s may have further depressed his already retiring and uncertain temperament. About 1877–87 he was settled at Montreux on Lake Geneva where the locality became his usual subject. Died Leeds 23 January 1888.

6251. *Study of Houses at a Street Crossing*
Watercolour, 16.6 × 24.5 cm (6⁹/₁₆ × 9⁵/₈ in)

A freely treated sketch probably painted on the spot and perhaps a page from a sketch-book. Here ascribed to Inchbold though Allen Staley was doubtful.[1] It is possibly a late work dating from the years at Montreux, of about 1877–87. Its fluid style is comparable with a watercolour of an Italian street scene which descended in the Leathart-Rae family. Both George Rae and James Leathart had examples of Inchbold's work.

PROV: Purchased from Mrs Sonia Rae, 1964.[2]

1 Oral opinion 18 April 1969.
2 Various watercolours and sketches in the artist's executors' sale, Fosters, 6.6.1888, were bt. by Rae.

6251. *Study of Houses at a Street Crossing*

Marshall, Peter Paul (1830–1900)

Born Edinburgh of a family of artists, and trained and practised as an engineer. Attended evening Life classes at the Edinburgh Academy and devoted his leisure to painting. He came to Liverpool in connection with the Rivington water project and met Liverpool artists and their patron John Miller, a daughter of whom he married. Exhibited at the Liverpool Academy occasionally, 1852–62, and afterwards at the British Institution in 1863 and the Royal Academy in 1877. He was a candidate for 'non-artistic' membership of the Hogarth Club in London, November 1858. Settled in London at Tottenham around 1860. Through Ford Madox Brown (to whom he was probably introduced by Miller) he met Rossetti and William Morris. He suggested the foundation of the decorating firm, Morris, Marshall, Faulkner and Company, 1861, designed a few stained-glass cartoons but dropped out of the firm when it was re-formed as Morris and Co. in 1875. Retired to Devon through ill health and died there. His son J. Miller Marshall was an artist.

7396. *Donald Currie*

Black, white and red chalk, 60 × 44.5 cm (20⅝ × 17½ in)
Signed in monogram and dated: *PPM / 77*

Sir Donald Currie (1825–1909), shipowner and one of the greatest figures of his day in the shipping world. He was born at Greenock and spent his childhood in Belfast. He joined the Cunard Steamship Company in Liverpool in 1844, and in 1862 founded his own steamship company, the Castle Line, trading largely with South Africa. He moved to London in 1865. In 1900 he amalgamated with his rival, the Union Line, as the Union-Castle Line. He received the KCMG in 1881. He formed a great collection of paintings in particular by J. M. W. Turner.

He married Margaret, daughter of John Miller, the merchant and collector of Liverpool (who similarly had some important Turners and who numbered some of the Pre-Raphaelite circle among his friends); he was thus a brother-in-law of the artist.[1]

The influence of Ford Madox Brown's later pastel style

7396. *Donald Currie*

is evident in this portrait. The artist exhibited a portrait of Miss Bessie Currie at the Royal Academy of 1877. An MS label with No. 7396 suggests that it was also submitted.[2]

PROV: Purchased from S. Dews, West Kirby by the Walker Art Gallery, 1970.

1 *Dictionary of National Biography*; see also Geoffrey Agnew, *Agnew's 1817–1967*, 1967, p.33.
2 Marked *No. 5*, and fully inscribed with artist, title and the same address: *Fairlawn, Stone, Dartford*.

Martineau, Robert Braithwaite (1826–69)

Born London, 19 January 1826, son of a Taxing Master; his mother Elizabeth, née Batty, was an amateur water-colourist. At first he studied law like some of his brothers, but after four years gave this up for art about 1846 and, following two years at Sass's School under F. S. Carey, entered the Royal Academy Schools; listed as a student in the School of Painting on 16 December 1848 and gained a silver medal in 1850 (his brother Edward had entered the School of Architecture in 1845). Holman Hunt states that Martineau contacted him through an 'old fellow student' and became his pupil, 1851–2; Martineau in turn introduced Hunt to Edward Lear, 1852. He showed his first picture at the Royal Academy 1852, *Kit's Writing Lesson*, which was completed in Hunt's studio. After Hunt's return from the Holy Land, 1855, Martineau for a time shared a studio with him and Mike Halliday at 49 Claverton Terrace, Lupus Street, Pimlico, and later at Hunt's house, 1 Tor Villa, Campden Hill; remained under Hunt's influence until his marriage in 1865 to Maria Wheeler. He exhibited with the Pre-Raphaelite Brotherhood at Russell Place 1857, and the USA exhibitions 1857–8, and was a member and treasurer of the Hogarth Club; also exhibited at the Liverpool Academy. His subjects were literary, historical and genre and his

execution extremely detailed. His most famous work, which he considered his masterpiece, was *The Last Day in the Old Home* (Tate Gallery), exhibited with great success at the International 1862 and also at Holman Hunt's exhibition at the Hanover Galleries, 1864. Lived at Lancaster Lodge, part of Little Campden House. Died London, of heart failure after rheumatic fever, 13 February 1869. See his portrait by Hunt (No. 2443 above).

1612. *Christians and Christians*
Oil on canvas, unfinished, 141.5 × 211.5 cm (55¾ × 83¼ in)
Inscribed, on unpainted areas with several names and addresses, probably of models.
Frame: Gilt carved wood with heavy rolled and diamond-cut borders and octagons at the corners cut with concave circles on the field.[1]

The artist was working on this unfinished painting at the time of his death in 1869.[2] It was probably the outcome of one of two commissions for a large picture which he had received before September 1864 from Thomas Fairbairn, patron and friend of Holman Hunt, and from Kirkman Hodgson, Governor of the Bank of England.[3] On its exhibition at the Cosmopolitan Club soon after his death, the catalogue gave a description: 'The subject of this Picture is suggested by its Title, and is supposed to relate to the time when the Jews were expelled from England in

1612. *Christians and Christians*

1613. *Study of Conway Castle for 'Christians and Christians'*

the 13th century. It was chosen to represent the contrasted effects of superstition and heart-belief upon the conduct of diverse individuals. A poor and aged Jew Pedlar has been hunted by the half-savage people of a town, and fallen in the last gasp of flight and fear at the door of a house which is tenanted by true and tender-hearted Christians, who come to his relief.' *The Athenaeum*[4] gave it a sympathetic review, considering it even in its incomplete state to display 'the strict love of Nature and great Art power of the painter. It is rich in colour, expression and signs of learning and carefulness . . .'.

The persecution of the Jews under Edward I included a statute forbidding their acquisition of Christian property through pledges in 1269, and their final banishment in 1290. Martineau's choice of a religious theme of this kind, overlaying the moral tone of some of his earlier work,[5] may show the influence of Holman Hunt, under whom he had worked, as well as the preference of his patron. Its ambitious scale illustrates an intention to show his full potential after his success at the International[6] and parallels Hunt's use of much larger canvases and increased scale in the later 1860s. The frame is similar in style to Hunt's designs of this period.

The canvas has been enlarged on three sides (the pin holes of the tacks show). The natural-coloured canvas is squared up on a 5½ in grid and perspective lines are visible, notably for the base of the octagonal column at the extreme right, supporting the porch of the house. Several of the figures have been moved in position more to the left while the heads and draperies of the five chief figures are far advanced in execution. The background of a street of mediaeval houses is barely visible. There was to have been a castle with hills beyond and sketches for this were made at Lincoln and Conway[7] (and see No. 1613 below).

The artist made several studies for the figures.[8] A series

of sketches in an album, Ashmolean Museum, Oxford, include a slight sketch for the whole composition (pencil, 3½ × 5¼ in), study of a porch (pen and wash, 4⅛ × 6 in); study of a doorway inscribed 'the Jews House, Lincoln' (pencil, 4⅜ × 3⅝ in) and various sketches for the heads of figures; in the same collection are two studies for the young woman's head (pencil, 6⅞ × 5⅝ in; 7⅛ × 5⅞ in). These were all bequeathed by Miss Martineau. A further pencil study for the woman's head is in the British Museum.[9] An oil study of a young woman's head in a three-quarter pose (15¼ × 12⅞ in), close to the final pose but with the hair in a looser arrangement and the shoulder line more in profile, was in a private collection.[10]

PROV: Presented to the Walker Art Gallery, with Nos 1613–6 below, by Miss Helen Martineau, daughter of the artist, 1942.

EXH: Cosmopolitan Club, 1869 (13); Brook Street Gallery 1922 (16).

1 Framemaker's label of Bourlet, Nassau Street, London.
2 Statement by Holman Hunt in a letter to Ernest Chesneau, 21 March 1882, published by Mary Lutyens, 'Letters of John Everett Millais . . . and William Holman Hunt . . . in the Henry Huntington Library . . .', *44th Volume of the Walpole Society, 1972–1974*, 1974, p.81, repr. pl. 13b; and by George Landow in ' "As Unreserved as a Studio Chat": Holman Hunt's letters to Ernest Chesneau', *The Huntington Library Quarterly*, Aug. 1975, p.364. See also unidentified press-cutting reviewing 1922 exhibition (Gallery files), and Helen Martineau, 'Robert Braithwaite Martineau: A Follower of the Pre-Raphaelites', *The Connoisseur*, Dec. 1942, p.97, repr. p.98.
3 Mentioned in a letter to his proposed father-in-law, Henry Wheeler, 13 Sep. 1864 (private collection: information kindly supplied by Mrs Penelope Gurland, 1986): the commissions for £700 and £800 had each been received 'some time ago' but he had not 'till now' had time to execute them. Fairbairn besides being the patron of Holman Hunt was a commissioner

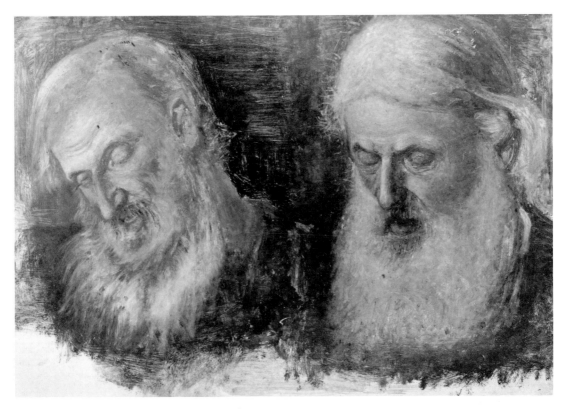

1614. *Two studies of a Jew's head for 'Christians and Christians'*

for the 1862 International Exhibition, as Martineau mentioned in his letter, and Martineau's success there may have led to these commissions.

4 *The Athenaeum*, 5 June 1869, p.770.
5 C. Lewis Hind in the *Pall Mall Gazette*, Jan. 1922 (quoted by Helen Martineau, loc. cit.), noted that the artist 'was not afraid to let it be known he was half moralist half artist'.
6 See note 3.
7 Press-cutting, loc cit.; *A Sketch of a Window at Lincoln* was No. 26 in the 1869 exhibition.
8 Cosmopolitan Club, 1869, Nos 14–26.
9 *The Connoisseur*, loc. cit., p.99 repr.
10 Photograph in Gallery files.

1613. *Study of Conway Castle for 'Christians and Christians'*
Oil on canvas, unfinished, 36.7 × 82 cm (14½ × 32¼ in)

PROV: With No. 1612 above.
EXH: ? Cosmopolitan Club, 1869 (24 or 25); Brook Street Gallery 1922 (14).

1614. *Two studies of a Jew's head for 'Christians and Christians'*
Oil on board, 24.1 × 35.5 cm (9½ × 14 in)

The left-hand study shows the head more bent over to the left and the right-hand study, with the head bent forward and the eyes closed, is followed in the picture.

PROV: With No. 1612 above.

EXH: ? Cosmopolitan Club, 1869 (18); Brook Street Gallery 1922 (18).

1615. *Study for the Young Woman for 'Christians and Christians'*
Pencil, black and white chalk, on grey paper, 54.9 × 28.2 cm (21⅝ × 11⅛ in)

1616. *Study for the Young Woman and the Jew for 'Christians and Christians'*
Pencil, black and white chalk, on grey paper, 55.3 × 28.9 cm (21¾ × 11⅜ in)

In both the figure of the woman is in the overdress of the final picture slightly differently arranged. No. 1615 shows her holding up the Jew's hand with her right arm, her head turned three-quarters to left. In No. 1616 she bends further over the Jew, whose head is indicated, wiping his head with a cloth, and a further study of her head on a slightly larger scale is in the margin.

PROV: With No. 1612 above.
EXH: ? Cosmopolitan Club 1869 (part of 19–23).

1615. *Study for the Young Woman for 'Christians and Christians'*

1616. *Study for the Young Woman and the Jew for 'Christians and Christians'*

Millais, John Everett (1829–96)

The most technically brilliant of the circle. Born Southampton, 8 June 1829 of a Jersey family of independent means. He early showed promise in drawing and his family moved to London to further his artistic career. Lived at 83 Gower Street, where he had his studio. Entered Sass's School 1838 and the Royal Academy Schools, 1840, registered as a student on 12 December. Quickly became a star pupil and gained various medals including the Gold Medal 1847 for *Benjamites seizing their Brides*; exhibited at the Royal Academy from 1846. There he became friendly, about 1847, with fellow-student William Holman Hunt and with him discussed a new approach to painting. After meeting also Dante Gabriel Rossetti about May 1848, he joined with them in founding the Pre-Raphaelite Brotherhood in the autumn of 1848.

He immediately changed from a conformist painting style in the romantic tradition to a clear-cut realism using friends as models, brighter local colours and minutely detailed technique, with a style finding its initial source in what the Brotherhood knew of art before Raphael. *Isabella* (No. 1637 below), the first essay in the new manner, was praised at the Royal Academy 1849, but his work came under severe censure after the meaning of P.R.B. leaked out in May 1850; nevertheless he always sold pictures easily, usually before exhibition. He met Ruskin after he championed their cause in May 1851 and brought a favourable turn to public opinion. His colour brightened and he developed a more realistic style as he turned to outdoor sunlit subjects in the early 1850s and at the same time the sharp-edged mannerisms of his early drawings gave place to more realistic but equally intensely felt subjects, increasingly illustrating modern life. First visited Scotland with Ruskin, 1853. He was elected ARA 1854. His technique began gradually to broaden in the mid-1850s and subsequent to his marriage to Effie Gray, in July 1855, a year after the annulment of her marriage with Ruskin, his work was again severely criticised for its looser finish and unpopular subjects. *Sir Isumbras*, Royal Academy 1857 (No. LL 3625 below), gained the particular opprobium of Ruskin. A return to popularity came with *The Black Brunswickers*, Royal Academy 1860 (No. LL 3643 below), deliberately painted to please. During the later 1850s and 1860s he turned to book illustration for reproduction in wood-engraving, notably for Moxon's *Tennyson, Parables of our Lord*, and Trollope's novels. After marriage lived for a time near Grays at Annat Lodge, Perth, with London studio in Langham Chambers; 1857–60 rented 16 York Terrace, Regent's Park and in 1861 settled at 7 Cromwell Place. Elected RA 1863. The later 1860s witnessed a complete change in manner maturing to a dashing and fluent technique for large-scale works and the evolution of subjects to please popular taste such as *The Boyhood of Raleigh*, 1870 (Tate Gallery). He became a fashionable portrait painter and as a relaxation painted large-scale landscapes during autumns and winters in Perthshire. His work was widely popularised through engravings.

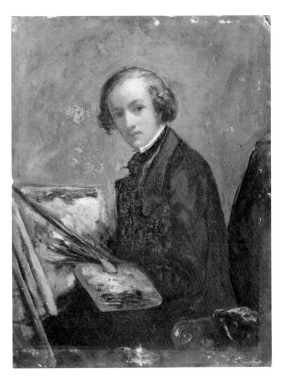

9240. *Self-portrait*

From 1878 he lived on a fashionable scale at 2 Palace Gate; he was created Baronet 1885 and elected President of the Royal Academy in 1896, after the death of Lord Leighton. He died of cancer of the throat, 13 August 1896 and was buried in St Paul's Cathedral.

9240. *Self-portrait*

Oil on mill-board, 27.3 × 22.2 cm (10¾ × 8¾ in)
Inscribed, verso: *J E Millais 1847*
Verso: sketch of two full-length oriental figures

The first oil self-portrait and very similar in appearance and dress to that in a drawing of the Lemprière family, also of 1847.[1] The technique is scumbly over a red bole ground, the flesh painted over red and some bitumen in the dress.

According to family tradition the portrait was given by Millais to John Kennedy (1833–1904) when a fellow student. Kennedy later practised as an artist and teacher in Dundee.[2]

The sketch on the verso may be connected with *The Widow's Mite*, the very large oil painting entered for the Westminster Hall Competition for the decorations of the new Houses of Parliament, 1847, where oriental figures appear at the right of the picture (Christchurch Priory, Hampshire).[3]

PROV: John Kennedy, from the artist, and thence by descent to Mrs Eleanor Prior, who presented it to the Walker Art Gallery, 1977.
EXH: Liverpool and R.A. 1967, *Millais* (7) repr.

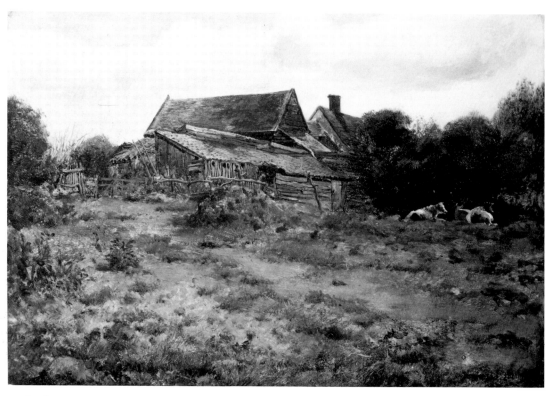

271. *Landscape, Hampstead* (colour plate XXII)

1 Liverpool and R.A. 1967, *Millais* (206), repr. G. Millais, *John Everett Millais*, 1979, p.27.
2 Letters from Mrs Prior to the compiler, 5 Sep. and 8 Oct. 1966.
3 Liverpool and R.A. 1967, *Millais* (5), photo Gallery files.

271. *Landscape, Hampstead*

Oil on panel,[1] 23.1 × 33.6 cm (9⅛ × 13¼ in)
Signed: *J E Millais*

A letter dated 25 January 1878 from the artist to G. H. Vicars states: 'The oil painting you send is by me, a sketch from Nature done many years ago. There is no fee. Yours truly, J. E. Millais. I think I painted it from Hampstead or thereabouts'.[2]

 Millais is known to have sketched on visits to the William Hugh Fenns at Hampstead in the summer of 1848[3] but no other views have recently reappeared.[4] The Fenns rented rooms in a farmhouse at North End. The location of No. 271 appears without doubt to be the back of Wylde Farm at North End which was popular with artists and literary figures throughout the nineteenth century (Linnell having first rented the cottage forming a part of it in the 1820s). Photographs and old views dating from before later nineteenth-century alterations and showing the front with cottage and farmhouse, and an upper passage joining it to the barn, correspond with the layout in No. 271 (fig. 47).[5]

 The low viewpoint with high horizon shows a characteristic trend in Millais' landscape studies of the late 1840s and 1850s, including the small *The Kingfisher's Haunt*,[6] begun about 1848 and probably finished about 1854/5, and the later *Waiting*[7] dated 1856, which Warner suggests[8] may indicate a wish to avoid tackling skies. While a similar impressionistic approach to the handling of the foreground grasses seems common to all three, a distinction lies in the earthy colours and scumbly, less certain handling of No. 271 in contrast to the fluent brushwork and sunlit spontaneity of *Waiting*. This seems to confirm the place of No. 271 safely before the onset of Pre-Raphaelite tenets.[9] The signature is similar to others of the later 1840s and the panelmaker, T. Brown of 163 High Holborn, is only listed at that address until 1853/4.

PROV: (?) G. H. Vicars; bought by George Holt, Liverpool from Thomas Joy (dealer, 47 Beaumont St, Portland Place), bill 26 Jan. 1878, £210 with an exchange picture valued at £40[10]; by descent to Miss Emma Holt, who bequeathed it to Liverpool, 1944. Sudley Art Gallery.
EXH: National Gallery, 1945. *Some Acquisitions of the Walker Art Gallery, Liverpool, 1935–1945* (24); Liverpool and R.A. 1967, *Millais* (9).

1 Stamped: *T. BROWN 163 High Holborn*.
2 Holt Papers, Walker Art Gallery.

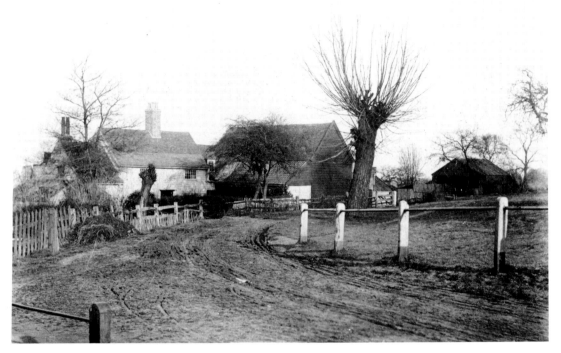

Fig.47 Anonymous photographer, 19th century, Wylde (or Collins) Farm, North End, Hampstead, with the barn on the right. By permission of the London Borough of Camden (Local History Library)

3 Spielmann 1898, p.71; W. W. Fenn, 'Memories of Millais', *Chambers' Journal*, 1901, p.835 (William Hugh Fenn sat for a figure in *Isabella*, No. 1637 below).
4 For example a 'View of some old cottages on the edge of the heath' was lent to the Royal Academy memorial exhibition 1898, No. 5, by a Thomas Whatmore.
5 Photograph reproduced by permission of London Borough of Camden, Local History Library; see also T. J. Barratt, *The Annals of Hampstead*, 1912, II, pp.24–5, III, pp.289–91, and T. Story, *The Life of John Linnell*, 1892, I, pp.142–9; the much altered house, which passed through various other names, still exists and is now divided (photographs kindly taken for our records by Lady Beaumont).
6 Destroyed World War II; repr. Staley 1973, pl.19a.
7 Birmingham City Art Gallery; repr. Staley 1973, pl.22.
8 Malcolm Warner, letter to the compiler, 25 Aug. 1981.
9 Staley 1973, p.45.
10 Holt Papers.

10364. *Ferdinand lured by Ariel*
Ink, 28.4 × 20.0 cm (11¼ × 7¾ in)
Signed in monogram and dated: *JEM/ 1848*
Inscribed: TEMPEST // ACT I SCENE II // *Ferd. Where should this music be? i' the air, or the earth*

Illustrating Shakespeare's *The Tempest*, Act I, scene 2, where Ferdinand is drawn along from the wreck of his ship on the shore of Prospero's enchanted island by the unseen voices of Ariel and his companions.

It must date from early in 1848 before the foundation of the Pre-Raphaelite Brotherhood and the radical change in Millais' style. The square monogram is used both in his slightly earlier drawings in his 'roundhand' style[1] and in the first of his angular 'mediaevalised' drawings such as *Isabella* (fig. 49), which dates from sometime in the summer of 1848.[2] In its use of shading it seems already to herald the new manner.

The Tempest, as William Vaughan has pointed out,[3] was extremely popular with outline illustrators in the earlier nineteenth century, for whom its fantasy had particular appeal. Following Moritz Retzsch, whose German theatrical mannerisms were much imitated, several English artists published sets of outline illustrations in oblong format.[4] Millais' illustration can be seen as an amalgam of ideas stemming from Retzsch and his followers, allied to current English book illustration of the more usual upright format in the medium of wood-engraving, particularly the fairy productions of Richard Doyle in the 1840s. The delicate line and hatching may have been intended for reproduction in etching, as was certainly the case for what must have been the somewhat later *Isabella*.[5] Most personal to Millais is the carefully observed natural detail, which heralds a new departure in his work and which Hunt noted quite early in 1848. He recorded[6] that Millais admitted, of his current painting,

10364. *Ferdinand lured by Ariel*

'but the more attentively I look at Nature, the more I detect in it unexpected delights: it's so infinitely better than anything I could compose, that I can't help following it whatever the consequences may be'. This interest is notable in such details as the frogs creeping out of the reeds and in the rustic framework; the latter, while echoing current fashion (for example in Doyle's work), is carefully naturalistic and minutely observed and becomes part of the exotic island setting as well as a border to it.

This highly finished and professionally presented design may have been one of the drawings circulated for mutual criticism by the shortlived Cyclographic Club which preceded the formation of the Pre-Raphaelite Brotherhood. The subject was taken up for an oil painting for a commission in 1849 (see No. 273 below).

PROV: Probably Abraham Solomon, sold Christie's 14.3.1863 (98) as 'A scene from the Tempest, 1848', 10½ × 7¼ in, crayons, bt. D. T. White 4 gns; his sale Christie's 21.4.1868 (615), bt. Ellis £3.15.0;[7] T. Ayres (brother of the pawnbroker to Charles Augustus Howell)[8], by family descent; Mrs T. Ayres; her executor's sale (Messrs Breadmore and Webb, at 270 Kew Road, Kew), 2.5.1907 (237) as An etching, 'The Tempest', bt. in, and thence by descent to Miss Sylvia Crawshay, who presented it to the Walker Art Gallery, 1983.

1 In particular, some of his designs for overdoors for a Leeds

house, 1847–8 (see Liverpool and R.A. 1967, *Millais* (210–26)). For a further discussion of this drawing see M. Bennett, 'An early illustration to "The Tempest" by John Everett Millais', *The Burlington Magazine*, Aug. 1984, pp.503–4, fig. 19.

2 See *Isabella* (No. 1637 below), note 3 for variant datings.

3 W. Vaughan 1979, p.140 and Chapter IV, 'F. A. M. Retzsch and the Outline Style'.

4 Vaughan, loc. cit., lists Joseph Severn, Frank Howard and Noel Paton in particular. A later edition of Retzsch's outlines from Shakespeare's plays was published in 1847.

5 Hunt 1905, I, pp.103–4.

6 Ibid, I, p.86.

7 Information on these two sales kindly supplied by Malcolm Warner, 23 June 1984.

8 Information from Malcolm Warner, from Tate Gallery, *English Pre-Raphaelite Painters lent by . . . Birmingham*, 1911–12 (72).

1637. *Isabella*

Oil on canvas, 103 × 142.8 cm (40½ × 56¼ in)
Signed, with initials in monogram and dated: *J. E. Millais 1849 PRB*; the initials PRB also appear on the side of Isabella's stool
Frame: Commercial gilt composition, the concave field stamped with shallow stylised flower and leaf repeat pattern stemming from the centre and narrow outer border in higher relief of oak leaves and acorns; scroll corners.[1]

The first painting by Millais following out the tenets of the newly formed Pre-Raphaelite Brotherhood, in a distinctive new style and with an original subject. Begun November 1848 and completed for the Royal Academy of 1849 where it was exhibited with a quotation in the catalogue from the poem by Keats, *Isabella or the Pot of Basil* (stanzas I and XXI):

Fair Isabel, poor simple Isabel!
　　Lorenzo, a young palmer in Love's eye!
They could not in the self-same mansion dwell
　　Without some stir of heart, some malady;
They could not sit at meals but feel how well
　　It soothed each to be the other by;

These brethren having found by many signs
　　What love Lorenzo for their sister had,
And how she lov'd him too, each unconfines
　　His bitter thoughts to other, well nigh mad
That he, the servant of their trade designs,
　　Should in their sister's love be blithe and glad,
When 'twas their plan to coax her by degrees
To some high noble and his olive-trees.

Millais was introduced to the poetry of Keats by Holman Hunt, whose own *Eve of St Agnes* had been exhibited in 1848 (see No. 1635 above).[2] At an uncertain date during the summer of 1848, apparently along with Rossetti and possibly at his instigation, they decided to illustrate the poem of Isabella with a series of outlines which they hoped to publish as etchings; a biography of the poet by Monckton Milnes, published August 1848, may have some bearing on the exact date of their conception.[3] Millais' ink design (Cambridge; 20.3 × 29.4 cm; fig. 49), while within the idiom of the popular outline style

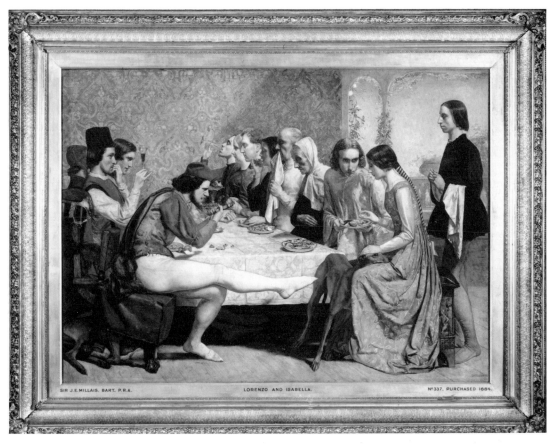

1637. *Isabella* (colour plate III)

evolved from Flaxman in England and Führich and Retzsch in Germany,[4] has a new angularity and 'mediaeval' mannerism which reflects the evolving ideas of the Brotherhood. Its composition was partly pre-figured in Millais' own outline lunette illustrating 'Hospitality' (National Trust; fig. 48), connected with his oil lunettes for John Atkinson of Littlewood House, Leeds which he was completing in the summer or autumn of 1848.[5] It also distantly echoes the feasting group at the right of plate XXVII after Gozzoli's *Marriage of Rebecca and Isaac* in the Lasinio volume of engravings after the frescoes in the Campo Santo at Pisa, of which Millais had a copy on loan in 1848 and over which the circle enthused[6] (fig. 50).

Holman Hunt recorded that: 'Though Millais had much oil work on hand which still had to be finished in the old style, he was impatient to begin in a new manner, and he announced his determination to paint his design. But his old work still hung about until we were almost doubtful of the time before the sending-in day being sufficient for the task, when suddenly, about November, the whole atmosphere of his studio changed, and the new white canvas was installed on the easel. Day by day advanced, at a pace beyond all calculation, the picture

. . . which I venture to say is the most wonderful painting that any youth still under twenty years of age ever did in the world.'[7]

The painting follows and elaborates upon the composition in the outline drawing and a pencil sketch for it (25.5 × 31 cm, British Museum; fig. 51), which take up the line in the opening stanza of Keats' poem, 'they could not sit at meals'. The employment of a table as a central motif round which to group his figures is one prevalent in Millais' early Pre-Raphaelite compositions.[8] In the first sketch the dominant grouping at the table is already established with the kicking gesture the pivotal motive both binding the opposing factions on either side and underlining the evil outcome of the story. Besides the brothers, the lovers, the serving man, the old nurse and the dogs,[9] only one or two vague figures are indicated, and the whole is in a contained space with the arched window wall at right angles. The outline drawing, in turn, multiplies the figures round the table to twelve, probably with the idea of paralleling a Last Supper;[10] a fur pelt is added to the wolf's head on the wall, and again, the Duomo of Florence is visible through the canopied embrasure. An oil sketch for the colour on the same scale as the drawings (22.2 × 29.8 cm, Makins collection; fig.

Fig.48 *Hospitality*. By permission of the National Trust

Fig.49 *Isabella*. By permission of the Syndics of the Fitzwilliam
Museum, Cambridge

Fig.50 Carlo Lasinio, *Pitture a fresco del Campo Santo di Pisa: Le nozze di Rebecca e d'Isacco* (1810; from 1828 edition). By courtesy of Liverpool City Libraries

Fig.51 *Sketch for 'Isabella'*. By permission of the Trustees of the British Museum

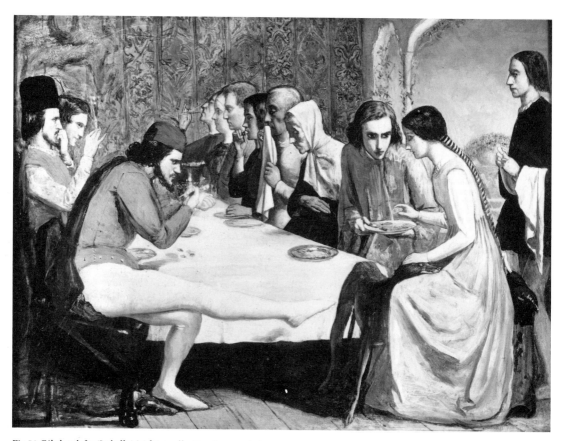

Fig.52 *Oil sketch for 'Isabella'*. Makins collection; by permission
of Lord Sherfield

52), largely follows this, though it was perhaps com-
pleted after studies had been made for the heads and it
also embodies changes made to the details in the large
picture.

In No. 1637 the figures and symbolic motifs of the
drawings are fully exploited. The malevolent brothers
confront the lovers, evil opposing good. One cracks nuts
as he kicks the pet dog (emblem of fidelity), whose
companion is trustingly asleep under his uneasily poised
chair. The other brother contemplates his glass of blood-
red wine. The lovesick Lorenzo offers a blood orange to
Isabella as she fondles her dog. The old nurse appears
apprehensive but the servant behind and the other
figures seem unaware of the tension. Further symbolic
references are introduced. A falcon tears at a white
feather. A carving on the side of Isabella's chair might
represent a beheading, or alternatively pilgrims.[11] The
table appointments, while including an anachronistic
early nineteenth-century two-handled silver cup, poss-
ibly intended as a loving cup and containing grapes
(symbolic of fertility), as well as a porcelain plate, also
embody a group of majolica dishes whose subjects seem
to bear on the story. The centre plate shows a beheading
beneath a tree, perhaps David slaying Goliath, or alterna-

tively, as suggested by Malcolm Warner, Judith and
Holofernes.[12] The plate behind shows three seated
figures, but for their seemingly male attire possibly
representing the Fates. Lorenzo's plate appears to in-
corporate a stricken tree (he was buried beneath a tree in
a wood). That of the brother at the left seems to show an
eagle with outstretched wings pecking at something. Salt
has been spilt from its container, passion flowers climb
the arches behind and an ominous pot of basil stands on
the window sill, pre-figuring Isabella's concealment of
the severed head of Lorenzo.

In conformity with the Pre-Raphaelite idea of greater
truth and verisimilitude, the heads were nearly all
modelled from the artist's friends. Some identities are
definite, but there are a few differences of opinion
between Stephens, Spielmann, W. M. Rossetti, and J. G.
Millais.[13] From the right they are: 1 the servant: given as
Wright, an architect, by Stephens and Spielmann, but J.
G. Millais says A. F. Plass, a student, and W. M. Rossetti
suggests Charles Compton, also a student; 2 Isabella: Mrs
Mary Hodgkinson (d.1896), wife of Millais' half-brother;
3 Lorenzo: undoubtedly W. M. Rossetti[14] with his hair
changed to yellow (Stephens and Spielmann suggest
Compton here; and Miss Millais in 1934,[15] suggested

Walter Deverell); 4 elderly man with napkin: Millais' father; 5 man with curly hair paring apple: W. Hugh Fenn (and confirmed by a portrait of him;[16] but thought to be Compton by the latter's granddaughter);[17] 6 man drinking: Dante Gabriel Rossetti; 7 youth at far end on the left of the table: variously thought to be W. B. Scott (Spielmann), Stoker, a medical student (W. M. Rossetti), confused with 8 by Stephens and J. G. Millais, but who is probably the handsome Walter Deverell, who is also said by J. G. Millais to have posed for the picture. 8 the brother holding a wine glass: F. G. Stephens (whose portrait in for example *Ferdinand and Ariel*, he resembles; fig. 59);[18] 9 brother kicking Isabella's dog: John Harris, an art student (probably the one who had been disagreeable to Millais when a child in the Royal Academy Schools and who died about 1855), though J. G. Millais thought also from Wright, an architect. The grey-haired woman, the youth or girl eating grapes and the old nurse on the right of the table have never been identified and are perhaps professional models.

Combined with the distinctive realism resulting from painting from the life is a mannered stiffness, particularly in the pose of Isabella, perhaps deliberately to retain the 'Primitive' quality of the drawing. Spielmann[19] points out that Isabella is modelled on 'Beatrix d'Este' in the illustrations by Mercuri to Camille Bonnard's *Costume Historique* (first published 1829), of which Millais had tracings (see Nos 6598–6601 below). He suggests that the general stiffness may have been derived from this source.

The figures are also no longer in the defined space of the first sketch. The background has been simplified and the angles blurred in order convincingly to accommodate the many extra figures on one side of the table. The wall is changed to a flat damask hanging (watercolour study 38.0 × 49.0 cm; Sir Ralph Millais collection), and the view of Florence, beyond the garden balustrade (mentioned stanza XXIII) has been obscured by flower pots, providing no outlet for the eye away from the drama. Tonally it is flatter and limited in contrasts in distinction to the figures. While the intention may have been to impart a frieze-like tension to the composition to echo early Italian art, more pressing would have been the hurry of completion between November 1848 and April 1849, with concentration on the heads, figures and table appointments, leaving little time fully to work out the background to the same pitch of colour.[20]

Its progress was watched with enthusiasm by his friends.[21] It was on show in Millais' studio before being entered for the Royal Academy, and Madox Brown saw it on 29 March when he commented in his diary: 'wonderfully painted, full of expression, sentiment, and colour, and extreme good painting, but somewhat exaggerated in character and careless in Drawing'.[22] It was apparently already sold before the artist's show day,[23] according to Holman Hunt to 'three tailors in Bond Street who were making an essay in picture dealing'.[24] Their identity has been convincingly established by Warner[25] as the dealers Richard Colls, William Wethered (also a tailor) and

Charles W. Wass, who had combined together before. Millais was usually to sell to dealers.

At the Royal Academy it was hung, with Holman Hunt's *Rienzi* as pendant, just above the line,[26] and excited much comment in the reviews. A general opinion was reflected in the *Art Journal*[27] review which considered it a 'pure aspiration in the feeling of the early Florentine School'; the composition was admired, though crowded, but 'with all the simplicity of the old painters . . . the relief being effected by opposition of colour'; it would establish the artist's fame. *Fraser's Magazine*[28] admired the delicate colour and the 'vigorous and original' idea of the kick, but found it too mannered. *The Athenaeum*[29] was most critical and discussed it in tandem with Hunt's *Rienzi* at length as 'a recurrence to the expression of a time when art was in a state of transition or progression rather than accomplishment . . . To attempt to engraft the genius of foreign nations upon our own is a most dangerous experiment.' The heads were admired but the kicking action considered unrational: 'This figure extends his unwieldy legs to the immediate front of the picture so as not merely to divide attention with, but to appropriate all attention from the love-sick Lorenzo and the fair Isabel . . . In addition to this absurd piece of mannerism there is in the picture that inlaid look, that hard monotony of contour and absence of shadow which are due to the causes before stated . . .'

Precise studies for some heads are at Birmingham:[30] Isabella, the brother with wine-glass, the serving man, the middle-aged woman, the old nurse in two studies, as she appears both in the outline and in the oil, and the unidentified youth seated centre right; also the dog under the chair at the left (figs 53, 55–8). A study from D. G. Rossetti drinking is in a private collection (fig. 54).[31] A study for a greyhound was with E. G. Millais.[32] An oil study for Isabella's head belongs to Basil Gray. Other studies are cited above. A watercolour (37 × 51 cm, Guildhall Art Gallery) must be a later copy, perhaps associated with the engraving published in *The Art Journal*, 1882.

REPR: A calotype is recorded by W. M. Rossetti, 1849.[33] Engraved by H. Bourne, *The Art Journal*, 1882, p.188.
PROV: Bought by 'three tailors in Bond Street', who must be Richard Colls, W. Wethered and C. W. Wass, 1849, £150,[34] who sold it before the end of the season[35] apparently direct to B. G. Windus of Tottenham;[36] Windus sale Christie's 19.7.1862 (53), bt. in, and 14.2.1868 (332), bt. Gambart, £682.10.0; Thomas Woolner, sold Christie's 12.6.1875 (73), bt. Willis £892.10.0; still with Woolner in 1878 and sold for £950;[37] on sale at the Fine Art Society, 1881, bt. C. A. Ionides;[38] his sale Christie's 5.5.1883 (131), bt. in at £1,102.10.0; Holland, bt. Boussod, Valadon & Co., from whom purchased by the Walker Art Gallery, July 1884, £1,050.[39]
EXH: Royal Academy 1849 (311); Manchester 1878, *Art Treasures* (223); Fine Art Society 1881, *Millais* (3); Walker Art Gallery 1884, *Liverpool Autumn Exhibition* (189); Manchester 1885; Grosvenor Gallery 1886, *Millais*

Figs 53,55–8 *Studies for some of the heads and the dog for 'Isabella'.* By permission of Birmingham Museums and Art Gallery

Bottom left: Fig.54 *Study of Dante Gabriel Rossetti for 'Isabella'.* Private collection; photograph Courtauld Institute of Art

(120); Conway 1888; Guildhall 1894 (114); Royal Academy 1898, *Millais* (23); Glasgow 1901 (319); Walker Art Gallery 1922, *Liverpool Jubilee Autumn Exhibition* (27); Manchester, 1929; Royal Academy 1934, *British Art* (545); Birmingham 1947, *P.R.B.* (48); Whitechapel 1948, *P.R.B.* (43); Tate Gallery 1948, *P.R.B.* (14); Royal Academy 1951–2, *First Hundred Years* (279); Sheffield 1952, *Some Famous Pre-Raphaelites*; Swansea and Aberystwyth 1955; Nottingham 1959, *Victorian Paintings* (45); Liverpool and R.A. 1967, *Millais* (18); Tate Gallery 1984, *P.R.B.* (18), repr. col.

1 Millais relied on stock mouldings, except for designing the frame for Charles Collins's *Convent Thoughts*, 1851: see Lynn Roberts, 'Nineteenth Century English Picture Frames, I The Pre-Raphaelites', *The International Journal of Museum Management and Curatorship*, June 1985, pp.157, 168.

2 Hunt 1905, I, pp.80, 103.

3 Hunt 1886, p.482, gives Aug. 1848; Hunt 1905, I, pp.103–4, implies soon after the sending-in day of April 1848, but in II, p.451, mentions June or July; see also Hunt 1886, p.480, mentioning Monckton Milnes's biography of Keats. A list of subjects from Isabella suggested by Rossetti for illustration by the Cyclographic Club is given in E. Wood, *Dante Rossetti and the Pre-Raphaelite Movement*, 1894, p.60, thus involving Rossetti in the scheme (quoted with a general discussion, by Judith Bronkhurst in Tate Gallery 1984, *P.R.B.* (163), on Hunt's companion drawing).

4 See Vaughan 1979, Chapter IV, 'F. A. M. Retzsch and the Outline Style' and p.154. An affinity to an outline by H. C. Selous, an artist whom Millais knew personally, of a feasting scene under a tent (plate I to *Robert the Bruce*, 1847), is

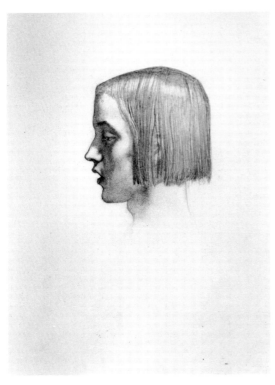

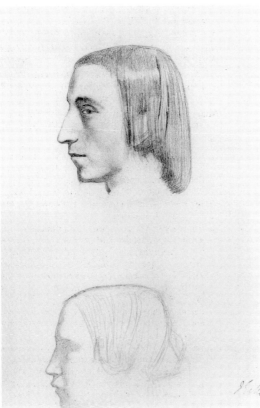

suggested by Stephen Calloway, MA Thesis, *Attitudes to the Mediaeval in English Book Illustration*, 1975, Courtauld Institute; but see also note 5.

5 See Liverpool and R.A. 1967, *Millais* (10–15, 210–226), and Arts Council 1979, *Millais* (36–40). *Hospitality* may in turn derive from Frank Howard's outlines to Shakespeare, 1833, III: *Richard III*, p.9, pl.6. Millais was evidently aware of the wide field of the outline illustrations of the period.

6 Hunt 1905, I, p.130.

7 Hunt 1886, p.482.

8 D. S. MacColl in a review of a Millais exhibition of drawings in 1901 (*Saturday Review*, 13 April 1901, p.468), noted the motif of grouping figures round a table in three of Millais' major early Pre-Raphaelite works: *Isabella*, end on, *The Carpenter's Shop*, broadside, and *The Deluge* (a drawing never finally executed as an oil), a semi-circular table. The first can be seen as separating good from evil; the second as an altar table; and the third might denote the family or marriage circle. See also Alastair Grieve, 'Style and content in Pre-Raphaelite drawings,' *Pre-Raphaelite Papers*, 1984, p.41.

9 Similar paired greyhounds also appear in Millais' lunette line drawing, *Youth* for his Leeds series (see note 5).

10 Suggested by Graham Parry in 'The Pre-Raphaelite Image: Style and Subject 1848–56', *Proceedings of the Leeds Philosophical and Literary Society, Literary and Historical Section*, XVII, part I, p.13.

11 Tate Gallery 1984, *P.R.B.*, p.69.

12 Ibid, pp.68–9.

13 F. G. Stephens, introduction to Grosvenor Gallery 1886, *Millais*; Spielmann 1898, pp.71, 84–5; W. M. Rossetti, *Magazine of Art*, 1888, p.vi; his *Dante Gabriel Rossetti, his Family Letters* 1895, I, p.130, and his annotations to an MS list sent to him by the Gallery, 11 Sep. 1917; J. G. Millais, I, pp.69–70.

14 Confirmed by the artist in a letter to C. Dyall, Curator, Walker

Art Gallery, 19 Aug. 1884, also confirming the identities of
D. G. Rossetti and Millais senior.

15 Brig. Gen. Ernest Makins to the Walker Art Gallery, 26 Feb.,
6 March 1934, citing her opinion.

16 Tate Gallery 1984, *P.R.B.* (14) repr.

17 Miss J. Turner, letter to Humphrey Brooke, Royal Academy,
10 March 1967 (Gallery files).

18 Confirmed by J. C. Francis in *Notes and Queries*, 18 March
1916, citing the opinion of Col. Stephens, the sitter's son.

19 Spielmann 1898, p.85; and see Roger Smith, 'Bonnard's
Costume Historique – a Pre-Raphaelite Source Book', *Journal
of the Costume Society*, 1973, VII, pp.28–37.

20 Millais noted in a letter to Hunt (27 May 1875, Pierpont
Morgan Library, New York), following the latter's article on
technique in *The Portfolio*, VI, 1875, that his early oils from
Isabella, and including *Sir Isumbras* (No. LL 3625 below),
were painted in copal or amber varnish and had kept well.

21 Hunt 1905, I, p.158.

22 Surtees, *Diary* p.61; and see Hunt 1905, I, p.170.

23 Hunt 1886, p.482.

24 Hunt 1905, I, p.177.

25 Tate Gallery 1984, *P.R.B.* (18), p.70.

26 Hunt 1905, I, p.177.

27 *The Art Journal*, 1 June 1849, p.171; see also *The Literary
Gazette*, 9 June, quoted by Warner in Tate Gallery 1984,
P.R.B., p.69. *The Times* of the following year, 4 May 1850,
referred back to it as a boccacciesque picture.

28 Quoted by F. G. Stephens in Grosvenor Gallery 1886, *Millais*,
followed by J. G. Millais, I, pp.70, 73.

29 *The Athenaeum*, 1849, p.575, quoted at length in Hunt 1905,
I, pp.178–9.

30 Birmingham City Art Gallery, *Catalogue of Drawings*, 1939,
pp.264–5 (see Liverpool and R.A. 1967, *Millais* (229–36)).

31 Repr. J. G. Millais, I, p.70, and *Liverpool Bulletin* 1967, p.43.

32 Christie's sale, 14.11.1967 (148), bt. Stone Gallery, Newcastle
upon Tyne.

33 Fredeman 1975, p.24, apparently referring to *Isabella*.

34 Identified by Warner, in Tate Gallery 1984, *P.R.B.*, p.70.

35 Hunt 1905, I, p.177.

36 Warner, loc. cit.

37 J. F. Cox in 'Thomas Woolner's Letters to Mr and Mrs Henry
Adams', *Journal of Pre-Raphaelite Studies*, Nov. 1981, p.5,
quotes a letter of Woolner's, 9 April 1882, referring to picture
sale prices: '. . . Every 40 or 50 years the fashions change in
these matters, now persons are beginning to buy early Millais.
I sold mine for £950. The Company sold it immediately for
£1,400, and the present possessor has been offered £2,500. A
short time ago I could not have got £800.' The Fine Art Society
Directors' meeting, 9 May 1881, Minutes, imply a purchase
price of £1,150 with £900 on that occasion to the unnamed
vendor.

38 Fine Art Society Minutes, loc. cit. Alderman Samuelson,
Chairman of Liverpool Arts and Libraries Committee, was
thinking of buying it in both 1881 and 1883 (letters Gallery
files).

39 Libraries and Arts Committee Minutes, 10, 24, and 31 July
1884 (Liverpool Record Office, 352 MIN/LIB 1/16).

6598. *Beatrix d'Este*

Inscribed: *MCCCC*, and on mount: *Bande de velours noir
garnie de perles*

6599. *Noble Milanaise*

Inscribed: *MCCCC*

6598. *Beatrix d'Este*

6600. *Reine de Chypre*

Inscribed: *MCCCC*, and on mount: *Robe de dessus
velours bleu*

6601. *Nobles Florentins*

Inscribed: *MCCCC*, and on mount: *Pourpoint velours noir*
Pen and ink and watercolour on tracing paper, each
7⅞ × 5⅜ in (20.0 × 13.6 cm)

Copies after four plates in Vol. II of Camille Bonnard's
Costume Historique, first published in Paris, 1829–30
with plates by Paul Mercuri; an edition with coloured
plates is in the British Museum.[1] Further copies of other
plates in Vol. II are in the Royal Academy Library, and in
the artist's family ownership. Malcolm Warner has
noted[2] that an inscription by Alice, daughter of the artist,
on a folder of those now belonging to her son R. A. Cecil,
states that the tracings were made not by Millais himself,
but by his father, who was an amateur watercolourist.
Beatrix d'Este is after pl.55, p.109, Vol. II.

Spielmann first noted[3] that *Isabella* herself in No. 1637
above is based on the plate of *Beatrix d'Este* (which is
after the Sforza altarpiece in the Brera, Milan). The stiff

Top left: 6599. *Noble Milanaise*
Top right: 6600. *Reine de Chypre*
Bottom left: 6601. *Nobles Florentins*

profile pose is similar both in the ink drawing (Fitzwilliam Museum; fig. 49), and in the oil, which would suggest that he was aware of Bonnard when designing the drawing,[4] but the single plait of ribbon-bound hair is only introduced in the latter and then in a slightly different form to the plate; the dress is in different folds in both and in dissimilar material.

Millais also used a plate of a *Jeune Italien* (tracing, R. A. Cecil collection), for his *Ferdinand and Ariel*,[5] but does not otherwise appear closely to have followed any of the plates.

PROV: By family descent to E. G. Millais; his sale Christie's, 14.11.1967 (139), bt. Walker Art Gallery.
EXH: Liverpool and R.A. 1967, *Millais* (237–40).

1 Roger Smith, 'Bonnard's *Costume Historique* – A Pre-Raphaelite Source Book', *Journal of the Costume Society*, VII, 1973, p.30.
2 Arts Council 1979, *Millais* (43), p.26.
3 Spielmann 1898, p.85.
4 Roger Smith, op. cit., p.29, suggests that the line drawing (Fitzwilliam Museum, Cambridge) pre-dates a viewing of Bonnard; certainly the plaited hair is different.
5 Warner, in Arts Council 1979, *Millais* (41), p.26.

273. *Ferdinand lured by Ariel*

Oil on board, oval, 14.6 × 10.9 cm (5¾ × 4⁵⁄₁₆ in)[1]
Signed, verso: *JM* (monogram)

A sketch for the oil painting which was taken up immediately after *Isabella*.[2] Ferdinand here walks beside a stream with rushes growing in the water, drawn on by the whisperings of Ariel disguised as a sea nymph, and the spirits of the air gliding before him playing music; in the distance below an expanse of sky is a wrecked ship on the seashore. The finished oil painting (25½ × 20 in, Makins collection; fig. 59),[3] with its differently treated background, painted in the summer of 1849, was completed about December 1849 and exhibited at the Royal Academy of 1850, with a quotation in the catalogue from Shakespeare's *Tempest*, Act I, scene 2:

Ferdinand
Where should this music be? i' the air or the earth?
Ariel
Full fathom five thy father lies;
 Of his bones are coral made;
Those are pearls, that were his eyes:
 Nothing of him that doth fade
But doth suffer a sea-change
Into something rich and strange.
Sea-nymphs hourly ring his knell:
 (*Burthen*, ding-dong).
Hark! now I hear them, -ding-dong, bell.

The design of this sketch is a development of the independent ink drawing of 1848 (No. 10364 above), and shows intermediate variations between that and the finished oil painting, which was commissioned by a Mr Wethered[4] (see also *Isabella* provenance, No. 1637 above). Its fluid handling and lightness of treatment in the figures is consistent with Millais' usual practice in oil sketches which precede the setting of models and the painting of the background from a particular spot. Ariel is still conventionally fairy-like, but both his group of spirits and the figure of Ferdinand display the new tautness of Millais' first Pre-Raphaelite manner. In the final oil, the figure is more realistically treated, the spirits more elf-like and weird, and acid green in colour rather than the conventional pink of this sketch. The background, the artist's first Pre-Raphaelite outdoor subject, is changed to a minutely detailed study of willows and undergrowth.[5]

In this sketch, the background beyond the rushes suggests the perhaps more appropriate seashore. The change to a wholly leafy scene along the grassy banks of a stream may have been a combination of three factors: convenience in taking advantage of local scenery on his summer visit to Oxford in 1849;[6] his developing enthusiasm to paint the minutiae of nature, to which W. M. Rossetti referred in the *Pre-Raphaelite Journal* of 23 May 1849 (soon after the oil had been taken up), 'Millais said that he had thoughts of painting a hedge (as a subject) to the closest point of imitation, with a bird's nest – a thing which has never been attempted', and 'a river sparrow's nest, built, as he says they are between three reeds . . .';[7] and thirdly, he may have been still uncertain in painting moving clouds and waves in his new minute Pre-Raphaelite manner.[8]

Ariel here drifts in front of Ferdinand, in half crouched position, holding cymbals rather than the lyre of the earlier drawing, as he whispers in his ear: he becomes sharply acrobatic in the final oil, enveloped in his gauzy wings. The spirits already have something of the bold and bat-like appearance finally developed, but are without wings. Ferdinand is almost in the final pose save for his left arm which gropes forward like the drawing, and his left leg which is slightly more forward; he is similarly bearded and costumed. Roger Smith,[9] followed by Malcolm Warner,[10] has pointed out that he is modelled on the 'Jeune Italien' in Camille Bonnard's *Costume Historique* (1829–30), of which Millais had tracings and had already used for *Isabella* (No. 1637 above). He may have seen this as an appropriate quotation for the subject of the play. Changes in the final oil were noted by W. M. Rossetti in the *Journal* in November 1849: the legs were altered and he noted that Millais 'means to make the spirits in the air half human and half like birds'.[11] The oil painting was virtually completed by the end of December.[12]

The commission for Mr Wethered was thrown up by Millais in January 1850, 'as Mr Wethered', W. M. Rossetti recorded, 'among other things on which they did not come to terms perfectly satisfactory to Millais, expressed some doubts of the greenness of his fairies, and wished to have them more sylph-like'.[13] He may have preferred the more conventional approach of this oil sketch.

Three slight drawings for the figures are known, showing developments subsequent to the ink drawing No. 10364 above, together with a study for the head of Ferdinand: 1. a slight pencil sketch (16.5 × 11.3 cm, private collection, 1979),[14] barely indicates the background and shows Ariel, fairy-like, drifting forward holding a lyre while some of the spirits push Ferdinand from behind; 2. a fragmentary sketch, on the back of a sketch for *The Carpenter's Shop* (19.10 × 33.5 cm, Fitzwilliam Museum, Cambridge), showing the spirits with batwings; 3. a pencil sketch (Victoria & Albert Museum, 25.4 × 16.7 cm)[15] concentrates on the figure and costume of Ferdinand in their final form with a slight suggestion of the final horizon. There is also the study of the head of Ferdinand from F. G. Stephens (18.0 × 12.7 cm, Yale Center for British Art, New Haven, Connecticut).[16] The sitter was newly acquainted with Millais and is mentioned as the model in the first entry of the *P.R.B. Journal*, 15 May 1849,[17] when Millais was painting on the beard, so was apparently already started on the head in the large canvas. Stephens himself implies[18] that he sat later in the year when the background had been painted in (as was the artist's usual subsequent practice). In whichever order, the head in the present oil sketch corresponds with the final form and may have been completed in tandem with it.

273. *Ferdinand lured by Ariel* (colour plate IV)

PROV: James Wyatt, of Oxford, sale Christie's 17.2.1883 (131), bt. Shepherd.[19] Bought by George Holt, Liverpool, from J. J. Lackland, dealer, 1883 (bill dated 26 July, £35);[20] by descent to his daughter Miss Emma Holt who bequeathed it to Liverpool, 1944. Sudley Art Gallery.

EXH: Liverpool and R.A. 1967, *Millais* (23).

1 In an elaborate, carved gilt-wood mount, cased in glass, probably dating from the time of acquisition by George Holt.
2 It is first mentioned in the first entry in the *Pre-Raphaelite Journal*, 15 May 1849: Fredeman 1975, p.3.
3 J. G. Millais, I, pp.82–87, repr. p.85; Staley 1973, col. pl.1a; discussed most recently by Malcolm Warner, Tate Gallery, 1984, *P.R.B.* (24) repr. col.
4 Fredeman 1975, p.42.
5 See Staley 1973, p.13 for *The Art Journal* critique of the microscopic botanical detail.

6 Fredeman 1975, p.9; Warner, loc. cit.
7 Fredeman 1975, p.6.
8 Malcolm Warner in letter to the compiler, 25 Aug. 1981, notes this tendency.
9 Roger Smith, 'Bonnard's *Costume Historique* – a Pre-Raphaelite Source-book', *Journal of the Costume Society*, 1973, VII, pp.28–37.
10 Arts Council 1979, *Millais* (43, 41b).
11 Fredeman 1975, pp.24, 26.
12 Ibid, p.39.
13 Ibid, p.42.
14 Arts Council 1979, *Millais* (42) repr. p.13.
15 J. G. Millais, I, repr. p.84.
16 Arts Council 1979, *Millais* (43) repr. p.26.
17 Fredeman 1975, p.3.
18 J. G. Millais, I, p.84.
19 Drawn to the attention of the compiler by Malcolm Warner.
20 Holt Papers, Gallery files.

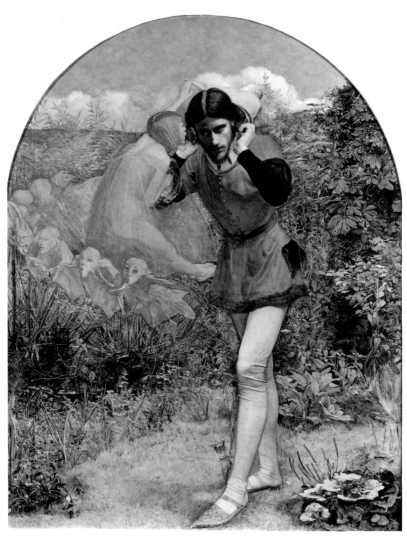

Fig.59 *Ferdinand lured by Ariel*. Makins collection; by permission of Lord Sherfield

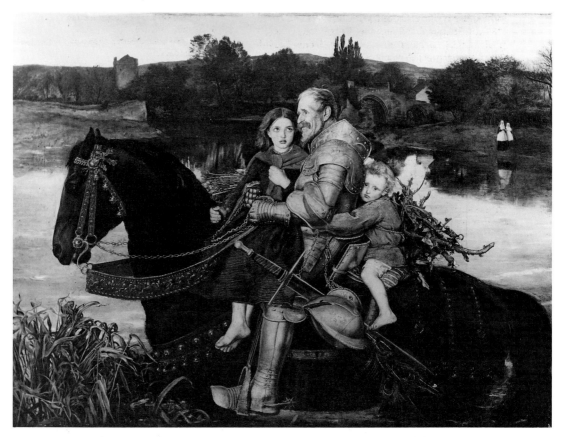

LL 3625. *A Dream of the Past: Sir Isumbras at the Ford*
(colour plate XXI)

LL 3625. *A Dream of the Past: Sir Isumbras at the Ford*[1]
Oil on canvas,[2] 125. 5 × 171.5 cm (49⅜ × 67½ in)
Signed in monogram and dated: *18 JM 57*
Frame: Gilt carved wood with a twisting grape vine in
high relief and undercut, within repeat borders (see text).

An old and honourable knight dressed in golden armour,
at the twilight of his splendid career, is not too proud to
convey the children of a poor woodcutter across the river
on his great charger at evening.

 The fourteenth-century English romance of Sir Isum-
bras may have been seen by the artist, or his wife (who
was an adept story-teller), in the Camden Society pub-
lication of the Thornton Romances, 1844; or Tom Taylor,
then professor of English at London University, who
was involved with the accompanying verses on its
exhibition, may have suggested it. The incident does not
occur in the romance, which tells

. . . of a knyghte,
That bothe was stalworthe and wyghte,
 (And worth)ily undir wede:
His name was hattene syr Ysambrace,
Swilke a knyghte als he was
 Now lyftes nowrewhare in lede.

The subject would be seen as an original variant on the
chivalric subjects popular at the Royal Academy
over the previous decade.[3] Millais' chance meeting
with the French artist Rosa Bonheur at Brig-o-Turk
around August 1856, on her Scottish tour with the dealer
Gambart, may have induced him to vie with her brilliant
animal painting.[4] The picture was painted in the autumn
and winter of 1856–7 at Annat Lodge, near Perth, the
artist's new home after his marriage, and exhibited at
the Royal Academy 1857 with verses in the catalogue
purporting to come from the old romance, but in fact
written by his friend Tom Taylor in order to explain the
disproportionate size of the horse:[5]

The goode hors that the knyghte bestrode,
I trow his backe it was full brode,
And wighte and warie still he yode,
 Noght reckinge of rivere:
He was so mickle and so stronge,
And thereto so wonderlich longe
 In londe was none his peer.
N'as hors but by him seemed smalle,
The knyghte him cleped Launcival;
But lords at borde and groomes in stalle
 Cleped him Graund Destrere.

And als he wente by a woode schawe,
Thare mette he with a lytille knave
 Came rynnaude him agayne –
'Gramèrcy, faire Syr Ysumbras,
Have pitie on us in this case,
And lifte us uppe for Marie's grace!'

 N'as never childe so fayre.
Theretoe of a mayden he was ware,
That over floude he mighte not fare,
Sir Ysumbras stoopede him thare,
 And uppe ahent hem twayne.

–Metrical Romance of Sir Ysumbras

The picture is the first of a group carried out on an alto-
gether larger scale than previous work. It can be seen as
an attempt to seek an amalgam between the 'mediaeval'
compositions and realistic approach of the artist's first
youth, such as *Isabella* (No. 1637 above) and his most
recent 'mood' paintings in modern dress with their more
fluid technique, in which the landscape forms an impor-
tant element in conveying an idea. It follows on im-
mediately after *Autumn Leaves*, 1855–6 (Manchester
City Art Gallery), as the second painting undertaken after
his marriage which incorporates Highland scenery at
twilight as a key element in evoking the idea of transi-
ence, there of youth, here of life itself. The hieratic format
of the equestrian figure owes much to early sources (see
under Sandys, No. LL 3453 below). The new fluid
handling seems to suggest the fleeting imagery of the
departing light of the autumnal landscape, while in the
dominating group of figures in the foreground, the more
precise but already coarsening handling seems to spell
an uncertain hold upon the style of the artist's youth from
which he had already turned away.

Effie Millais kept an account[6] of work on the picture
and noted that her husband was 'extremely expeditious
in finishing the background, which did not take him
more than a fortnight. During the end of October and
beginning of November, 1856, he went every day to the
Bridge of Earn and painted the old bridge and the range of
the Ochils from under the bridge, composing the rest by
adding a mediaeval tower.' The tower was, according to
J. G. Millais,[7] from Elcho Castle on the Tay below Perth
and further trees were added. In earlier years the back-
ground in his paintings, taken from one spot, had
occupied Millais for many weeks. Malcolm Warner
quotes his letters to F. G. Stephens about the earlier
Autumn Leaves,[8] in which he explains his change of
approach for this type of picture as 'really more difficult
to paint than any other, as they are not to be achieved by
faithful attention to Nature, such effects are so transient
and occur so rarely that the rendering becomes a matter
of feeling and recollection'. His statement here, that
Autumn Leaves was intended 'to awaken by its solem-
nity the deepest religious reflection . . .', might equally
refer to the present painting on which he was working
around the time of writing.[9]

The slight pencil sketch (No. LL 3604 below) probably
post-dates the painting of the landscape as this is shown

lightly blocked in in its final form. (Malcolm Warner
notes that the artist was getting advice on the armour at
the end of October).[10] In a squarer format, with arched
top, the horse is shown occupying the full breadth of the
foreground. The figure grouping is delicately handled
with a youthful-seeming knight and the children in a
closer, more rhythmic pose. In setting the picture from
the life, the bulk of the armour has given a squat effect to
the knight's pose, with his head jutting forward emph-
asising his age. The children, while gaining in realism
have lost the grace of the sketch. Spielmann[11] gives the
sitter for the girl as Alice Gray, the artist's young
sister-in-law, while J. G. Millais[12] gives Nellie Salmon,
and both give Everett Millais for the boy (but he was only
born 30 May 1856).[13] There are two studies for the head
of the knight, both dated 1857. The first of these (Whit-
worth Art Gallery; fig. 60), shows a middle-aged man, the
other (Oxford; fig. 61) the elderly man of the final picture,
though with more upright head; this model was
apparently from a Colonel Campbell of Perth.[14] The
proportion of the Knight's leg in the stirrup has been
altered, after the Royal Academy 1857,[15] during the
further re-painting of the horse, whose proportions
caused a continual problem. Vertical folds down the
sides of the canvas, and two faint impressions of the
horse's head just visible to the left,[16] indicate the artist's
varied attempts at repositioning the animal and finalis-
ing the pictorial shape.

Effie Millais gives a detailed summary of the initial
alterations before the Royal Academy:[17] 'The horse gave
him a world of vexation from first to last. He always said
he had chosen a fine animal to paint from, but most
people thought not. He painted it day after day in the
stableyard at Annat Lodge, and had made a very beautiful
horse when Gambart, the dealer, saw the picture and
offered £800 for it, but said the horse was too small.
Millais refused this price, thinking he ought to get more,
and Gambart left. After a little while Millais began to
think the horse was too small, and most unfortunately
took it out, and finished by making his animal too large.
All the critics cried out about the huge horse, called it
Roman-nosed, and said every kind of absurd thing about
it, forgetful of the beauty of the rest of the picture . . .'

In London before the Royal Academy, Holman Hunt
thought the animal 'glaringly too large'[18] but Millais
would not alter it and, according to Hunt, at that stage got
Tom Taylor to write the imitative ballad for the catalogue
which made a point of its great size.

The picture was not well received. *The Athenaeum*[19]
commented: 'Mr Millais, anxious to produce an effect at
all risks, and to astonish if not to please, plunges with
vigour into seas of fancy, not always free from mud at the
bottom; though in that sullying ooze lie jewels, as we all
know. He does not paint with that such frantic love and
vehement patience as he used to do years ago; indeed the
decline from pictures like the 'Release' to 'Sir Isumbras'
is extraordinary. [The picture] . . . is monstrous, and is
scarcely redeemed by glimpses and eyelet-holes of
beauty . . .'

Fig.60 *Study for the knight in 'Sir Isumbras at the Ford'.* By permission of the Whitworth Art Gallery, University of Manchester

Fig.61 *Study of Colonel Campbell for the knight in 'Sir Isumbras at the Ford'.* By permission of the Visitors of the Ashmolean Museum, Oxford

The Times[20] summed up current opinion for the widest public: 'We look upon Mr Millais as in about the most dangerous position in which it is possible for a young artist to be placed. Contemptuously or vehemently decried by one set of judges, indiscriminately and outrageously praised by another, he cannot, it is to be feared, hope for reliable guidance from public criticism. The judgements usually passed on his pictures this year may irritate him, but from their sweeping censure he will probably take refuge in commendation as sweeping . . .' Wishing to provide criticism 'honestly and kindly meant', it continued: 'His picture of "Sir Ysumbras at the Ford" sins so conspicuously and unmistakeably against positive laws both of proportion and light that we can scarcely believe Mr Millais himself to be blind to the worse of his own mistakes.' The background was admired: 'Nothing can exceed the solemn twilight hush and calm of this background.' The figures, however, were not: 'The head of the old knight, taken by itself, is worthy of the background; and, though there is good reason for exception to the size of the girl's eyes and the drawing of her lower limbs, there is a vivid rendering of the expression intended to be conveyed in her face and action. But the proportions of the horse are impossible, and, even if we grant that extraordinary size which the verses in the catalogue attribute to the "Grande Destrere," the drawing of the animal is thoroughly faulty, and the

texture of his coat untrue to nature. The knight himself appears stunted and dwarfish, and his foot, making every allowance for the clumsiness of the solleret, is out of proportion to the rest of the body.' A graver defect was found in the reflection of the sky in the water which did not darken towards the foreground: 'Worse than this, we must insist upon it that the whole foreground group is represented under a light far more vivid and displaying local colour far more positively than is consistent with the time of day. Granting that the background is true to the solemnity of twilight, and the foreground group strong in colour and forcible in relief, we maintain that the respective merits of the two are incompatible. The picture has thus missed being, what it might easily have been made, an impressive and grand work.' Its most severe criticism was reserved for the technique: '. . . Mr Millais has not trusted to finish; indeed, much of the picture is carelessly painted, while the composition invites criticism, so daringly does it depart from all received notions of agreeableness and grace. Every man is at liberty to throw these over if he can substitute for them deeper and more thoughtful qualities. But the mistakes of the artist here go far to rob his work of any such redeeming merit, which, if more correctly painted and drawn, it might have claimed.' The Times then made a concluding criticism on the artist's contributions at the Royal Academy: '. . . there is so much of daring, so much

of shortcoming, so much that looks as if Mr Millais fancied himself no longer a learner, but one who has reached the point at which he can throw finish on one side, and defy minute criticism.'

John Ruskin in a long notice in *Academy Notes*[21] was the most damning, but was also the most understanding of the picture's real message: 'The change in his manner, from the years of "Ophelia" and "Mariana" to 1857, is not merely Fall – it is Catastrophe; not merely a loss of power, but a reversal of principle: his excellence has been effaced, "as a man wipeth a dish – wiping it, and turning it upside down." ' Summarising its faults he continued, 'These, and other errors or shortcomings . . . are the less excusable because the thought of the picture was a noble one . . . It does not matter whether we take it as a fact or as a type: whether we look verily upon an old knight riding home in the summer twilight . . .; or whether we receive it as a type of noble human life, tried in all war, and aged in all counsel and wisdom, finding its crowning work at last to be bearing the children of poverty in its arms . . . It might bear a deeper meaning even than this: it might be an image less of life than of the great Christian Angel of Death, who gives the eternal nobleness to small and great: Death, bearing the two children across the calm river, whither they know not . . . All this, and much more than this . . . it would have brought home at once to the heart of every spectator, had the idea been realised with any steadiness of purpose or veracity of detail . . .'

A satirical print, by Frederick Sandys, called *The Nightmare* (No. LL 3453 below) was published during the summer. Several political cartoons based on it date from the twentieth century.[22]

Millais found it difficult to sell, its size was disliked and he planned to keep it rather than get less than a £1,000 for it.[23] After the exhibition he repainted the horse again (Lewis Carroll had noted its gigantic effect at the Royal Academy, 'increased by being partly out of the picture').[24] Effie described the repainting:[25] 'The same animal came and stood day after day in our yard, the representation of the old one having been completely removed from the canvas by means of benzole . . . The new horse now appeared, to my mind, exactly like the first one.' The picture was then damaged in the head of the knight in an accident. 'I thought this picture doomed to failure . . . However, with the new horse and the knight's leg lengthened, it attracted considerable attention at Liverpool, and the committee did not know whether to give Millais the prize of £50 for it or for his "Blind Girl".'[26] According to Hunt,[27] the water was also dimmed at this time.

The unpopularity at Liverpool over the prize given, once again, to one of the Pre-Raphaelites was also reflected in the local criticisms on this picture. The Liverpool *Mercury*[28] echoed Ruskin: 'There is always a "best" even of bad things, and some objects less ugly than others. Of the above picture we perhaps may say that it is the finest Pre-Raphaelite effort yet out; but what a meagre compliment to such a genius as Mr John Everett Millais.'

Crowds gaze upon that production as they would (but less venturesomely), upon a lovely creature, in all the ripeness of youth, infested with the plague. It is the lazar house of limning, the rock a painter hard to match for power and thought has irrevocably split upon – a painter who has had the noblest pen of criticism in Europe to maintain him on his throne, if that throne had been raised on a surer base; but the kingmaker himself has turned away in dudgeon . . .'

Millais sold it to Charles Reade the writer, possibly in 1858 and certainly by July 1859, at a considerable reduction in price,[29] and at the same time was planning to sell 'a little sketch of it' to White, the dealer[30] (see No. LL 3603 below).

According to Spielmann[31] the horse was again re-touched at the time of the Grosvenor Gallery exhibition, 1886. In 1892 Millais added the present elaborate trappings and retouched the horse, strengthening the neck and girth, at the request of the new owner R. H. Benson. The original much simpler harness can be seen in the watercolour sketch and in a small oil version (see No. LL 3603 below). The artist found a source for the bells on the harness in drawings of the *Field of the Cloth of Gold* in the Herald's Office.[32] Benson replaced the frame, which had been of stucco with arched top corners with the present deeply carved frame, 'made from one of the fine models in the South Kensington Museum'.[33]

Related works, besides those below, are: a slight pencil sketch for the composition ($3\frac{1}{2} \times 4\frac{3}{8}$ in), Ashmolean Museum, Oxford; study for the head of Sir Isumbras, pencil, $10\frac{5}{8} \times 7\frac{1}{2}$ in, signed and dated 1857, Whitworth Art Gallery, University of Manchester; study of Colonel Campbell for head of Sir Isumbras, pencil, $9\frac{11}{16} \times 7\frac{3}{8}$ in, signed and dated 1857, Ashmolean Museum, Oxford (both heads mentioned in text above and figs 60, 61); small oil version, private collection (see No. LL3603).[34]

PROV: Sold to Charles Reade (1814–84), by July 1859,[35] (?) £400 or £500;[36] John Graham of Skelmorlie by 1869; his sale Christie's, 30.4.1887 (80), bt. Agnew £1,365; thence to Robert Benson, 2 May 1887;[37] thence bought 9 Jan. 1906 by Agnew for George McCulloch;[38] his sale Christie's 29.5.1913 (167), bt. Gooden £8,190 for W. H. Lever (1st Viscount Leverhulme), with commission £8,394.15.0;[39] thence to the Lady Lever Art Gallery.
EXH: Royal Academy 1857 (283); Liverpool Academy 1857 (217); Glasgow Institute 1869 (145); Grosvenor Gallery 1886, *Millais* (124); Guildhall 1894 (116); Royal Academy 1898, *Millais* (47); Fine Art Society 1901, *Millais* (30); Royal Academy *Winter* 1906 (115) and 1909 (10); Rome 1911 (39) repr; Tate Gallery 1913 (23); Glasgow 1915; Walker Art Gallery 1922, *Jubilee Autumn Exhibition* (21); Royal Academy 1934, *British Art* (596); Port Sunlight 1948, *P.R.B.* (136); Walker Art Gallery 1960, *150th Anniversary of Liverpool Academy* (66); Liverpool and R.A. 1967, *Millais* (55).

1 Initially called just *Sir Isumbras at the Ford* but Graves gives this longer title and it is repeated in the *Athenaeum* criticism, 9 May 1857, and *The Art Journal*, 1857, p.170, while Ruskin in *Academy Notes* gives merely *A Dream of the Past*.

2 Relined.

3 *The Thornton Romances* (The early English Metrical Romances of Percival, Isumbras, Eglamour and Degrevant, Selected from Manuscripts at Lincoln and Cambridge, edit. by James Orchard Halliwell, Camden Society, 1844), are referred to in Grosvenor Gallery 1886, *Millais*, p.78 (and pointed out to the compiler by Richard Ormond, 22 Feb. 1967). Mark Girouard, in *The Return to Camelot*, 1981, p.146, comments of the 1850s that 'knights in armour jostled each other on the walls of the Royal Academy' (see also pp.157–9, repr., for this picture). See note 5.

4 J. G. Millais, I, pp.210–11, 305. The correct year of this meeting is clarified by Jeremy Maas, in *Gambart, Prince of the Victorian Art World*, 1975, pp.85–6.

5 J. G. Millais, I, p.313. Ruskin in his *Academy Notes* for 1857, commented that the legend 'does not exist in the Romance from which it professes to be quoted, and is now pretty generally understood to be only a clever mystification by one of the artist's friends, written chiefly with the view of guarding the awkward horse against criticism'. While this incident does not appear, lines 12–24 are lifted from stanza VI of the original and one adventure involves the knight carrying his family over a river (stanzas XIV–XVIII).

6 J. G. Millais, I, p.306.

7 Ibid.

8 Stephens Papers, Bodleian Library, Oxford (MS Don. e. 57 fols 31–2), published by Malcolm Warner, 'John Everett Millais' "Autumn Leaves": "a picture full of beauty and without sentiment" ' in *Pre-Raphaelite Papers*, 1984, pp.139, 127.

9 Written following F. G. Stephens' criticism in *The Crayon*, III, Nov. 1856.

10 Arts Council 1979, *Millais* p.32, mentioning a letter to F. R. Pickersgill, 27 Oct. 1856, thanking him for advice. Millais made a youthful Book of Armour, 1845, from studies chiefly at the Tower Armoury (repr. J. G. Millais, I, pp.31–3: several examples from it are at Birmingham City Art Gallery).

11 Spielmann 1898, p.96.

12 J. G. Millais, I, p.310: II, p.469 (list).

13 Ibid, I, p.305.

14 Ibid, p.310. A Mr Alexander Miller, writing to the Lady Lever Art Gallery in 1939, commented that his uncle, Thomas Sharp, who had lived at Annat Lodge, Perth, sat for the figure and told him that a Col. Mitchell of the Perth Militia had sat for the face of the knight.

15 J. G. Millais, I, p.310.

16 A photograph in the Gallery files makes this clear.

17 J. G. Millais, I, pp.306, 309–10.

18 Hunt 1905, II, pp.152–3.

19 *The Athenaeum*, 9 May 1857, p.602.

20 *The Times*, 13 May 1857, third notice.

21 Ruskin, XIV, pp.107–11. In a note he commented that *The Times* had anticipated him and chosen similar points for animadversion. His pamphlet was not yet out when Millais wrote to Effie on 15 May (J. G. Millais, I, p.323, and see G. H. Fleming, *They Ne'er Shall Meet Again*, 1971, p.115).

22 The following examples are in the Lady Lever Art Gallery collection: 1. F. C. Gould, in *Westminster Gazette*, 8 Oct. 1912 (inscribed: 'Home Rule, Welsh Disestablishment, Franchise' and 'Autumn Session' on the figures and water); the pen and ink drawing for it is also in the Lady Lever Art Gallery. 2. A. W. Floyd, in *News of the World*, 12 Feb. 1928 ('Women and children First', Baldwin and the 1928 session of Parliament). 3. *Daily Express*, 13 Jan. 1934 ('Sir Isumbras [Beaverbrook] at the Ford', in 'Old Masters from the British Art Exhibition'). 4.

A. W. Floyd, in *Punch*, 18 April 1934 ('Sir Isumbras, the Minister of Transport carries the bairns across'). 5. L. G. Illingworth, in *Punch*, 18 Feb. 1948 (inscribed 'The Children Bill' and 'Crossing the Ford, the Second reading of the Bill to provide better care for neglected children was moved in the House of Lords last week'); the pen and ink drawing for it is also in the Lady Lever Art Gallery. The identity of A. W. Floyd was established by Julie F. Cadell in a letter, 4 Aug. 1986.

23 Undated letter to Effie, 'Tuesday' (Pierpont Morgan Library, New York): the dealers, Farrer, Gambart, White, thought it too big for a room and purchasers did not have galleries; Millais thought of painting a series of small pictures which would pay double. And see J. G. Millais, I, p.323.

24 Roger Lancelyn Green, edit., *The Diaries of Lewis Carroll*, 1953, p.114.

25 J. G. Millais, I, pp.309–10.

26 Its exhibition at Liverpool was uncertain at the end of August: John Miller wrote to Ford Madox Brown on the 29 Aug. that 'Millais who had promised to finish his "Sir Isumbras" has written to say that it has met with an accident while painting it out of doors and consequently it will be too late. This is to all of us a great disappointment, but more especially as I understand the number of works of worth and merit is very small . . .' (artist's family Papers). It was, however, sent by 13 Sep. (*Weekly Albion*, 14 Sep. 1857, p.4). Liverpool Academy Minutes, 14 Sep. 1857, record that after Solomon's *Waiting for the Verdict* was proposed and lost on the vote, both Millais' pictures were proposed and each received four votes; the chairman's casting vote was given to *The Blind Girl*.

27 Hunt to Ruskin (draft), 4 May 1858 (Henry E. Huntington Library, San Marino, California).

28 Liverpool *Mercury*, 5 Oct. 1857.

29 J. G. Millais, I, pp.313–14, 348: it was to be hung in the drawing-room. Charles L. Reade and the Rev. Compton Reade, *Charles Reade, a Memoir*, 1887, II, p.91 (kindly pointed out to me by Josephine Edmonds): in an undated letter Reade notes 'Millais has offered me £500 for Sir Isumbras', presumably meaning the selling price to Reade. Millais recorded its being sent off in a letter to Effie 21 July 1859 (Pierpont Morgan Library, New York; and see J. G. Millais, I, p.348). The artist John Gilbert saw it at Reade's house on 14 Aug. 1863 and noted in his diary, 'I was astonished and offended by the slovenly coarse painting, the badness of the drawing, and the entire vulgarity of the picture'. (Richard Ormond, 'Sir John Gilbert, The Private Life of a Victorian Painter', *Country Life*, 25 Aug. 1966, p.462). See also note 36.

30 J. G. Millais, I, p.348.

31 Spielmann 1898, p.96.

32 J. G. Millais, I, pp.317–19.

33 Ibid: not identified, and probably after one of the plaster models; details of the Roslin Chapel model are not dissimilar.

34 Malcolm Warner, forthcoming Catalogue Raisonné (Ph.D. MS Nos 536–7).

35 See note 29.

36 Hunt 1905, II, p.153, gives £400. Walter Armstrong in 'Sir John Everett Millais', *Art Journal*, Special Number, 1885, p.14, gives even less: 'He paid £300 for it, and soon after sold it for £700. A few years later it again changed hands at a still larger price, viz. £1,200.'

37 Agnew Picture Stock Book 5, No. 4414.

38 Agnew Picture Stock Book 8, No. 1782 (Christie's stencil 617 CD).

39 Invoice 26 May 1913, Gallery files.

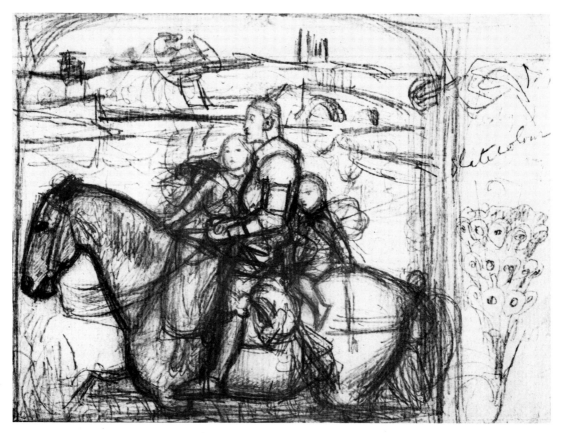

LL 3604. *Sir Isumbras at the Ford: Sketch for the composition*

LL 3604. *Sir Isumbras: Sketch for the composition*
Pencil, 12.2 × 17.1 cm (5³⁄₁₆ × 6³⁄₄ in)

Discussed in the text above. The horse occupies the full width of the composition within a pencilled border having an arched top and with several varying lines to its right-hand margin in order to extend the horse's tail. A pointer to the area by the small boy is inscribed in the extra margin of paper at the right *slate colour*, and a (?) seed-head is also lightly sketched in there.[1]

PROV: (?) With the Fine Art Society 1901; anon. sale Christie's, 31.1.1913 (76), bt. Johnson 8 gns;[2] bought from Miss Geraldine Turner by W. H. Lever (1st Viscount Leverhulme), 1916, 15 gns,[3] and thence to the Lady Lever Art Gallery.

EXH: ? Fine Art Society 1901, *Millais* (31) as *Original sketch for Sir Isumbras*; Birmingham 1947, *P.R.B.* (187); Port Sunlight 1948, *P.R.B.* (138); Liverpool and R.A. 1967, *Millais* (361); Arts Council 1979, *Millais* (58).

1 The composition only, repr. J. G. Millais, I, p.312.
2 Christie's stencil 784 CB.
3 Her letter to Sir W. H. Lever, 15 March 1916, acknowledging his cheque in Lady Lever Art Gallery files.

LL 3603. *Sir Isumbras at the Ford*
Watercolour, 14 × 17.7 cm (5½ × 7 in)
Signed with monogram: *JM*

Sketches of the picture are recorded both in 1859 and 1863. On 20 July 1859 Millais wrote to his wife when the oil was due to go to Charles Reade: 'The Knight leaves by carrier today and I go up to town with a small sketch of it for White.'[1] J. G. Millais lists a watercolour under 1859 as belonging to the artist's brother William Millais.[2] Unless this was, in fact, a small oil version now in a private collection[3] it is unaccounted for. The present small version must be that listed in Effie's account book under 1863[4] and was sold that year to Agnew's (see provenance). This work falls into the category of many small versions of his paintings which the artist produced as pot-boilers for the dealers, and is of interest for showing the picture before the much later alterations to the horse trappings and with a less hefty horse. The sword hilt differs slightly from the picture. Both this and the small oil version display a broader expanse of water at the left.

PROV: Sold by the artist 7 Dec. 1863 to Agnew, who sold it to Samuel Mendel, 30 Dec. 1863;[5] bt. back from Mendel by Agnew 12 Feb. 1872 and sold to John Heugh 11 March

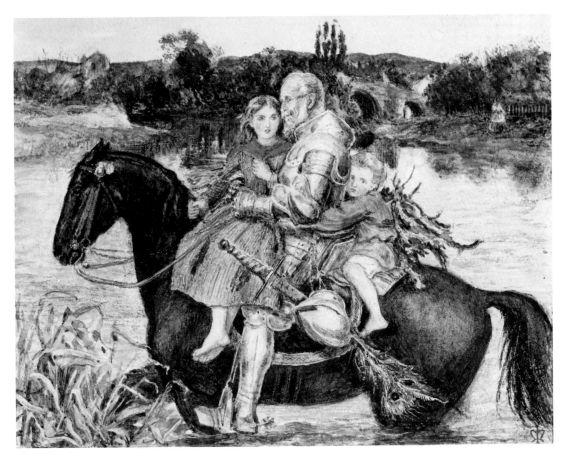

LL 3603. *Sir Isumbras at the Ford*

1872;[6] his sale Christie's 24.4.1874 (32), bt. Agnew, with
Vale of Rest, £220.10.0, and thence sold to John Knowles
1 May 1874;[7] his sale Christie's 19.5.1877 (52), bt. Vokins
95 gns; J. Grant Morris, sold Christie's 23.4.1898 (47), bt.
Laurie £294; A. Sanderson by 1904; his sale Christie's
3.7.1908 (16), bt. Agnew 125 gns, who sold it to Mrs
George McCulloch 14 July 1908;[8] George McCulloch,
sold Christie's 30.5.1913 (213), bt. Gooden £357 for W. H.
Lever (1st Viscount Leverhulme), £365.18.6[9] and thence
to the Lady Lever Art Gallery.
EXH: Bradford 1904 (463); Royal Academy, Winter 1908,
Collection of George McCulloch (310); Birmingham
1947, *P.R.B.* (94); Port Sunlight 1948, *P.R.B.* (139);
Liverpool and R.A. 1967, *Millais* (364); Arts Council
1979, *Millais* (61).

1 J. G. Millais, I, p.348.
2 Ibid, II, p.487 (list).
3 Private collection, 15½ × 19 in; photograph Gallery files (see
 Malcolm Warner, forthcoming Catalogue Raisonné; Ph.D. MS
 Nos 539, 540). Similarly showing the simpler horse trappings
 and thinner horse, but without the nuns appearing on the bank.
 Prov: first appearing in John Morley sale, Christie's 16.5.1896
 (43) under watercolours, as 10½ × 14 in, bt. Vokins £903;
 Howard Morley, who bequeathed it to the Hon. Charles
 Lawrence; thence given to Sir Arthur Worley Bart, and thence
 by descent.

4 Published *Liverpool Bulletin* 1967, p.56, list No. 38.
5 Agnew Drawing Stock Book IA, No. 5664; noted in 'Visits to
 Private Galleries: the Gallery of S. Mendel, Esq., Manchester',
 The Art Journal, 1870, p.210.
6 Ibid, Book 3, No. 1010 (Mendel Cat. No. 78).
7 Ibid, Book 3, No. 2480.
8 Ibid, Book 9, No. 6791.
9 Invoice Lady Lever Art Gallery files.

LL 3624. *Spring (Apple Blossoms)*
Oil on canvas, 113 × 176.3 cm (44½ × 69⅜ in)
Signed in monogram and dated: *M 1859*

A group of girls have been playing at milkmaids, gather-
ing wild flowers and adorning their hair with cowslips,
bluebells, violets, lilac and gentian blossom. They have
set down their milk cans and repose for refreshment
round a great bowl of settling cream; they hold wooden
porringers and gold spoons while one pours milk from a
silver jug and another eats curds. Their warm attire
suggests a cool Northern climate for their fête
champêtre.[1] The low wall separates them from the apple
orchard in bloom and emphasises the frieze-like pattern-
ing, while the scythe introduced at the right acts as a
pointer to the theme of transience.

The picture dates from the period of transition when

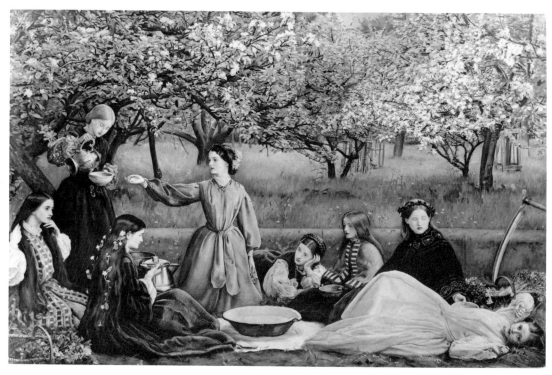

LL 3624. *Spring (Apple Blossoms)* (colour plate VIII)

Millais was seeking a broader technique and larger format. It was taken up initially in 1856 when he was particularly attracted to the scenery around his new home at Perth in its varied seasonal phases as suitable background to underline the mood of his paintings. He was turning both to 'mediaeval' themes and, more particularly, to themes without specific literary content but 'full of beauty and without subject'.[2] According to Effie Millais' later account,[3] quoted below, the picture was to have been of apple trees in blossom with a knight and lady for subject. She states that this was begun in the autumn of 1856 which places it alongside *Sir Isumbras* (No. LL 3625 above) in conception. It may at this stage have been seen as a companion, or antithesis to that picture, presenting spring and youthful love in contrast to age and autumn. The subject may have been given up owing to the failure of *Sir Isumbras* at the 1857 Royal Academy. The change to a modern-dress subject, employing the same orchard setting, is a development of Millais' deeply moving *Autumn Leaves* (City Art Gallery, Manchester) of 1856, showing a continued awareness of the adolescent world of his young sisters-in-law which then surrounded him and developing the same theme of the transience of youth echoed in the changing seasons. Here, the promise of a spring morning takes the place of the passing of an autumn evening, but the pointers to its theme are much more in evidence.[4] The girls, like the apple blossom, are in their fragile bloom; the orchard is

untrodden, they are yet untouched by time and skim the cream or lie contemplative; but the spring flowers are cut and the scythe heralds the coming harvest and the inevitability of time and the seasons.

The idea for the figures may go back to the early 1850s and stem from a pen and ink sketch of a picnic scene dating probably from 1851 (Oxford; fig. 62),[5] where a group of young people sit in a field by willow trees; a girl lying on her back sucking a blade of grass may have suggested the pose, though from a different viewpoint, of the girl in yellow lying at the right of *Spring*. This figure provides both the decorative horizontality overlaying the realistic vision and the relaxed moody dreaminess pervading the picture, which together anticipate the Aesthetic movement of the 1860s.

Millais' first concern, implied in Effie's account,[6] evidently written later around 1860–1 when the picture was still unsold, was the painting of the apple blossom itself, which would be viewed as an original *tour de force*. This is confirmed by his concern, expressed to Holman Hunt in 1858, two years after its commencement, that his idea might be copied. As Warner points out, in that year Ruskin was advocating the detailed painting of spring blossom by Pre-Raphaelite artists.[7] Effie's account seeks to indicate that Millais anticipated Ruskin's suggestion:

'This picture, whatever its future may be, I consider the

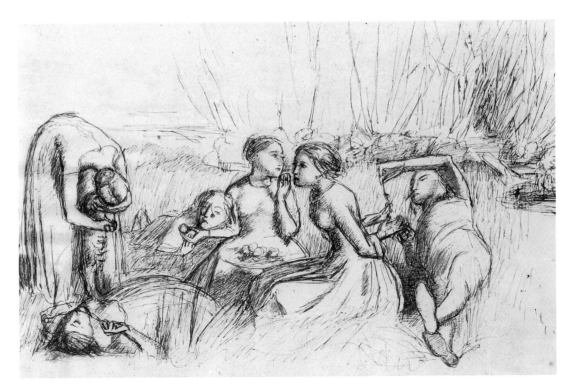

Fig.62 *A Picnic Scene*. By permission of the Visitors of the
Ashmolean Museum, Oxford

most unfortunate of Millais' pictures. It was begun at
Annat Lodge, Perth, in the autumn of 1856, and took
nearly four years to complete. The first idea was to be a
study of an apple tree in full blossom, and the picture was
begun with a lady sitting under the tree, whilst a knight
in the background looked from the shade at her. This was
to have been called "Faint Heart Never Won Fair Ladye".
The idea was, however, abandoned, and Millais, in the
following spring, had to leave the tree from which he had
made such a careful painting, because the tenant at
Annat Lodge would not let him return to paint . . . but
Millais, looking for some other suitable trees, soon found
them in the orchard of our kind neighbour Mrs Seton
(Potterhill), who paid him the greatest attention . . . and
he painted there in great comfort for three weeks whilst
the blossom lasted. During that year (1857) he began to
draw in the figures, and the next year he changed to some
other trees in Mr Gentle's orchard, next door to our home.
Here he painted in quiet comfort, and during the two
springs finished all the background and some of the
figures. The centre figure (in grey, kneeling) was painted
from Sir Thomas Moncrieff's [sic] daughter Georgiana
(afterwards Lady Dudley);[8] Sophie Gray,[9] my sister, is at
the left of the picture. Alice[10] is there too, in two
positions, one resting on her elbow [third from right],
singularly like, and the other lying on her back with a
grass stem in her mouth. He afterwards made an etching
of this figure for the Etching Club and called it "A Day in
the Country".'[11]

Other sitters noted are Helen Moncreiffe, later Lady
Forbes,[12] who is presumably the red-haired girl second
from the right by the scythe,[13] and a local girl Henrietta
Riley, who may also have sat for the recumbent girl at the
right.[14] Agnes Stewart, probably another local girl, is
mentioned as a model by the artist in July 1858 when he
was finishing Alice's 'top-knot'.[15] Agnes might be the
child in the cloak, third from the right; neither this figure
nor that of the girl pouring milk are otherwise identified.
Alice may appear yet again in the second left-hand seated
figure, on the strength of a remark by the artist in a letter
to Effie during April 1859.[16] He was working on the
figures during July 1858 out in the open air, '. . . where I
think one gets a much broader, and better grasp of both
drawing, and effect', he commented to Holman Hunt.[17]
The 'young ladies' he was painting from were due to
leave in mid-August;[18] Sophie was due to sit on her
return from a July holiday,[19] and he was painting from a
little girl in early September and in despair got a lady to
photograph her, 'wh. gave me the first feeling of comfort I
had felt for a very long while – it was so *hideous* that I was
certain my head of her was prettyish'.[20]

Four slight pencil sketches for the figures (art market
and private collection)[21] would appear to post-date the
painting of the orchard and arrive quickly at the final
grouping through slight variants in the minor poses and
number of figures. The figures seem, however, to be in a
deeper circular format, though already the strong hori-

zontal bands of blossom and grass are indicated in some. There is no indication of the wall. This, together with the scythe at the right, first appears in what must be the second of two photographs taken when the picture was far advanced. Millais may have decided to introduce the wall to mask an uncertain spatial relationship between the figures and their background (commented upon by at least one reviewer).[22] More particularly, it parallels the hedged-in format of the *Vale of Rest* (Tate Gallery),[23] with its convent theme, which was begun in the autumn of 1858 and also exhibited in 1859. In *Spring* the low wall is a barrier to the as yet untrodden perfection of the orchard; the scythe is a more obvious strengthening of the common theme of transience.

The earlier of the two photographs (fig. 63)[24] reveals some preliminary features and some of the heads and dresses as yet incomplete, as well as trial touchings on the photograph by the artist. What appears to be a further head is slightly indicated between the third and fourth girls at the left; the figure of Georgina is sketched in in a slightly more relaxed pose than the stiffer, more frontal view finally chosen; the face of the girl seated at the extreme left is different to the final head, moodier and less 'pretty'; a strip of canvas, as yet hardly touched, has been added at the bottom fully to accommodate the two girls in the foreground. This 3½-in strip, the seam of which is still visible in a line running below the cream bowl and through the face of the reclining girl at the right, alters the measurements which must before have matched those of the *Vale of Rest*.[25] The second photograph (fig. 64)[26] shows the picture nearly completed with the wall and scythe introduced. Only the face of the girl holding the jug, the bowl of cream and part of the bottom strip are still unfinished. The head of the girl at the far left is still unchanged. Its later repainting, in a prettier character, was no doubt due to the generally antagonistic reviews which followed a similar pattern in carping on ugliness in the features and an overall lack of 'finish'.[27]

The Times[28] led off in its first review of the Royal Academy exhibition of 1859 on 30 April, with a considered discussion of Millais' two chief pictures[29] in its opening paragraphs. Initial praise for the profundity of the landscape in the *Vale of Rest* led on to an outspoken attack on the ugliness of both pictures and what appeared to be the echo of a general murmuring of doubts on Millais' future. In *Spring*, the 'sentiment of the landscape' was considered less profound than that in the *Vale of Rest*, and the picture 'marred by incompleteness, ugliness and disproportions which we should be startled to see united with such singular power and beauty in the work of any other painter. But Mr Millais has already given us the measure of his weakness as well as his strength. When he combines apple blossom of the natural dimensions with figures not one-third the size of life, when he groups perfect girlish grace, as in the figure stretched at length, on the right of the picture, with almost Hottentot repulsiveness, as in the two girls seen in profile on the left; when he joins his most startling truth of imitation (as in the grass and flowers and the apricot

barège dress of the outstretched figure already referred to) with the most sordid coarseness and slovenliness (as in the heads and draperies of most of the other figures in this group), we can only shrug our shoulders, and admit that all gifts are not given to all, and that heights of powerful achievement are not impossible with the lowest depths of failure. There is no mistake now possible about Mr Millais's strength. He is without any rival in point of vigour. But many are disposed to question if he is not too deficient in the appreciation of beauty to reach the highest rank of his art, which he aspires, and with good reason, to attain . . .'

The Athenaeum[30] of the same date was prepared to like the figures but likewise stressed the coarseness of handling: '. . . There is no romping, but a serene, lady-like enjoyment . . . In a certain ideal of girlish beauty, not very tender or loving, but bold, untroubled and rather stony-dignified, Mr Millais, as he showed us in the 'Autumn Leaves', is excellent . . . Mr Millais still dreads distance, and is here coarse and unfinished, where minuteness would have discovered a thousand subtle beauties. Nothing can be so worthy of dwelling on as the little pink, shell-leaves of the apple blossom, the red, woolly tops, the snowy whiteness, the blushing flushes, the sudden crimsons: all the growth and hope of spring is in it and the red and white intermingle in inexhaustible variety. Here it is strongly, but coarsely expressed: – there is in these later works of Mr Millais too much haste and too much defiant temerity. He, surely, – this knight-errant of Art – is not going to turn manufacturer, and glut the market with bold, clever sketches.'

Ruskin, in *Academy Notes*,[31] while more reasonable and understanding in his judgment of the *Vale of Rest*, nevertheless pointed out a consistent decline and increasing crudity in Millais' work and damned both the apple blossom and the girls: 'And when we look on this fierce and rigid orchard. – this angry blooming – petals, as it were, of japanned brass:[32] and remember the lovely wild roses and flowers scattered on the stream in the "Ophelia"; there is, I regret to say, no ground for any diminution of the doubt which I expressed two years since, respecting the future career of a painter who can fall thus strangely beneath himself.' In the 'fierce colour', 'unsightliness' or 'grimness' of the faces he discovered 'an illustration of the song of some modern Dante, who, at the first entrance of an inferno for English society, had found, carpeted with ghostly grass, a field of penance for young ladies: where girl-blossoms, who had been vainly gay, or treacherously amiable, were condemned to recline in reprobation under red-hot apple blossom, and sip scalding milk out of a poisoned porringer.'

Provincial papers copied Ruskin and the London reviews and a depth of vituperation was reached in the *Dublin University Magazine*.[33] Among artists, however, the two chief 1859 pictures were better received. Millais recorded Landseer's admiration and Sir Francis Grant's cordiality at the preview.[34] Whistler and his friend Fantin-Latour liked them.[35] Whistler's admiration for the formal realism and intensity of mood in Millais' work

Top: Fig.63 Anonymous photographer, *Spring (Apple Blossoms)*, in progress (Gray Family Album). Private collection

Bottom: Fig.64 Anonymous photographer, *Spring (Apple Blossoms)*, in progress. Repr. from J. G. Millais, *Life and Letters of Sir John Everett Millais*, 1899

Fig.65 The reclining girl in *Spring (Apple Blossoms)*. Repr. from
M. Spielmann, *Millais and his Works*, 1898

of this period has been seen to underly his own work of
the early 1860s;[36] he may have been the link also to the
French artist James Tissot, on whose *Printemps* at the
Salon of 1865, contemporary French reviews noted the
influence of *Spring*.[37]

Millais was already aware of the clique against him
before the Royal Academy private view on 29 April; he
had set a high price and feared he would not sell,[38] but
the dealers, D. T. White and Gambart, in turn finally
bought, respectively, the *Vale of Rest* at a reduced
price,[39] and his third picture.[40] *Spring* was sent on direct
to the Liverpool Academy in August,[41] where it was
again badly reviewed[42] and did not sell. Gambart,
however, purchased it before May 1860[43] and put it in his
sale at Christie's in May 1861, where it was described in
the catalogue, under the new title of *Apple Blossoms*, as
'Exhibited at the Royal Academy of 1859 in an un-
finished state, and since completed and most of the
figures re-painted for Mr Gambart'. This was probably to
counteract the bad reviews as retouching appears to be
confined, apart from the girl's face at the extreme left,
mentioned above, to some thicker touches of paint to
some of the faces and hands.

Besides the pencil studies and photographs mentioned
in the text, a pencil drawing for the reclining girl is
reproduced by Spielmann (untraced; fig. 65).[44] Millais
mentioned to Effie in May 1859[45] that D. T. White had
ordered sketches of his pictures but no small version of
Spring has re-emerged: a possible candidate for it might
be the work called *Spring* in the Plint sale, Forsters', 17
May 1860 (88), again untraced.

ENGRAVED: Reproduced *Art Journal* 1891, p.323.
PROV: Sold to Gambart for unspecified price 1859/60: his
sale Christie's, 4.5.1861 (298) as *Apple Blossoms*, bt.
Crofts £483; Jacob Burnett of Tyneside by June 1861,[46]
sold Christie's 25.3.1876 (101), bt. Watkins £1,459.10.0;
bought by Agnew from Lefevre 1 Dec. 1881 and thence

sold to William Graham 16 June 1882;[47] Graham sale
Christie's 2.4.1886 (88), bt. E. White £1,050; David Price,
sold Christie's 2.4. 1892 (90), bt. Clarke, £693; Thomas
Clarke, late of Allerton Hall, Liverpool, sold Christie's
27.2.1920 (153), bt. Gooden & Fox for W. H. Lever (1st
Viscount Leverhulme) (£1,995 plus commission)
£2,044;[48] thence by descent to the 3rd Viscount
Leverhulme, from whom purchased with the aid of a
grant from the National Heritage Memorial Fund, 1986.
Lady Lever Art Gallery.
EXH: Royal Academy 1859 (298) as *Spring*; Liverpool
Academy 1859 (180); London 1862, *International* (699);
Cork 1902 (101); Brussels 1929; Bradford 1930 (76);
Birmingham 1947 *P.R.B.* (62); Port Sunlight 1948, *P.R.B.*
(140); Royal Academy 1951–2, *First Hundred Years*
(294); Liverpool and R.A. 1967, *Millais* (58) repr. detail;
Tate Gallery 1984, *P.R.B.* (96) repr. col.

1 Dr John Shaw, Royal Museum of Scotland, in reply to an
enquiry from the compiler made the following comments in a
letter of 11 Nov. 1986: 'I think you can safely rule out May Day
or Spring customs. Besides the lack of evidence for applicable
customs I cannot imagine it being warm enough for this kind
of exercise in Perth in early May.

'The silver jug and the gold spoon obviously do not belong;
the bowls are of a kind widely used for eating oatmeal foods –
porridge, brose, sowens – and are usually referred to as "brose
caups". Brose was made by pouring boiling water over
oatmeal, with milk added – but I do not think that brose, or
porridge or sowens are being eaten here (problems with
boiling water, no sign of oatmeal). As you suggest, the two
cans probably contain (or have contained) milk. My own
theory runs as follows. The cans have been brought out
containing milk. This has been transferred to the settling dish
(centre foreground) to thicken and acidify. Rennet, or some-
thing else (see below), has been added to separate the curds
from the whey. The scallop shell may be a strainer rather than
a skimmer, though I can see no perforations. This would be
used to separate off the curds (the solid bit) from the whey.
The substance on the golden spoon looks as if it might be
curds. The silver jug probably contains cream: in Aberdeen-

shire, in the 1950s, a small quantity of curds destined for cheesemaking was put aside to be eaten from a saucer, with cream over it.

'There may be other possibilities, but this one fits. There is even a very tenuous link between the curds and the flowers, in that stalks of marsh marigold and ladies' bedstraw were used on Mull (and possibly elsewhere) in place of rennet to curdle milk. To make anything of that, however, might be pushing one's luck a bit *too* far.'

2 Effie Millais' account of *Autumn Leaves* in her contemporary Journal, cited in Liverpool and R.A. 1967, *Millais* (53) and Tate Gallery 1984, *P.R.B.* (74).

3 J. G. Millais, I, pp.323–4.

4 Note F. G. Stephens' later comment, when *Apple Blossoms* was in the Burnett collection (*The Athenaeum*, 20 Sep. 1873, p.373): 'Its inspiration is similar to that of "Autumn Leaves," and it is only less successful than its forerunner, because it is more obviously expressive, that is to say, Mr Millais in designing it was not, as before, content to leave the subtler points of his fine idea to the perception of the observer. The scythe and the pile of flowers the scythe has destroyed, the untrodden but lush grass of the orchard, the rathe abundance of the trees in bloom, to say nothing of the moody looks of one or two of the girls, who partake, or do not partake, of the syllabubs and cream which are dispensed while they sit, lie, kneel, or loll on the sward that grows at the foot of the old wall, – these are poetics which it is hard to misunderstand.' See also Malcolm Warner, 'John Everett Millais's "Autumn Leaves": a picture full of beauty and without subject', *Pre-Raphaelite Papers*, 1984, p.140, and passim.

5 Tate Gallery 1984, *P.R.B.* (172) repr.

6 J. G. Millais, loc. cit.

7 Warner, in Tate Gallery 1984, *P.R.B.*, p.172 cites Millais' letter to Holman Hunt, 16 May 1858, commenting with annoyance on Arthur Hughes' painting an orchard in bloom. Warner points out that Ruskin's *Academy Notes* of 1858 incited such artists through his comment on that year's pictures, that 'among all this painting of delicate detail, there is not one true one of English Spring! – that no Pre-Raphaelite has painted a cherry-tree in blossom – nor an almond-tree, nor the flush of apple blossom . . .' etc.

8 Georgina (sic) Elizabeth (1846–1929), third daughter of Sir Thomas Moncreiffe of that Ilk, Bart, married in 1865 as his second wife, the 1st Earl of Dudley, and became a famous beauty. Her husband loaded her with magnificent jewels, which were later irretrievably lost. Walburga, Lady Paget, in her memoirs, mentions first seeing her about 1866: 'At another party, I saw Lady Dudley, just married. She was dressed in a little pink gauze frock, with rosebuds in her hair, and not a single jewel, which must have provoked Lord Dudley, who had given her gorgeous ones. She was very pretty and simple looking, but not then the splendid beauty she afterwards became.' Lord Dudley was not over-liked but, Lady Paget records, 'Lady Dudley was so good and simple that everybody liked her' (*Embassies of other Days*, 1923, I, p.205, II, p.279). See also note 12.

9 Sophie Gray (1843–82), married in 1873 James Caird of Dundee. She had earlier been a model for the centre girl in *Autumn Leaves*.

10 Alice Gray (1845–1929), married in 1874 George Davey Stibbard. She had sat for the girl at the left in *Autumn Leaves*.

11 'Summer Indolence': *Passages from Modern English Poets illustrated by the Junior Etching Club*, 1862, pl.10 (7 × 10 in); a lettered state (Victoria & Albert Museum) is dated 1 Dec. 1861.

12 J. G. Millais, II, p.470, in list of sitters. Helen (1845–1913),

second daughter of Sir Thomas Moncreiffe, married in 1864 Sir Charles Forbes of Newe. Lord Frederic Hamilton commented on the fashionable world of 1876 that it 'boasted an extraordinary constellation of lovely women. First and foremost came the two peerless Moncreiffe sisters, Georgina Lady Dudley, and Helen Lady Forbes. Lady Dudley was then a radiant apparition, and her sister, the most perfect example of classical beauty I have ever seen, had features as clean-cut as those of a cameo. Lady Forbes always wore her hair simply parted in the middle, a thing that not one woman in a thousand can afford to do, and glorious auburn hair it was, with a natural ripple in it. I have seldom seen a head so perfectly placed on the shoulders as that of Lady Forbes.' (Lord Frederic Hamilton, *The Vanished World of Yesterday*, 1950, pp.190, 778).

13 Sir Iain Moncreiffe of that Ilk, in a letter to the Royal Academy, 5 March 1967 (Gallery files).

14 Helen Riley (1844–1925), according to her daughter Miss Henrietta Mallock, in letter to the compiler 22 Jan. 1967: she was chosen by the artist for her colouring and hair and was supplied with a plush dress.

15 J. G. Millais, I, p.324, quoting a July letter from the artist to Effie: 'I have been working hard all day; have finished Alice's top-knot, and had that little humbug Agnes Stewart again, but I am not sure with what success.'; II, p.470, in list of sitters.

16 J. G. Millais, I, p.342: in a letter of 26 April 1859 Millais reported that the Hanging Committee of the Royal Academy thought the picture spoilt 'by Sophie's and Alice's heads to the left of the picture'.

17 Millais to Hunt 26 July 1858 (Henry E. Huntington Library, San Marino, California), quoted by Malcolm Warner, loc. cit. See also Effie's excuse to the Dalziels 9 Aug. for lack of progress with their illustrations (Hartley Papers, Museum of Fine Arts, Boston), published in Dalziel, p.106.

18 Effie Millais to Dalziels, loc. cit.

19 J. G. Millais, I, p.327: 'Sophie must also come back blooming, to be painted in my picture'.

20 Millais to Hunt, 10 Sep. 1858 (Henry E. Huntington Library), quoted at length by Malcolm Warner, loc. cit. The photographer is unidentified but compare for example, Graham Ovenden, *Pre-Raphaelite Photography*, 1965, pl.99, anon (Cameron circle), profile portrait, to right, of 'Julia Jackson', which is of a type similar to Millais' and also to Arthur Hughes' portraits at the end of the 1850s.

21 All formerly E. G. Millais, sold Christie's 14.11.1967 (138): two later Christie's 23.4.1974 (92); two in a private collection; two repr. Stone Gallery, Newcastle upon Tyne, exhibition catalogue, summer 1971 (21, 22).

22 See, for example, *Illustrated London News* review, 7 May 1859.

23 J. G. Millais, I, p.328 f.; Warner in Tate Gallery 1984, *P.R.B.* (100).

24 Gray Family Album (private collection), repr. *Liverpool Bulletin* 1967, p.46.

25 40½ × 48 in. This was also photographed with the figures incomplete (repr. *Liverpool Bulletin*, loc. cit.).

26 Repr. J. G. Millais, I, p.325 (the original untraced).

27 For a summary of reviews, etc., see G. H. Fleming, *They Ne'er Shall Meet Again*, 1971, pp.117–20.

28 *The Times*, 30 April 1859, p.12.

29 Millais also showed a third, small picture, the *Love of James I of Scotland*.

30 *The Athenaeum*, 30 April 1859, p.586.

31 Ruskin, XIV, pp.214–6. Millais noted that the pamphlet was out in his letter to Effie, 10 May (J. G. Millais, I, p.344): he had not seen it.

32 Compare with his incitement to Pre-Raphaelite artists in 1858: see note 7.

33 Aug. 1859, pp.240–1: Ruskin's likening to a modern *Inferno* was embroidered to explain the picture as an allegory showing the children of sin.

34 J. G. Millais, I, p.342: Millais to Effie, 26 April 1859.

35 E. R. and J. Pennell, *The Life of J. M. Whistler*, 1911, p.53, quoting a letter of Fantin-Latour.

36 See Allen Staley, in exhibition catalogue *From Realism to Symbolism: Whistler and his World* (Wildenstein, New York and Philadelphia), 1971; and Alastair Grieve, 'Whistler and the Pre-Raphaelites', *Art Quarterly*, XXXIV, 1971, p.219 f.

37 Michael Wentworth, *James Tissot*, 1984, pp.51–2, pl.30. Tissot might have seen *Spring* at the London International exhibition 1862. *Printemps* was sold Christie's, 30.11.1984 (93) repr.

38 J. G. Millais, I, p.339 f., quoting a series of letters to Effie. £1,000 was the asking price for the *Vale of Rest*.

39 £700: Millais to Effie, 17 May 1859 (Pierpont Morgan Library, New York); it was for B. G. Windus, the collector, of Tottenham.

40 Millais to Effie, 17 May 1859 (Pierpont Morgan Library); J. G. Millais I, pp.347, 349.

41 J. G. Millais I, p.349: Millais to Effie 20 Aug. 1859.

42 For example, *The Albion*, 12 Sep. 1859: the girls were 'hideously ugly' and out of drawing, the apple blossoms the wrong scale, 'Crude, harsh and gaudy colours thrust themselves before the eye, to the intense disgust of every one who looks at the work'.

43 Millais to Effie, 6 May 1860 (Pierpont Morgan Library), quoted by Warner in Tate Gallery 1984, *P.R.B.* (96), p.173. Warner discusses Millais' problems in selling his pictures this year in his Ph.D. thesis on the artist, Chapter V.

44 Spielmann 1898, p.153.

45 Millais to Effie, 6 May 1859 (Pierpont Morgan Library).

46 Millais to Effie, 21 June 1861 (Pierpont Morgan Library), cited by Malcolm Warner, loc. cit.

47 Agnew's Picture Stock Book 4, 1879–85 No. 2213 (I have to thank Malcolm Warner for this reference).

48 Invoice and correspondence, Lady Lever Art Gallery files: Leverhulme was prepared to go up to £4,000 if necessary.

LL 3643. *The Black Brunswickers*

Oil on canvas,[1] 104 × 68.5 cm (41 × 27 in)
Signed in monogram and dated: *18 M 60*

The subject was intended to represent an imaginary incident before the battle of Waterloo, June 1815. The Brunswick regiment fell in great numbers in a valiant stand before Napoleon's initial advance at Quatre-Bras. Here, an English girl tries in vain to restrain her German sweetheart from leaving her in response to the call to arms,[2] her lap-dog echoing her plea. She is dressed for the ballroom, presumably the famous ball of the Duchess of Richmond at Brussels on the night of 15 June. On the wall of the drawing-room an engraving after David's equestrian portrait of *Napoleon I crossing the St Bernard*[3] gives a clue to the period and probable Continental location, confirmed by the famous black uniform of the soldier with its death's head insignia.[4]

The artist had decided on his subject by November 1859 (see below). He must have begun considering a new subject once the Royal Academy exhibition was opened in May. That month he met Mrs Jones of Pantglas, an

Fig.66 *A Huguenot*. Makins collection; by permission of Lord Sherfield

intimate of the Duke of Wellington, 'the duke's enchantress' and 'talked with her all evening'.[5] Perhaps this meeting gave him the idea of a Waterloo subject, when he decided to undertake a pendant to his highly successful picture *A Huguenot*, of 1852 (fig. 66), having found that his recent larger paintings with their broader handling did not sell easily.[6] 'Whatever I do', he wrote to Effie on 17 May 1859,[7] 'no matter how successful, it will always be the same story, "Why dont you give us the *Huguenot* again" '.

The Black Brunswickers was conceived on similar lines, to present a pair of lovers from different factions in adversity. It would appeal both to sentiment and patriotism. Wellington's name was still in the forefront[8] and Millais would know Byron's 'Childe Harold'.[9] More particularly, his presentation can be seen to have a topical allusion. In May 1859 Napoleon III entered upon a war in Northern Italy for the expulsion of the Austrians:[10] England took a peaceful role and was against taking up arms; Prussia, on friendly terms with England, took up a stance of armed preparedness; the engraving on the wall would point not only to the Napoleonic era but to current events. The girl's dress,

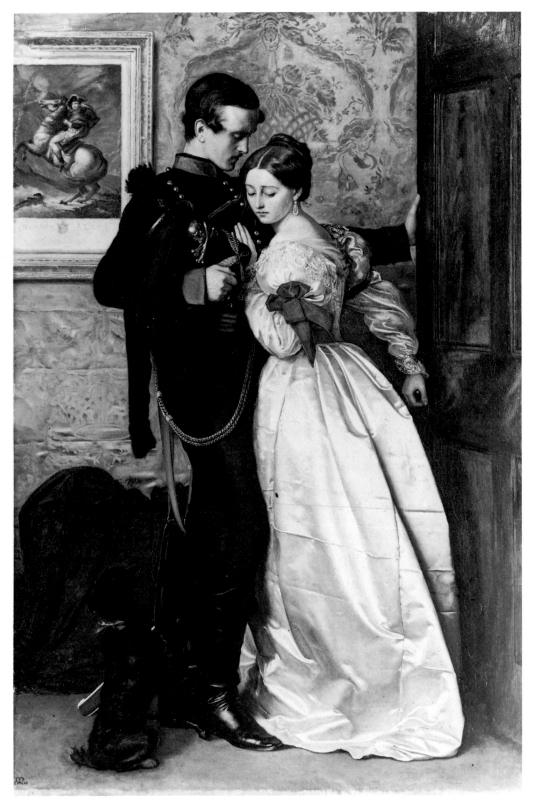

LL 3643. *The Black Brunswickers* (colour plate IX)

which is very much a compromise between the fashions of 1859 and 1815, when waists were high, might also be seen as ambivalent, though perhaps appearing sufficiently antique at the time of painting.[11] The red ribbons in her dress were perhaps intended as a martial touch. The interpretations put upon the picture at its exhibition by some critics (see below), seem to indicate a consciousness of the picture's relation to current events and the general political shilly-shallying during the protracted negotiations for peace in 1859–60.

Millais described his initial idea in a letter to Effie of 18 November 1859[12] after he had discussed it in confidence with William Russell, the *Times* war correspondent: 'My subject appears to me, too, most fortunate, and Russell thinks it first-rate. It is connected with the Brunswick Cavalry at Waterloo. "Brunswickers" they were called, and were composed of the best gentlemen in Germany. They wore a black uniform with death's head and cross-bones, and gave and received no quarter. They were nearly annihilated, but performed prodigies of valour. It is with respect to their having worn crape on their arms in token of mourning that I require some information; and as it will be a perfect *pendant* to "The Huguenot", I intend making the sweetheart of a young soldier sewing it around his arm, and vainly supplicating him to keep from the bugle-call to arms. *I have it all in my mind's eye, and feel confident that it will be a prodigious success.* The costume and incident are so powerful that I am astonished it has never been touched upon before. Russell was quite struck with it, and he is the best man for knowing the public taste. Nothing could be kinder than his interest, and he is to set about getting all the information that is required.'

The picture took three months to paint.[13] The model for the girl was Kate Dickens, daughter of the novelist. She sat independently of the soldier, who was posed by a private soldier in the Life Guards.[14] The extant sketches contain the motif of the girl holding the door,[15] but Millais tried out the design with the figures posed the same way as in *A Huguenot* with the soldier facing left. A sketch in this format alongside a companion sketch of the Huguenot and closely matching it both in scale and in the puffed sleeves of the girl, is on a sheet with two slight studies of the soldier facing to left (Oxford; figs 67, 68). The more advanced study, No. LL 3644 below, is also in this format (but sketched the other way on its reverse). Millais must have discarded this arrangement, as well as the crape-tying idea even earlier, as too obviously repetitive. Sketches of the final format are in the Tate Gallery, together with a sketch of the girl's head in a different pose (5902; fig. 69)[16], at Birmingham (623/06);[17] and a larger and more advanced study is on the reverse of the Ashmolean sheet cited above (fig. 68). A further sketch belongs to Andrew McIntosh Patrick and one is in a private collection.[18]

Millais touched up the girl just before the Royal Academy opening; he found this figure 'looking much better than I had hoped, and I very much improved her. The whole picture is by far the most satisfactory work I

have ever sent there. Everyone has expressed the same opinion; its success is certain . . .'[19]

The *Times* reviewer discussed it at length:[20] 'In this picture Mr Millais has escaped alike from the too equally distributed elaboration of his earlier pictures, and the slovenliness of some of his later ones. The picture may pass for a companion to the "Huguenot." It is painted with a firm and masterly hand, and with careful balance of chiaroscuro and colour. Like most of his pictures, it has the high merit of provoking questions as to its exact meaning. So many of our so-called dramatic pictures – which the taste of the time so hankers after – are so transparently intelligible, they ram their moral and their meaning so remorselessly home – so italicise their emphatic parts, and give such a tremendous allowance of emphasis, that it is a real refreshment to find a picture which is dramatic in the variety as well as the expressiveness of its sentiment, and which interests us in the passing thoughts and feelings of its actors as well as in the application of its text. As we read Mr Millais's picture, this is not the mere struggle of a fearful loving girl to keep her lover from the dangers of the battle. There is more than that in the averted look of the girl, and in the bent brow and flushed face of the boy. We read in her expression the restraint that follows sudden detection in a secret, and a secret she is ashamed of; in his, the pain of a sudden and unwelcome discovery of that secret. Is it, as we infer by the aid of the print from David's "Napoleon crossing the Alps", that her reluctance is due in part to a romantic admiration for this great conqueror, which lies mingled in her sentimental German soul with the love for her *sabreur*? Has some turn in their parting interview suddenly revealed to the lover this unpatriotic piece of hero-worship in his lady-love?

This interpretation we venture to submit as the reading that best meets the facts and expressions of the picture. Let Mr Millais decide the point, and either accept our explanation if he likes it, or find another that shall account for the Great Napoleon's picture on the wall, and the subtly perplexed expressions of the two faces.'

The artist considered the review flippant and commented that 'it reads the story wrong'.[21] F. G. Stephens in *The Athenaeum*[22] of the same date also suggested 'a French leaning in the lady's mind' and her likely French origin (which he repeated in the notes to the Grosvenor Gallery exhibition, 1886), but such allusion towards sympathy with France, in line with contemporary favour for a free Italy, was perhaps outside Millais' intention. J. G. Millais (1898) certainly explains that he intended the girl to be English.[23] The *Art Journal*[24] commented rather on the use of the plural in the title, which indicated that the artist 'wishes to carry the imagination beyond his picture; it becomes, therefore, the frontispiece to history . . .'; their critic thought the lovers were man and wife, and that the engraving intended 'to keep the oath of vengeance warm'; the composition was considered too flat and the figures awkward. Neither their critic nor F. G. Stephens in *The Athenaeum* liked the lady's face or colouring but admired the satin: the

Figs 67,68 *Studies for 'The Black Brunswickers'*, with a companion sketch of *A Huguenot*. By permission of the Visitors of the Ashmolean Museum, Oxford

Fig.69 *Sketches for the figures and for the head of the girl in 'The Black Brunswickers'*. By permission of the Trustees of the Tate Gallery

latter commented: 'Compelled by his subject to intro-
duce a large mass of black in the centre of the design, the
artist has overcome a great difficulty by skilful disposi-
tion of the colour round about; and the whole is brilliant
and warm enough to hold a place, even in the Royal
Academy, amongst the high tinted pictures there. This
has been partly effected by the contrast of the lady's
dress, which, being white satin, tells potently and
vigorously in lighting up the work. We have seldom seen
so fine a piece of textural rendering as this: it looks
sheeny and soft, full and deep, plump . . . a success that
will delight ladies and artists alike . . .'

It was sold to the dealer Gambart apparently for 1,000
guineas, the highest price Millais had yet received.[25] J. G.
Millais lists two watercolours of it made for Gambart,
under 1863 and 1867.[26] A watercolour with half-length
figures (Whitworth Art Gallery, University of Manches-
ter; $11\frac{5}{8} \times 9\frac{1}{2}$ in), might be one. The other could be that
certainly sold to Agnews in 1864 for £30[27] (now British
Museum, $6 \times 3\frac{3}{4}$ in, showing the whole composition).[28]
During the summer of 1860 Millais undertook for Gam-
bart 'an exact copy'[29] of the picture in oil, in which he
employed his brother William for some assistance with
the basic work,[30] but this was left unfinished and
remained with the family[31] (untraced). A full-sized copy
was made by Charles Compton (1828–84), who had been
a fellow student with Millais, and is still with his
descendants.

PROV: Bought from the artist by Ernest Gambart, dealer,
1,000 gns;[32] thence to T. E. Plint, Leeds, for £1,150;[33] T. E.
Plint, sold Christie's 7.5.1862 (331), bt. Graves £819;
Albert Grant, sold Christie's 20.6.1868 (120), bt. Moore
£840; Agnew, who sold it to James Price 27 Aug. 1868;[34]
bought back from J. Price by Agnew 27 April 1887 and
sold to J. Renton 24 May 1887;[35] J. Hall Renton, sold
Christie's 30.4.1898 (90), bt. Agnew £2,782.10.0 for W. H.
Lever (1st Viscount Leverhulme), with commission
£3,060.15.0,[36] and thence to the Lady Lever Art Gallery.
EXH: Royal Academy 1860 (29); Grosvenor Gallery 1886,
Millais (123); Royal Academy 1898, *Millais* (21); Glas-
gow 1901 (230); Hulme Hall, Port Sunlight 1902, *Corona-
tion* (146) and *Autumn* (166); Rome 1911 (60) repr.;
Birkenhead 1912; Walker Art Gallery 1922, *Liverpool
Jubilee Autumn Exhibition* (36); Birkenhead 1929;
Toronto 1936 (148); Port Sunlight 1948, *P.R.B.* (143);
Liverpool and R.A. 1967, *Millais* (59); Sheffield 1968,
Victorian Paintings (40); Baden-Baden 1973, *P.R.B.* (77)
repr.; Tate Gallery 1984, *P.R.B.* (108) repr. col.

1 Not relined. Inscribed in brown paint on back of canvas: *John
Everett Millais / South Cottage / Kingston on Thames* (this
was his parents' house).
2 J. G. Millais, I, pp.350, 353, 356 n.
3 The print is inscribed in Italian: 'Napoleon Il Grande', and is
presumably after the earliest engraving, by Giuseppe Longhi
(1766–1831), dating from 1801, the year after the picture was
commissioned by Napoleon. David executed five oil versions
for Napoleon, one of which was brought to England by
Wellington; another was taken to Berlin by Blücher; a third

had been destined for Milan (see Paris exhibition catalogues,
David, 1948 No. 53, and *Napoleon*, 1969 No. 112).
4 J. G. Millais, I, p.354 note, commented that the artist 'had
been at great trouble and expense to procure the exact
costume'.
5 Ibid, p.344, letter to Effie 10 May 1859.
6 In a letter to Effie (about 1857; Pierpont Morgan Library, New
York), he reminded her of her disbelief at his much earlier
conclusion that large pictures received 'no encouragement'.
See also under *Sir Isumbras*, No. LL 3625 above.
7 J. G. Millais, I, p.348.
8 Recently published was the translation, *History of the Life of
Arthur, Duke of Wellington from the French of M. Brialmont
with emendations and additions by the Rev. G. R. Gleig*: the
battles of Quatre-Bras and Waterloo are described in Vol.II,
dated 1858. Several biographies appeared or were repub-
lished in the 1850s immediately following the duke's death in
1852 and Wellington College was opened 1859. The Black
Brunswickers and the death of the Duke of Brunswick are
mentioned, for example, in W. H. Maxwell's *Life* (5th edition
1852, Vol.III, pp.466, 469).
9 Canto 3, verses xxii – xxiv, etc.: describing the call to arms
and the battle.
10 There are extensive coverage and illustrations in the popular
Illustrated London News, 1859.
11 Opinion kindly confirmed by Anne Buck, letter 2 Nov. 1985,
in which she points out the similar problem which Thackeray
had in illustrating his own *Vanity Fair* in the 1840s:
'It was the author's intention, faithful to history, to depict
all the characters of this tale in their proper costumes, as they
wore them at the commencement of the century. But when I
remember the appearance of people in those days, and that an
officer and a lady were actually habited like this [there is here
a small sketch] I have not the heart to disfigure my heroes and
heroines by costumes so hideous; and have on the contrary,
engaged a model of rank dressed according to the present
fashion.' (footnote to Chapter VI, p.75 in the Oxford Thack-
eray).

Miss Buck also comments on the puzzling fold-lines in the
skirt: 'Perhaps Millais is painting exactly what he sees – a
property dress, which has been taken from a drawer and put
on just as it was! Whereas most women, 1815 or 1860 would I
should think have removed the creases from their dress
before putting it on. But museums experience is that anything
like this well creased is not easy to uncrease.' Millais was
perhaps also wishing to display a skill equal to seventeenth-
century Dutch Masters such as Terborch.
12 J. G. Millais, I, pp.350, 353.
13 Ibid, p.355n.
14 Ibid, pp.353–5, with Kate Dickens's description of her
sittings.
15 Two sketches, repr. Ibid, pp.346, 347, of Kate Dickens in a
modern flounced dress and a pose facing to the front were
either discarded at an early stage or intended for some other
illustration.
16 Repr. Arts Council 1979, *Millais* (63–5).
17 J. G. Millais, I, repr. p.339.
18 Cited by Warner, Tate Gallery 1984, *P.R.B.*, p.186, and Arts
Council 1979, *Millais* (76 verso).
19 J. G. Millais, I, p.356.
20 *The Times*, 5 May 1860.
21 J. G. Millais, I, p.356.
22 *The Athenaeum*, 5 May 1860, p.442.
23 J. G. Millais, I, p.356 note.

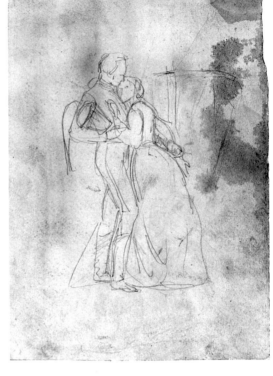

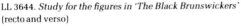
LL 3644. *Study for the figures in 'The Black Brunswickers'*
(recto and verso)

24 *The Art Journal*, 1860, p.162.
25 See notes 32, 33.
26 Ibid, II, p.487.
27 Agnew Drawings Stock Book 8, No. 6517.
28 Arts Council 1979, *Millais* (66) repr., and giving full provenance and discussion on the drawings.
29 J. G. Millais, I, p.355n.
30 MS letters to Effie dating variously from 7–17 Aug. 1860 (Pierpont Morgan Library, New York).
31 J. G. Millais, I, p.355n.
32 J. G. Millais, I, p.354; see note 33.
33 Ibid, p.365, Millais to Effie 6 June 1861 citing information presumably direct from Plint. In its review of Plint's later sale, *The Art Journal* 1862, p.105, noted that they had heard that Plint had paid '£1,000 in guineas'. Confusing is J. G. Millais' footnote to the p.365 statement from the artist, where is added 'When first sold to a dealer "The Black Brunswicker" fetched £816 . . .', but the reference here is presumably a slightly incorrect reading of the 780 gns (£819) gained at the Plint 1862 sale when bought by the dealer Graves.
34 Agnew Picture Stock Book 1A, No. 5041.
35 Agnew Picture Stock Book 5, No. 4473.
36 Agnew Picture Stock Book 6, No. 8405; invoice 22 Sep. 1904 for 2 May 1898, Gallery files.

LL 3644. *Study for the figures in 'The Black Brunswickers'*

Pencil, 19.7 × 12.0 cm (7¾ × 4¾ in)
Verso: a slight pencil outline of the same figures, on the same scale in reverse.

In the pose of what must have been the artist's first idea, to have the soldier facing left making the pose of the figures close to that of *A Huguenot* (fig. 66). The girl is in contemporary dress with balloon sleeves and natural waistline (repeated in the picture); the plumes from the soldier's helmet, spilling high over his shoulder still reflect the similarly positioned scarf in *A Huguenot*. Much of the outline is thickened, perhaps for tracing through the paper as the verso sketch suggests the point at which the artist simply turned his drawing over to try the pose the other way about.

PROV: F. M. Barwell (1898); ? Mrs A. L. Bickmore, Tonbridge; anon. sale Christie's 22.11.1926 (54), bt. (Bird £102.10.0) Gooden & Fox for the Trustees of the Lady Lever Art Gallery.
EXH: Royal Academy 1898, *Millais* (225); Port Sunlight 1948, *P.R.B.* (144).

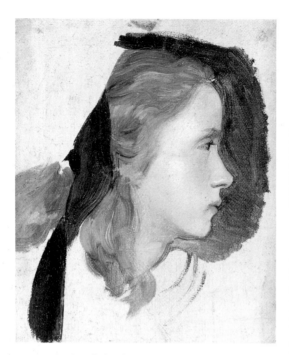

6327. *Study of a girl's head*

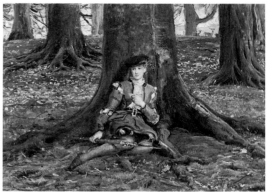

730. *Rosalind in the Forest*

6327. *Study of a girl's head*

Oil on canvas, stuck down on panel, 15.2 × 12 cm
(6 × 4¾ in)

A profile head to right of a young girl with reddish hair
and with black drapery (?a long ribbon) partly painted in
down the back of her head perhaps hanging from a cap. It
is painted on natural canvas in a fluid technique and left
incomplete. A similar profile, but to the left, appears in
the artist's *Red Riding Hood*, 1864 (14 × 10 in)[1] which
was posed by his eldest daughter Effie, but the character
of the child differs. His daughter Mary had a not
dissimilar profile,[2] but the model might equally be some
other young girl among the many who sat to the artist.

PROV: Bequeathed by M. D. and B. P. Legge through the
National Art-Collections Fund, 1965.

1 J. G. Millais, I, p.395, II, p.473 (list). In Sotheby's (Belgravia)
 sale, 19.3.1979 (25) repr. col.
2 For example in *The Sisters*, Royal Academy 1868 (Christie's,
 2.7.1971, lot 190 repr.) and *The Bridesmaid*, 1879 (Liverpool
 and R.A. 1967, *Millais* (97)).

730. *Rosalind in the Forest*

Oil on board,[1] 22.6 × 32.7 cm (8⅞ × 12¹⁵⁄₁₆ in)
Signed in monogram: *JM*

A version of the painting *Rosalind and Celia* exhibited at
the Royal Academy 1868 (46 × 63 in),[2] which marked a
development in the artist's style towards greater breadth.

Millais was in the habit of making small replicas of his
paintings and continued to do so in the 1860s.[3] The
present picture seems to fall into this category though it
varies in some details from the large picture. Here,
Rosalind, dressed as a man, sits alone beneath a tree and
rather more of the beech-wood in the background is
visible. In the large work, Celia is introduced leaning on
Rosalind's shoulder (the artist is said to have had trouble
with this figure)[4] and Touchstone, in jester's costume,
sits behind at the right. The background was painted in
Knole Park near Sevenoaks, Kent, in June 1867.[5]
Spielmann[6] suggests a debt to Holman Hunt's *Valentine
rescuing Sylvia from Proteus* (Birmingham City Art
Gallery) of 1850 which was also painted at Knole but in
the autumn. Mrs Madley, a professional model, possibly
sat for Rosalind.[7]

In this picture, the fluent sketchy technique and rather
thickly applied paint captures the dappled effect of light
and breezy atmosphere with a mature mastery. Rosalind
also has a livelier sense of character than she seems to
have in the large picture.

PROV: Presented by George Audley,[8] 1925.
EXH: Walker Art Gallery, 1933, *Liverpool Autumn Exhibi-
tion* (not in catalogue); Liverpool and R.A. 1967, *Millais*
(72).

1 An MS label on the back reads: ' *"Rosalind"/painted by J. E.
 Millais R.A. / The original Sketch of the Picture/Exhibited in
 the Royal Academy / 1868'*. This overlays an inscription on the
 board in which the artist's name is alone now visible.
2 The engraving after it repr. J. G. Millais, II, p.3. The picture
 belonged originally to A. G. Kurtz of Liverpool (died 1890),
 who also owned *The Martyr of the Solway* (No. 2123 below).
3 Mrs Millais' records for example, under oils of 1864 (the last
 year she enters in her Account Book): 'small copy 2nd Sermon'
 and 'ditto Charlie is my Darling' (*Liverpool Bulletin* 1967,
 p.57).
4 J. G. Millais, II, p.2.
5 Ibid, p.5. Millais had painted within the house at Knole his *Eve
 of St Agnes* (Collection of HM Queen Elizabeth the Queen
 Mother) in the winter of 1862.
6 Spielmann 1898, p.72.
7 J. G. Millais, II, pp.5, 6: his statement, p.5 conflicts with his
 father's letter, quoted p.6, evidently referring to painting from
 Mrs Madley for Celia.
8 *George Audley Catalogue of Pictures*, 1923, No. 123.

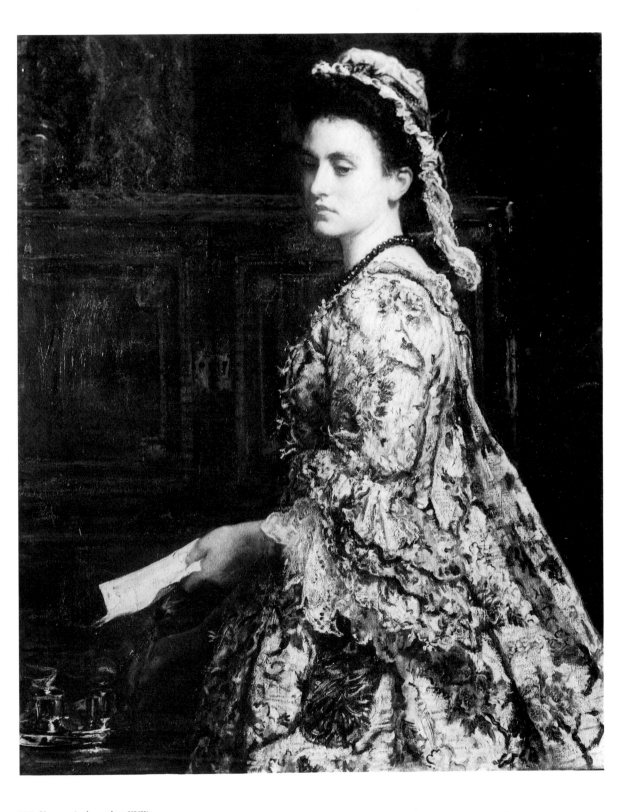

272. *Vanessa* (colour plate XVII)

272. *Vanessa*

Oil on canvas,[1] 112.7 × 91.5 cm (44⅜ × 36 in)
Signed in monogram and dated: *18 M 68*

A 'fancy picture' of Swift's *Vanessa* (Miss Esther Vanhomrigh),[2] painted as a companion to *Stella* of a year earlier (now Manchester City Art Gallery).[3] Both show Swift's fair young correspondents reading a letter, presumably from him, which seems to cause them dissatisfaction. *Vanessa* is dressed in a heavily textured brocade sacque gown, which appears to be authentic eighteenth-century. The model has been identified as Mrs Madley (a professional), who later married Sir Coutts Lindsay of the Grosvenor Gallery, as his second wife.[4]

Millais informed the dealers Thomas Agnew & Sons in August 1868 that the picture was finished and stressed in a second letter that if they did not want her, there were others who did, he considered her a beauty. 'Vanessa must be £900'.[5]

The artist's change to a vigorous, bravura style had been marked by his pictures at the 1868 Royal Academy exhibition, where *Stella* had been shown with his Diploma work, the *Souvenir of Velasquez*, which pinpointed the source of his inspiration. At the 1869 exhibition at which *Vanessa* appeared, the *Times*[6] critic gave a lengthy appreciation of his new style in commenting on another painting (the exceptional *Nina Lehmann*), as '. . . a complete justification of the painter's change of method and manner, so often lamented by some of his old pre-Raffaelite associates, and the critics who echo them'. He was, however, more critical of *Vanessa* which he considered 'extraordinary for force of painting, but with a dress of such colour and so painted that no head could possibly stand against it'. *The Art Journal*[7] repeated its own enthusiasm of the previous year and made an interesting contrast between Millais' work and that of his chief rival, Frederick Leighton: '. . . while Mr Leighton is thin in texture, somewhat poor in colour, yet ideal in form, Mr Millais is distinguished by the loading on of pigments, by a refulgence of harmonies supremely decorative, and by a pronounced character, much more individual than generic. "Vanessa" (357) is after the artist's *bravura* manner, Velasquez never wielded a brush more boldly or bravely. But to surpass Velasquez merely will not content MR MILLAIS, R.A.: Titian likewise must be thrown into distance. Still our English Academician holds his own on independent footing: in the painting of flesh we doubt if he be surpassed by any contemporary artist in the world; so transparent are his tissues, so clear his tones, so much of the pulse of young life and the blush of redolent health are present beneath the soft skin. Flesh painting is the most difficult of arts; perhaps since the time of Reynolds no one has succeeded better than Mr Millais.'

A similarly enthusiastic response came from the artist John Gilbert,[8] when he saw *Stella* and *Vanessa* together in the Potter sale, 1884, 'painted on the rough *back* of the canvas – heavily loaded with paint, wonderfully fine in colour, and so forceable that every picture round about them was completely *smashed* – At the proper distance they looked perfectly finished and in perfect harmony both in colour and tone – On looking closer they looked coarse, crude and unfinished . . .' He considered that they had had time to become their most harmonious in tone and were at their best, but feared that time might affect the thick impasto.

ENGRAVED: T. L. Atkinson, 1876, published by Thomas Agnew & Sons (see No. 6592 below).

PROV: Bought from the artist by Agnew, 28 Aug. 1868 and thence sold to Samuel Mendel, Manchester, 26 Nov. 1868, £1,060;[9] bt. back by Agnew 22 Sep. 1873 (Catalogue No. 231) and sold to E. Crompton Potter, 8 Dec. 1873;[10] E. Crompton Potter, Rusholm House, Manchester, sold Christie's 22.3.1884 (36), bt. Agnew, £1,365; and sold to George Holt, Liverpool, 4 March 1885, £1,575;[11] by descent to his daughter Emma Holt who bequeathed it to Liverpool, 1944. Sudley Art Gallery.

EXH: Royal Academy 1869 (357); Manchester 1878, *Art Treasures* (55); Grosvenor Gallery 1886, *Millais* (24); Royal Academy 1898, *Millais* (12); Whitechapel 1898; Bradford 1904 (184); Manchester 1911, *P.R.B.* (265); Walker Art Gallery 1922, *Liverpool Autumn Exhibition* (395) and 1933 (56); National Gallery, 1945, *Some Acquisitions of the Walker Art Gallery, Liverpool, 1935–1945* (23); Liverpool and R. A. 1967, *Millais* (73).

1 On panelled wood stretcher.
2 See Stephen Gwynn, *The Life and Friendships of Dean Swift*, 1933, pp.137–8, 164, 170–1.
3 Also formerly in the Mendel and Potter collections.
4 Miss Mary Millais, in letter to Lawrence Haward, Manchester, 26 Oct. 1939 (Manchester City Art Gallery files). This model also sat for one of the figures in *Rosalind and Celia* (see No. 730 above).
5 Millais Papers, Pierpont Morgan Library, New York.
6 *The Times*, 10 May 1869.
7 *The Art Journal*, 1869, p.198.
8 John Gilbert Papers (MIS/G1–1), Royal Academy of Arts.
9 Agnew Picture Stock Book 1A, No. 5082.
10 Ibid, Book 2, No. 8077.
11 Ibid, Book 4, No. 3142; bill of 11 Nov. for 4 March 1885, Gallery files.

2123. *The Martyr of the Solway*

Oil on canvas,[1] 70.5 × 56.5 cm (27¾ × 22¼ in)
Signed with monogram: *JM*

Representing Margaret Wilson of Wigtownshire (1667–85), a Covenanter sentenced to be drowned in the Solway for refusing to acknowledge the Episcopacy. The young girl, dressed in a plaid skirt and pink jacket with her red-gold hair falling about her shoulders, is tied to a stake on the shore, with the rising tide seen in the background.

In 1870 the artist produced his only full-length nude painting of *The Knight Errant* (Tate Gallery), which he had by him for some time before being able to sell it. He decided that the head in it, which faced the spectator, was unsuitable and replaced this portion with a new piece of canvas and altered the pose to look away.[2] The

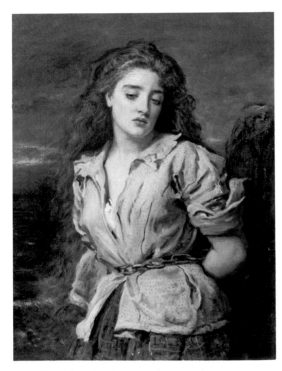

2123. *The Martyr of the Solway*

irregularly shaped fragment was inserted in new canvas and the figure clothed.[3] For his subject he turned to his earlier illustration of *Margaret Wilson* which had appeared in *Once a Week*, July 1862, p.42 (see No. 9301 below), where the girl is shown in similar pose but full-length. He had already produced a small water-colour version of this in 1863.[4]

ENGRAVED: Published in *Scribner's Magazine*, 1896 and as an engraving by Cadbury, Jones & Co., 1898.[5]
PROV: Bought from the artist by Agnew, 16 Dec. 1872 and thence sold to Andrew George Kurtz, 29 Dec. 1872, £840;[6] his sale Christie's, 9.5.1891 (86), bt. Agnew[7] for George Holt, 450 gns, plus commission £519.15.0;[8] presented by him to the Walker Art Gallery, 1895.

1 An irregularly shaped fragment cut in a line just above the head and below the waist and incorporating the figure's left arm, is inserted in a larger canvas.
2 J. G. Millais, II, p.24, 475 (list); Spielmann 1898, pp.80, 152.
3 Confirmed by the X-ray in the Gallery files.
4 J. G. Millais, II, p.487 (list); *Liverpool Bulletin* 1967, p.56: Mrs Millais' Account Book; the watercolour, 6 × 4¼ in, was on the art market 1961 and was subsequently in a private collection.
5 List of reproductions in Gallery files. An engraving, or touched photograph, is reproduced J. G. Millais, II, p.15.
6 Agnew Picture Stock Book 2, No. 7434.
7 Ibid, Book 5, No. 5963.
8 Invoice June 1891 for 14 May, Gallery files. A new 6½-in frame is also listed in the bill, at £5.12.6.

2829. *The Good Resolve*
Oil on canvas, 110 × 82.2 cm (43¼ × 32⅜ in)
Signed in monogram and dated: *18 JM 77*

A young woman stands in front of an open bible with her finger on a passage in the Psalms. The subject represents an old Scottish custom of opening the Bible haphazard and resolving to act upon the lines picked out at random. The model wears contemporary dress of greenish-blue and white patterned overblouse and brown skirt; a glass of flowers stands on the table and a satchel hangs from the wall behind.

The Times[1] in its review of the second Grosvenor Gallery exhibition (where this picture appeared, with a portrait of the *Twins: Daughters of T. R. Hoare*), commented that 'Mr Millais once more exhibits the highest pictorial power of our time in the directest application to portraiture'. On re-exhibition in 1898 Spielmann[2] noted that the picture 'is painted with verve and strength, and makes a better impression than it did on the occasion of its last exhibition'.

PROV: Julius Reiss; anon. sale Christie's, 17.5.1923 (95), bt. Sampson, 225 gns; George Audley,[3] who presented it to the Walker Art Gallery, 1924.
EXH: Grosvenor Gallery 1878 (74); Royal Academy 1898, *Millais* (75); Wembley 1924; Bradford 1930; Jersey 1979, *Millais* (55).

1 *The Times*, 2 May 1878.
2 Spielmann 1898, p.108.
3 *George Audley Catalogue of Pictures*, 1923, No. 114.

2829. *The Good Resolve*

LL 3613. *Alfred, Lord Tennyson* (colour plate XXIX)

LL 3613. *Alfred, Lord Tennyson*

Oil on canvas, 127 × 93 cm (50 × 36⅝ in)

Signed in monogram and dated: *18 JM 81*

Alfred, later Lord Tennyson (1809–92), appointed Poet Laureate in 1850. His *Idylls of the King* confirmed his fame; he was created a peer 1884. In 1880 he published *Ballads and Poems* after a break of some years, and in January 1881 a successful production of one of his more recent essays in poetic drama, *The Cup*, was put on by Irving.[1]

This portrait was commissioned by the Fine Art Society, possibly under the influence of Joseph Jopling, a friend of the artist, who organised the first exhibition of a group of Millais' works there in February 1881.[2] They finalised the commission at their meeting on 9 March, agreeing to the artist's price of £1,000 (later increased to 1,000 guineas to include copyright).[3] Millais was very busy at that time,[4] but Tennyson sat during March and April[5] and the portrait was placed before the directors of the Fine Art Society on 27 April.[6] It was added to the exhibition.[7] In the catalogue *Notes*,[8] Andrew Lang quoted Tennyson's own words from his 'Elaine' in the *Idylls*:[9]

... his face before her lived,
As when a painter, poring on a face,
Divinely thro' all hindrance finds the man
Behind it, and so paints him that his face,
The shape and colour of a mind and life,
Lives for his children, ever at its best

The poet is represented in his characteristic dress of a dark voluminous cloak with his 'wide-awake' hat.[10] The bravura technique and colouring of Millais' later manner, echoing Velasquez, underlines the Mediterranean cast of feature.[11] Millais had first met Tennyson in the 1850s, in particular in connection with the commissioning of illustrations for the Moxon edition of his poems, published in 1857, but they were not apparently intimate.[12] Millais told the poet's son that it was the finest portrait he had ever painted,[13] and to a fellow artist later gave his opinion 'without immodesty' that it was the best portrait of Tennyson.[14] The *Magazine of Art* review in 1881[15] considered it 'a vigorous, frank, and realistic work, very characteristic of the master's later manner. In expression it is unquestionably felicitous, having fixed the more thoughtful, and less shrewd, look of a face that has many moods . . .' Spielmann, writing in 1898,[16] perhaps best summed it up as: 'Millais' masterpiece in this section of his art . . . – but the man, not the poet: the latter was reserved to Mr Watts to achieve'.

It was acquired by (Sir) James Knowles,[17] editor of the *Contemporary Review* and of *The Nineteenth Century*, and friend of the sitter.

ENGRAVED: T. O. Barlow,[18] 1882: mezzotint, published by the Fine Art Society.

PROV: Painted for the Fine Art Society, 1881, 1,000 gns; thence sold to (Sir) James Knowles, May/June 1881;[19] on loan to the Tate Gallery from the trustees of his estate,

about 1910–21 or 1922;[20] Barbizon House,[21] from whom purchased by 1st Viscount Leverhulme, March 1923, £1,500;[22] thence to the Lady Lever Art Gallery.

EXH: Fine Art Society 1881, *Millais* (16); Grosvenor Gallery 1886, *Millais* (40); Royal Academy 1898, *Millais* (130); loan to Tate Gallery, about 1910–22; Walker Art Gallery 1923, *Liverpool Autumn Exhibition* (1089); Port Sunlight 1948, *P.R.B.* (149); Paris 1951; Liverpool and R.A. 1967, *Millais* (101).

1 (Hallam Tennyson), *Alfred, Lord Tennyson, A Memoir by his Son*, 1898, II, p.258.
2 J. G. Millais, I, p.430, II, p.132.
3 Minutes of Directors' Meetings, 9 and 23 March, 1881 (Fine Art Society archives).
4 Millais to Jopling, 4 March, 1881 in J. G. Millais, loc. cit. He was beginning his portraits of Disraeli, also bought by the Fine Art Society, and of Sir Henry Thompson.
5 J. G. Millais, II, p.137; Tennyson, op. cit. II, p.261.
6 Minutes, loc. cit.
7 *Magazine of Art*, 1881, supplement, p.xxxiii.
8 *Notes on a Collection of Pictures by Mr. John Everett Millais, R.A.*, Fine Art Society, 1881, No. 16.
9 According to Hallam Tennyson, op. cit., II, p.205, embodying George Frederick Watts' views on the ideal portrait painter which Tennyson had requested from him.
10 An identical costume, given to a friend in 1870 is in the Usher Art Gallery, Lincoln, *Tennyson Collection*, 1963, No. 285 repr.
11 See Tennyson, op. cit., I, p.76 for the 'foreign colouring' of all the family.
12 J. G. Millais, I, p.179, II, p.143; Tennyson, op. cit., I, p.376.
13 Tennyson, op. cit., II, p.261.
14 J. G. Millais, II, p.143; repr. (head only) fp. 142.
15 Loc cit.
16 Spielmann 1898, p.126.
17 Fine Art Society Minutes, 11 May, 22 June 1881.
18 Fine Art Society Minutes, 8 June, 1881: the commission given to him subject to completion by 1 Feb. 1882, at 450 gns. A print was exhibited at the Royal Academy, 1882 (1289).
19 See note 17. He also wished to purchase the copyright but this was declined (Minutes, 25 May, 8 June 1881).
20 Tate Gallery Minutes of Trustees meetings. It was on offer to the National Art-Collections Fund 1908, after Knowles' death, at £3,000 (*The Burlington Magazine*, June 1908, pp.127–8 repr.), and was considered for purchase by the Tate, Sep. 1922.
21 *Barbizon House 1923, An Illustrated Record*, No. 33, repr.
22 Account dated 16 March, receipted 13 May, 1923 (Lady Lever Art Gallery files).

LL3618. *An Idyll of 1745*

Oil on canvas, 140 × 191 cm (55⅛ × 75¼ in)

Signed in monogram and dated: *18 JM 84*

A youthful fifer and drummer of the British army of the '45 sits relaxed beneath a tree, his companion looking on as he plays on his fife, watched by three poor Scottish girls, one of whom wears a scarf of red (?) tartan. Beyond a stream the army tents are visible in the open countryside below the hills.

It can be seen as the artist's more matter-of-fact response to the idyllic pastorals fashionable at the period (one dictionary definition of an idyll being 'a short poem

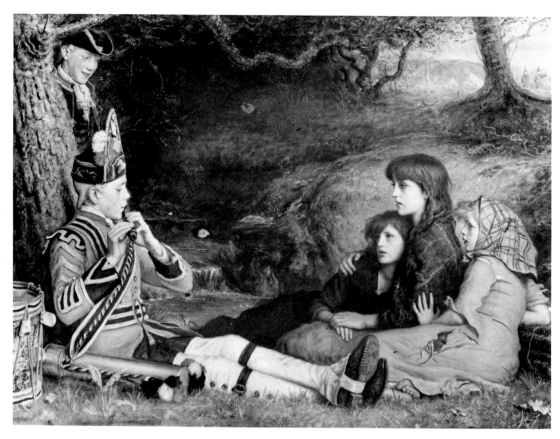

LL 3618. *An Idyll of 1745* (colour plate XX)

descriptive of some picturesque scene or moment, chiefly in rustic life').[1] Its composition seems to reflect that of Lord Leighton's classical 'Idyll' of 1881,[2] where dreamy, superbly draped women recline absorbed by the notes of a beautiful piping youth who faces away into a wide landscape with a distant river; while in subject, it is in counterpoise. Millais' rustic conception with very real children, plain boys and pretty girls, presents the concrete idea that innocent youth can find a common happiness in simple things in spite of warring factions.

The scene was initially, according to J. G. Millais,[3] to have taken place on board ship. Millais may have been aware besides Hogarth's satirical *March to Finchley* (see below), of the anecdote in Smith's *Nollekens and his Times* about the re-introduction of the martial fife, probably by the Duke of Cumberland, about 1745,[4] and this, together with the advent of three pretty girls as new models, may have determined him upon a Scottish landscape setting.

The models for the girls were the three Pettigrew sisters, Hetty, the eldest, Lily and Rose. It was apparently their first professional work.[5] J. G. Millais described

them as gypsies and very unpunctual.[6] The boy was described by Rose as a 'scotch boy, who was playing a flute' in the sketch the artist made of them when they first came to his studio (untraced); she thought him 'very ugly'.[7] It is by no means clear whether she referred to his role in the picture or to his own nationality, and the artist's conception may have developed subsequent to this.

Its progress was recorded in the diary of Beatrix Potter, whose father, Rupert, photographed models for the artist. According to her,[8] it was begun on Saturday 26 January 1884. On the Sunday, Millais again had the boy, 'a real drummer-boy and not particularly good-looking'. 'He is to be dressed', she noted, 'in the Queen Anne's time uniform, which they will get from a print of Hogarth's [*The March of the Guards towards Scotland in the Year 1745* (*The March to Finchley*), 1746, in the Coram Foundation, engraved Luke Sullivan 1750, and touched and improved by Hogarth 1761].[9] A tailor was there receiving instructions. The boy sits on a bed. Papa photographed him but it did not come out well'. This photograph (fig. 70) is in both the Millais and Potter Albums,[10] and shows the boy in similar uniform and hat

Fig.70 Rupert Potter, photograph of a boy fifer for *An Idyll of 1745*. By permission of the National Trust, Rothay Holme, Ambleside

to the painting, but looking drabber in colour, seated on a bed. In a photograph of the painting in progress (fig. 71),[11] the boy again appears in an apparently similar costume with light facings. Presumably the specially made uniform was in brighter colours, the red with dark

Figs 71,72 Rupert Potter, touched photographs of *An Idyll of 1745*, in progress. By permission of the National Trust, Rothay Holme, Ambleside

blue facings of the final painting (though see the *Art Journal* review quoted below). Beatrix Potter noted later[12] that while the uniform was brand new, the hat was not. In the progress photograph, the boy at the left (who seems to be the same model),[13] looks over a branch of the tree and wears the same uniform as the drummer. His face remains in the same position in the final painting but with different hat and uniform. The background was only roughed in at this stage. An earlier progress photograph (fig. 72) shows the three girls with only their heads and hands fairly advanced and with the girl at the right (?Rose, the youngest), as yet wearing a plain scarf, though lines of a plaid are laid in on the shawl of the centre girl. Both photographs show the artist's inking-in lines strengthening composition and detail.

Already by 30 January, Millais wanted a photograph of a running stream from Rupert for his background.[14] On 14 March he asked him whether there might not be a suitable landscape in Devonshire, 'without going up to Scotland', which the Potters thought not;[15] Millais put in a background 'without leaving town'.[16]

It was already sold before the 1884 Royal Academy opened,[17] where it was his principal picture in the great room, and Beatrix Potter noted that it was criticised 'rather harshly'. According to the *Times* review,[18] it was 'much talked of already, and destined to be discussed for many a day to come'. The critic commented: '. . . The red and blue of his uniform, painted in the most uncompromising way by Mr Millais, forms a brilliant spot of colour that seems to catch the eye all across the room. His face is a triumph of painting of humorous imagination, while that of the principal figure among the Highland children, with its eerie, far-away look, its look of wonder and romantic admiration, forms a singularly effective contrast to the face of the prosaic, business-like English lad, who takes his music as part of his day's work, just as he would take any game or any duty'. *The Art Journal*[19] was harsher on the 'garish red and white and yellow' of the piper's dress but liked the little girls: 'Prettier children than these girls were never seen, though the piper's red and yellow dress is not perhaps so wonderfully fine to us as to their sweet simple eyes'.

Most devastating were the comments on it by William Morris in *Today*.[20] He thought the whole exhibition 'wretched twaddle' and found this painting as worthless in aim and false in method as Orchardson's *Mariage de Convenance* in the same exhibition and considered it 'the result of a ruined reputation, of a wasted life, of a genius bought and sold and thrown away: Mr Millais' Idyll, the subject of which, when we heard of it, seemed good enough for a painter of whom it must be said at his best that his treatment of a subject reconciles us to the subject itself. But the first glimpse of the picture made an end of any hope the subject had given us. It is true that the drummer-boy, both face and figure, does recall, not Mr Millais at his best, but yet Mr Millais as one yet hoped he might be; although he has made not the slightest attempt to temper in to something tolerable the horrible red and yellow of an English drummer's coat as worn today,

though, not, if Mr Millais knew it, in the Pretender's time. But beyond this one figure there is absolutely nothing in a biggish canvas; the heads of the three Highland girls are mere caricatures of the artist's former work; the glen in which they are seated, which the painter of Ophelia could, if he pleased, have made beautiful by merely painting the glen as it was without selection, the glimpse of the royal army, the drummer's companion, are so much meaningless scrabble, the very drum is painted without pleasure: the canvas is filled up, and since it has Millais's name on it, is now ready for market – that is all. To judge Mr Millais by this picture one would suppose he is now heartily sick of his art, regrets his past career, and laments that he does not live a life of pure commercialism.'

ENGRAVED: W. Hole, 1897, etching, published by Virtue and Co., as premium plate to *Art Journal* subscribers.[21]
PROV: Sir Frederick Wigan, Bart, sold Christie's, 9–10.12.1915 (98), bt. Sampson, £1,050; Arthur Tooth & Sons, from whom purchased by W. H. Lever (1st Viscount Leverhulme), 14 Dec. 1915, £1,155;[22] thence to the Lady Lever Art Gallery.
EXH: Royal Academy 1884 (347); Grosvenor Gallery 1886, *Millais* (20); Guildhall 1894 (27); Royal Academy 1898, *Millais* (100); Port Sunlight 1948, *P.R.B.* (150); Liverpool and R.A. 1967, *Millais* (106).

1 *Shorter Oxford Dictionary*.
2 L. and R. Ormond, *Lord Leighton*, 1975, pl.189.
3 J. G. Millais, II, p.165.
4 J. T. Smith, *Nollekens and his Times*, first published 1828, Vol. I, p.342. See H. G. Farmer, 'The Martial Fife, the bicentenary of its first introduction', *Journal of the Society of Army Historical Research*, Vol.23, 1945, pp.66–71, citing also Grose, *Military Antiquities*, 1801, I, p.265, referring to Cumberland's role: information from Michael Ball, National Army Museum, July 1987.
5 Bruce Laughton, *Philip Wilson Steer*, 1971, pp.113ff, Appendix I, 'Autobiographical typescript by Rose Pettigrew (Mrs H. Waldo Warner)'. One of them, presumably the centre, older, girl, sat in 1885 for *The Ruling Passion* (J. G. Millais, II, p.173).
6 J. G. Millais, II, p.165; and see Laughton, op. cit., p.113, note 2.
7 Laughton, loc. cit.
8 Leslie Linder, transcriber, *The Journal of Beatrix Potter, 1881–1897*, 1966, pp.62–3.
9 Ibid, p.80.
10 Collections respectively, Sir Ralph Millais, and the National Trust, Rothay Holme, Ambleside.
11 Millais Album.
12 Linder, op. cit., p.80.
13 Rose Pettigrew refers only to one boy model.
14 Linder, op.cit., p.63.
15 Ibid, p.71.
16 Ibid, p.80, entry for 29 April 1884.
17 Ibid: 5 May 1884, 'Mr Millais sold the Drummer about a month since for £5,000 to a Brewer. . .'.
18 *The Times*, 3 May 1884, p.7.
19 *The Art Journal*, 1884, p.210.
20 Mary Morris, *William Morris – Artist, Writer, Socialist*, 1936, I, pp.236–7, reprinted from *Today*, July 1884, 'The Exhibition of the Royal Academy 1884 by a Rare Visitor'.
21 *The Art Journal*, 1898, p.3.
22 Invoice Gallery files; label of Arthur Tooth & Sons.

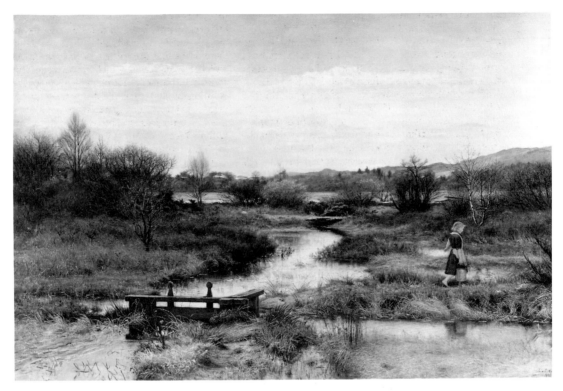

LL 3137. *Lingering Autumn* (colour plate XXIII)

LL 3137. *Lingering Autumn*
Oil on canvas, 124.7 × 195.5 cm. (49⅛ × 77 in)
Signed and dated: *John E Millais / 1890*

Exhibited at the Royal Academy 1891 with a quotation
from John Donne in the catalogue:

No spring, nor summer beauty hath such grace
as I have seen in one autumnal face.

The artist stayed in Perthshire during most autumns in
the neighbourhood of his wife's home. He was much
attached to Scottish landscape and beginning with *Chill
October* in 1870 (private collection: see the engraving No.
LL 3457 below), he painted at intervals a series of large
landscapes evoking the transient moods of the bleak
season of the year, which at the same time in their
straightforward and realistic approach, reflect the objec-
tive eye of the camera. Millais would seem to set the
limitations of photography at defiance. From 1881–90 he
rented the shooting and fishing at Murthly, staying at
Birnam Hall.[1] His winter landscapes there each present a
varied aspect of the light and weather and time of day.[2]
Lingering Autumn,[3] painted in the mellow yellows and
greys of the season during his last visit in the autumn of
1890, is a view of the mill-stream at Murthly looking
south;[4] the river Tay is visible in the background. The
child carrying water away from the sluice is said to have
been posed by Effie Stewart, daughter of a local
ploughman.[5]
 At the Royal Academy, *The Athenaeum*[6] gave it high
praise: '. . . There will be no division of opinion as to the
merit of both his Scottish views of this year. The more
important lacks nothing but sentiment to be equal to
"Chill October" and "Over the Hills and Far Away", the
latter of which it somewhat resembles. Its title *Lingering
Autumn* (293) brings it into relationship with the former,
while the view itself was found near Birnam, and the
motto . . . is appropriate. The charm the poet found in fair
but fading human life the painter has recognised in the
beginning of the year's decay . . . Its subject is the serene
charm, the tender pathos of incipient decline, more
beautiful because more touching than the earlier splen-
dours of the year. Nothing can be more highly finished
than the water and herbage in the foreground of this
work, every inch of which has been devotedly studied
from nature. Its most delicate feature is the upper sky of
pale, warm turquoise blue, and the thin filmy clouds
drawn across the lower portion of it . . .'
 The *Magazine of Art*[7] on the other hand, found it not
quite up to *Chill October*, '. . . that is to say, that it just
misses being a truly great work. This opinion might be
modified after a certain time: it is indeed peculiar to Sir
Everett's landscape pictures that, upon longer acquaint-
ance they impress the beholder with greater and greater
favour. But the fact remains that, in spite of the artist's
great grasp of landscape, which always makes itself felt,
the crispness of his light and atmosphere, and the
perfection of his tree-drawing, there is that lacking which
prevents its being classed with his greatest efforts . . .'

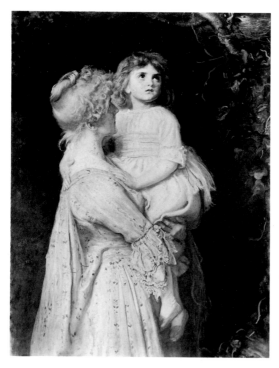

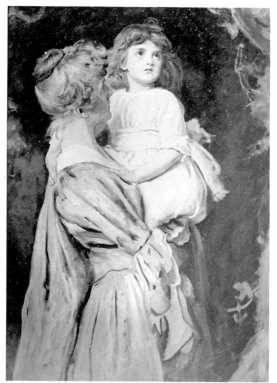

LL 3141. *The Nest* (colour plate XXXI)

Right: Figs 73,74 Anonymous photographer, touched photographs of *The Nest*, in progress (Millais Album). Private collection

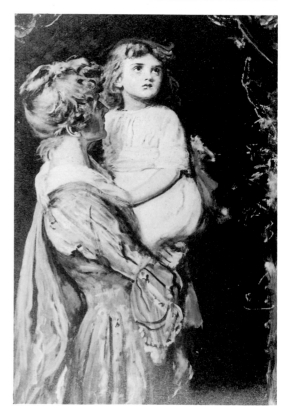

ENGRAVED: T. Chauvel, 1892, etching for Arthur Tooth & Sons (see No. 3459 below).

PROV: ?Arthur Tooth & Sons, who presumably acquired the copyright; George McCulloch by 1898, sold Christie's, 23–25.5.1913 (78), bt. Gooden & Fox for W. H. Lever (1st Viscount Leverhulme), 1,450 gns, plus commission, £1,561.3.0.;[8] thence to the Lady Lever Art Gallery.

EXH: Royal Academy 1891 (293); Chicago, 1893; Royal Academy 1898, *Millais* (151); Royal Academy, Winter 1909 (16); Port Sunlight 1948, *P.R.B.* (152); Liverpool and R.A. 1967, *Millais* (112); Royal Academy 1980, *Lord Leverhulme* (26) repr.

1 J. G. Millais, II, pp.147–8, 182.
2 Close in date with No. LL 3137 were *The Moon is Up*, 1889–90 (Tate Gallery); *Dew Drenched Furze*, 1889–90 (private collection); and *Glen Birnam*, 1890–1 (Manchester City Art Gallery).
3 J. G. Millais, II, p.285; repr., p.309.
4 J. G. Millais, note in Gallery files.
5 Alexander Walker, Dundee, letter to the Curator, 12 Oct. 1926 (copy in Gallery files).
6 *The Athenaeum*, 2 May, 1891, p.574.
7 *Magazine of Art*, 1891, p.254.
8 Invoice in Gallery files.

LL 3141. *The Nest*

Oil on canvas, 129.5 × 99 cm (51 × 39 in)

A young woman in a yellow striped silk sacque dress raises a little girl in her arms to look at a bird in its nest in an ivy-covered tree. The artist had designed a similar subject for an etching, *Happy Springtime*, in 1860.[1]

The model for the woman also sat for *The Ruling Passion*, 1885 (Glasgow Art Gallery).[2] Two photographs (figs 73, 74) in the Millais Album[3] show the painting in progress and indicate the very fluid initial handling of the draperies, underlining the development in the artist's style from the bravura of handling in, for example, *Vanessa* (No. 272 above). In both, the heads are nearly complete, but the draperies not fully worked out, and experiments are tried on the photographs with the shadows and the lines of the dresses, for example, a bow to the child's sash is indicated which is finally eliminated, probably as too fussy.

It was purchased by Agnew before the Royal Academy sending-in day, 27 April 1887.[4] Reviews of this characteristic example of Millais' later sentimental subjects were not encouraging. *The Art Journal*[5] considered it 'certainly the best of the five works he exhibits, the action of the mother holding up the child is very good, and the head of the thrush is a beautiful bit of painting'. The *Magazine of Art*[6] considered it and the *Lilacs* 'suggestive of the Christmas number style of art, dry and disagreeable in colour, and steeped in the tritest kind of popular sentiment'. *The Academy*[7] summed up: 'there are excellencies of a very high order especially in the head . . . but here too a cheapness of sentiment, an obvious disinclination to deal with the higher elements which even such subjects contain, detract from the enjoyment afforded by the easy mastery of technical difficulties'.

ENGRAVED: G. H. Every, mezzotint, published Thomas Agnew & Sons, 1890.[8]
PROV: Bought from the artist by Agnew, 27 April 1887, with copyright; thence to W. H. Lever (1st Viscount Leverhulme), 15 May 1896, £2,200,[9] with six artist's proofs of engraving;[10] and thence to the Lady Lever Art Gallery.
EXH: Royal Academy 1887 (25); Royal Academy 1898, *Millais* (125); Hulme Hall, Port Sunlight, 1902 (150); Walker Art Gallery, 1902, *Liverpool Autumn Exhibition* (170); Port Sunlight 1948, *P.R.B.* (151); Royal Academy 1980, *Lord Leverhulme* (25) repr.

1 *A Selection of Etchings by the Junior Etching Club*, 1865, pl.1.
2 J. G. Millais, II, p.173.
3 Sir Ralph Millais collection; list published in *Liverpool Bulletin* 1967, pp.58–9; copy photograph in Gallery files.
4 Agnew Picture Stock Book 61, No. 4466.
5 *The Art Journal* 1887, p.245.
6 *Magazine of Art* 1887, p.272.
7 *The Academy* 1887, p.368.
8 J. G. Millais, II, p.496 (list).
9 Invoice in Gallery files.
10 One of these, which entered the collection (WHL 1018/LP 15), was sold at Bonham's 1961.

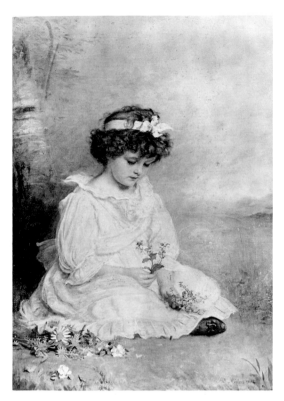

LL 3620. *Little Speedwell's Darling Blue* (colour plate XXX)

LL 3620. *Little Speedwell's Darling Blue*

Oil on canvas, 98 × 73 cm (38⅝ × 28¾ in)
Signed and dated: *J E Millais 1892*

The title is taken from Tennyson's *In Memoriam* (stanza LXXXII, verse 3):

Bring orchis, bring the foxglove spire,
The little speedwell's darling blue,
Deep tulips dash'd with fiery dew,
Laburnums, dropping-wells of fire.

The model was the artist's granddaughter Phyllis, daughter of Effie and Captain William Christian James, and sister of Willie James who sat for *Bubbles*, 1886 (see the engraving No. LL3466 below). It was 'finished enough for the moment'[1] in August 1891 when the artist was about to leave on holiday. Spielmann relates[2] that he was puzzled for a little at first for a title and didn't want 'Forget-me-not', which he had in any case used before.

At the 1892 Royal Academy, *The Art Journal*[3] thought it might be classed either as portrait or genre: 'This Reynolds-like study of sweet English childhood, although for this painter unusually slight in handling, and moreover somewhat flat in the modelling of the face, has a charm unusual in the works of the master, showing it to have been rather a labour of love'.

ENGRAVED: Photogravure, published Thomas Agnew & Sons.[4]

PROV: Bought by Agnew, from the Royal Academy exhibition, 7 April 1892;[5] thence to Sir Julian Goldsmid, 7 Nov. 1895; his sale Christie's, 13.6.1896 (46), bt. Agnew[6] for W. H. Lever (1st Viscount Leverhulme) £1,470 plus commission, £1,603.9.0;[7] and thence to the Lady Lever Art Gallery.

EXH: Royal Academy 1892 (256); Royal Academy 1898, *Millais* (43); Hulme Hall, Port Sunlight 1902, *Coronation* (95) and *Autumn* (174); Port Sunlight 1948, *P.R.B.* (153); Liverpool and R.A. 1967, *Millais* (115).

1 J. E. Millais, letter to his wife, 3 Aug. 1891, in J. G. Millais, II, p.289.
2 Spielmann 1898, p.93.
3 *The Art Journal*, 1892, p.219.
4 J. G. Millais, II, p.497 (list).
5 Agnew Picture Stock Book 6, No. 6342.
6 Ibid, No. 7671.
7 Invoice Gallery files.

Millais, John Everett, after

Atkinson, Thomas Lewis (1817–about 1890)
LL 3471. *The Black Brunswickers*
Mezzotint and stipple engraving on laid paper, artist's proof, printed surface (arched top) 63.2 × 42.5 cm (24⅞ × 16¾ in)
Signed in pencil: *John Everett Millais*
Impressed lower left corner, with Printsellers' Association stamp (..E)[1]
After the picture in the collection (No. LL 3643 above). Published by Henry Graves and Moore, McQueen & Co., 1864. As Warner points out,[2] the print is the same size as the engraving after *A Huguenot* (fig. 66), published 1856, thus emphasising its role as a pendant.

PROV: W. H. Lever (1st Viscount Leverhulme); at Thornton Manor by 1907;[3] thence to the Lady Lever Art Gallery.

1 Print declared at the Printsellers' Association, 16 June 1864: 350 artist's proofs at 8 gns; 25 presentation proofs; 150 proofs before letters at 6 gns; 150 lettered proofs at 4 gns, and unspecified prints at 2 gns.
2 Tate Gallery 1984, *P.R.B.*, p.186.
3 Thornton Manor Picture Inventory, June 1907.

Atkinson, Thomas Lewis (1817–about 1890)
6592. *Vanessa*
Mezzotint, proof on laid paper, printed surface 43.2 × 34.2 cm (17 × 13½ in)
Signed in pencil: *J. E. Millais* and *T. L. Atkinson*
Impressed, lower left corner, with Printsellers' Association stamp[1]

After the picture in the collection (No. 272 above). Published by Thomas Agnew & Sons, 1875 with a companion engraving of *Stella*, a proof of which was also shown at the 1876 Royal Academy.

PROV: Presented to the Walker Art Gallery by Thomas Agnew & Sons 1967.
EXH: An example at Royal Academy 1876 (1154).

1 Declared at the Printsellers' Association, 18 June 1875: 225 artist's proofs at 6 gns; 25 presentation proofs; 100 proofs before letters at 4 gns; and 150 lettered proofs at 2 gns.

Atkinson, Thomas Lewis (1817–about 1890) and Cousins, Samuel (1801–87)
LL 3496. *In Perfect Bliss*
Mezzotint and engraving, artist's proof, on laid paper, printed surface 51 × 36.7 cm (20⅛ × 14⁷⁄₁₆ in)
Signed and inscribed in pencil: *J. Millais* and *T. L. Atkinson/assisted by Saml. Cousins*
Lettered: *London Published June 1st 1886 by Thomas McLean 7 Haymarket*
Impressed, lower left corner, with Printsellers' Association stamp.[1]

After the painting of 1884 (48 × 34½ in), formerly in the Wertheimer and McCulloch collections.[2]

PROV: W. H. Lever (1st Viscount Leverhulme), ? from Thomas Agnew & Sons;[3] at Thornton Manor by 1907,[4] thence to the Lady Lever Art Gallery.
EXH: An example at Royal Academy 1886 (1531).

1 Print declared at the Printsellers' Association, 30 March 1886: 300 artist's proofs at 6 gns; 25 representation proofs; 50 proofs before letters at 4 gns; 200 lettered proofs at 2 gns, and unspecified prints at 1 gn.
2 J. G. Millais, II, pp.165, 482 (list); Barbizon House, *An Illustrated Record*, 1930, No. 32 repr.
3 Label on back, which might only refer to framing by them.
4 Thornton Manor Picture Inventory, June 1907.

Brunet-Debaines, Alfred Louis (1845–?)
LL 3457. *Chill October*
Etching, artist's proof on vellum paper, printed surface 42.6 × 56 cm (16¾ × 22 in)
Signed in pencil: *A Brunet-Debaines* and *J. E. Millais*
Lettered: *Published January 1st 1883 by Thos. Agnew & Sons, London, Liverpool & Manchester & by Knoedler & Co. New York* and on the print *A. Brunet Debaines*.
Impressed, lower left corner, with Printsellers' Association stamp (AV)[1]

After Millais' first large Scottish landscape of his later period (55½ × 73½ in). Painted in the autumn of 1870 on a backwater of the Tay near Perth, where he spent his autumn holidays near his wife's former home, it was highly praised on exhibition at the Royal Academy 1871: the *Times* critic commented that 'it embodies a sentiment and expresses a feeling'.[2] It was purchased by Agnews, who published the engraving. The painting is now in a private collection.[3] *The Art Journal*[4] commented with surprise on the long delay in publishing a

print, but put this down to the search for the right etcher, preferable to an engraver, which they considered found in Brunet-Debaines: 'his style . . . combines with vigour a singular delicacy and refinement. These rare qualities in etched work were a necessity for this plate and Mr Debaines has succeeded in endowing it with them. . . '.

PROV: Bought from Thomas Agnew & Sons by W. H. Lever (1st Viscount Leverhulme), 22 March 1898, £33;[5] at Thornton Manor by 1905;[6] thence to the Lady Lever Art Gallery.

EXH: An example at Royal Academy 1883 (1351).

1 Print declared at the Printsellers' Association, 2 Feb. 1882: 150 artist's proofs on vellum paper at 10 gns; 25 presentation proofs; 125 artist's proofs on Japanese paper at 8 gns; 100 proofs before letters at 5 gns, and prints unspecified; H. Beraldi, *Les Graveurs du XIXe Siècle*, 1886, Vol.4, p.24, No. 35; Lady Lever Art Gallery, *Catalogue of Foreign Paintings, Drawings . . . and Prints*, 1983, p.136.
2 *The Times*, 29 April 1871.
3 Exhibited Liverpool and R.A. 1967, *Millais* (76) repr., and Tate Gallery 1984, *P.R.B.* (140) repr.
4 *The Art Journal*, 1883, p.272.
5 Invoice Gallery files, one of fourteen prints after Millais framed by them at that time.
6 Thornton Manor Picture Inventory, May 1905.

Chauvel, Théophile-Narcisse (1831–1910)
LL 3459. *Lingering Autumn*
Etching, artist's proof on vellum paper, printed surface 46.3 × 70.4 cm (18¼ × 27½ in)
Signed in pencil: *J E Millais* and *T N Chauvel*
Lettered: *London, Published August 2nd 1892 by Arthur Tooth & Sons, 5 & 6 Haymarket SW. Copyright registered by the British Art Publishers Union Limited, New York & Messrs. Stiefbold & Co. Berlin. Printed by A. Salmon & Ardail, Paris*
Impressed, lower left corner, with Printsellers' Association stamp (UZ)[1]

After the picture in the collection (No. LL 3137 above).

PROV: Bought through Gooden & Fox from the George McCulloch collection by W. H. Lever (1st Viscount Leverhulme), 17 July 1913,[2] £10:10:0, thence to the Lady Lever Art Gallery.

1 Print declared at the Printsellers' Association, 4 Aug. 1892: 350 artist's proofs on vellum paper at 10 gns; 25 presentation proofs; 25 artist's proofs on Japanese paper at 5 gns; 500 proofs before letters at 2 gns and no prints; Lady Lever Art Gallery, *Catalogue of Foreign Paintings, Drawings . . . and Prints*, 1983, p.137.
2 Invoice of Oct. 1913 in Gallery files.

Every, George H. (1837–1910)
LL 3607. *'For the Squire'*
Mezzotint, artist's proof on laid paper, printed surface 36 × 26.8 cm (14⅛ × 10¼ in)
Signed in pencil: *J E Millais* and *Geo H. Every*
Lettered: *Published January 1st 1886 by Thos. Agnew & Sons, London, Liverpool & Manchester*

Impressed, lower left corner with Printsellers' Association stamp (LG)[1]

After the painting (33 × 25 in) dating from 1882 and exhibited at the Grosvenor Gallery the following year (Forbes Magazine Collection).[2]

PROV: W. H. Lever (1st Viscount Leverhulme) by 1898;[3] at Thornton Manor by 1905;[4] thence by descent and presented by the 3rd Viscount Leverhulme to the Lady Lever Art Gallery, 1985.

EXH: An example at Royal Academy 1886 (1542).

1 Print declared at the Printsellers' Association 2 Nov. 1885; 500 artist's proofs at 6 gns; 25 presentation proofs; 100 proofs before letters at 4 gns; India prints at 2 gns and prints at 1 gn.
2 J. G. Millais, II, repr. (detail) p.435, 481 (list); Lord Sherfield sale Christie's, 10.7.1970 (161) repr.; Forbes Magazine Collection, *The Royal Academy Revisited*, 1975 (46) repr.
3 Agnew's invoice March 1898, for framing, Gallery files.
4 Thornton Manor Picture Inventory, May 1905.

Every, George H. (1837–1910)
LL 3466. *Bubbles*
Mezzotint, artist's proof, on laid beige paper, printed surface 45.7 × 32.4 cm (18 × 12¾ in)
Signed in pencil: *J E Millais* and *Geo. H. Every*
Lettered: *London. Published July 18th 1887 by Arthur Tooth & Sons, 5 & 6 Haymarket, S.W. Copyright Registered. Entered According to Act of Congress in the year 1887 by Messrs. Knoedler & Co. New York in the Office of the Librarian of Congress at Washington & Messrs Stiefbold & Co. Berlin*
Impressed, lower left corner, with Printsellers' Association stamp (QBA)[1]

After one of the most famous of Millais' paintings which was popularised through its reproduction as an advertisement for Pears' soap. It represents his grandson Willie James (afterwards Admiral Sir William James GCB), blowing bubbles. The painting (43 × 31 in) was exhibited in 1886 by Messrs Tooth, who afterwards published the engraving. It was bought initially by Sir William Ingram, who reproduced it in colour in the Christmas number of his *Illustrated London News*, 1887, when it had already been sold to Messrs. Pears, who still own it.[2] It was one of the paintings cited in an article for and against the use of paintings in advertising by W. P. Frith and the editor in the *Magazine of Art* in 1889, when they were increasingly being put to this use.[3]

PROV: Bought by W. H. Lever (1st Viscount Leverhulme) from A. & F. Pears, 22 Sep. 1914, £4.18.3;[4] thence to the Lady Lever Art Gallery.

1 Print declared at the Printsellers' Asssociation, 21 July 1887: 500 artist's proofs at 8 gns; 25 presentation proofs; 500 lettered proofs at 2 gns; no prints.
2 J. G. Millais, II, pp.186, 189, 483 (list), engraving repr. p.187; *Magazine of Art*, April 1886, p.xxvii; Liverpool and R.A. 1967, *Millais* (109) repr. of painting; G. H. Fleming, *That Ne'er Shall Meet Again*, 1971, pp.347–9, and Malcolm Warner in Arts Council catalogue, 1978, *Great Victorian Pictures* (37) for detailed coverage.

3 *Magazine of Art*, 1889, pp.421–7, and see also Edward Morris, Royal Academy Catalogue, 1980, *Lord Leverhulme* (16), on Frith's reactions. Warner, loc. cit., publishes the *Times* correspondence of 1899 arguing against the claim by Millais' biographer that he was furious over the use of *Bubbles* by Messrs Pears.

4 Invoice in Gallery files.

Every, George H. 1837–1910
LL 3606. *Lilacs*

Mezzotint, artist's proof, on laid paper, printed surface 40 × 27.5 cm (15⅞ × 10⅞ in)

Signed in pencil: *J E Millais* and *Geo H Every*

Lettered: *Published October 20th 1888 by Thos. Agnew & Sons, London, Liverpool & Manchester*

Impressed, lower left corner, with Printsellers' Association stamp (YMF)[1]

After the painting (41 × 28 in) dating from 1886, exhibited at the Royal Academy the following year (formerly on loan to the Iveagh Bequest, Kenwood).[2]

PROV: Bought by W. H. Lever (1st Viscount Leverhulme) from Thomas Agnew & Sons, March 1898, £5;[3] at Thornton Manor by 1905;[4] thence by descent and presented by the 3rd Viscount Leverhulme to the Lady Lever Art Gallery, 1985.

1 Print declared at the Printsellers' Association, 11 Jan. 1887: 500 artist's proofs at 6 gns; 25 presentation proofs; 100 proofs before letters at 4 gns; India prints at 2 gns and prints at 1 gn.

2 J. G. Millais, II, repr. p.215; p.483 (list).

3 Invoice in Gallery files.

4 Thornton Manor Picture Inventory, May 1905.

Swain and Company
9301. *Margaret Wilson*

Wood engraving, 12.7 × 10.0 cm (5 × 3⁵⁄₁₆ in)

Inscribed on the block with the artist's monogram and *SWAIN Sc*

Published in *Once a Week*, Vol.VII, July 1862, p.42, with the following verses:

Murdered for owning Christ supreme
Head of his Church, and no more crime
But her not owning Prelacy,

And not abjuring Presbytery;
Within the sea, tied to a stake,
She suffered for Christ Jesu's sake.

Millais received £6 for this design which is listed under 1862 in Mrs Millais' Account Book.[1] A watercolour of the same subject is listed under 1863:[2] recently in a private collection[3] (6½ × 4¼ in), this is similar in composition with the same full-length figure of the martyr tied to a stake in the rising tide, and a ship in the distance in the Solway Firth. The artist later made use of the composition in a half-length for his *Martyr of the Solway* (No. 2123 above).

PROV: Presented to the Walker Art Gallery by Marco Livingstone, 1978.

EXH: Another impression, Liverpool and R.A. 1967, *Millais* (163).

1 Published from the original in *Liverpool Bulletin* 1967, pp.54–7 (the original in Sotheby's sale, 23.7.1985 (472)).

2 Loc. cit., and J. G. Millais, II, p.487.

3 Exhibited King's Lynn, 1971, *Pre-Raphaelites* (75); Sotheby's (Belgravia), 29.6.1976 (209) repr.

Waltner, Charles Albert (1846–1925)
LL 3490. *John Everett Millais, R.A.*

Etching, proof on vellum paper,[1] printed surface 26.2 × 19.7 cm (10⁵⁄₁₆ × 7¾ in)

Lettered: [*Entered According to*] *Act of Congress in the year 1881 by Knoedler & Co. in the Office of the Librarian of Congress at Washington/Published London January 1st 1881 by The British & Foreign Artists Association*, and on the plate *J. E. Millais R.A.* and *Waltner Sc*[2]

After the self-portrait painted at the invitation of the Uffizi Gallery, Florence, in 1879–80.[3]

PROV: W. H. Lever (1st Viscount Leverhulme) by 1898;[4] at Thornton Manor by 1905;[5] thence to the Lady Lever Art Gallery.

EXH: An example at Royal Academy 1880 (1288).

1 A defective proof.

2 Print declared at the Printsellers' Association, 17 Nov. 1881: 200 artist's proofs at 6 gns; 25 presentation proofs; 25 proofs before letters and 1,250 lettered proofs; H. Beraldi, *Les Graveurs du XIXe Siècle*, 1892, Vol.12, p.263, No. 81; Lady Lever Art Gallery, *Catalogue of Foreign Paintings, Drawings . . . and Prints*, 1983, p.140.

3 J. G. Millais, I, repr. frontispiece; II, pp.127, 218–9. The painting was exhibited at the first group exhibition of Millais' paintings at the Fine Art Society, 1881 (18).

4 Thomas Agnew & Sons framed fourteen etchings after pictures by Millais in March 1898 including this subject (invoice Gallery files and Agnew label on back of frame).

5 Thornton Manor Picture Inventory, 1905, p.4.

Munro, Alexander (1825–1871)

Sculptor. Born Inverness 26 October 1825, son of a stonemason employed on the Duke of Sutherland's estates. Through the Duchess (Harriet), obtained work under Charles Barry as a decorative carver for the Houses of Parliament. Worked in the studio of Edward Baily RA and entered Royal Academy Schools after unsuccessful attempts, as a student, 25 April 1847. A man of agreeable temperament, he gained a wide acquaintance in poetic and artistic circles. Friendly particularly with D. G. Rossetti, whom he met certainly before mid-1848, and visited Paris with him in 1855; met Arthur Hughes about 1850, who shared his studio at 6 Upper Belgrave Place 1852–8. He was probably responsible for the leaking to the press of the meaning of the initials P.R.B. in 1850. Began exhibiting at the Royal Academy from 1849. Produced portrait medallions and busts, and was particularly successful with young men, women and children. His style was of a more poetic and delicate quality than his contemporary, Woolner, q.v., and can perhaps be compared with Hughes' work in painting, tending in later years to the over-sweet. His sculptural groups had similarly poetic overtones, the first being *Paolo and Francesca*, 1851–2 (Wallington, Northumbria), which relates to Rossetti's interpretation of the same subject and is Munro's most distinctively Pre-Raphaelite composition in the early intense 'mediaeval' manner. He modelled reliefs of his friends (W. Bell Scott and Millais, 1852); Oxford sitters appear from 1855 and during 1856–7 he made some of the portrait statues for the Oxford Museum and a tympanum after a design by Rossetti for the Oxford Union. Ruskin admired his work and Munro gave classes at the Working Men's College. According to William Bell Scott, a rift developed in his relations with Woolner, a rival for the same commissions (certainly with the Trevelyans); it may have been the cause for his not being elected to the Hogarth Club, 1858, and was exacerbated by F. T. Palgrave's attack on his work in distinction to Woolner's in the handbook to the International Exhibition, 1862. Married Mary Carruthers, September 1861. His health broke down and he wintered in the south of France from 1865. Died at Cannes, 1 January 1871.

9026. *Mrs George Butler*

Plaster relief, oval, 48.5 × 35.8 cm (19¹/₁₆ × 14¹/₈ in)
Incised with monogram (in form of a double x): AM

Josephine Butler, née Grey (1828–1906); see No. 8782 below.

Here she appears in a more youthful pose than in No. 8782, in profile to left with morning-glory entwined in her long hair. Two other examples of this design in plaster are known.

PROV: Josephine Butler Memorial Home, Liverpool,[1] whence presented by the Diocese of Liverpool, at the closure of the Home, to the Walker Art Gallery, 1975.

1 Fitted in the wall over a mantelpiece. Perhaps acquired from the sitter's heirs about 1920 as portrait cited under No. 8782, note 8.

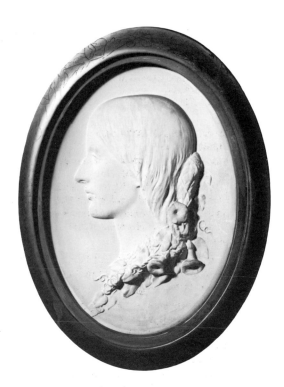

9026. *Mrs George Butler*

8782. *Mrs George Butler*

Marble bust, 69 cm high (27½ in)

Josephine Butler, née Grey (1828–1906), daughter of John and Hannah Grey of Milfield, Northumberland, social reformer in the cause of women and leader in the fight against the White Slave traffic. She married in 1852, George Butler, a brilliant classical scholar who later took orders. They lived successively at Oxford from 1852, Cheltenham from 1857, and Liverpool 1866–82 when he was Principal of Liverpool College, until his appointment as a canon of Winchester Cathedral. He actively supported her in her campaign for women. In 1869, while living at Liverpool, she was invited to lead the successful campaign for the repeal of the pernicious Contagious Diseases Act. Among other writings she published her *Personal Reminiscences of a Great Crusade* in 1896.[1] The Josephine Butler Memorial Home was founded in Liverpool in 1920 as a women's training college for moral welfare work.

She and her husband are described as good amateur artists; her husband introduced lectures on art at Oxford and contributed art exhibition reviews to the *Morning Chronicle* and *Fraser's Magazine*.[2] They met Munro when he was preparing statues for the decoration of the Oxford Museum, about 1855, George Butler being the secretary to the committee. He often stayed with them in their post-Oxford years and worked on his clay models of busts while in their house.[3]

Two busts of her by Munro are recorded as well as a

relief[4] (for which see No. 9026 above). The earlier of the two busts, dating from 1855 and now at Girton College, Cambridge,[5] shows her in a more youthful intimate image, presenting her in loose drapery with long flowing hair, caught in a chaplet of stars, and looking upwards.[6] The relief is in similar style. In the present bust she appears more mature with delicately thoughtful expression, looking down, wearing a simple gathered yoked dress and chemise; her hair is smoothed back in a deep sinuous curve round her neck into an elaborately twisted plait at the back. Thomas Woolner refers apparently to this bust in a letter to Lady Trevelyan early in 1857:[7] 'I saw a bust of Mrs Butler that Munro has done, there are some points of merit in it, but he has lost her eyes by dropping the lids; those wonderful sad eyes! how on earth he could shut up those "magic casements" when he could have had them open and looking out upon this sad world of ours, is a quaint touch of artistic choice I cannot at all sympathise with'.

Munro also sculpted the sitter's only daughter Evangeline, who was killed in an accidental fall in 1864.[8]

Other recorded portraits of Mrs Butler are:[9] a crayon portrait as a young woman, by George Richmond; a miniature by J. H. Mole, 1845 (Liverpool University Special Collections);[10] an oil portrait by Julius Jacob (Royal Academy 1853, 196); an oil portrait by G. F. Watts, 1895 (National Portrait Gallery, 2194); and a pencil study by Emily Ford, 1903, for a print of 1906.

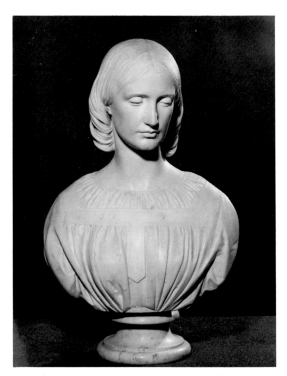

PROV: George Grey Butler, son of the sitter; presented by Miss Hetha Butler and her brother, grandchildren of the sitter, to the Josephine Butler Memorial Home, Liverpool, when their family home, Ewart Park, Wooler, Northumberland, was sold just before World War II;[11] presented by the Diocese of Liverpool, at the closure of the Home, to the Walker Art Gallery, 1975.

EXH: ?Royal Academy 1861 (1072).

1 G. W. and L. Johnson, *Josephine E. Butler, An Autobiographical Memoir*, 1909; *Dictionary of National Biography*.
2 Josephine Butler, *Recollections of George Butler* (1892), pp.81, 83; Johnson, op. cit., pp.20–2 (Ruskin visited them at Liverpool and admired Dr Butler's geological studies made in the Alps – Johnson, op. cit., p.54).
3 Butler, op. cit., p.112.
4 *D.N.B.*
5 Formerly with the sitter's brother-in-law, Dr Henry Montagu Butler, Master of Trinity College, Cambridge, and presented by his widow to Girton, with which she was herself connected, 1918 (information from Joyce Ansell in letter 20 Sep. 1978). It is perhaps worth noting that H. M. Butler was concerned in acquiring Woolner's bust of Tennyson for Trinity College Library in the 1850s, as well as commissioning from Woolner a posthumous bust of Archdeacon Hare for the same location in 1860 (Woolner, pp.173, 200). This illustrates a seeming preference in this family, echoing what was perhaps more general, for male portraits by Woolner and women and children by Munro.
6 Repr. Johnson, op. cit., p.20.
7 Letter, 10 Feb. 1857, Trevelyan Papers, University of Newcastle, Special Collections (by permission of the Trevelyan family), kindly pointed out to the compiler by Ben Read.

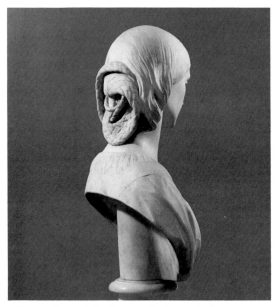

8782. *Mrs George Butler* (front and back views)

8 Johnson, op. cit., repr. fp. 336, a high relief. Photographs of a similar portrait in low relief and of a bust in similar pose, are in the St Paul and Butler Papers, Northumberland County Record Office.
9 *D.N.B.*
10 Having been presented by G. G. Butler to the Josephine Butler Memorial Home, Liverpool, 1922.
11 Information from Miss Hetha Butler, in letter from Joyce Ansell, loc. cit.

Rossetti, Dante Gabriel (1828–82)

Equally accomplished as an artist and poet. Born London, eldest son of Gabriele Rossetti, an Italian political refugee and Dante scholar, and Frances, neé Polidori, herself half Italian. His sister Christina was to become a distinguished poet and his brother William the family biographer. He combined extensive reading among the poets with designing highly-charged romantic illustrations and art training at Sass's School, 1841–4, followed by the Royal Academy Schools, where he first entered as probationer, summer 1844 and registered as student on 19 December 1845. Found this uncongenial and wrote to Leigh Hunt and to W. Bell Scott for advice on poetry or painting as a career, and in March 1848 to Ford Madox Brown, whose pupil he became for a few weeks; he was influenced by his 'Early Christian' style and remained a lifelong friend. He had purchased a notebook of William Blake, 1847 and completed a translation of Dante's *Vita Nuova*, 1848. In 1848 he helped found the Cyclographic Club, joined in a studio with W. Holman Hunt, a fellow admirer of Keats' poetry, to paint his first important oil, *The Girlhood of Mary Virgin* (Tate Gallery) reflecting his High Church background, and with him and Millais founded the Pre-Raphaelite Brotherhood that autumn (introducing his brother William, James Collinson and Thomas Woolner). The most cultivated of the circle, he provided the imaginative enthusiasm. In his own work he pursued the 'mediaeval' and romantic ideals rather than the path of 'Truth to Nature' followed by the others.

He visited Paris and Belgium 1849 with Hunt, founded the short-lived journal, *The Germ*, 1850, and exhibited at the Free Society, following the lead of Madox Brown, instead of at the Royal Academy. Harsh reviews in 1850 led to his almost total withdrawal from public exhibition, except the private Russell Place exhibition 1857 and the Hogarth Club. He turned to poetic themes of fateful romantic love, from Dante and later from the Arthurian romances, concentrating on watercolours. He met Elizabeth Siddall, probably late 1849, and she became his pupil and chief model; they married 1860. Following studios shared with Hunt and Walter Deverell, he lived at 14 Chatham Place, Blackfriars Bridge, from November 1852 until after his wife's death in 1862, and subsequently at 16 Cheyne Walk, Chelsea. From 1854 Ruskin, turning from Millais, became an influential patron. In 1856 he met William Morris and Edward Burne-Jones who became enthusiastic followers and participants in the Arthurian decorations of the Oxford Union, 1857, and subsequently in the foundation of the decorating firm of Morris, Marshall, Faulkner and Co., 1861, for which Rossetti produced stained-glass cartoons and furniture decoration. He published *Early Italian Poets*, 1861, helped with Gilchrist's *Blake*, and first published his own poems, 1870. Swinburne and Whistler were among his intimates. He returned to oil painting, 1859, in idealised subjects of beautiful women in a richly sensuous style heralding the Aesthetic movement, Art Nouveau and the Symbolists. His later models included the voluptuous blonde Fanny Cornforth and the darkly sibylline Jane Morris. W. J. Knewstub and Henry Treffry Dunn were in turn his studio assistants in the preparation of replicas. He depended upon a few enthusiastic patrons, in particular George Rae, Frederick Leyland and William Graham. In the late 1860s his health deteriorated, with eye trouble and insomnia, and he used chloral for relief, which undermined his constitution. The attack on his poetry by Robert Buchanan precipitated a breakdown in 1872. He was much at Kelmscott Manor (shared with Morris), 1871–4, but afterwards led a reclusive life at Chelsea and broke off many friendships. He died at Birchington-on-Sea, 9 April 1882. His grave there is marked by a celtic cross designed by Madox Brown.

295. *Two Mothers*

Oil on canvas, fragment made up, 30.5 × 25.8 cm (12 × 10⅛ in) (Triangular additions, at top left and right, contain, respectively, the sconce and the statuette.) Frame: Rossetti 'thumb-nail' and arrow borders with incised roundels on oak flat, gilt.[1]

A fragment of a picture, *'Hist', said Kate the Queen* from Browning's poem of *Pippa Passes*.[2] The subject was designed in 1848–9 and the oil painting, which was on an ambitious 7½ × 4-ft canvas with about thirty figures was being worked on during 1850.[3] It was one of three subjects of this time taken from Browning, of whose work Rossetti was an enthusiastic admirer.[4] The composition is extant in the oil sketch (signed and dated 1851, 12¾ × 23½ in, Eton; fig. 75),[5] which shows a wide interior with the Queen having her hair brushed while listening to an attendant reading from Boccaccio's *Decameron*, interrupted by a page breaking into song outside. Compositionally, it reflects the earlier work of both Holman Hunt and Millais, and may be compared with their illustrations to Keats' poem of *Isabella*, which in turn derives from the *Decameron* (see Millais, No. 1637 above).

The canvas was soon afterwards abandoned, Rossetti's excuse being that it was too late to finish it for the Academy.[6] After turning almost exclusively to watercolour during the 1850s,[7] at the end of the decade he again took up oil and began to produce a series of half-lengths of youthful female figures, initially on a small scale, with a restricted depth, foreground detail, bright colour and concentration on moody introspection. This fragment from the early canvas, of the older woman at the centre reading to her mistress, was re-worked as a woman with her hand on a missal, and with her child, contemplating a statuette of the Virgin and Child and is an amalgam of two styles. It reflects aspects of his later works in its new compositional form and may anticipate them.[8] Though generally listed under 1852,[9] the date of the re-working overall seems likely to be later: the frame is of an 1860s type; another fragment, *Fiametta*, is dated 1866.[10] The early painting is clearly apparent in the flesh painting of the head and more particularly the

hands which show the restrained clarity of outline and delicate technique of Rossetti's early Pre-Raphaelite style, derived from his initial study under Ford Madox Brown. This is quite distinctive from the 'rapid flesh painting' which he deliberately undertook in his half-length oils from 1859 in order to eradicate his earlier tendency to stipple.[11] However, retouching appears evident to the mouth and around the eyes of the woman to bring her into line with his later more sensuous style. The child and much of the detail, particularly the roses, are in a coarser technique while the headdress and costume with their jewelled decorations, differing from the oil sketch, can be compared with the richly jewelled costume details of pictures of the 1860s.

PROV: T. H. McConnel of Manchester, sold Capes and Dunn, Manchester, 30–31.7.1872 (301) as 'bought from the artist', bt. -?;[12] John Heugh, sold Christie's, 24–25.4.1874 (152), bt. Agnew 145 gns;[13] thence sold to J. F. Hutton of Manchester, 9 Oct. 1874;[14] his sale Christie's, 10.5.1884 (87), bt. Graham £105; John Graham, sold Christie's 30.4.1887 (83), bt. Agnew 185 gns, thence sold to Sir Charles Tennant, 2 May 1887;[15] returned to Agnew 24 May 1887 and sold to George Holt, Liverpool,[16] invoice 20 June 1888, £210;[17] by descent to Miss Emma Holt, who bequeathed it to Liverpool, 1944. Sudley Art Gallery.

EXH: Manchester 1878, *Art Treasures* (49); Burlington Fine Arts Club 1883, *D.G.R.* (7); Liverpool 1896 (8); Whitechapel 1905, *British Painting Fifty Years Ago* (349); Blackburn 1907; Manchester 1911, *P.R.B.* (217); Walker Art Gallery 1922, *Jubilee Autumn Exhibition* (467); Tate Gallery 1923, *Paintings of the 1860s period* (34).

1 See Alastair Grieve, 'The Applied Art of D. G. Rossetti – 1. His Picture-Frames', *The Burlington Magazine*, Jan. 1973, pp.16. 20; and Lynn Roberts, 'Nineteenth Century English Picture Frames, I: The Pre-Raphaelites', *The International Journal of Museum Management and Curatorship*, June 1985, p.158.
2 First published 1841 as the first number in *Bells and Pomegranates*; see also Mrs Sutherland Orr, *Life and Letters of Robert Browning*, 1891, pp.111–14.
3 A detailed initial drawing, now lost, is referred to in a letter to W. M. Rossetti, Aug. 1848 (Doughty and Wahl, I, p.42, No. 35); W. M. Rossetti records in the *P.R.B. Journal*, that his brother was 'redesigning' the subject in May 1849 and that in

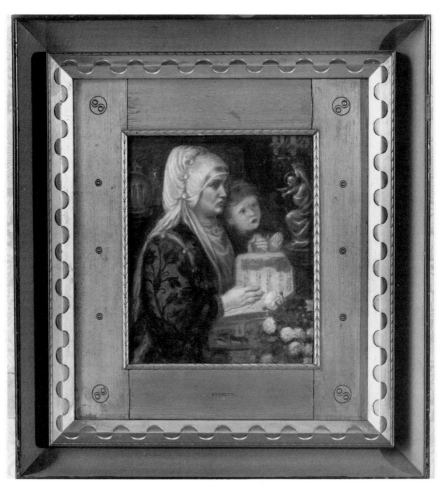

295. *Two Mothers*

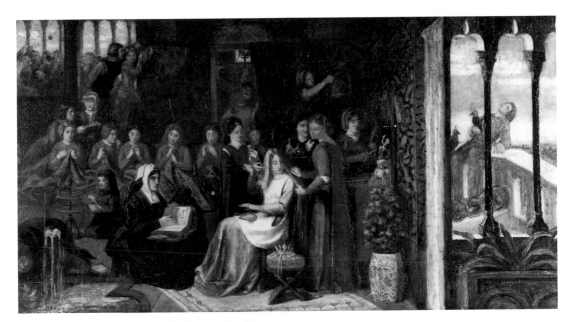

Fig.75 *'Hist', said Kate the Queen*. By kind permission of the Provost and Fellows of Eton College; photograph Courtauld Institute of Art

October, following a visit to France and Belgium, he planned to make an 'entirely new design for Kate the Queen when he is prepared to paint the subject'. (Fredeman 1975, pp.3, 5, 19); the coloured sketch was nearly finished and the large canvas begun in (?) January 1850 (Doughty and Wahl, I, p.88, No. 51; p.91, No. 56): See also Alastair Grieve's discussion in Newcastle 1971, *D.G.R.*, p.4.

4 *Taurello's first sight of Fortune* and *The Laboratory*, both of 1849 and this picture (Surtees 1971, Nos 39, 41, 53, pls 24, 25, 44); and see W. M. Rossetti 1895, I, pp.101–2.

5 Surtees 1971, No. 49, pl.38. Also listed are pencil sketches for the subject (Nos 49A, B), a watercolour fragment of a version, *Rossavestita*, 1850 (No. 45) and an oil fragment, *Fiametta*, 1866 (No. 192, pl.282). Marillier 1899, p.34 reproduces another supposed fragment of a woman's head.

6 Doughty and Wahl I, p.98, No. 63, Rossetti to his aunt, Charlotte Polidori (?February 1851).

7 Two other unfinished oils were the landscape begun autumn 1850, and taken up for *The Bower Meadow*, 1871, and the modern subject, *Found*, begun on the canvas autumn 1854 and never completed (Surtees 1971, Nos 229, 64).

8 Compare for example *Girl at a Lattice*, 1862 and *Fazzio's Mistress*, 1863 (Surtees 1971, Nos 114, 164, pls 186, 234).

9 William Sharp, *Dante Gabriel Rossetti: A Record and a Study*, 1882, No. 40; Marillier 1899, No. 25 and Surtees 1971, No. 53.

10 Surtees 1971, No. 192, pl.282 (12⅞ × 11½ in).

11 Described in Rossetti's letter to W. Bell Scott, Nov. 1859 (Doughty and Wahl, I, p.358, No. 319); W. Minto, edit., W. Bell Scott 1892, II, p.51.

12 W. M. Rossetti 1889, p.77 cites a letter from McConnel, May 1872 to Rossetti mentioning it. Frederic Shields of Manchester introduced this patron to Rossetti (and to Ford Madox Brown) about 1867 (Ernestine Mills, *The Life and Letters of Frederic Shields*, 1912, p.113). Information on the sale kindly supplied by Julian Treuherz.

13 Rossetti asked Murray Marks to bid for this picture up to £50 if necessary and to run up the price of *The Annunciation* in the same sale (Doughty and Wahl, III, pp.1274–5, No. 1476).

14 Agnew Picture Stock Book 2, 1871–4, No. 8464.

15 Agnew Picture Stock Book 5, 1885–91, No. 4416.

16 Ibid, No. 4532.

17 Gallery files.

LL 3628. *Sibylla Palmifera*

Oil on canvas, 98.4 × 85 cm (38¾ × 33¼ in)
Frame: Gilt with broad plain sloping field between tiered mouldings: set at the centre of each side with a roundel parallel to the picture plane having stylised design of concentric circles: designed by the artist.[1]

At first called *Palmifera*,[2] the sibyl is presented holding a palm-sceptre and seated upon a throne before a marble canopied niche. A festoon of olive boughs hangs over her head. Butterflies, symbol of the soul, hover at one side; lamps at either hand illuminate the carved pilasters above, that at the left representing a blindfolded cupid, beneath a circlet of roses, and that at the right a skull, beneath a wreath of poppies; carved in the niche appears a winged sphinx and, at the left, perhaps a many-headed serpent. The dominant colours are provided by the robe of purplish-red and the peacock-blue coif over her long auburn hair. The model was Alexa Wilding,[3] who first sat to Rossetti in 1865, the year of this picture's conception. She was subsequently to sit, among other works, for a handmaid in *Dante's Dream* and for *The Blessed Damozel* (Nos 3091 and LL 3148 below).

Rossetti turned at this time to a larger half-length format for his portraits of idealised women celebrating the power of beauty and each with their harmonious

scheme of colour and rich materials. They reflect Venetian sources and herald the Aesthetic movement. While forming a trio with *The Beloved* and *Monna Vanna* (Tate Gallery, both similarly from the collection of George Rae of Birkenhead; figs 1–2), this picture in its use of allegorical motifs aspires to greater profundity and heralds his later subjects of deeper intent.

It was offered to Rae in December 1865 while the artist was still working on *The Beloved*, which Rae had earlier commissioned: 'I am just commencing a picture (female half length life size) to be called *Palmifera* which is really to bear away the palm from all my doings hitherto. This is as yet disengaged and no one has yet seen it. It is from a glorious new model of mine and will be the very best of the sort I ever did, the design and combination of materials being *nuts* to me [i.e. 'a source of pleasure']. The price will be 550 guineas & I'll consider it yours if you say the word.'[4]

The commission was a typical transaction of the artist. It was to replace another subject now dropped, called *The Queen of Beauty*, for which he had already received £100 on account and in January 1866 he reduced the price to 400 gns to ensure Rae's acceptance, on the understanding that the £100 was to stand over for other work as a separate transaction: he wrote to Rae, 'It harmonises so well with *The Beloved* in my studio that I should like both to hang together on your walls'[5], he had by then enlarged it to about 35 × 30 in. The title Palmifera was 'to mark the leading place which I intend her to hold among my beauties, and have represented her carrying a sort of palm-sceptre'.[6] Mrs Rae apparently felt some disquiet at the description of its classical accessories.[7] The architectural details, of a type unusual in Rossetti's work, while stemming ultimately from early Venetian masters, parallel the contemporary classicism on a more idiosyncratic level.[8]

By May 1866 he had apparently sent the canvas to be enlarged and had written a sonnet embodying his conception[9] which he later published in his 1870s poems under the title of *Sibylla Palmifera*,[10] and subse-

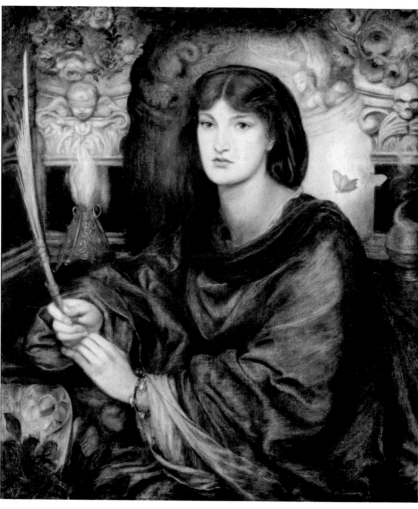

LL 3628. *Sibylla Palmifera* (colour plate XVI)

quently as 'Soul's Beauty' sonnet 77 in his *House of Life*,[11]

UNDER the arch of Life, where love and death,
 Terror and mystery, guard her shrine, I saw
 Beauty enthroned; and though her gaze struck awe,
I drew it in as simply as my breath.
Hers are the eyes which, over and beneath,
 The sky and sea bend on thee, – which can draw,
 By sea or sky or woman, to one law,
The allotted bondman of her palm and wreath.

This is that Lady Beauty, in whose praise
Thy voice and hand shake still, – long known to thee
 By flying hair and fluttering hem, – the beat
 Following her daily of thy heart and feet,
How passionately and irretrievably,
In what fond flight, how many ways and days!

He planned to inscribe this on the frame but it was not yet done at the time of sending the picture to Rae.[12]

Its slow progress followed a usual pattern. He reported to Rae in August and September 1867 that he had made some little progress and had painted in both poppies and roses but was not pleased with the latter, his model having been 'too highly cultivated', so he had removed them. A blue laying-in had apparently confused (?W. L. Windus, who must have made a visit at this time) into supposing the background to be of blue and white tiles instead of its black and white marble.[13] A bill of £20 for the frame had been sent to Rae by Green's too soon, in mid-1868,[14] the frame itself going to the artist, who admitted this was expensive but similar to the cost of Leyland's *Lilith* and not to be had cheaper.[15] Rossetti's eyes began to give trouble in 1868 but in March 1869 he again reported a little progress.[16] He was working on it that summer and was planning to produce a full-scale replica while staying at Penkhill in Ayrshire, 'tempted by a handsome offer'.[17] This was from F. R. Leyland, who had not responded to an initial offer for the original in 1865 but who now wanted it quickly;[18] nothing was done at this time. In September Rossetti was requesting James Smetham's advice about the perspective in the background.[19] Again in September 1870 he further excused himself to Rae, in that he had been preoccupied with two important pictures: 'One is already more than half done and will be completed by the close of this year I doubt. It is "Dante's Dream" 10 ft × 7 [No. 3091 below]. My absorption in this work must be my excuse for not having got on with the Palmifera again. I trust yet to do so shortly . . .'[20] He had already received the first £300 during 1866, and acknowledged the final payment of £120 on 20 December 1870.[21] Rae heard of its completion at that time with 'transports of joy'.[22]

It and *Monna Vanna* were hung as pendants to *The Beloved* in Rae's house, 57 Devonshire Road, Birkenhead.[23] F. G. Stephens commented[24] that it was 'more essentially Titianesque in colour than most of Mr Rossetti's works appear to be. . . .'. Swinburne, in *Notes on Some Pictures of 1868*[25] was enthusiastic and compared

it with its opposite type, the *Lilith*, as 'a head of serene and spiritual beauty, severe and tender . . . an imperial votaress truly, in maiden meditation: yet as true and tangible a woman of mortal mould, as ripe and firm of flesh as her softer and splendid sister. The mystic emblems in the background show her power upon love and death to make them loyal servants to the law of her lofty and solemn spirit . . . The cadence of colour is splendid and simple, a double trinity of green and red, the dim red robe, the deep red poppies, the soft red roses; and again the green veil wound about with wild flowers, the green down of poppy-leaves, the sharper green of rose-leaves.'

The artist was apparently again proposing to make a replica in oil or watercolour in 1869–70 for William Graham,[26] but this did not materialise. Surtees lists[27] a watercolour study for the head (private collection; 13 × 11 in). Two lost drawings are cited by Marillier;[28] both exhibited at the Burlington Fine Arts Club, 1883: a black crayon, 24¼ × 19½ in, 'first finished study' 1864, lent A. Stevenson (No. 132),[29] and a red crayon study, 35 × 28 in, lent R. Valpy (No. 82). Surtees also lists[30] a coloured chalk drawing, possibly studio work (private collection; 40½ × 30 in).

PROV: Commissioned by George Rae, of Birkenhead, Jan. 1866, 400 gns,[31] delivered Dec. 1870;[32] bt. from the executors of his estate by W. H. Lever (1st Viscount Leverhulme), with works by Rossetti and others, 1917;[33] thence to the Lady Lever Art Gallery.
EXH: Royal Academy 1883, *D.G.R.* (294); Manchester 1887, *Royal Jubilee Exhibition* (701); Guildhall 1890 (27); Walker Art Gallery 1922, *Jubilee Autumn Exhibition* (38), as *Venus Palmiphora*; Williamson Art Gallery, Birkenhead 1928; Port Sunlight 1948, *P.R.B.* (168); Newcastle 1971, *D.G.R.* (63); Royal Academy and Birmingham 1973, *D.G.R.* (324); Bordeaux 1977, *De Gainsborough à Bacon* (134) repr.

1 A pattern employed by Rossetti from about 1868, see Alastair Grieve, 'The Applied Art of D. G. Rossetti – 1. His Picture Frames,' *The Burlington Magazine*, Jan. 1973, p.23, and Lynn Roberts, 'Nineteenth Century English Picture Frames, I: The Pre-Raphaelites,' *The International Journal of Museum Management and Curatorship*, June 1985, pp.166–7 and fig. 16.
2 Marillier 1899, p.143; Surtees 1971, No. 193, pl.285.
3 Alexa (Alice) Wilding, who worked as a dressmaker. Rossetti had seen her in the street and finally persuaded her to sit to him: see W. M. Rossetti 1895, I, pp.242–3, and Surtees 1971, I, p.200.
4 7 Dec. 1865, Rae Papers No. 41 (Lady Lever Art Gallery with other letters to Rae cited in the text; published by kind permission of Mrs Imogen Dennis). It was apparently also offered to F. R. Leyland in a letter of 29 Dec. 1865 (Val Prinsep, 'A Collector's Correspondence,' *The Art Journal*, 1892 p.249), and Leyland later commissioned a replica. See note 18.
5 17 Jan. 1866, Rae Papers No. 45.
6 19 Jan. 1866, Rae Papers No. 46, quoted in part in W. M. Rossetti 1889, p.55.
7 Noted in Rossetti to Rae 15 March 1866, Rae Papers No. 59.
8 Simeon Solomon's very personal approach in his religious

subjects of the later 1860s should be borne in mind as well as Leighton's work.

9 W. M. Rossetti, loc. cit. (letters of this period, Nos 56–58, are missing from the Rae Papers).

10 It is given this title in Rossetti to Rae, 29 Jan. 1867, Rae Papers No. 61. W. M. Rossetti 1889, p.145, states that it first appeared with two other sonnets, to *Lady Lilith* and *Venus Verticordia* in the pamphlet-review by Swinburne and himself, *Notes on the Royal Academy Exhibition*, 1868.

11 Published *Ballads and Sonnets*, 1881: it was there paired with *Body's Beauty*, the sonnet to his *Lilith* (Surtees 1971, No. 205), which he had re-worked in 1872–3 with Alexa Wilding as the new model, and to which he saw *Palmifera* as the spiritual counterpart.

12 Rossetti to Rae, 'Saturday' (Dec. 1870), Rae Papers No. 85.

13 22 Aug. and 20 Sep. 1867, Rae Papers Nos 64, 65.

14 Rae to Rossetti (draft), 3 July 1868, Rae Papers.

15 Rossetti to Rae, 6 Aug. and 25 Nov. 1868, Rae Papers Nos 70, 73.

16 20 March 1869, Rae Papers No. 75.

17 Doughty and Wahl, II, p.708, No. 842: Rossetti to Miss Losh, 16 July 1869.

18 See note 4. Fennell 1978, Nos 23, 24, 30, 38: Leyland commented, 7 June 1869, 'you know how essential this one is to my happiness as well as the furnishing of my house'; he later cited 700 gns as the price agreed (an increase on the price to Rae) and the initial £200 advance for the unexecuted work was put to *Veronica Veronese*, from the same model, 1872.

19 Surtees 1971, p.193, citing letter in the Victoria & Albert Museum Library.

20 20 Sep. 1870, Rae Papers No. 81.

21 £100 acknowledged 22 Jan. 1866 and receipt of same date; £50, receipt 31 Jan. 1866; £150 acknowledged 20 Feb. 1866; and £120 acknowledged 20 Dec. 1870 (Rae Papers Nos 47–9, 52 and 84). He had temporarily forgotten the initial £100 transaction but proposed to supply a drawing for this.

22 (draft) 19 Dec. 1870, enclosing the final payment and asking for the picture to be sent as soon as possible before a party to be held on 12 Jan. 1871: Rae Papers.

23 (F. G. Stephens) 'The Private Collections of England, No. XVII – Mr George Rae's, Birkenhead', *The Athenaeum*, 2 Oct. 1875, p.444.

24 Ibid. See note 29 for an earlier criticism of the drawing for it.

25 E. Gosse and T. J. Wise, *The Complete Works of Algernon Charles Swinburne*, 1927, XV, p.213.

26 W. M. Rossetti, op. cit., p.56 referring to a letter to George Rae of May 1870 (two letters of this period, Nos 77 and 78 are missing from the Rae Papers), and p.66. W. M. Rossetti 1903, p.487, cites a letter from Graham, Nov. (?)1869, in which he hoped for a watercolour.

27 Surtees 1971, No. 193A, pl.187.

28 Marillier 1899, under No. 179; Surtees 1971, No. 193B.

29 (F. G. Stephens), 'The Private Collections of England', *The Athenaeum*, 27 Sep. 1873, p.407, records this drawing in the collection of Alexander Stevenson at Tynemouth: 'an extremely fine work, with a nobly serious and infinitely suggestive expression on the beautiful face'; there were 'some shortcomings in the outline and contour modelling of the sibyl's chin, jaw and throat.'

30 Surtees 1971, No. 193C.

31 See notes 21, 22.

32 An indistinct chalk inscription on the top edge of the frame was recorded as: ?'*Sep 30 '75 Lot 95*' (no sale has been traced).

33 Letter of confirmation (typescript), 15 Feb. 1917 and receipts (Gallery files). For a total price of £2,500 the transaction

3207. *Jane Morris*

included six Rossettis: *Palmifera, Christmas Carol, Venus Verticordia, Death of Breuse, Fight for a Woman, Dante meeting Beatrice* (pen and ink) (Surtees 1971, Nos 193, 195, 173R.I., 101, 180, 116A), F. Madox Brown's *Windermere* (No. LL 3638 above) and Arthur Hughes' *The Music Party* (No. LL 3642 above); Lever also paid a commission of £250 to Harold Rathbone. Other important pictures from the Rae estate were acquired by the Tate Gallery and see also Madox Brown's *Coat of Many Colours* (No. 1622 above).

3207. *Jane Morris*

Pencil, 25.4 × 23.8 cm (10 × 9⅜ in)

Jane Morris, née Burden (1840–1914), wife of William Morris, the poet, craftsman and socialist. Rossetti and Burne-Jones had first discovered her while staying at Oxford during the Long Vacation, 1857. She was persuaded to sit to the circle of artists painting the murals in the Oxford Union, of whom Morris was one; they married in April 1859.[1] In the later 1860s she became the favourite model for Rossetti, appearing in a series of idealised subject paintings and it appears that he fell in love with her at this time.[2] Her dark sombre beauty was in complete contrast to the ethereal delicacy of the red-haired Elizabeth Siddall (who had died in 1862), but equally in his studies of both, Rossetti conveys their mysterious and withdrawn personalities.

A series of drawings of her, many of them showing her resting on a sofa, date from 1869 to the early 1870s.[3] She was in particularly poor health at this time. She also posed in 1870 in a semi-reclining pose for a drawing for the dead Beatrice (British Museum; fig.77)[4] in *Dante's Dream* (No. 3091 below). The present drawing[5] explores the decorative qualities and contained movement in the mass of her dark wavy hair and swirling silk gown as she settles into repose and it features her long delicate hands which Rossetti so much admired.

PROV: Artist's executors' sale, Christies', 12.5.1883 (183), as *A Lady Reclining, c. 1869*, bt. P H. Rathbone, £5.15.6, for the Walker Art Gallery.

1 Initially mentioned in W. Minto, edit., W. Bell Scott 1892, II, pp.60–1; for an early description of her, see W. M. Rossetti 1895, I, p.199 (repeated in G. H. Fleming, *That Ne'er Shall Meet Again*, 1971, p.104); see also J. W. Mackail, *The Life of William Morris*, 1899, Chapter IV.
2 For his letters to her, see Bryson and Troxell 1976.
3 Listed Surtees 1971, I, pp.174–80.
4 Ibid, No. 81 R.I.E., repr. pl.103.
5 Ibid, No. 387, dated about 1870.

3091. *Dante's Dream*

Oil on canvas,[1] 216 × 312.4 cm (84 × 123 in)

Signed: *D. G. Rossetti*

Inscribed on two scrolls on frame: [left] SOMNIUM DANTIS IN EXTREMA BEATRICIS HORA / JUNII DIE. 9 ANNO 1290; [and right] *Allor diceva Amor: "Più non ti celo: / Vieni a veder nostra donna che giace" / L'immaginar fallace. // Mi condusse a veder mia donna morta; / E quando l'avea scorta, / Vedea che donne la covrian d'un velo; // Ed avea seco umiltà si verace, / Che parea che dicesse: Io sono in pace. / Dante: La Vita Nuova*

Frame: Gilt and carved with panels of formalised flowers, sprays and stars joined by oval-headed panels at the top corners containing the sun (left) and the moon (right) and headed by a row of smaller oval-headed niches containing butterflies; a scroll repeat pattern incorporating circular discs at intervals is engraved round three sides of the outer stepped rebate: designed by the artist (see text).

The largest of Rossetti's works,[2] the culminating expression of his lifelong interest in Dante and in themes of earthly and heavenly love. It is based on the watercolour completed in 1856 for Miss Heaton of Leeds (18½ × 25¾ in, Tate Gallery; fig. 76),[3] as the last and largest of his series of Dante subjects of that period. Rossetti published his English translation of Dante's *Vita Nuova* in his *Early Italian Poets*, 1861. The translation of the passage transcribed on the frame also appeared in the catalogue of the Liverpool Autumn Exhibition, 1881, together with a description, supplied by the artist.[4] This was the occasion of the picture's first public exhibition:

Then Love said: 'Now shall all things be made clear:
Come and behold our lady where she lies.'
 These 'wildering fantasies
Then carried me to see my lady dead.
 Even as I there was led,
Her ladies with a veil were covering her;
And with her was such very humbleness
That she appeared to say, 'I am at peace.'
 Dante: Vita Nuova

'The subject of the picture is drawn from the "Vita Nuova" of Dante, the autobiography of his earlier life. It embodies his dream on the day of the death of Beatrice Portinari; in which, after many portents and omens, he is led by Love himself to the bedside of his dead lady, and sees other ladies covering her with a veil as she lies in death. The scene is a chamber of dreams, where Beatrice is seen lying on a couch recessed in the wall, as if just fallen back in death. The winged and glowing figure of Love (the pilgrim Love of the "Vita Nuova", wearing the scallop shell on his shoulder,) leads by the hand Dante, who walks conscious but absorbed, as in sleep. In his other hand Love carries his arrow pointed at the dreamer's heart, and with it a branch of apple blossom, which may figure forth the love here consummated in death – a blossom plucked before the coming of fruit. As he reaches the bier, Love bends for a moment over Beatrice with the kiss which her lover has never given her; while the two dream ladies hold the pall full of may-bloom suspended for an instant before it covers her face for ever. These two green-clad women look fixedly on the dreamer as if they might not speak.

'The chamber of dreams is strewn with poppies, and on either side of the recessed couch two open passages lead to staircases, one upward, one downward. In these staircases two birds are seen flying, of the same glowing hue as the figure of Love – the emblems of his presence filling the house. Through the openings, and above where the roof also lies open, bells are tolling for the dead; and beyond, in the distance, is the outer world of reality – the City of Florence, which, as Dante says, "sat solitary" for his lady's death. Over all, the angels float upwards, as in his dream, "having a little cloud in front of them;" – a cloud to which is given some semblance of the beautiful Beatrice.'

Alastair Grieve[5] suggests a debt to Blake's title page to *Songs of Experience* for the composition of the original watercolour and points out the Eyckian quality of the dawn views over Florence through the openings on either side. The same dreamlike stillness is repeated in the large oil but the austere mediaevalism gives place to the languorous richness of Rossetti's mature style. Various elaborations and differences are evident in the details. The literary content and elaborate symbolism were explained by T. Hall Caine in a paper delivered in Liverpool at the time of its purchase:[6] Love's flame-coloured robe refers to Dante's vision of this figure in a mist of fire; the scallop shell on his shoulder is emblematic of Love's pilgrimage on earth; the poppies signify the sleep in which the lover walks and also the sleep of death; the may and apple blossom, violets and roses, symbolise purity and virginity; the doves on the staircases symbolise the presence of love in the house; and the dying lamp in the dawning light is suggestive of the 'life which has taken flight . . . leaving behind it only the burnt out socket where the live flame burned'. The scroll suspended from the roof bears the first words of the wail from the Lamentations of Jeremiah, quoted by Dante: *Quomodo Sedet Solo Civitas*. (How doth the city sit solitary).

Rossetti had thought of beginning an oil version in the autumn of 1863, when he borrowed the watercolour from Miss Heaton.[7] Allied to the recent publication of his translations he may have afterwards become aware of

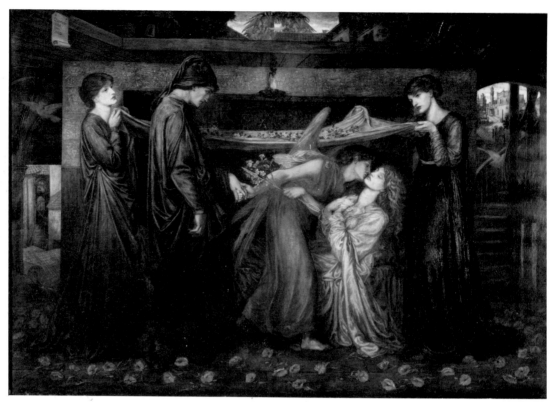

3091. *Dante's Dream* (colour plate XVIII)

Fig.76 *Dante's Dream at the Time of the Death of Beatrice*. By
permission of the Trustees of the Tate Gallery

Leighton's large *Dante in Exile*, which was a great success at the 1864 Royal Academy and led to the artist's election as ARA.[8] This may have confirmed a wish to establish his own supremacy in Dante subjects. He offered the subject in January 1868 to C. P. Matthews as among those he wished to carry out in his lifetime, and commented that the watercolour he had always regarded only as a preparation for a larger work.[9] In April it was offered at £2,000[10] to William Graham (who had been introduced by F. R. Leyland),[11] and Graham finally agreed to a price of 1,500 gns for a canvas of about 6 × 3½ ft, as the largest he could hope to accommodate comfortably.[12] Surtees cites his letter to Miss Heaton asking for the loan of the watercolour: he already had a photograph and 'should only need the drawing as a guide when I come to the *colour* of the picture, and then not for long.'[13] He was forced to write again asking to borrow it in January 1869.[14]

He was planning to take studies in hand in December 1869 after a long period of trouble with his eyesight.[15] He made 'careful studies of the heads, of a certain size; which should be adhered to in order to trace them, which is the only way of such work in painting. . .',[16] and in April 1870 his assistant Henry Treffry Dunn was grouping the studies together ready for him to begin painting,[17] and making use of a photograph of the watercolour for the cartoon for the canvas.[18] The drawings were on offer to Graham, who bought 'four small head studies'.[19] Surtees lists the various drawings.[20] These include studies from the artist's friends for the heads: for Dante from Charles Augustus Howell (Victoria & Albert Museum; 19¾ × 17 in),[21] though W. M. Rossetti states that W. J. Stillman sat for this figure;[22] for Love from Johnstone Forbes Robertson the actor (24¹¹⁄₁₆ × 21¼ in; Tate Gallery), who long after published his recollection of sitting;[23] for Beatrice from Jane Morris (23¾ × 20 in, dated 1870, British Museum; fig. 77);[24] for the left handmaiden from Alexa Wilding, the only professional model, and for the right handmaiden from Marie Stillman, née Spartali, (18½ × 15⅜ and 17¼ × 15 in, both dated 1870, Fogg Art Museum, Harvard; figs 78, 79).[25] Other studies include: a study of Dante, head and shoulders in mediaeval head-dress, given to Alderman Samuelson of Liverpool (30¼ × 21½ in, dated 1871, private collection),[26] the angels bearing Beatrice's soul aloft (6⅛ × 17¼ in, private collection);[27] the clasped hands of Love and Dante, full size (7½ × 10 in, Birmingham).[28] A full drapery study for the right handmaiden (62 × 26 in) was on the art market 1980.[29] Nude and drapery studies are recorded.[30] Dunn mentions that he himself constructed a Florentine-type staircase for use in the picture.[31]

It was carried out on a canvas 'about 10 or 11 feet by 7', far in excess of Graham's wishes, and Rossetti found 'A big picture is glorious work, really rousing to every faculty one has or even thought one might have. . .': he planned in August 1870 to finish the figures though the background was not yet touched.[32] At the same time he was having problems with the relative heights of the figures.[33] It was advanced during 1871 and he was

Fig.77 *Study for Beatrice in 'Dante's Dream'*. By permission of the Trustees of the British Museum

completing the effect and glazing during June.[34] While away at Kelmscott during July to October it was left to dry for the last touches and the frame was ordered.[35] His brother recorded seeing it on the occasion of a family party at Cheyne Walk on 23 October 1871 in its carved frame, executed by Foord and Dickinson, which he considered 'a very fine piece of decorative work'.[36] It was not quite finished but was apparently complete when G. P. Boyce saw it on 21 November 1871 at Rossetti's invitation, and thought it 'a very fine picture, although not so perfect in colour and tone as many of his other works'.[37]

At that stage Rossetti was planning to exhibit it during the 1872 season but was hoping for an overture from the Royal Academy, and he wanted a suitably important notice from F. G. Stephens in *The Athenaeum*.[38] A brief appreciative notice appeared there on 25 November,[39] commenting that 'the colour is magnificent yet sombre, and the whole work is intensely pathetic, and wrought in the grandest style'; critical comment was left over until it might be exhibited in public. In 1872 Ernest Gambart was apparently tempted to have it engraved by Blanchard, but Rossetti did not like the price and did not want at that time to produce any more replicas of his works.[40] It was not exhibited in public in London.

The complications of its subsequent history enabled Rossetti to receive payment for it three times over. It proved too large for Graham's house, at 44 Gloucester Gate, where a place was finally found for it over the staircase, which was unsatisfactory.[41] In 1873 it was

returned to the artist by mutual agreement in exchange
for a reduced replica with predella panels, chiefly to be
painted by Rossetti himself,[42] which was not completed
until 1880[43] (52 × 76 in, dated 1880, Dundee Art
Gallery).[44] The re-sale of No. 3091 was organised by the
reputedly somewhat devious Charles Howell, after var-
ious convoluted negotiations, ultimately to Leonard R.
Valpy, a solicitor, for the original price, without
copyright.[45] After keeping it for a time he also returned it
to Rossetti, due to his retirement to Bath late in 1878,
again in an exchange agreement.[46]

The angel in No. 3091 was worked on around 1879
before 'transferring the material improvements' to the
replica, and the drapery of the handmaiden at the right
was re-designed;[47] Beatrice in the replica was being
re-designed and altered during November 1879.[48] These
changes may have led to the subsequent alterations to
these figures in No. 3091: Beatrice's hair was changed
from brunette to golden and the draperies of the hand-
maiden were worked at in June 1881 shortly following
the initial negotiations in March with Alderman Samuel-
son for the purchase of the picture for Liverpool.[49]

The young T. Hall Caine of Liverpool, who had sought
out Rossetti's acquaintance, was at the centre of the
negotiations which culminated with the agreed exhibi-
tion of the picture at the Autumn Exhibition 1881, on the
private understanding of its sale.[50]

Stephens, in his report on this first public exhibition of
the picture,[51] in spite of a fulsome enthusiasm, caught at
the essence of its quality: 'The pathos of this fine picture
lies, of course, in the consummate sadness and grave
mournful character of the design, the dignified tender-
ness of the ladies' faces as they look on the life-parting of
those who had been lovers of the heart and mind; the
stately grace of their attitudes, and the sober, glowing,
and wonderfully rich colouring of their broad, almost
statuesque draperies, are among the most striking qual-
ities of this superb painting . . .'

ENGRAVED: *Magazine of Art*, 1889, p.51 (4¾ × 6½ in).[52]
PROV: Commissioned by William Graham 1869, com-
pleted 1871, 1,500 gns; returned to the artist in an
exchange arrangement, 1873, and sold to Leonard R.
Valpy, 1873–4 for the same price; again returned to the
artist, 1878–9, retouched and sold to the Walker Art
Gallery for 1,500 gns, 1881.[53]
EXH: Walker Art Gallery 1881, *Liverpool Autumn Exhibi-
tion* (450); Royal Academy 1883, *D.G.R.* (318); Man-
chester 1884; Glasgow 1888, *International*; Walker Art
Gallery 1922, *Jubilee Autumn Exhibition* (37); Manches-
ter City Art Gallery 1929; Port Sunlight 1948, *P.R.B.*
(170).

1 Relined.
2 Surtees 1971, No. 81, R.I., pl.97.
3 Ibid, No. 81, pl.95.
4 W. M. Rossetti 1889, p.116, where he states that Rossetti
 required from Alderman Samuelson 'that his own descrip-
 tion of the work should appear in the catalogue'. It was partly
 quoted in *The Athenaeum*, 1 Nov. 1879, p.567 and again 20

Fig.78 *Study for 'Dante's Dream'*: head of Marie Stillman (née
Spartali). By permission of the Fogg Art Museum, Harvard
University, Cambridge, Massachusetts

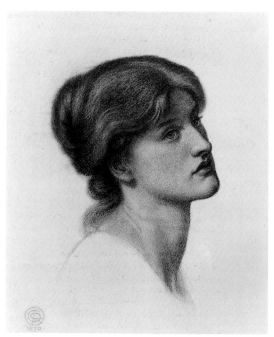

Fig.79 *Study for 'Dante's Dream'*: head of Alexa Wilding. By
permission of the Fogg Art Museum, Harvard University,
Cambridge, Massachusetts

Aug. 1881, p.250. Gale Pedrick, *Life with Rossetti*, 1964, quotes a letter of 30 Aug. (? 1873) to Dunn mentioning a printed description when the picture was again in the studio.

5 Alastair Grieve, in Tate Gallery 1984, *P.R.B.* (218).

6 Published in a pamphlet and republished in T. Hall Caine, *Recollections of D. G. Rossetti*, 1882, pp.50–8 and in Walker Art Gallery, *Catalogue of the Permanent Collection*, 1927, pp.161–4.

7 Surtees 1971, I, pp.42–3, quoting a letter to Miss Heaton, 26 Sep. 1863 (Miss Heaton, on the advice of Ruskin, refused to allow him to retouch the watercolour at this time, but Ruskin planned to get it photographed).

8 L. and R. Ormond, *Leighton*, 1975, p.59, No. 100, pl.86.

9 Doughty and Wahl, II, No. 764, p.648, 3 Jan. 1868.

10 W. M. Rossetti 1903, quoting his own diary for 7 April 1868.

11 Fennell 1978, No. 17, Rossetti to Leyland 11 April 1868, reporting the transaction, 'for does it not come through you in the first instance?'

12 W. M. Rossetti 1903, p.350, Graham to Rossetti, 9 April (?)1868, from 44 Grosvenor Place.

13 Surtees 1971, p.44, quoting Rossetti's letter of 9 Jan. 1868.

14 Ibid, letter of 25 Jan. 1869.

15 Doughty and Wahl, II, No. 911, p.780, letter to Frederic Shields, 24 Dec. 1869.

16 W. M. Rossetti 1889, p.72, quoting a letter to an unidentified correspondent.

17 Doughty and Wahl, II, No. 989, p.848, letter to his mother 18 April 1870.

18 Ibid, No. 987, p.846, letter to Fanny Cornforth (17 April 1870).

19 Ibid, No. 987, p.846 and No. 1009, p.862, letter to Ford Madox Brown, 3 May 1870; W. M. Rossetti 1889, p.71, states ten were on offer, and gives the date of 29 June 1870.

20 Surtees 1971, R.I., A-L, pls 99–104.

21 Surtees 1971, R.I.C., pl.101, identified by Dunn.

22 W. M. Rossetti, *The Art Journal*, 1884, p.205.

23 W. M. Rossetti, loc. cit.; Surtees 1971, R.I.D., pl.102: J. Forbes Robertson, 'The Tribute to a Friend', *The Times*, 11 May 1928: '. . . When the picture was nearly finished Rossetti asked my father if I might sit to him for the head of Love and this I did much to my pride and delight. I remember well that the space left for the head was scrumbled over with Venetian red on which he painted the profile. I had to pose over a cushion on a sofa . . .'

24 Surtees 1971, R.I.E., pl.103.

25 Ibid, R.I.G. and J., pls. 99, 100.

26 Surtees 1971, R.I.B.

27 Ibid, R.I.L., pl.98.

28 Surtees 1971, R.I.K., pl.104.

29 Sold Sotheby's, 6.10.1980 (24) repr.

30 W. M. Rossetti 1889, p.72.

31 Surtees, p.44; quoting Dunn's papers.

32 Doughty and Wahl, II, No. 1065, p.898, letter to Frederic Shields, 28 Aug. 1870.

33 Ibid, No. 1066, p.899, letter to Ford Madox Brown, Aug. 1870.

34 Bornand 1977, pp.59, 61, 72, comments in W. M. Rossetti's diary for 29 April, 10 May and 23 June 1871.

35 Doughty and Wahl, III, No. 1185, p.1022, letter to Miss Losh, 28 Oct. 1871.

36 Bornand 1977, p.118.

37 Surtees 1980, *Boyce Diaries*, p.53.

38 Bornand 1977, pp.122, 127, entries for 1 and 15 Nov. 1871.

39 *The Athenaeum*, 25 Nov. 1871, p.694.

40 Bornand 1977, p.202, entry for 22 May 1872.

41 Doughty and Wahl, IV, No. 1947, p.1584: to Graham, 18 Aug. 1878 mentioning the unsatisfactory position it had had.

42 Ibid, III, Nos 1391, 1396–7, pp.1208, 1212: letters to FMB, 26 Aug., 5, and to W. M. Rossetti, 6 Sep. 1873 and passim; W. M. Rossetti 1889, pp.87–8: £300 were added for the predellas.

43 Doughty and Wahl, IV, No. 2192, p.1713: to Dunn, 17 Feb. 1880; W. M. Rossetti 1889, pp.96, 107.

44 Surtees 1971, No. 81, R.II, with studies. It was reviewed with other recent work in a lengthy notice in *The Athenaeum*, 1 Nov. 1879, p.567. At a later stage it belonged to William Imrie of Liverpool.

45 Doughty and Wahl, III, No. 1425, p.1238: detailed at length in letter to Ford Madox Brown, 25 Nov. 1873; No. 1519, p.1309, to Valpy, 2 Sep. 1874 asking for first instalment; and No. 1535 (copy) to Valpy, 6 Nov. 1874, declining to include copyright; W. M. Rossetti, loc. cit.

46 Doughty and Wahl, IV, No. 1993, p.1612: to Valpy, 26 Nov. 1878; W. M. Rossetti 1889, pp.105–6.

47 Doughty and Wahl IV, No. 2042, p.1635; to Graham, 5 May 1879. *The Athenaeum*, 1 Nov. 1879, reviewing the replica, commented that it was in the figure of the handmaiden that 'the chief change in the picture occurs.'

48 Doughty and Wahl, IV, No. 2140, p.1685: to Dunn, 22 Nov. 1879.

49 Bryson and Troxell 1976, p.178, No. 136, 31 March 1881, reporting the recent visit of a deputation from Liverpool; Doughty and Wahl, IV, No. 2486, p.1875: to his mother 26 April 1881, commenting that he had sent a photograph to Samuelson, and No. 2513, p.1899: to Samuelson, 20 July 1881; W. M. Rossetti 1889, pp.113–15.

50 W. M. Rossetti, loc. cit.; Bryson and Troxell 1976, No. 146, 4 Sep. 1881, reporting the purchase.

51 *The Athenaeum*, 20 Aug. 1881, p.250.

52 Hollyer photographed it about Nov. 1891 and it was extensively reproduced in colour (list of reproductions given permission, Gallery files); and see note 49.

53 Arts and Exhibitions Sub-Committee Minutes, 23 Aug. 1881; reporting concluding of purchase.

LL 3148. *The Blessed Damozel*

Oil on canvas, 111 × 82.7 cm (43¾ × 32½ in) plus predella, 36.5 × 82.8 cm (14⅜ × 32⅝ in)
Signed on the predella: *D G Rossetti*
Frame: gilt and carved in classical style with columns beneath a broken pediment and reliefs of trailing vine and leaves and two winged cherub heads.[1]

Illustrating the artist's poem of the same title, first published in the Pre-Raphaelite journal, *The Germ*, February 1850 and with differences in the *Poems* of 1870. It tells the story of a damozel dying in the fullness of youth and before her lover, waiting for his coming to heaven:[2]

The blessed damozel leaned out
 From the gold bar of Heaven;
Her eyes were deeper than the depth
 Of waters stilled at even;
She had three lilies in her hand,
 And the stars in her hair were seven.

It was the rampart of God's house
 That she was standing on;
By God built over the sheer depth
 The which is Space begun;
So high, that looking downward thence
 She scarce could see the sun.

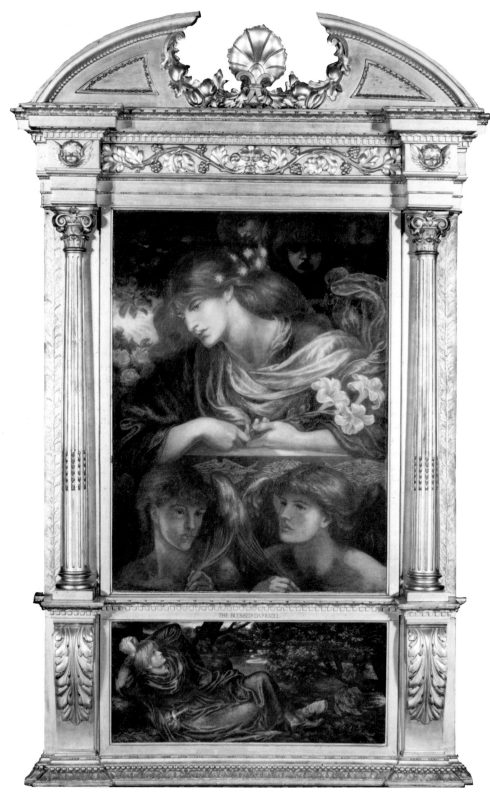

LL 3148. *The Blessed Damozel* (colour plate XIX)

'I wish that he were come to me,
 For he will come,' she said.
'Have I not prayed in Heaven? – on earth,
 Lord, Lord, has he not pray'd?
Are not two prayers a perfect strength?
 And shall I feel afraid?'

Her lover reclines by a river in a wooded autumnal landscape below, looking up to heaven:

(To one, it is ten years of years.
 . . . Yet now, and in this place,
Surely she leaned o'er me – her hair
 Fell all about my face . . .
Nothing: the autumn-fall of leaves.
 The whole year sets apace).[3]

This is a replica, on a slightly smaller canvas and with some differences in the details, of the picture commissioned, and the subject suggested by William Graham in February 1871,[4] the year following the publication of the *Poems* (68½ × 37 in overall, Fogg Art Museum, Harvard).[5] The idea of doing this subject apparently went back at least to 1856 when T. E. Plint of Leeds wished to commission it.[6] It now took its place among the mystic-poetical subjects with lethargic idealised beauties of the artist's final period.

In 1873 Rossetti finished a drawing for F. R. Leyland, of the central figure, which he considered so complete that he ought to 'set to work and paint a picture right out from it, as I really believe such pictures have more unity if one does not do them from nature but from cartoons.[7] He began a picture from it at that time, having discarded an earlier canvas.[8] Rossetti mentioned to Graham in 1876 having worked on three canvases of which Graham's was then designated the third picture.[9] Alexa Wilding was the model for the damozel.[10] In December 1877 Graham asked for a predella to be added and this Rossetti thought enormously improved the picture when completed early in 1878.[11] It cost Graham £1,000 plus £100 for the predella.[12]

Rossetti was considering completing the present picture, on which it is not clear how much had already been done, in 1878 to pay off old claims from Charles Howell.[13] He was working on it in April 1879, and may have had in mind F. R. Leyland[14] (his other major patron besides Graham in his later years), who already possessed and much admired the earlier drawing.[15] The artist mentions in a letter to Graham that May,[16] having had an earlier request for a replica of the predella and in August requested permission for his assistant Dunn to make a study from it at Grosvenor Place, from which he might work, as Graham would not lend him the picture.[17] Leyland considered the picture but did not 'bite' at it in June 1880,[18] but the following October suggested taking it in default of an unexecuted *Hero* for which he had already paid £850; he wanted something at once to fill the remaining space in his new drawing-room at 49 Princes Gate, and offered an additional payment.[19] Rossetti was glad to get the additional £500 at a period of financial distress.[20] Leyland found it superb and it was initially hung in the portico room,[21] but in a photograph of 1892 (fig. 4) it is shown hung with a series of Rossetti's pictures in the drawing-room, flanked in triptych form by *Mnemosyne* and *Proserpine*.[22]

It differs from the larger version in the more limited field around the damozel, precluding the flowers at either hand; there are only two angel heads below her, but three winged cherubs' heads appear above her to replace the many groups of embracing lovers in the other work. In the predella, part of the tree and landscape at the right are cut off in this narrower format. Surtees lists a study for No. LL 3148 of the two angels' heads below the damozel (Wichita Art Museum, Kansas, 15¾ × 29¾ in).[23] A cartoon for the damozel, perhaps a studio work connected with all the versions, was on the art market 1984.[24]

The subject was described at length by F. G. Stephens in a laudatory review of recent work in *The Athenaeum*, 1877 with a short update for this picture in 1879.[25] He summed up on the prime version: 'technically speaking this is a rich and supersubtle study, in various hues of deep blue and green. Solemn as the design is, it owes much of its solemnity to the broad and subdued wealth of its chiaroscuro. A great charm of the whole consists in the grace of the attitude of the damozel, but the noblest point of all is the intensity of the expression of her face.' Sidney Colvin, writing in 1883,[26] in contrast thought: '. . . what a decay of the colour-sense is shown in the unwholesome pink stars and haloes, the dusky hotness and livid colours of the "Blessed Damozel"'! The role of Leyland (and of Graham) in the evolution of Rossetti's later style was the subject of another reviewer in 1892 at the disposal of the collection after Leyland's death:[27] 'It is evident that the merely decorative use of pictures was in his [Leyland's] mind subordinate to the ideas they conveyed, and to the poetic feeling they stimulated. The explanation of his strongly-marked preference for the mystic, super-sensuous art of D. G. Rossetti does not concern us. It is enough for us to know that he and Mr Graham of Glasgow were the instruments by which this interesting phase of nineteenth-century Art was stimulated. Without these patrons Rossetti would have been forced to adapt his powers to pleasing the popular taste, but by their help he was able to work out his own theories of Art, and, like his great inspirer, Dante, to painting, with a brush instead of the pen, "the sphere of the infinite images, of the soul".'

REPR: Marillier 1899, fp. 188.[28]
PROV: Sold to F. R. Leyland, Feb. 1881, £500 (plus £850 from an earlier commission);[29] his sale Christie's, 28.5.1892 (55), bt. McLean £1,029; the Hon. Mrs O'Brien (later Lady Inchiquin); bt. by the 1st Viscount Leverhulme from D. Croal Thomson, Barbizon House, Nov. 1922, £2,300,[30] and thence to the Lady Lever Art Gallery.
EXH: Burlington Fine Arts Club 1883, *D.G.R.* (72); New Gallery 1897–8 (63); Franco-British 1908 (91); Walker Art Gallery 1933, *Liverpool Autumn Exhibition* (62); Port Sunlight 1948, *P.R.B.* (171); Paris 1972, *P.R.B.* (221)

repr.; Royal Academy and Birmingham 1973, *D.G.R.* (352); Rotterdam, Brussels and Baden-Baden 1975–6, *Le Symbolisme en Europe*, repr. col. (206); Royal Academy 1980, *Lord Leverhulme* (36) repr.

1 Frame: probably by Foord and Dickinson, Rossetti's usual framemaker at this period.
2 Described by F. G. Stephens, *The Athenaeum*, 14 April 1877, p.487.
3 W. M. Rossetti, *The Collected Works of Dante Gabriel Rossetti*, 1897, I, pp.232–4, stanzas 1, 5, 12 and 4.
4 Bornand 1977, p.45, entry for 19 Feb. 1871.
5 Surtees 1971, No. 244, pl.355, with studies (stanzas 1, 7, 3 and 4 are inscribed on the frame); this replica, No. 244. R.I., with a study.
6 W. M. Rossetti 1889, p.20.
7 Doughty and Wahl, III, No. 1339, p.1170, Rossetti to Ford Madox Brown (14 May 1873); Marillier 1899, p.188; Surtees 1971, No. 244A (31 × 35 in; private collection).
8 Fennell 1978, No. 51, Rossetti to Leyland, 23 May 1873: 'the drawing . . . is so much better than the commencement of the picture which I made some time back, that I have commenced the picture afresh from it on a new canvas. . .'; he would need the drawing again for this purpose. For the discarded canvas see Surtees 1971, No. 244C, also called *Sancta Lilas* (Tate Gallery).
9 Doughty and Wahl, III, No. 1677, p.1420.
10 W. M. Rossetti 1895, I, p.242.
11 Bryson and Troxell 1976, No. 26, p.54, to Jane Morris, 27 Feb. 1878. Graham's collection of early Italian paintings was no doubt the cause for his request for predellas for *Beata Beatrix*, the smaller *Dante's Dream* and this picture as Oliver Garnett has pointed out in his lecture, '*William Graham: Pre-Raphael Collector and Pre-Raphaelite Patron*', Mellon Centre, 21 March 1985; and see Doughty and Wahl, III, No. 1224, p.1059.
12 W. M. Rossetti 1889, p.89 (Rossetti knocked off £50 on the predella subject to Graham buying a painting by Smetham: Doughty and Wahl, IV, No. 1947, p.1583, 18 Aug. 1878).
13 Doughty and Wahl, IV, No. 1885, p.1552, to Theodore Watts-Dunton 11 Feb. 1878.
14 Ibid, No. 2037; p.1632, to his mother, 27 April 1879.
15 Fennell 1978, No. 52, Leyland to Rossetti, 28 May 1873. Rossetti had probably had Leyland in mind from the first (see M. Susan Duval, Courtauld Institute thesis, *A Reconstruction of F. R. Leyland's Collection*, 1982, discussing their relationship and Leyland's early wish for a triptych arrangement of his pictures).
16 Doughty and Wahl, IV, No. 2042, p.1636, 5 May 1879.
17 Ibid, No. 2081, p.1659, 4 Aug. 1879.
18 Ibid, No. 2279, p.1784, to Watts-Dunton 15 June 1880; Fennell 1978, No. 119, Leyland to Rossetti 10 June 1880.
19 Fennell 1978, No. 121, 11 Oct. 1880.
20 Fennell 1978, No. 126, Leyland to Rossetti 31 Jan. 1881, enclosing a cheque for £500; Doughty and Wahl, IV, No. 2408, p.1844, Rossetti to Watts-Dunton (6 Feb. 1881).
21 Fennell 1978, No. 128, Leyland to Rossetti 12 July 1881.
22 Photograph by H. Bedford Lemere (1864–1944), National Monuments Record: Nicholas Cooper, *The Opulent Eye*, 1976, pl.39 and M. Susan Duval, 'F. R. Leyland: A Maecenas of Liverpool', *Apollo*, Aug. 1986, p.113 repr. See note 15.
23 Surtees 1971, No. 244 R.I.A., pl.363.
24 Christie's sale, 18.12.1984 (48) repr.; see Doughty and Wahl, III, No. 1715, p.1452.
25 *The Athenaeum*, 14 April 1877, p.487; 1 Nov. 1879, p.567.
26 Sidney Colvin, 'Rossetti as a Painter', *Magazine of Art*, 1883, p.183.
27 Lionel Robinson, 'The Leyland Collection', *The Art Journal*, 1892, p.136.
28 Marillier 1899, p.190: From a photograph taken by Caswall Smith while in the Leyland collection.
29 See notes 19, 20.
30 Invoice, 7 Nov. 1922, Gallery files.

LL 3647. *Pandora*

Pastel on paper,[1] 100.8 × 66.7 cm (39⅞ × 26¼ in)
Signed in monogram and dated: *DGR / 1878*
Frame: Rossetti/Madox Brown type, gilt and oak with ribbed sides with engraved circles and squares on the sides; the flat with a border of lozenges and circles.[2]

Pandora, the first woman on earth and the giver of all. Versions of the myth give her a power from each of the gods to work the ruin of man, or, of having a vessel containing all the blessings for man all of which escaped, she having opened it.[3] Alastair Grieve points out[4] the version in Heywoode's *Tuniaken – or Nine Books of Various History Concerning Women*, 1624, which Rossetti had in his library, describing her being sent by Jupiter to Prometheus with a box full of mischiefs which he refused and gave to Epimetheus, 'who taking off the cover or lid, and perceiving all these evils and disasters to rush out at once, he scarce had time to shut againe, and keep in Hope, which was the lowest and in the bottome.'

Rossetti initially designed the subject, of which this is a later variant, in 1868–71 with Jane Morris as the model; he painted both an oil and a pastel three-quarter figure at that time and still wished to paint a full-length figure in 1874.[5] His pastel drawings were a significant part of his work, most particularly after he began to have eye trouble in the late 1860s, and were highly worked out and complete in their own right whether or not used for the basis of an oil painting.

He wrote a sonnet for his picture; which he afterwards published in his *Poems*, 1870:[6]

What of the end, Pandora? Was it thine,
 The deed that set these fiery pinions free?
 Ah! wherefore did the Olympian consistory
In its own likeness make thee half divine?
Was it that Juno's brow might stand a sign
 For ever? and the mien of Pallas be
 A deadly thing? and that all men might see
In Venus' eyes the gaze of Proserpine?

What of the end? These beat their wings at will,
The ill-born things, the good things turned to ill, –
 Powers of the impassioned hours prohibited.
Aye, clench the casket now! Whither they go
Thou mayst not dare to think: nor canst thou know
 If Hope still pent there be alive or dead.

Swinburne's review[7] of the *Poems*, exactly captures the quality of Rossetti's design concept: 'Of the sonnets of the writer's own pictures and designs I think that on Pandora to be the most perfect and exalted, as the design is among his mightiest in its godlike terror and impressionable trouble of beauty, shadowed by the smoke and fiery vapour of winged and fleshless passions crowding from

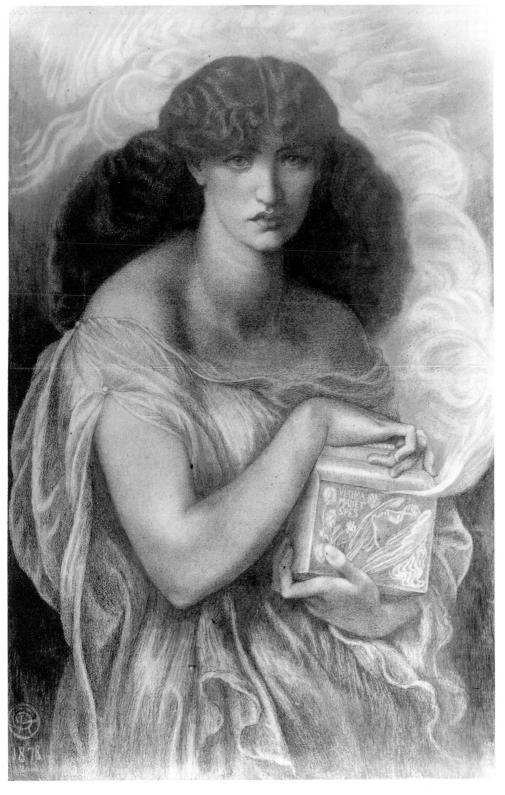

LL 3647. *Pandora*

the casket in spires of flame-lit and curling cloud round her fatal face and mourning veil of hair.'

The artist retained a study from Jane Morris,[8] along with others of her, in his studio and in 1878 he again returned to the subject and wrote to her in March:[9] 'I have taken up the Pandora drawing again with a fresh system of bogies round the head, and have now made it very complete indeed.' A year later he commented[10] that he had done this subject and Proserpine in replica, 'for the market as I wouldn't part with the originals, but haven't spotted a buyer yet'. There are two very similar versions of the present pattern of which one was intended for Theodore Watts-Dunton in recognition of his unfailing legal usefulness to the artist. In May 1879 Rossetti wrote to him that 'As I have not yet been able to get on with the *Pandora* that was traced out for you, I wish you would accept of the one I did in the winter . . .'[11] In August 1879 Rossetti was re-drawing the face[12] and the Watts-Dunton version (38 × 24½ in, now Fogg Art Museum, Harvard),[13] is dated 1879, a year later than the present work. The present version[14] has broader features in the face. Both versions, no longer taken from the life, replace the doom-laden introspection of the earlier idea with a writhing menace, which reflects the troubled thoughts of the artist's last years. The bare arm and massive shoulders parallel his recent *Astarte Syriaca*[15] of 1875–7 and likewise, as Grieve suggests,[16] find a source in Michelangelo. The hands, always of great importance in the artist's work, have become almost talons, as they embrace the barely shut casket whose wreaths of evil bogies curve away about Pandora's head. A winged head of Hope with flowers on the side of the casket and its inscription: ULTIMA / MANET / SPES, recall that the last hope remains.

PROV: Artist's executors' sale, Christie's, 12.5.1883 (52), bt. Smith £120.15.0; L. R. Valpy, sold Christie's, 26.5.1888 (102), bt. Scott £157.10.0; Sir George A. Drummond, sold Christie's, 26.6.1919 (128), bt. Gooden & Fox for W. H. Lever (1st Viscount Leverhulme) £199.10.0 plus commission, £204.9.9;[17] thence to the Lady Lever Art Gallery.
EXH: Port Sunlight 1948, *P.R.B.* (176); Tate Gallery 1984, *P.R.B.* (250) repr.

1 Made up of two sheets, the join visible across the shoulders of the figure.
2 An invoice from Gooden & Fox (Aug. 1920 for 13 April: Gallery files), specifies a list of pictures including this item, charged for partial regilding and repair work ('a 1¾ in reeded oak frame').
3 See D. and E. Panofsky, *Pandora's Box*, 1956, p.86f., discussing the re-emergence of the subject and the introduction of a box in nineteenth-century English art. This picture is repr. p.108.
4 Tate Gallery 1984, *P.R.B.* (245).
5 Surtees 1971, Nos 244, 244A–C, pl.318; W. M. Rossetti 1889, pp.65, 71, 79, 80; Marillier 1899, pp.156, 163–4; Doughty and Wahl, III, No. 1547, p.1324.

6 W. M. Rossetti, *The Collected Works of Dante Gabriel Rossetti*, 1897, I, p.360.
7 E. Gosse and T. J. Wise, *The Complete Works of Algernon Charles Swinburne*, 1927, XV, pp.31–2; quoted in W. Sharp, *Dante Gabriel Rossetti*, 1882, p.212.
8 W. M. Rossetti 1889, p.80.
9 Bryson and Troxell 1976, No. 28, 18 March 1878.
10 Ibid, No. 52, 15 Feb. (1879).
11 Doughty and Wahl, IV, No. 2043, p.1636.
12 Ibid, No. 2083, p.1660, Thursday (7 Aug. 1879).
13 Surtees 1971, No. 224, R.I., pl.317; Fogg Art Museum, Harvard 1946, *Paintings and Drawings of the Pre-Raphaelites and their Circle* (86).
14 Surtees 1971, No. 224, R.I.A.
15 Ibid, No. 249.
16 Tate Gallery 1984, *P.R.B.* (250).
17 Invoice, June 1919, Gallery files.

Rossetti, Dante Gabriel, after
381. *Love and Beatrice in 'Dante's Dream'*
Red and black crayon heightened with white, on grey paper, 57.5 × 43 cm (22⅝ × 17 in)
Inscribed with monogram: *DGR*

Perhaps connected with the replica of the painting or a work by H. Treffry Dunn, the artist's assistant. Beatrice's hair is in the lighter colouring Rossetti ultimately used.

PROV: Purchased from C. J. Sawyer, 1940, said to be from the collection of William Michael Rossetti. Walker Art Gallery.

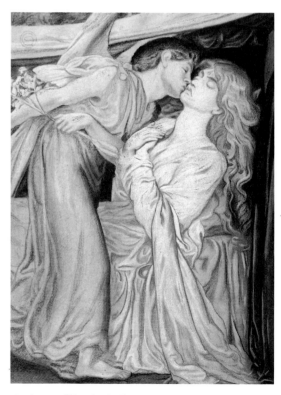

381. *Love and Beatrice in 'Dante's Dream'*

Ruskin, John (1819–1900)

Art critic, writer, lecturer and amateur artist, son of a successful wine merchant and of independent means; born London, 8 February 1819. He had a discerning, delicate and detailed draughtsmanship based on drawing lessons from established watercolourists and from study of J. M. W. Turner. His large output in landscape, architectural and geological studies stemmed from the observations of his isolated childhood and from his almost annual Continental trips which had commenced in company with his parents, who had provided a repressive, religious and cultivated upbringing. His early enthusiasm for the watercolours of Turner led to the publication of the first volume of *Modern Painters* in his defence, 1843 (Vol.II, 1846 and subsequent volumes). These in turn influenced the ideas of the aspiring young Holman Hunt, leading to the formation of the Pre-Raphaelite Brotherhood, 1848. His subsequent prolific output on matters of art, architecture, political and social economy, etc., original and discerning if often self-contradictory, exerted an enormous influence. He took up the Pre-Raphaelite cause in 1851 in defence of Millais' and Hunt's vilified paintings, met them both that year, Rossetti in 1854 and attempted to influence the style and objectives of various members of the circle, not always with wisdom; Madox Brown and he were mutually antagonistic. His marriage to Euphemia Chalmers Gray was annulled in 1854 and she married Millais in 1855. His *Academy Notes*, 1855–9 provided an instructive viewpoint on current, and especially Pre-Raphaelite art. He was appointed first Slade Professor at Oxford, 1869, but suffered a first mental breakdown in 1878 and ceased to write after 1889. Bought Brantwood on Coniston Water, 1871 and died there 10 January 1900.

8280. *Coniston Old Hall and boat house seen across the lake*

Watercolour, oval, 11.2 × 16 cm (4⅜ × 6¼ in)
Inscribed and dated: *J. Ruskin to Alice Rathbone 8th September 1878*

Alice, daughter of P. H. Rathbone of Liverpool, collector and late Chairman of the Arts Sub-Committee, was a guest at Ruskin's house, Brantwood on Coniston Water, for a week from 31 August 1878, 'making the days fly by'.[1] Ruskin was fond of the society of young girls and was relaxed and cheerful at this time after a severe illness. He took her to Peel Island,[2] walking back by the road. This vignette of Coniston Old Hall, across the lake from Brantwood, was painted for or presented to Alice the day before she left, apparently after a discussion as to whether a cabbage field could be made a beautiful subject for a picture.[3]

PROV: Alice Rathbone, and thence by descent to her daughter Elinor; purchased by the Walker Art Gallery from her estate, 1972.

1 Joan Evans and John Howard Whitehouse, *The Diaries of John Ruskin*, III, 1874–87, 1959, p.977.
2 Loc. cit.
3 MS label, verso.

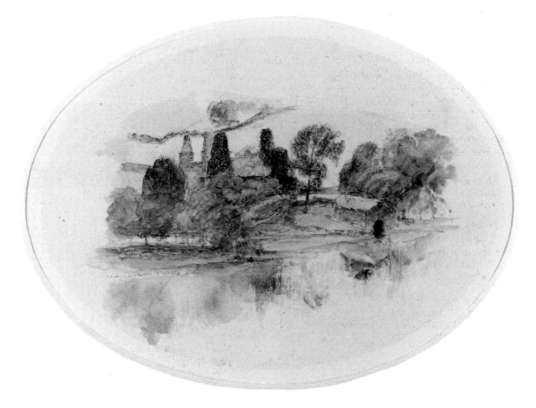

8280. *Coniston Old Hall and boat house seen across the lake*

Sandys, Frederick (1829–1904)

Born Norwich 1 May 1829, son of a textile dyer, turned drawing master and artist, Anthony Sands (sic). He trained at Norwich School of Design and was patronised by the Rev. James Bulwer. In London by 1851, he was working as a draughtsman for the wood-engravers and began exhibiting at the Royal Academy that year, first with pastel portraits. He developed a skilled and finely detailed draughtsmanship and clear-cut style in landscape painting, particularly of his native Norfolk, and in portraiture and subject pictures, in which Pre-Raphaelite influence was apparent. He became known to Rossetti and the circle through his skit *The Nightmare*, 1857 (No. LL 3453 below) and lived in Rossetti's house for some months during 1866; his idealised female portraits showed Rossetti influence and the latter accused him of plagiarism; their friendship broke down between 1869 and 1875. He made an outstanding series of intensely dramatic wood-engravings during the 1860s. Set up home with Mary Jones, a young actress, probably in the late 1860s. Later he concentrated on pastel portraits and idealised female figures often using his family as models. Died London 25 June 1904.

2633. *Helen of Troy*

Oil on panel, 38.4 × 30.5 cm (15⅛ × 12 in)

The artist's illustration of *Helen and Cassandra* was published in *Once a Week*, Vol. I, 28 April 1866, p.454 (fig. 80).[1] It shows two full-length figures with Helen's head in a similar pouting pose to the present oil, which must be a development of the same idea, though considerably softened. Here the artist concentrates on the head only which echoes the exotic type of female portraits which Rossetti was developing in the 1860s. It was, indeed, one of three subjects in which Rossetti accused Sandys of copying his ideas, however unconsciously, in general approach if not in detail.[2] Rossetti's own *Helen of Troy*, 1863,[3] shows a half-length youthful blonde set against a flaming city. Their friendship terminated at this time.

In this picture, the hair is arranged rather differently from Sandys' illustration: Helen wears a rose in it and does not catch it in her lips. She also wears a rich coral necklace.[4] The background is filled with blue bell-flower sprays of bougainvillaea type, in place of flames. Appropriate lines in the verses, written by Alfred B. Richards, which accompanied the illustration, where Cassandra confronts her with the destruction of Troy, describe her as:

'. . . but the one as a dream
Or a picture by moonlight, so ruthlessly fair,
You would drink from her cup though you knew that the cream
Of a fatal drug mantled in treachery there.

'Her blue eyes, forget-me-nots freshened with dews,
 Her locks, liquid gold down an ivory stair:
Go, pillage Love's rose-beds a rose-bud to choose,
 Have its heart-folds a blush-tint with hers to compare?'

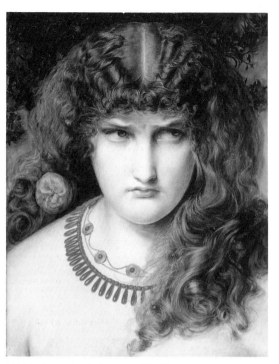

2633. *Helen of Troy* (colour plate XXXII)

Fig.80 Swain after Sandys, *Helen and Cassandra, Once a Week*, 28 April 1866. By courtesy of Liverpool City Libraries

and Cassandra denounces her:

'Perjured wanton! rejoice o'er the doom thou hast
brought
To my sire's ancient throne, to this people and land;
Tis thy small busy hand ev'ry murder hath wrought,
 And to each burning roof thou alone wast the brand.

'Thou art fair, so is Summer when Pestilence breathes,
And the blue mist of Famine at eve shrouds the plain;
Thou art like a painting that loveliness wreathes,
 But behind it leers Death with the worm's icy strain.

'Dost thou cower and crouch? Nay, thou need'st feel no
dread;
Thou shalt live the vile prize of the sword that is first, . . .'

The model is probably Mary Jones (known as an actress
as Mary Clive), who first appears in Sandys' work around
1867 and who afterwards set up house with him.[5] Her
smooth classical features, pouting charm and superb
wavy hair became a feature of his work.

W. M. Rossetti saw *Helen* in the Gambart sale at
Christie's in 1871, and did not think it followed his
brother's treatment and recorded his own opinion of it as
'a very bad picture, almost the worst thing Sandys ever
produced'.[6]

Sandys may also have intended to carry out a larger
and closer variant of the illustration design, based on an
unfinished drawing (15¹/₁₆ × 14⁵/₁₆ in; Birmingham City
Art Gallery,[7] which shows Helen in a similar half-length
pose and against a similar background of flames, her head
with the eyes gazing to the left as in the original drawing
for the illustration,[8] and the flames alone carried out in
detail), as an unfinished canvas, 32 × 24½ in, with a
half-length figure was on the art market in 1922.[9] There is
also a charcoal and coloured chalk drawing, 13½ × 11 in,
signed and dated 1867 (art market 1964).[10] Another chalk
drawing of *Helen of Troy*, 1893, is also recorded.[11]

PROV: Ernest Gambart, dealer, sold Christie's, 31.3.1871
(231) as *Helena*, 12 × 14½ in, bt. Pilgeram £63; E. C.
Potter, Manchester, by 1878; his sale Christie's,
22.3.1884(57), bt. Warr £147; G. C. Warr (1894); Mrs
Constance Emily Warr, who bequeathed it to the Walker
Art Gallery, on behalf of her husband, the late Professor
George Warr, 1908.

EXH:Manchester 1878(239); Grafton Galleries 1894, *Fair
Women* (133); Royal Academy *Winter* 1905(308).

1 Reprinted in Thornbury's *Historical and Legendary Ballads
 and Songs*, 1876.
2 Rossetti to Sandys, (?)1 June 1869, Doughty and Wahl, II, No.
 828, p.697; W. M. Rossetti 1903, pp.393, 395, quoting his own
 diary, 27 May, 4 and 5 June 1869 on this matter.
3 Kunsthalle, Hamburg: Surtees 1971, No. 163, pl.232.
4 Believed by Mr and Mrs Anthony Crane, grandchildren of the
 artist, still to be in the family (visit 10 Sep. 1984).
5 See Betty O'Looney, Catalogue of exhibition, *Frederick
 Sandys*, Brighton and Sheffield, 1974.
6 Bornand 1977, p.52, entry for 29 March 1871.
7 O'Looney, op. cit., No. 67, pl. 38: Birmingham, *Catalogue of
 Drawings*, 1939, p.381(859/06) with other studies for the
 illustration.

2251. *Kittie*

8 O'Looney, op. cit., No. 271, plate 166.
9 Sotheby's, 10.5.1922 (79), bt. Heygate.
10 Sotheby's, 29.10.1964 (240), bt. Maas.
11 Royal Academy *Winter* 1905(265), 29½ × 21½ in, lent Wil-
 liam Gillilan: half-length looking at the spectator, holding her
 long hair in front of her with both hands.

2251. *Kittie*

Coloured chalks, 98.4 × 75.6 cm (38¾ × 29¾ in)
Signed, dated and inscribed, on a simulated label: *Kittie
1873/F. Sandys*
Frame: Rossetti/Madox Brown pattern of reeded gilt with
inset roundels and wide gilt oak flat with roundels.[1]

Portrait of the donor, Miss Ellen Ellis. Painted for her
step-father Thomas Chappell (of 50 New Bond Street),
who was also portrayed by Sandys with his wife and
their young son.[2]

PROV: Thomas Chappell; thence to Miss Ellen Ellis, who
presented it to the Walker Art Gallery, 1911.

1 Framemakers' label of Foord and Dickinson, Wardour Street,
 London.
2 Letter from the donor, 22 May (1911), Gallery files.

LL 3453. *A Nightmare*

Zincotype, proof, image 33.6 × 48.6 cm (13¼ × 19⅛ in)
Inscribed on the print: JR/OXON on rump of donkey; *PRB*
on paint can, and ORATE.P.NOBIS on scroll above Raphael
in background; verses below (see text) titled A NIGHTMARE
and followed by publisher's letters: *Published by Smithe
ye Eldere, at the Signe of Sainte Luke his Head, Cornhill,*

London. May ye 4th 1857 [the 5 in the year altered from a 4, which is still visible]
Inscribed in pencil, supposedly by Sandys,[1] with the verses translated into modern English (see text)

A parody on Millais' *A Dream of the Past: Sir Isumbras at the Ford* (No. LL 3625 above), directed at Ruskin's role as art critic. It shows Ruskin as a braying ass with Millais as the knight, the little girl before him having Rossetti's head and the boy behind that of Holman Hunt. The knight's sword is changed into a mahlstick, his casque into a tin of paint and the boy's firewood into a bundle of paint brushes. The two nuns walking on the bank of the river are changed into Michelangelo with Raphael and Titian kneeling in front. The background is a careful transcript into line of the painting.

The verses on the scroll beneath read as the left column below; there is a gap between *the* and *Man in Brasse* at the end of the verses. The modern translation in pencil is transcribed in the right column.

Sandys did not know the Pre-Raphaelites personally when he produced this satirical print. He is supposed to have contrived to see Rossetti by calling at his house, in order to memorise a likeness,[2] and not long afterwards became a friend until their acquaintance broke down from 1869. The head of the donkey is an exact copy from an etching by Robert Hills (1769–1844) published in 1809. The drawing and a copy of the etching are in a group connected with the *Nightmare* at Birmingham (figs 81–3).[3] Also in the group are two sheets of studies of armour:[4] one for the leg armour and gauntlet is inscribed *Meyrick's Antient Armour*, and copied from an equestrian suit of armour of 1558 in pl.XXIX, Vol.1 of Sir S. R. Meyrick, *Engraved illustrations of ancient armour from the collection of Goodrich Court . . .*, John Skelton, 1830; and the other includes a detail of a horse's bit, inscribed

A Nightmare

The queynte asse that the Millere rode,
I trow hys braye it ful was loode,
He sent it forthe through londes brode,
 It filled every lugge.
When that thys Millere wold chaffare,
Yerlich thys asse wold draw hys ware,
 Right lustilie he dragge.
A Tournor's asse he anes had bene,
Millare him cleped Russet – skene,
But dames y wis and men konninge,
 Cleped him Graund Humbugge.
Befelle, that thys Millere talle
Rydinge hys asse, by aventure yfalle,
Mette two knaves, sworn brothers alle,
 Pre-Raphaele Companie.
"Wala-wa" quod they "Millere, alas!
"Have pitie on us in thys cas,
"And lyfte uppe us for Luke hys Grace,
 Do thys for curtesie".
Quod Myllere, "Rose, what do you here?
"Jump uppe swote Rose, also Huntere,"
"We wol," quod they, "nede has no pere".
 N'as there such jiaperie!
Soden thys asse, most wonderlich,
Wagged hys eies, and then gan kicke,
Adoun he sent the Millare quicke,
For of hys loade he was ful sicke.
N'as there such surquedrie!

Metrical Romance
of the Man
in Brasse and his asse
by Thomas le Tailleur

Syr Isumbras

The quaint ass that the Miller rode
I trow his bray it was full loud
He sent it forthe through lands broad
 It filled every ear –
When that this Miller would traffic
Yearly this ass would draw his ware
 Right lustily he did dragg
A Turner's ass he once had been
Miller him called Russet skin
But dames so wise and men cunning
 Called him Grand Humbug.
Befell that this Miller tall
Riding his ass by chance be fall
Mett two knaves sworn brothers all
 Pre-Raphael Companie
Wala-wa quod they Miller alas
Have pity on us in this case
And lift us up for Luke his grace
 Do this for Curtesye
Quod Miller Rose [Rossetti added] what do you here
Jump up sweet Rose also Huntere
We will quod they need has no peer
 Never was there such tom-foolery
Sudden this asse most wonderfull
Wagged his eares and then began to kick
Adown he sent the Miller quicke
For of his load he was full sick
Never was there such insolent conceit and arrogance

LL 3453. *A Nightmare*

Durer, and is copied from Dürer's engraving of the *Knight, Death and the Devil*. While Dürer's engravings are an obvious source for Sandys' own developing style in illustration, and the *Knight* an appropriately well-known source on which to draw for this satire, the Meyrick outline engraving with its 'mediaeval' overtones akin to miniature painting, may also have been a source for Millais' own design.

The printing method was an adaptation of lithography with the artist's pen and ink drawing in special ink transferred to a zinc plate;[5] the process had the advantage of rapidity. 100 prints are said to have been taken and the plate afterwards lost.[6] The print appeared anonymously after the opening of the Royal Academy but the date on it must refer to the opening of the exhibition not to its publication. The drawing of armour noted above[7] is dated *May 22nd*. Ruskin's *Academy Notes* had appeared after the *Times* review of 13 May and the verses here must bear on his damning review of *Sir Isumbras*.[8] George Price Boyce saw a print in Hogarth's shop on 27 June and thought the ass 'by far the best thing in the etching in every respect'.[9] A review appeared in *The Athenaeum* in July (see below). Caricatures of various of the Pre-Raphaelite pictures then on show at the Manchester Art Treasures Exhibition, including one after Millais' *Autumn Leaves* also appeared that season.[10]

The Athenaeum[11] commented on it as an 'amusing caricature by an anonymous hand. There does not seem at the first blush much fun in drawing Mr Millais as a squat knight in drossy armour, riding a donkey (Mr Ruskin), and carrying before and behind him on his saddle two children, Mr H. Hunt and Mr Rossetti, both easily recognizable, one by his oval chivalrous thought-ful face, and the other by his round, bluff visage, hearty and bearded. But for all this there is much honest fun and harmless personality in the drawing, which is a most successful, and even favourable, rendering of the origin-al, – especially its twilight background, with its peel tower, dark netted trees, and dusky ford. The caricature verses are excellent imitations of the caricature verses appended to the real picture and so ingeniously fabri-cated to meet the exigencies of the Bartholomew Fair horse. The hatching is bold and masterly, and swept in with the freedom of a wave's curve and the force of a breaker's dash'.

PROV: Purchased from Miss Constance Sandys, daughter of the artist, by the Trustees of the Lady Lever Art Gallery, 1933 (LP 35).

EXH: Birmingham 1948, *P.R.B.* (277); Brighton and Sheffield, 1974, *Frederick Sandys* (42) repr.

Fig.81 *Study for the donkey in 'A Nightmare'*. By permission of Birmingham Museums and Art Gallery

Fig.82 Robert Hills, *Head of a donkey* (etching), published 1809. By permission of Birmingham Museums and Art Gallery

1 Information from the artist's daughter, in letter 1 March 1933. She also thought the printed verses were by her father: see also Dr W. S. Dale in *The Burlington Magazine*, May 1965, p.251, note 9, giving a Bulwer family tradition that James R. Bulwer QC was the author. Tom Taylor himself is possible (see p.131).

2 Esther Wood, 'A Consideration of the Work of Frederick Sandys', *The Artist*, Special Winter Number, Vol.XVIII, Nov. 1896, p.11.

3 *Catalogue of Drawings*, 1939, Nos 817 and 818 in the group 814–820/1906 and 983–4/1906.

4 Nos 983, 984/1906.

5 Described by Raymond Watkinson, in his introduction to the 1974 exhibition catalogue loc. cit., p.9.

6 Note in Lady Lever Art Gallery files and letter from Miss Sandys, loc. cit. A smaller facsimile was published in R. Fisher, *Catalogue of a Collection of Engravings*, 1879.

7 Birmingham, No. 983/1906.

8 See Millais, *Sir Isumbras*, note 21.

9 Surtees 1980, *Boyce Diaries*, p.17.

10 *Poems inspired by certain pictures at the Art Treasures Exhibition, Manchester by Tennyson Longfellow Smith . . . Illustrated by the Hon. Botibol Bareacres, and dedicated . . . to . . . the Immortal Buskin* (sic).

11 *The Athenaeum*, 25 July 1857, p.948, 'Fine Art Gossip'.

LL 3452. *A Nightmare*

Zincotype 33.9 × 49.2 cm (13⅜ × 19⅜ in)

Inscribed: as No. LL 3453 but the printer's line *1857* has no visible correction

The print appears blacker and harsher than the proof No. LL 3453 above.

PROV: Either acquired from Harold Rathbone, 1916,[1] or presented by Mr and Mrs Robert Benson, to W. H. Lever (1st Viscount Leverhulme) 1920 (WHL 2702). The provenance of this and No. LL 3109 below is confused. Lady Lever Art Gallery.

1 The frame has a framemaker's label of George Barnes, Bolton. An envelope was attached to the back (by Lady Lever Art Gallery staff) containing two letters, one dated 7 Nov. 1916 from H. C. (Hall Caine), Heath Row, Hampstead, giving a resumé of the subject and adding 'the above may interest you – as you have the picture and caricature'. The other is dated 27 May 1920 from Robert H. Benson presenting a copy of the print.

Fig.83 Study of armour, from S. R. Meyrick, *Engraved illustrations of ancient armour*, 1830. By permission of Birmingham Museums and Art Gallery

5620. *A Nightmare*

Zincotype 33.8 × 48.6 cm (13⁵⁄₁₆ × 19⅛ in)
Inscribed: as No. LL 3452 above, with the *1857* clear

PROV: Presented by H. E. Kidson to the Walker Art Gallery, 1917.

LL 3109. *A Nightmare*

?Zincotype 33.9 × 48.6 cm (13⅜ × 19⅛ in)
Inscribed with verses as No. LL 3453 above, with the addition in the gap at the bottom of the text between *the* and *Man* of '*Millere* and ' added after *Brasse* to read the '*Millere Man/of Brasse*'; and no printer's line:this has been added in pencil *London Published by ye Elder Smythe St Luke's Head Cornhill May 4 1857*

Perhaps a later reproduction or reprint. The print is blacker and harsher than No. LL 3453 above.

PROV: See No. LL 3452 above.[1]

1 The unframed print has no identifying marks.

Wallis, Henry (1830–1916)

Historical painter, on the fringe of the Pre-Raphaelite circle. Born London, 21 February 1830, son of Mary Ann Thomas; adopted his stepfather's surname when she remarried in 1845. Trained at Carey's and at the Royal Academy Schools, where he was admitted probationer, 7 January 1848, and student in the School of Painting, 31 March 1848; must there have met Arthur Hughes whom he seems to have known first of the circle. He also apparently studied in Gleyre's Atelier and the École des Beaux-Arts, Paris. Began exhibiting 1853. His subjects during the 1850s and early 1860s had strong literary associations and illustrated the lives and more specifically the habitations of Shakespeare, Dr Johnson, Andrew Marvell, Montaigne and Sir Walter Raleigh. His first certain picture following Pre-Raphaelite principles of style (various earlier, and later, pictures are untraced), was his *Death of Chatterton*, Royal Academy 1856 (Tate Gallery), which was an immediate and outstanding success. This was followed by the even more intensely moving *Stonebreaker*, Royal Academy 1858 (Birmingham). T. E. Plint of Leeds acquired several of his following pictures, notably *Elaine*, RoyalAcademy 1861. He became a member of the Hogarth Club, 1858. Between 1857 and 1858 he eloped with Mary Ellen (d.1861), wife of the novelist and poet George Meredith, who had sat for Chatterton. The inheritance in 1859 of property from his stepfather apparently freed him from the need to paint for an income, but he continued to exhibit occasionally, in particular with the Old Watercolour Society of which he was elected Associate 1878, and Member 1880. Travelled widely and became an important collector and expert on ceramics. Died Croydon 20 December 1916.

1640. *A Coast Scene, Sunset, Seaford*

Oil on composition board,[1] 22.5 × 35.5 cm (8⅞ × 14 in) Inscribed in ink, verso: *By / Henry Wallis / 62 Grt Russell St. / W.C.*

A (?) twentieth-century label on the back gives this title and the date 1859. The view is of the coast line at Seaford, near Newhaven, Sussex, probably from a point by the Roman fort on the high ground above Seaford Head to the south-east of the town, over the saltings towards the Martello tower, with Selsey Bill in the far distance beyond.

Seaford was the location of summer lodgings for George Meredith and his wife Mary Ellen (née Peacock) during the mid-1850s. Wallis met them about 1855 and both of them sat to him for paintings, Mary Ellen for *Fireside Reverie*, Royal Academy 1855, and Meredith for *The Death of Chatterton*, 1856 (Tate Gallery). Mary Ellen appears to have stayed again at Seaford in the summer of 1857, in 1858, before she and Wallis went abroad, and again in 1859;[2] Wallis only took his lodgings in Great Russell Street in 1859, by which time they appear to have separated.[3]

Twilight studies had already formed a part of the artist's interests, as they had for others of the Pre-Raphaelite circle. He exhibited a *Night Study* at Suffolk

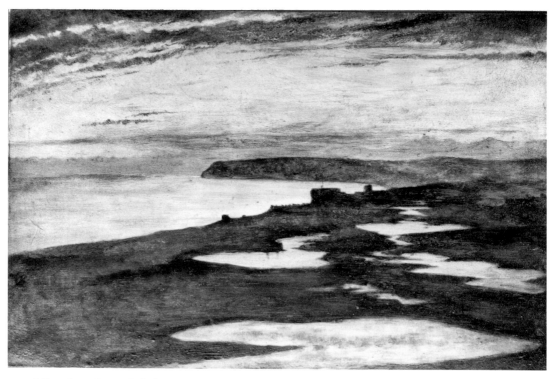

1640. *A Coast Scene, Sunset, Seaford*

Street in 1855; the dying day and sunset sky are significant parts of his *Stonebreaker* of 1857–8 (Birmingham City Art Gallery); while a picture called *Nightfall* was exhibited at the Liverpool Academy 1860, for which the present painting might well be a candidate. The same meticulous and thoughtful vision apparent in his *Stonebreaker* also pervades this study of sunset clouds sharpened with red light, sweeping across the still and shadowy landscape and reflected in the saltings.

PROV: Presented by the artist to G. P. Boyce, R. W. S.;[4] his executors' sale Christie's, 1–3.7.1897 (218), bt. C. Fairfax Murray; Mrs A. A. C. Boyce, widow of the artist, thence apparently to Dr P. R. Dodwell;[5] Miss S. Browne, Liverpool, from whom purchased by the Walker Art Gallery, 1954.

EXH: Arts Council 1984 (Hayward, Bristol, Stoke-on-Trent and Sheffield), *Landscape in Britain, 1850–1950* (34) repr.

1 Label of Charles Roberson, 51 Long Acre.
2 George Meredith in *Dictionary of National Biography*; S. M. Ellis, *George Meredith: his life and friends in relation to his Work*, 1920, pp.86, 88, 91, 94; H. F. B. Brett-Smith, *Collected Works of Thomas Love Peacock*, 1934, I, pp.clxxxix–cxci; Diane Johnson, *The True History of the First Mrs. Meredith and other Lesser Lives*, 1973, pp.90, 99, 101, 104; information from Josephine Haven, 2 June 1985.
3 Listed at that address in Royal Academy catalogues 1859–61.
4 According to Christie's sale catalogue (loc. cit.).
5 On the label cited in text.

Woolner, Thomas (1825–92)

Sculptor; a founder-member of the Pre-Raphaelite Brotherhood. Born Hadleigh, Suffolk, 17 December 1825. Trained in studio of William Behnes and entered Royal Academy Schools, as a student, 16 December 1842. He exhibited at the Royal Academy from 1843 and entered the Westminster Hall sculpture competition 1844. He was a friend of the sculptors John Hancock and Bernard Smith, and met D. G. Rossetti about 1847 and through him F. G. Stephens, Holman Hunt and Millais. He visited Paris in 1848 and was impressed by Ingres. His concern to combine classical simplicity with exhaustive natural detail led to his being invited to become the sole sculptor member of the Pre-Raphaelite Brotherhood, 1848. The circle met at his studio in Stanhope Street. He also wrote poetry and made the acquaintance of Tennyson, 1848 and Coventry Patmore, 1849 (the latter gained Ruskin's support for the Brotherhood in 1851). He contributed poetry to *The Germ*, 1850, and published a first volume of poems in 1863. He produced a series of portrait medallions of contemporary poets and philosophers (Patmore, Tennyson, Wordsworth, Carlyle), but failure to gain a commission for the Wordsworth Monument, 1852, determined him to emigrate to the Australian gold fields to raise money. He embarked for Melbourne with Bernard Smith and Edward Latrobe Bateman, July 1852, but failed in his project and turned to sculpting medallion portraits in Melbourne and Sydney before returning to London, October 1854 on the strength of a hoped-for but abortive major Australian commission. He made a new series of medallions of the poets, etc., was commissioned for sculpture for the Oxford Museum, 1857, and Llandaff Cathedral, 1858, and gained patrons in the Trevelyans, Thomas Fairbairn, Thomas Combe, etc., leading to a successful career as portrait and monumental sculptor. He was a founder-member of the Hogarth Club, 1858. His friendship with his contemporary Munro (q.v.) terminated finally by 1862. He married Alice Waugh 1864, later becoming Holman Hunt's brother-in-law (twice over), but the latter's second marriage ended their friendship. After a studio in Rutland Street, he bought a house, 29 Welbeck Street in 1861, where he had studios built; later also had country retreats in Sussex. From 1871, when elected ARA, he gained many major public commissions; Royal Academician 1875; Professor of Sculpture at the Royal Academy, 1877–9. He was also a collector and amateur dealer, owning for example, Millais' *Isabella* (No. 1637 above). Died London 7 October 1892.

4110. *Thomas Carlyle*
Plaster relief, 22.5 cm diam. (9 in)

Woolner is recorded as working on two medallion portraits of Carlyle, in 1851 and in 1855.[1] The sitting for the first was arranged through the poet Coventry Patmore in January 1851 and Carlyle wrote to the sculptor in May that 'The Medallion is fairly set up; and excites the approbation of a discerning public – as it deserves to

4110. *Thomas Carlyle*

do'.[2] The second medallion (as with a similar one of Tennyson), appears to be a re-working of the earlier design and not taken from a new sitting from Carlyle who had by then grown a beard. It is mentioned in a letter to W. Bell Scott of May 1855:[3] 'I have made a new one of him [Tennyson], much better than the last; also a new Carlyle, better than the old one. Carlyle is extremely pleased with it, and says it is the best likeness of him that has ever been done.' Woolner exhibited at the Royal Academy in 1852 (1396), a medallion portrait in unspecified material, which is presumably the first pattern, a portrait in 1856 (1370) without description, which might be a plaster of the second pattern, and in 1857 (1370) a bronze medallion, which might be a cast of the second pattern (also at the 1857 Royal Academy was a bronze medallion of Tennyson).[4]

One type, which may be the earlier pattern of 1851, is represented by a vigorously rugged and realistic portrait in plaster, unsigned, in the Mount Allison University, New Brunswick.[5] Ben Read makes the point that this can be seen as representative of the realistic style which drew Woolner into the circle of Rossetti and Holman Hunt at the foundation of the Brotherhood.[6] Complicating this assessment, however, is the engraved reproduction of this pattern, perhaps sharper in its detail, dark in colour and inscribed and dated 1855, which is reproduced in the *Magazine of Art*, 1900 (p.76).

A second type, represented by the present plaster medallion (of which there is another example in the Scottish National Portrait Gallery, Edinburgh, copied in turn for the National Portrait Gallery, London), has a more formal stylisation which seems to represent a thorough re-working.[7]

It may have been that Woolner took up his original plaster in 1855 and sharpened it up for possible casting

9350. *John Torr*

8236. *James Aikin*

in bronze, for which, as suggested by Timothy Stevens,[8] its rugged style is entirely suitable, before executing an entire remodelling. A commercial, somewhat simplified, version of the first type, with the 1855 inscription, also exists.[9]

PROV: Given to Miss Helen Martineau by her mother, 9 Sep. 1906;[10] and presented by her to the Walker Art Gallery, 1942.

1 Woolner, pp.336, 337 (list).
2 Ibid, pp.11–12.
3 W. Bell Scott 1892, II, p.29.
4 In the Woolner studio exhibition and sale, 15–28 Feb. 1913, were only two appropriate items:
 112 Carlyle, bronze medallion, 1855.
 182 Thomas Carlyle, original plaster medallion.
5 Mary Mellish Archibald Memorial Library, Mount Allison University, New Brunswick, Canada (photograph Conway Library, Courtauld Institute); see Richard Ormond, *Early Victorian Portraits*, National Portrait Gallery, 1973, I, p.91.
6 Ben Read, oral opinion to the compiler, Feb. 1987.
7 See Ormond, loc. cit.; and Ben Read oral opinion to the compiler, Feb. 1987.
8 In a discussion with the compiler, Feb. 1987.
9 An example in a private collection is stamped by the Lion Foundry. (Information from Ben Read and photograph Conway Library).
10 MS label on backboard.

9350. *John Torr*

Marble term bust, 61.3 cm high (24⅛ in)
Incised: T. WOOLNER SC./R.A./LONDON. 1879[1] and on the front
JOHN TORR / M.P. FOR LIVERPOOL

John Torr (1813–80), MP for Liverpool in the Conservative interest, 1873. A native of Lincolnshire, he joined T. & H. Littledale, Liverpool merchants, in 1835 and settled at Eastham and later at Carlett Park, Eastham (since demolished).

A plaque attached to the back reads:

BORN AT THE GROVE, RIBY, LINCS. 13TH OCT., 1813 / SECOND SON OF WILLIAM AND CATHERINE TORR / T & H LITTLEDALE & CO. LIVER-POOL, 8TH JULY, 1835 / MARRIED 29TH JANUARY, 1845 / TOOK BANKFIELDS EASTHAM, FEBRUARY, 1847 / BOUGHT CARLETT PARK, NOVEMBER, 1849 / FOUNDATION STONE OF HOUSE 8TH JULY, 1859 /

FOUNDED HULL SEAMEN'S AND GENERAL ORPHAN ASYLUM /
(THANK OFFERING FOR 50TH BIRTHDAY, 1863) / ELECTED M.P. FOR
LIVERPOOL 7TH FEBRUARY, 1873 / RE-ELECTED 5TH FEBRUARY, 1874 /
VISCOUNT SANDON (C) 20,206 J. TORR (C) 19.763* / *THE THIRD
LARGEST NUMBER OF VOTES IN GENERAL ELECTION / INITIATOR
(22ND NOV. 1863 AT CARLETT) AND FIRST TREASURER OF THE
LIVERPOOL BISHOPRIC SCHEME / DIED AT CARLETT FRIDAY 16TH
JANUARY, 1880 / BURIED AT RIBY

Characteristic of the intellectual realism of Woolner's male portraits with its clear-cut perception of bone structure beneath the taut surface emphasising the individual character of the sitter.

The plaster bust was in the artist's studio collection in 1913.[2]

PROV: Cyril Humphris Ltd, London, from whom purchased by the Walker Art Gallery, 1978.

1 Woolner, p.343 (list).
2 *Studios of the late Thomas Woolner R.A., 29 Welbeck Street W,* 15 Feb. – 28 Feb. 1913, privately printed, No. 77; items were for sale (from a copy of the catalogue kindly supplied to the compiler by Ben Read).

8236. *James Aikin*
Marble term bust, 70 cm high (27½ in)
Incised: T. WOOLNER. SC. LONDON 1879 and on the front
JAMES AIKIN 1792–1878

James Aikin (1792–1878), merchant and shipowner in Liverpool, where he settled from his native Dumfries in 1806. A Town Councillor in the Liberal interest, JP and active in philanthropy and the arts.[1]

A memorial to him by public subscription was proposed in July 1878, and a marble bust, rather than a statue, was determined on in accordance with the wishes of his family.[2]

One of two portraits by John Ewart Robertson, 1873, is in the Walker Art Gallery.[3]

PROV: Presented to Liverpool Corporation for the Town Hall by a body of subscribers, 21 Nov. 1879;[4] transferred to the care of the Walker Art Gallery, 1972 (Liverpool Town Hall).

1 *Liverpool Daily Post*, 8 July 1878: and see portrait by J. E. Robertson in Walker Art Gallery Catalogue, *Merseyside Painters, People & Places*, 1978, p.184.
2 Liverpool *Mercury*, 30 July 1878, recording a meeting at the Town Hall chaired by the Mayor: subscriptions were to be limited to 2 gns per person and the bust was to be by an 'eminent sculptor'; Woolner, p.343 (list).
3 A portrait presented to the Sailors' Home, 1859 by the Magistrates was destroyed by fire 1860 (Liverpool *Mercury*, loc. cit.).
4 Town Council, Minutes for 10 Dec. 1879, reporting a letter from Henry A. Bright, Secretary and Thomas Mills, Hon. Treasurer; Finance and Estate Committee, Minutes for 12 Dec. 1879.

Appendices

Abbreviations

(The entries up to that date are based on William E. Fredeman, *Pre-Raphaelitism, A Bibliocritical Study*, 1965).

Arts Council 1979, *Millais*
The Drawings of John Everett Millais, Arts Council tour (Bolton, Brighton, Sheffield, Cambridge, Cardiff), 1979. Catalogue by Malcolm Warner.

Birmingham 1947 *P.R.B.*
The Pre-Raphaelite Brotherhood, City Museum and Art Gallery, Birmingham, 1947 (Introduction by Mary Woodall).

Bornand 1977
Odette Bornand, editor, *The Diary of W. M. Rossetti, 1870–1873*, 1977.

Brook Street Gallery 1922
Works of the late R. B. Martineau, London, Brook Street Gallery, Jan. 1922.

Bryson and Troxell 1976
John Bryson, editor, in association with Janet Troxell, *Dante Gabriel Rossetti and Jane Morris: Their Correspondence*, 1976.

Burlington Fine Arts Club 1883, *D.G.R.*
Pictures, Drawings, Designs and Studies by the Late Dante Gabriel Rossetti, London, Burlington Fine Arts Club, 1883 (Introduction by H. Virtue Tebbs).

Cosmopolitan Club 1869
Works by the late Robert B. Martineau On view at the Cosmopolitan Club, London, 30 Charles Street, Berkeley Square, n.d. (1869).

Dalziel
The Brothers Dalziel, *A Record of Fifty Years' Work . . . 1840–1890*, 1901.

Doughty and Wahl
Oswald Doughty and John Robert Wahl, editors, *Letters of Dante Gabriel Rossetti*, 4 Vols, 1965–7 (Oxford University Press).

Fennell 1978
Francis L. Fennell Jr., editor, *The Rossetti-Leyland Letters*, 1978.

Fine Art Society 1881, *Millais*
The Collected Works of John Everett Millais, London, Fine Art Society, 1881 (accompanying *Notes* by Andrew Lang).

Fine Art Society 1886, *Hunt*
The Pictures in the Holman Hunt Exhibition, London, Fine Art Society, 1886 (accompanying *Notes* by A. G. Crawford).

Fredeman 1975
William E. Fredeman, editor, *The P.R.B. Journal, William Michael Rossetti's Diary of the Pre-Raphaelite Brotherhood 1849–1853*, 1975.

Glasgow 1907, *Hunt*
Pictures and Drawings by William Holman Hunt, Glasgow Art Gallery and Museum, 1907.

Grafton Galleries 1897, *F.M.B.*
The Works of Ford Madox Brown, Grafton Galleries, 1896–7 (Introduction by Ford Madox Hueffer).

Grosvenor Gallery 1886, *Millais*
The Works of Sir John Everett Millais, 1886 (with notes by F.G. Stephens).

Hueffer
Ford Madox Hueffer, *Ford Madox Brown: A Record of His Life and Work*, 1896.

Hunt 1886
William Holman Hunt, 'The Pre-Raphaelite Brotherhood: A fight for Art', *Contemporary Review*, 1886, pp.471–88, 737–50, 820–33.

Hunt 1887
William Holman Hunt, 'Painting the Scapegoat', *Contemporary Review*, 1887, pp.21–38, 206–20.

Hunt 1905
William Holman Hunt, *Pre-Raphaelitism and the Pre-Raphaelite Brotherhood*, 2 Vols, 1905 (2nd edition 1913, with additions).

Leicester Galleries 1906, *Hunt*
The Collected Works of W. Holman Hunt, London, Leicester Galleries, Oct.–Nov. 1906 (with Prefatory Note by Sir William Blake Richmond).

Leicester Galleries 1909, *F.M.B.*
Collected Work of Ford Madox Brown, London, Leicester Galleries, June–July 1909.

Liverpool Bulletin* 1967, *Millais
Mary Bennett, 'Footnotes to the Millais Exhibition', Walker Art Gallery, *Liverpool Bulletin* 12, 1967, p.33f.

Liverpool Bulletin* 1969, *Hunt
Mary Bennett, 'Footnotes to the Holman Hunt Exhibition', Walker Art Gallery, *Liverpool Bulletin* 13, 1968–70, p.27f.

Liverpool 1907, *Hunt*
Collective Exhibition of the Art of William Holman Hunt, Walker Art Gallery, Liverpool, Feb.–March 1907.

Liverpool and A.C. 1964, *F.M.B.*
Ford Madox Brown, 1821–1893, Walker Art Gallery, Liverpool, 1964, City Art Gallery, Manchester, 1964–5, and City Museum and Art Gallery, Birmingham, 1965: Arts Council exhibition (Catalogue by Mary Bennett).

Liverpool and R.A. 1967, *Millais*
Millais, P.R.B./P.R.A., Royal Academy and Walker Art Gallery, Liverpool, 1967 (Catalogue by Mary Bennett).

Liverpool and V. & A. 1969, *Hunt*
William Holman Hunt, Walker Art Gallery, Liverpool and Victoria & Albert Museum, London, 1969 (Catalogue by Mary Bennett).

Manchester 1906, *Hunt*
The Collected Works of W. Holman Hunt, City Art Gallery, Manchester, 1906 (Introduction by J. E. Phythian).

Manchester 1911, *P.R.B.*
Loan Exhibition of Works by Ford Madox Brown and the Pre-Raphaelites, City Art Gallery, Manchester, Autumn 1911.

Marillier 1899
H. C. Marillier, *Dante Gabriel Rossetti: An Illustrated Memorial of His Art and Life*, 1899.

J. G. Millais
John Guille Millais, *The Life and Letters of Sir John Everett Millais*, 2 Vols, 1899.

Newcastle 1971, *D.G.R.*
Dante Gabriel Rossetti, Laing Art Gallery, Newcastle upon Tyne, Oct.–Nov. 1971 (Catalogue by Alastair Grieve).

Paris 1972, *P.R.B.*
La peinture romantique anglaise et les pré-raphaélites, Paris, Petit Palais, 1972.

Piccadilly 1865, *F.M.B.*
The Exhibition of WORK, and other Paintings, by Ford Madox Brown, 191 Piccadilly, London, 1865 (Catalogue by the artist).

Pointon 1979
Marcia Pointon, *William Dyce 1806–1864: A Critical Biography*, 1979.

Port Sunlight 1948, *P.R.B.*
Centenary Exhibition of works by The Pre-Raphaelites – Their Friends and Followers, Lady Lever Art Gallery, Port Sunlight, Cheshire, June–Aug. 1948.

Pre-Raphaelite Papers 1984
Leslie Parris, editor, *Pre-Raphaelite Papers* (articles published in conjunction with the Tate Gallery exhibition), 1984.

W. M. Rossetti 1889
William Michael Rossetti, *Dante Gabriel Rossetti as Designer and Writer*, 1889.

W. M. Rossetti 1895
William Michael Rossetti, editor, *Dante Gabriel Rossetti, His Family Letters with a Memoir*, 1895, 2 Vols, 1895.

W. M. Rossetti 1903
William Michael Rossetti, editor, *Rossetti Papers, 1862–1870*, 1903.

Royal Academy and Birmingham 1973, *D.G.R.*
Dante Gabriel Rossetti, Painter and Poet, Royal Academy, London and City Museum and Art Gallery, Birmingham, 1973 (Introduction by John Gere, Catalogue by Virginia Surtees).

Royal Academy 1883, *D.G.R.*
Works ... Including a Special Selection from the Works of John Linnell and Dante Gabriel Rossetti, Royal Academy, London, 1883.

Royal Academy 1898, *Millais*
Works by the Late Sir John Everett Millais, Royal Academy, London, 1898.

Ruskin
E. T. Cook and A. D. O. Wedderburn, editors, *The Works of John Ruskin: Library Edition*, 39 Vols, 1904–12.

Russell Place 1857, *P.R.B.*
(Pre-Raphaelite Exhibition), 4 Russell Place, Fitzroy Square, London 1857.

W. Bell Scott 1892
W. Minto, editor, *The Autobiographical Notes of the Life of William Bell Scott*, 2 Vols, 1892.

Seddon
(J. P. Seddon), *Memoir and Letters of the Late Thomas Seddon, Artist. By his Brother*, 1858.

A. C. Sewter
A. C. Sewter, *The Stained Glass of William Morris and his Circle*, Vol. I, 1974, Vol. II, Catalogue, 1975.

Spielmann 1898
Marion H. Spielmann, *Millais and His Works: With Special Reference to the Exhibition at the Royal Academy*, 1898.

Staley 1973
Allen Staley, *The Pre-Raphaelite Landscape*, 1973.

F. G. Stephens 1860
(F. G. Stephens), *William Holman Hunt and His Works: A memoir of the Artist's Life, with Descriptions of His Pictures*, 1860.

Surtees 1971
Virginia Surtees, *The Paintings and Drawings of Dante Gabriel Rossetti (1828–1882), A Catalogue Raisonné*, 2 Vols, 1971.

Surtees 1980, *Boyce Diaries*
Virginia Surtees, editor, *The Diaries of George Price Boyce* (reprint from *Old Water-Colour Society's Club Annual Volume*, xix 1941: A. E. Street, editor, 'George Price Boyce with extracts from G. P. Boyce's Diary, 1851–75').

Surtees, *Diary*
Virginia Surtees, editor, *The Diary of Ford Madox Brown*, 1981.

Tate Gallery 1913, *P.R.B.*
Works by Pre-Raphaelite Painters from Collections in Lancashire, National Gallery, Millbank, July–Sep. 1913, and at Bath, Nov.–Dec. 1913.

Tate Gallery 1948, *P.R.B.*
The Pre-Raphaelite Brotherhood, A Centenary Exhibition, National Gallery, Millbank, Sep. 1948.

Tate Gallery 1984, *P.R.B.*
The Pre-Raphaelites, Tate Gallery, 1984 (Introduction by Alan Bowness; Catalogue by Alastair Grieve, Benedict Read, Deborah Cherry, David Cordingly, Judith Bronkhurst, John Christian, Leslie Parris, Mary Bennett, Malcolm Warner, Robin Hamlyn and Ronald Parkinson).

Vaughan 1979
William Vaughan, *German Romanticism and English Art*, 1979.

Woolner
Amy Woolner, *Thomas Woolner, R.A., Sculptor and Poet: His Life in Letters*, 1917.

Acquisition Chronology

Walker Art Gallery

HUNT, W. HOLMAN, after: *Finding of the Saviour in the Temple* (engraving) Bequeathed 1878

WOOLNER, THOMAS: *James Aikin* Presented by subscribers to Liverpool Town Hall 1879 (from artist) (transferred to care of Walker Art Gallery 1972)

ROSSETTI, D. G.: *Dante's Dream* Bought 1881 (from artist)

ROSSETTI, D. G.: *Jane Morris* Bought 1883

MILLAIS, J. E.: *Isabella* Bought 1884

HUNT, W. HOLMAN: *Triumph of the Innocents* Bought 1891 (from artist)

BROWN, F. MADOX: *Hugh de Balsham* Presented 1894

BROWN, F. MADOX: *St Jude* Presented 1894

MILLAIS, J. E.: *Martyr of the Solway* Presented 1895

BRETT, JOHN: *Trevose Head* Bought 1900 (from artist)

BROWN, F. MADOX: *Coat of Many Colours* Presented 1904

HUNT, W. HOLMAN: *Edward Lear* Presented 1907 (by Hunt)

HUNT, W. HOLMAN: *R. B. Martineau* Presented 1907 (by Hunt)

HUGHES, ARTHUR: *'As You like It'* Bequeathed 1908

SANDYS, FREDERICK: *Helen of Troy* Bequeathed 1908

SANDYS, FREDERICK: *Kittie* Presented 1911

HUNT, W. HOLMAN: *Nijmi* Presented 1912

SANDYS, FREDERICK: *A Nightmare* Presented 1917

BRETT, JOHN: *The Stonebreaker* Bequeathed 1918

BRETT, JOHN: *Rocks, Scilly* Presented 1919

MILLAIS, J. E.: *The Good Resolve* Presented 1924

HUGHES, ARTHUR: *Sir Galahad* Presented 1925

MILLAIS, J. E.: *Rosalind in the Forest* Presented 1925

HUNT, W. HOLMAN: *Harold Rathbone* Bequeathed 1927

ROSSETTI, D. G., after: *Dante's Dream*, drawing Bought 1940

MARTINEAU, R. B.: *Christians and Christians*, and sketches and drawings for (4) Presented 1942

WOOLNER, THOMAS: *Thomas Carlyle* Presented 1942

HUNT, W. HOLMAN: *Eve of St Agnes* Bequeathed 1948

HUNT, W. HOLMAN: Study for *Finding of the Saviour in the Temple* Bequeathed 1949

HUNT, W. HOLMAN: *Haunt of the Gazelle* Bequeathed 1952

WALLIS, HENRY: *Coast Scene, Sunset, Seaford* Bought 1954

HUGHES, ARTHUR: *Demon Lover* Presented 1960

INCHBOLD, J. W.: Study of *Houses* Bought 1964

MILLAIS, J. E.: Study of *a girl's head* Bequeathed 1965

MILLAIS, J. E.: Studies from *Bonnard* (4) Bought 1967

MILLAIS, J. E.: *Vanessa* (engraving) Presented 1967

HUNT, W. HOLMAN: Studies for *Triumph* (2) Bought 1967

HUNT, W. HOLMAN: Study for *Triumph* Bought 1969

MARSHALL, P. P.: *Donald Currie* Bought 1970

BROWN, F. MADOX: *Millie Smith* Bought 1972

BROWN, F. MADOX: Study for *Wycliffe* Bought 1972

RUSKIN, JOHN: *Coniston Old Hall* Bought 1972

MUNRO, ALEXANDER: *Mrs George Butler* (2) Presented 1975

MILLAIS, J. E.: *Self-portrait* Presented 1977

WOOLNER, THOMAS: *John Torr* Bought 1978

MILLAIS, J. E., after: *Margaret Wilson* (engraving) Presented 1978

MILLAIS, J. E.: *Ferdinand lured by Ariel* (drawing) Presented 1983

BOYCE, G. P.: *Sandpit near Abinger* Bequeathed 1984

BROWN, F. MADOX: Portrait studies of his family (8) Bought 1984

BROWN, F. MADOX: Design for a *'Lohengrin' Piano* Bought 1984

BROWN, F. MADOX, studio of: *St Oswald receiving St Aidan* Bought 1984

BROWN, F. MADOX, circle of: Study of *hawthorn berries* Bought 1984

BROWN, F. MADOX: Household Account Book Bought 1984

BROWN, F. MADOX, after: *The Footpath Way* (engraving) Presented 1985

BROWN, F. MADOX: *Waiting* Bought 1985

BROWN, F. MADOX: *St Jerome* Bought 1985

HUNT, W. HOLMAN: Studies for *Eve of St Agnes, etc.* Bought 1985

HUNT, W. HOLMAN: Studies for *The Scapegoat* (2) Bought 1985

HUNT, W. HOLMAN: Study for *May Morning on Magdalen Tower* Bought 1985

BROWN, F. MADOX: *Nehemiah* Bought 1987

Pictures in the Walker Art Gallery reascribed

MILLAIS, J. E.: *Ideal Portrait* (now British School 2830)

MILLAIS, J. E.: *Matilda in the Garden of Delight* (now British School 2503)

Sudley Art Gallery

Acquired by George Holt

DYCE, WILLIAM: *The Garden of Gethsemane* Bought 1878

MILLAIS, J. E.: *Landscape, Hampstead* Bought 1878

MILLAIS, J. E.: *Ferdinand lured by Ariel* Bought 1883

MILLAIS, J. E.: *Vanessa* Bought 1885

HUNT, W. HOLMAN: *Finding of the Saviour in the Temple* Bought 1887

ROSSETTI, D. G.: *Two Mothers* Bought 1888

Lady Lever Art Gallery

Acquired by W. H. Lever, 1st Viscount Leverhulme, and the Trustees of the Lady Lever Art Gallery

MILLAIS, J. E.: *The Nest* Bought 1896

MILLAIS, J. E.: *Little Speedwell's Darling Blue* Bought 1896

MILLAIS, J. E.: *The Black Brunswickers* Bought 1898

MILLAIS, J. E.: Engravings after (4) Bought, uncertain, ?1898

BROWN, F. MADOX *Cromwell on his Farm* Bought 1899

MILLAIS, J. E.: *Sir Isumbras*, oil and watercolour Bought 1913

MILLAIS, J. E.: *Lingering Autumn* and engraving after Bought 1913

MILLAIS, J. E., after: *Bubbles* (engraving) Bought 1914

BROWN, F. MADOX, studio of: *St Oswald receiving St Aidan* Bought 1915

MILLAIS, J. E.: *An Idyll of 1745* Bought 1915

BROWN, F. MADOX, studio of: *Baptism of St Oswald* Bought 1916

MILLAIS, J. E.: Study for *Sir Isumbras* Bought 1916
SANDYS, FREDERICK: *A Nightmare* Bought 1916
BROWN, F. MADOX: *Windermere* Bought 1917
HUGHES, ARTHUR: *A Music Party* Bought 1917
ROSSETTI, D. G.: *Sibylla Palmifera* Bought 1917
BROWN, F. MADOX: *The Nosegay* Bought 1918
HUNT, W. HOLMAN: *May Morning on Magdalen Tower* Bought 1919
ROSSETTI, D. G.: *Pandora* Bought 1919
SANDYS, FREDERICK: *A Nightmare* Presented 1920
ROSSETTI, D. G.: *The Blessed Damozel* Bought 1922
HUNT, W. HOLMAN: *The Scapegoat* Bought 1923
MILLAIS, J. E.: *Alfred, Lord Tennyson* Bought 1923
BROWN, F. MADOX: *Cordelia's Portion* Bought 1924
MILLAIS, J. E.: Study for *The Black Brunswickers* Bought 1926
SANDYS, FREDERICK: *A Nightmare* Bought 1933
MILLAIS, J. E., after: *'For the Squire'* (engraving) Presented 1985
(Bought by 1st Viscount Leverhulme ? 1898)
MILLAIS, J. E., after: *Lilacs* (engraving) Presented 1985 (Bought by 1st Viscount Leverhulme 1898)
MILLAIS, J. E.: *Spring (Apple Blossoms)* Bought 1986 (Bought by 1st Viscount Leverhulme 1920)

Pictures formerly in the collection of the 1st Viscount Leverhulme and items sold from the Lady Lever Art Gallery

Abbreviations:

AG Anderson Galleries, New York
B Bonham's, London
Bt. Bought
C Christie's, London
KFR Knight, Frank and Rutley: 9/17 November 1925 at The Bungalow and Rivington Hall; 15/18 June 1926, London, pictures removed from Cheshire
LP Inventory prefix
WHL Inventory prefix

BROWN, F. MADOX

Supper at Emmaus (WHL 4746): Bt. 1894.
Design for 8 Saxon Kings (WHL 2639): Bt. 1915, sold KFR 15/18 June 1926 (203).
Chaucer Reading poems, pencil (–): Bt. 1919, sold KFR 15/18 June 1926 (204).
Jacob Foscari in Prison, watercolour (WHL 4703): Bt. 1923, sold C 6 June 1958 (8).

BROWN, F. MADOX, after (engraving)
Rhead, *Romans Building Manchester* (WHL 2670): Bt. 1915.

HUNT, W. HOLMAN

The Mosque As Sakreh-Interior, watercolour (WHL 1513): Bt. 1897.
Portrait of Etty, pencil (WHL 2647): Bt. about 1915, sold KFR 15/18 June 1926 (341).

MILLAIS, J. E.

A Visit to a Dungeon, watercolour (WHL 1665): Bt. ?, sold KFR 15/18 June 1926 (335).
The Violet's Message (WHL 1658): Bt. 1897, sold C 6 June 1958 (138).
The Olden Style (WHL 1656): Bt. 1902, sold KFR 15/18 June 1926 (89).
Wedding Cards: Jilted (WHL 1655): Bt. 1902, sold C 6 June 1958 (139).
Contemplation (WHL 698): Bt. 1910, sold C 6 June 1958 (137).
Cymon and Iphigenia (WHL 2799): Bt. 1916.
Mary, Queen of Scots, watercolour (WHL 3062): Bt. 1916, sold AG 2/4 March 1926 (236).

Queen Esther (WHL 3312): Bt. 1917, sold AG 17/19 February 1926 (180).
An Indian (WHL 3508): Bt. 1918, sold KFR 15/18 June 1926 (90).
Caller Herrin' (WHL 3691): Bt. 1918, sold AG 17/19 February 1926 (179).
Figures on a Seashore, pen and ink (WHL 4173): Bt. 1920.
Drawing (–): Bt. 1913.
Head of a Girl, profile (Life class at Royal Academy) (WHL 4176): Bt. 1920, sold ?AG 17/19 February 1926 (181).
Royal Procession in 17th century, silverpoint (WHL 4784): Bt. 1924, sold AG 2/4 March 1926 (235).
Romans carrying off Sabine Women, pen and ink (WHL 4785): Bt. 1924, sold AG 2/4 March 1926 (237).
Preaching to the Roundheads, watercolour (WHL 4786/LP20): Bt. 1924, sold C 6 June 1958 (72).

MILLAIS, J. E., attributed to
The Novice (WHL 3184): Bt. 1917.
Rosalind and Celia (WHL 3311): Bt. 1917.

MILLAIS, J. E., after (engravings)
Murthly Moss (WHL 1613): Bt. ?1889, sold B 16 April 1961.
W. E. Gladstone, 1877 (WHL 1567): Bt. ?1895.
The Nest (6 proofs) (WHL 1618/LP 15): Bt. 1896, 1 item sold B 16 April 1961, remainder untraced.
Cherry Ripe (WHL 1581): Bt. ?1898, sold B 16 April 1961.
Christmas Eve (–): Bt. ?1898.
Caller Herrin' (WHL 1603): Bt. ?1898, sold B 16 April 1961.
Little Miss Muffet (WHL 1607): Bt. ?1898, sold KFR 9/17 November 1925 (186).
Lady Peggy Primrose (WHL 1608): Bt. ?1898.
Stella (WHL 1609): Bt. ?1898.
Vanessa (WHL 1612): Bt. ?1898.
Sir John Bright (WHL 1619): Bt. ?1898.
W. E. Gladstone and Grandson (May 1905 inventory).

ROSSETTI, D. G.
Head of a Lady, brown chalk (WHL 2886): Bt. 1916, sold C 6 June 1958 (81, part) (Surtees 1971, No. 564).
Head of a Lady, brown chalk (WHL 2887): Bt. 1916, sold C 6 June 1958 (81, part) (Surtees 1971, No. 567).
Christmas Carol (WHL 3150): Bt. 1917 (Surtees 1971, No. 195).
Venus Verticordia, watercolour (WHL 3151): Bt. 1917 (Surtees 1971, No. 173 R.I.).
Death of Breuze, watercolour (WHL 3152): Bt. 1917, sold AG 2/4 March 1926 (270) (Surtees 1971, No. 101).
Fight for a Woman, watercolour (WHL 3153): Bt. 1917, sold AG 2/4 March 1926 (267) (Surtees 1971, No. 180).
The Salutation of Beatrice, pen and ink (WHL 3154): Bt. 1917, sold AG 2/4 March 1926 (272) (Surtees 1971, No. 116A).
Head of Miss Wilding, chalk (WHL 3700): Bt. 1918, sold AG 2/4 March 1926 (271).
Magdalen with pot of ointment (WHL 4195): Bt. 1920, sold ? (Surtees 1971, No. 250A).
Woman holding a crystal, pastel (WHL 4097): Bt. 1920, sold AG 2/4 March 1926 (268) (Surtees 1971, No. 237).
Head of a Lady, red chalk (WHL 4098): Bt. 1920, sold AG 2/4 March 1926 (269).
Monna Rosa (WHL 4099): Bt. 1920, sold KFR 9/17 November 1925 (1147) (Surtees 1971, No. 153).
A Sea Spell (WHL 4392): Bt. 1922, sold AG 17/19 February 1926 (238) (Surtees 1971, No. 248).
The Lady of Pity (WHL 4714): Bt. 1923, sold AG 17/19 February 1926 (237).

General Index

To artists, subjects, locations and sitters; owners, dealers and funding; early exhibitions and societies, and reviewers; artists' colourmen; and chief sources (see also Abbreviations, pp. 196–7).